The Poetic Vision:
American Tonalism

Cover: Birge Harrison, *Late Winter Afternoon* (detail of Cat. 12)

Published in the United States of America in 2005 by
Spanierman Gallery, LLC, 45 East 58th Street, New York, NY 10022.

Library of Congress Control Number: 2005934825

ISBN 0-945936-74-5

Design: Marcus Ratliff Inc.
Composition: Amy Pyle
Photography: Roz Akin
Lithography: Meridian Printing

The Poetic Vision: American Tonalism

Ralph Sessions

Jack Becker

Nicolai Cikovsky, Jr.

Ellen Paul Denker

Diane P. Fischer

William H. Gerdts

Carol Lowrey

Linda Merrill

Lisa N. Peters

November 12, 2005 – January 7, 2006

Spanierman Gallery, LLC

www.spanierman.com

45 East 58th Street New York, NY 10022 Tel (212) 832-0208 Fax (212) 832-8114
ralphsessions@spanierman.com Monday through Saturday, 9:30 to 5:30

Contents

Foreword

IN THE FALL OF 2003 an exhibition entitled *George Inness and the Visionary Landscape* was held at the National Academy of Design. I went to see it four or five times, and each time I was amazed by how well attended it was and how passionate was the response of attendees. The ability of the audience to share with Inness his search for an inner truth in the "reality of the unseen," to connect with the spirituality of his art, was something new.

At Spanierman Gallery, I had also observed a similar growing interest in Tonalism. It dawned on me that over the course of ten years we had sold fifty paintings by the previously obscure artist Charles Warren Eaton, who had worked in a studio next to Inness's and, later in his career, shared a studio in Montclair, New Jersey, with Inness's son. I also saw a new receptiveness to such artists as J. Francis Murphy, Bruce Crane, and Leonard Ochtman. This shift, it seems, reflects the pluralism of today. In art it is manifested in the view that old hierarchies are now invalid and, therefore, each work and artist must be assessed on an individual basis. Such an attitude left space for the growing awareness of Tonalism to develop.

That the Tonalist movement was a distinct part of the American art scene of its day has also spurred a growing attention to it, spawning an attempt to understand how and why it emerged. Scholarship on artists such as Inness and Henry Ward Ranger have further opened up avenues for future inquiries.

In addition, the desire today for a genuine spiritual experience that goes beyond words and slogans also underlies the increased focus on art that expresses the ineffable and delves into truths beyond appearances. Only a few modernist artists, Mark Rothko among them, have approached the Tonalists in this emphasis.

Because the term "Tonalism" has been so broadly applied to such a wide range of works, coming to terms with it has been an enormous challenge; this challenge has been met by Ralph Sessions, the organizer of this exhibition. Under Ralph's guidance, this catalogue and the show it accompanies provide the broadest understanding of the movement thus far, exploring both its nature in general and some of its particular manifestations, in painting, poetry, photography, and the decorative artists. I would like to thank Ralph for his unfailing enthusiasm and diligence in coordinating this project, along with the rest of the Spanierman Gallery staff who played critical roles in this exhibition, whose genesis has been long and painstaking. We hope it will provide a significant eye-opening contribution to the continuing dialogue of the history of American art.

IRA SPANIERMAN

Acknowledgments

For too long, American Tonalism has not received the attention it deserves. Some significant exhibitions and publications on the subject have appeared since 1970, but, all in all, public recognition of Tonalism lags far behind that of other nineteenth- and early-twentieth-century American art movements, such as the Hudson River School and American Impressionism. I am therefore particularly pleased to have had the opportunity of organizing this exhibition and catalogue, which together offer a reevaluation of previous scholarship and new perspectives on this much-neglected topic.

Spanierman Gallery has long been involved with Tonalist painting. Its records and resources created a strong foundation for this project, which has been a group effort from the beginning. Ira Spanierman provided a depth and knowledge from his years of experience with Tonalism that played a vital role in the initiation and development of this endeavor. William H. Gerdts offered his extensive expertise and key catalogue essays, along with his constant support and advice. In addition to her contributions as an author, Lisa N. Peters oversaw all aspects of the editorial process and was a valuable advisor. Carol Lowrey, the author of the entries, also provided essential consultation.

I must also thank the other catalogue authors, whose essays I briefly summarize in the Introduction, as well as the lenders to the exhibition. We are fortunate to have the participation of museums and private collectors from across the country. During the course of my research, I spoke with a great many people. So many, in fact, that it would be difficult to list them all here. I only hope that I do not forget to recognize those who so generously shared their time and expertise. From museums and related institutions, I would like to acknowledge Jeffrey W. Andersen, Florence Griswold Museum;

Rocio Aranda-Alvarado and Motrja P. Fedorko, Jersey City Museum; Kevin J. Avery, Metropolitan Museum of Art; Jack Becker, Cheekwood Museum; Elizabeth Broun, Smithsonian American Art Museum; Anita J. Ellis, Cincinnati Art Museum; Jill Meredith, Mead Art Museum, Amherst College; Kenneth J. Myers and James W. Tottis, Detroit Institute of Arts; Brian H. Peterson and Constance Kimmerle, James A. Michener Art Museum; Dolores Tirri, Weir Farm National Historic Site; Marshall Price, National Academy of Design Museum; and the curatorial committee of the National Arts Club. David Smith, New York Public Library, was also very helpful. Among collectors, scholars, and dealers, I would like to thank Warren Adelson, Max and Heidi Berry, Gary Breitweiser, Thomas Colville, Marion and Demosthenes Dasco, Mark Doren, Robert A. Ellison, Susan A. Hobbs, Betty Krulik, Susan G. Larkin, Frank Martucci, Susan Mason, and Curtis R. Welling.

Everyone at Spanierman Gallery contributed to this project in one way or another. In addition to those already mentioned, I would particularly like to acknowledge Kristen Wenger for her extensive work on all phases of the catalogue, and Cleo Pahlmeyer for her help in securing the illustrations. Many thanks, too, go to Jodi Spector and Katrina Thompson, archivists, Rosalind Akin, photographer, and Bill Fiddler and David Major, registrars. As always, our designers, Amy Pyle and Marcus Ratliff, are to be commended for their excellent work, as is Fronia W. Simpson for her fine job of copyediting.

Ralph Sessions

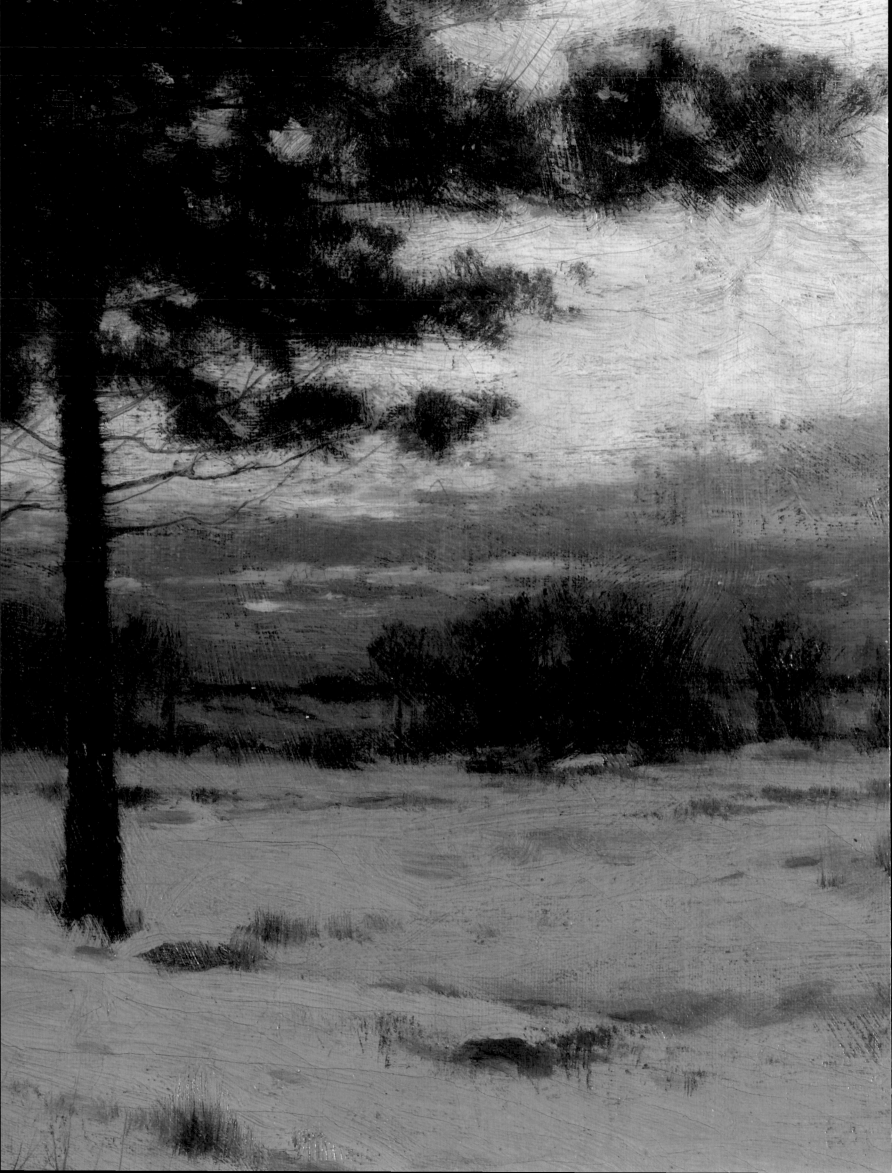

Introduction

RALPH SESSIONS

Tone is of paramount importance in painting as in music. American artists strive for tone, the art-lover looks for it, and the critic appreciates it. Its presence excites the keenest pleasure and liveliest interest in artists and connoisseurs, and to the poet-mind it brings profound and lasting emotions. The future of art in America is the future of the tonal picture.

—LEIGH HUNT, "Art in America" (1898)

THIS OPTIMISTIC prediction was written in 1898, at the height of interest in the style of painting now known as American Tonalism. Promoted by a relatively small group of devotees—artists, collectors, and critics—its influence was widespread. The landscapes of such artists as Henry Ward Ranger, Dwight William Tryon, Bruce Crane, and Birge Harrison were hailed by sympathetic observers as the new school of American painting.[1] At the same time, Tonalism was as much a mode of painting as a movement, and its impact can be found in the work of many artists who, although not totally committed to its tenets, adopted its techniques when it suited their purposes. Nor was it an isolated phenomenon, for it had affinities with several other artistic developments in areas such as photography, the Arts and Crafts Movement, and poetry. It can, in fact, be seen as the expression of a cultural mindset as well as an aesthetic with a broad reach.

The style itself had been evolving for several decades before the late 1890s. Its most ardent adherents around the turn of the twentieth century saw themselves as the American heirs of the French Barbizon tradition, and they further recognized the contributions of some of their countrymen, including William Morris Hunt and particularly George Inness, whose innovative art was considered the starting point of the movement. They claimed a long lineage for Tonalism, declaring it the successor to previous manifestations of tonal painting, from Titian and the sixteenth-century Venetian School through early-nineteenth-century English artists such as John Constable and John Crome to the contemporary Dutch Hague School. The American expatriate James McNeill Whistler was also regarded as an important source of inspiration.

In the end, Tonalism's moment was brief. The characteristics that came to define the style emerged in the early 1880s. From the beginning,

Tonalism coexisted uneasily with Impressionism, as its practitioners variously criticized the methods of the pleinairists and quietly adopted some of their strategies. By about 1905, though, it had been overtaken by Impressionism, which itself was beginning to be viewed as a kind of conservative classicism. Then came the urban realism of the Ashcan School, quickly followed by the bold experimentation of modernism. Rooted as it was in the genteel idealism and spiritualism of the late nineteenth century, Tonalism could not withstand the multiple cultural and artistic upheavals of the first two decades of the twentieth, not to mention the earth-shattering impact of World War I. By 1920 Tonalism had ceased to be a coherent force altogether, although its remaining proponents continued to create individual works that adhered to the aesthetic.

To introduce American Tonalism, it is useful to begin with a strict definition of the style and then move to a broader interpretation.[2] As generally understood today, Tonalist painting at its most characteristic features unpopulated landscapes, focused views that are more reductive than their Barbizon predecessors. Where a Barbizon painting might include field-workers or some village architecture, Tonalist pictures favored a corner of the field, a forest interior, or the low horizon of a salt marsh. They often include evidence of human presence seen in a clearing, fence, or path, but are not concerned with activity in and of itself. As one writer noted, they were "pictures with repose, rather than of action and story."[3] Appropriately, the Tonalist painters strove for "harmonious modulation of color," in Ranger's words, through unified tonal values, subtle gradations of color, and subdued harmonies.[4] Ranger was the self-styled leader and spokesman for the group. He and his colleagues prided themselves on the use of traditional techniques as well. Their canvases were studio productions, done from memory with the aid of sketches,

Opposite:
Charles Warren Eaton
Snowy Landscape at Dusk
(detail of Cat. 7)

usually constructed with glazes, thin washes of color suspended in oil or varnish, and sealed with a final coat of varnish.[5]

In its own time, Tonalist painting was defined as much by the approach of the artist, by his or her motivation and conception, as by his or her subject and composition. It was painting that was concerned with emotion, mood, conceptual truth, and the reality beyond appearances, not the transcription or objective rendering of nature. In this, the Tonalists attempted to distance their work from that of the preceding Hudson River School, on the one hand, and contemporary Impressionism, on the other. In Ranger's words, it was "the poetic impulse, the deep feeling, the suggestion of more than is expressed, the power of making you feel" that distinguished great art, past and present.[6] The intent was to transport the viewer from everyday life to subtler realms, to transcend ordinary perception and engage the imagination. According to Harrison, whose extensive writings provide another important contemporary source, "Thus the modern painter . . . has learned that the veiled and half-seen things make a stronger appeal to the human imagination than the commonplace and obvious facts of nature."[7] True vision is "the power to see the soul of the thing and to grasp its essential beauty. For any landscape has a soul as well as a body. . . . Its soul is the spirit of light—of sunlight, of moonlight, of starlight—which plays ceaselessly across the face of the landscape."[8]

This emphasis on soul, spirit, and truth beyond appearance aligned Tonalism with one of the major cultural and religious phenomena of the nineteenth century, the widespread belief in transcendent reality and otherworldly spiritual existence, as manifested in such diverse movements as Transcendentalism, Swedenborgianism, and Spiritualism. George Inness's dedication to the beliefs of the eighteenth-century Swedish philosopher and visionary Emanuel Swedenborg is well known, for example, as is that of several of those who were influenced by him, such as Charles Warren Eaton. Birge Harrison was raised Unitarian, which exposed him at an early age to Transcendentalist principles espoused by Ralph Waldo Emerson, Henry David Thoreau, and others. J. Francis Murphy was also inspired by the writings of Thoreau.[9] Even those painters who were not active believers would have been familiar with the basic tenets of these movements due to their widespread popularity in all segments of American society. Contemporary spirituality informed Tonalist painting on many levels, from the complex theoretical system underlying Inness's compositions to the more general search for universal principles of truth and beauty.[10] As Harrison wrote, "I believe it to be one of the artist's chief functions, as it should be his chief delight, to watch for the rare mood when [nature] wafts aside the veil of commonplace and shows us her inner soul in some bewildering vision of poetic beauty."[11]

In terms of composition and execution, the insistence on truth and beauty was also one of the hallmarks of academic painting. It was another example of Tonalism's espousal of tradition in the face of the challenge presented by Impressionism. Yet at the same time, the Tonalists considered themselves modern painters. They embraced the ideals of individual expression, originality of conception, and personal vision. In the pursuit of mood and emotion, color and form were central concerns, not the narrative content emphasized by academic painting. In short, Tonalism can be seen as an attempt to reconcile traditional techniques with contemporary sensibilities to create a modern style of painting.

Because of their emphasis on conception and artistic intent, the Tonalists embraced stylistic diversity to a larger extent than is generally recognized today. Reading essays by artists such as Ranger, Harrison, Arthur Hoeber, and Elliott Daingerfield, as well as those by the critics who supported them, and then reviewing the paintings used as illustrations can reveal seeming inconsistencies. In addition, the Tonalist exhibitions organized by the Society of American Landscape Painters and members of the Lotos Club frequently included tonal works in a number of different guises, some evidencing a decided Barbizon influence with others showing Impressionist tendencies.[12] This was not particularly troubling to contemporary observers. To Ranger, for example, it was an issue of harmony, which to him was entirely consistent with the guiding precepts of mood, emotion, and personal vision. He wrote, "If you were to make a collection of the famous work, the work of the past four centuries, it would hang together and harmonize in a way that would surprise you."[13]

It is evident from contemporary sources that Ranger and Harrison were in agreement with the lineage that was constructed for Tonalism in the late 1890s and early 1900s. This might be expected, since they both helped to articulate it, but it is important to note that they did not have any significant differences of opinion, suggesting that the consensus on the origins and development of the style was widespread. The title of the first major exhibition organized by William T. Evans for the Lotos Club in February 1896 presents a succinct summation of that history—*Some Tonal Paintings of the Old Dutch, Old English, Barbizon, Modern Dutch, and American Schools.* As for its evolution in the United States, Ranger summarized it as "beginning with Hunt and Fuller and continuing with Inness, Wyant, and Martin."[14]

William Morris Hunt and George Fuller were two of the main proponents of Barbizon painting in

the United States. Hunt is credited with being the first to introduce the style to Boston when he returned from France in the 1850s. Fuller's lyrical and expressive paintings influenced many younger artists in the 1870s and early 1880s. The two artists can rightly be viewed as forerunners of Tonalism.

Later in their careers, George Inness, Alexander Wyant, and Homer Dodge Martin all turned to tonal landscapes, and, while their individual approaches were quite different, they created the paintings that became the foundation of Tonalism in America. Of the three, Inness certainly had the most significant impact. At the end of his life, he was the most popular landscape painter in America.

As self-professed modern painters, the Tonalists were open to a range of new ideas. Ranger, in fact, credited the Impressionists with important innovations, and while he ultimately thought that their methods were misguided, he is quoted as saying that their influence "will be felt, consciously or unconsciously, in every 'landscape' of the future."[15] It is not surprising, then, that at times he and other Tonalist painters incorporated aspects of Impressionism in their work. They also admired the philosophy of the Arts and Crafts Movement, and wholeheartedly agreed with the importance that it placed on craftsmanship, handwork, and truth in materials. The fact that the three principal instructors at the short-lived painting department at the Brydcliffe Arts and Crafts colony in Woodstock, New York—Hermann Dudley Murphy, Birge Harrison, and Leonard Ochtman—are all identified with the Tonalist group demonstrates this congruence.[16]

Other cultural alignments can be identified as well. To note just one famous example, in 1891 Dwight Tryon and Thomas Wilmer Dewing were engaged by the Detroit industrialist and patron Charles Lang Freer to create paintings and decorative schemes for his new house, a project that furthered the connection between Tonalism and Whistler and the English Aesthetic Movement. The results of this and related Tonalist endeavors were largely private and introspective, rarefied and genteel experiences that intersected generally accepted notions of class and privilege in late-nineteenth- and early-twentieth-century America. It was art for the discriminating few, though with the avowed intention of educating and elevating the common taste in America. As Tryon wrote to Freer, the appreciation of art is a "necessity of general culture" furthering the need for "education in taste."[17]

All of these contemporary currents informed Tonalism. For a time, it was a vital artistic endeavor that attempted to maintain certain aspects of tradition while adapting to a rapidly changing society.

Unity was sought in overriding principles rather than stylistic conformity. Harrison wrote that:

> This movement in modern art is therefore symptomatic. To a discerning student of sociology it indicates a like tendency in all other fields of contemporary thought. It parallels and explains our present devotion to the more abstruse problems of psychology, our tireless search for the mysterious sources of life, of spirit, of force and chemical action. The artist simply keeps pace with the spirit of his times.[18]

Ultimately, though, the world moved along too quickly. Tradition was not to be reconciled with modernity in the first two decades of the twentieth century—far from it—and the goals of Tonalism proved to be elusive.

THE OPENING ESSAY in this catalogue, "American Tonalism: An Artistic Overview" by William H. Gerdts, which was first published in 1982 and has been out of print for many years, is a principal text on the subject and a foundation for current scholarship. Due to its significance, it is presented here with an addendum by the author, providing an informative discussion of the history and distinguishing characteristics of the style. Jack Becker then examines the central role that exhibitions at the Lotos Club, organized by the collector William T. Evans and others working closely with artist members like Henry Ward Ranger, played in defining and promoting Tonalism from the mid-1890s to about 1910.[19] He also investigates the use of the words "tone" and "tonal" in reviews and essays to establish a date for the emergence of critical recognition of the style. Together these two essays offer a comprehensive appraisal of many of the principal personalities and developments that shape current understanding of the movement.

One of the least-known aspects of the Tonalist enterprise is its short-lived exhibiting group, the Society of American Landscape Painters, which is considered here for the first time by William H. Gerdts. Formed in 1898, in the wake of the Impressionist group, the Ten, the society held five annual exhibitions until 1903. Only the first two of these had much impact, though, and while generally well-received, even they were met with mixed reviews. Gerdts highlights several reasons for the society's lack of success, including the fact that with only twelve members, it was not fully representative of the range of Tonalist painting. In addition, some of the best-known Tonalists, such as Henry Ward Ranger, Dwight Tryon, and Birge Harrison, never exhibited with the group.[20] In a larger sense, though, the society did reflect the nature of the Tonalist movement. It was a diverse

group of painters who shared an interest in the aesthetic, but who ultimately pursued their own paths. If this did not make for an ideal exhibiting group, it is illustrative of the distinctive blend of convention and individualism that marks Tonalism.

Nicholai Cikovsky, Jr. then considers the importance of George Inness's art and ideas. He demonstrates in his essay that by the early 1880s, Inness was widely recognized for his innovative use of suggestive form and rich, subdued coloration. In 1884, a critic called him a "tonalist," which is one of, if not the earliest, use of the term applied to American painting. Inness himself was after something deeper than that, something he called "the reality of the unseen." The theoretical system that he applied to his landscapes was not only instrumental in establishing the parameters of the Tonalist style, but was also, as Cikovsky posits, the result of a belief in the relativity of reality that prefigured certain aspects of twentieth-century scientific inquiry.

In contrast, James McNeill Whistler, whose masterful work was also highly influential, did not share the Tonalists' concerns with emotion or mood, as Linda Merrill demonstrates in her essay. His art-for-art's-sake aestheticism had no place for the expression of soul and spirit. Still, his Arrangements and Nocturnes struck a vital chord in the United States and helped create the atmosphere within which Tonalism flourished. So much so that many American artists and critics attributed Tonalist ideals to his work. Harrison, for example, once characterized Whistler's Nocturnes as embodying "the brooding mystery of night" that captured the mood of his subject.[21]

Two members of the Ten are the subject of Lisa N. Peters's essay. In it, she demonstrates that J. Alden Weir and John H. Twachtman, viewed in their day as leading lights of American Impressionism, frequently merged the style with Tonalism in the 1890s to create evocative, poeticized paintings that were considered quintessentially American. Although they were among the first Americans to embrace French Impressionism, they were also inspired by many of the same sources as the Tonalists, including the Barbizon painters, the Hague School, and Whistler. Their work from this period exemplifies a more lyrical, subjective trend in American Impressionism that diverged from the French style to align with Tonalism, even if the artists considered themselves Impressionists.

The catalogue also explores the relationship between Tonalist painting and other arts, namely photography, ceramics, and poetry. In her essay on Alfred Stieglitz, Diane P. Fischer shows that early in his career, the well-known photographer and advocate of modernism adopted the European Pictorialist mode, which featured soft focus and subjects borrowed from paintings, as well as Tonalist strategies in an effort to create a distinctly American form of photography and to promote it as a fine art. Sympathetic critics supported him and the other Photo-Secessionists, noting that the limited tonal range of their work in black and white was a significant expression of Tonalism. Although Stieglitz abandoned tonal photography about 1907 and his quest to convince the New York art establishment of its importance ended in frustration, his experiences with it formed a solid basis for a modernist enterprise that finally embraced both media.

Ellen Paul Denker considers how Tonalism applied to art pottery. The range of its influence on contemporary ceramics is investigated through three examples, the Rookwood Pottery in Cincinnati and the Newcomb Pottery in New Orleans, two of the leading manufacturers, and an individual artist, Charles Volkmar, who trained as a painter and etcher before becoming one of the most innovative potters in the United States. Denker maintains that the education and inclinations of the artist-decorators were the principal determinants, and that Tonalist ceramics can best be defined by the familiarity of these painters with the style and their ability to translate tonal compositions within the boundaries of the established decorative style of a particular workshop or commercial operation.

Moving beyond the visual and decorative arts, William H. Gerdts's essay on Adelaide Crapsey explores the analogies between her poetry and Tonalist painting. Some of her personal preferences, particularly her habit of dressing mainly in gray, indicate additional equivalences. Overall, the correspondences are striking, providing further evidence of the shared worldview from which Tonalism evolved and emerged. If Crapsey found much of her inspiration in Japanese poetry, as so many painters did in Japanese art, her delicate and evocative poems reveal an intense personal vision as well as a dedication to nature and transcendent beauty that parallel the work of many of the Tonalists.

These nine essays are followed by entries on the paintings in the exhibition by Carol Lowrey, with contributions by Lisa N. Peters and Linda Merrill. The inclusions are selective, due to the impossibility of representing all of the artists who participated in the movement in one way or another. Complementing them are paintings by some of their Barbizon predecessors and Tonal-Impressionist contemporaries, while some examples of Tonalist painting in California emphasize the importance of regional developments, an area that merits much future investigation. Finally, an index complied by Lisa N. Peters lists the artists who

exhibited with the Society of American Landscape Painters and participated in key Tonalist exhibitions at the Lotos Club. The list provides an important reference that augments the essays and entries by further highlighting the diversity of artists who contributed to "the poetic impulse" in American landscape painting.

Epigraph: Leigh Hunt, "Art in America," *Art Collector* 9 (November 1, 1898), p. 5; quoted in Jack Becker, "A Taste for Landscape: Studies in American Tonalism" (Ph.D. diss., University of Delaware, 2002), chap. 1, p.39.

1. See, for example, Clara Ruge, "The Tonal School of America," *International Studio* 27 (January 1906), p. 57.

2. The best contemporary sources for this come from two of its main proponents, Henry Ward Ranger and Birge Harrison. Ranger's ideas are recorded in his published essays and in Ralcy Husted Bell, *Art-Talks with Ranger* (New York: G. P. Putnam's Sons, 1914), which is based on a series of interviews with the artist. Harrison wrote extensively, publishing essays, art criticism, and travel narratives in numerous magazines and newspapers during his lifetime. His influential book, *Landscape Painting* (New York: Charles Scribner's Sons, 1909) is based on a series of lectures that he gave at the Art Students League Summer School in Woodstock, New York, which he established in 1906.

3. "The Comparative Exhibition," Whistler Scrapbooks, Charles Lang Freer Papers, Archives of American Art, Smithsonian Institution, microfilm roll 4752, quoted in Becker, "Studies in American Tonalism," chap. 4, p. 12.

4. Bell, *Art-Talks with Ranger*, p. 130.

5. Birge Harrison was an exception. He did not use glazing because he believed that the technique destroyed the possibility of "vibration," which he defined as the "scintillating effect of living light" transferred to canvas. See Harrison, *Landscape Painting*, p. 37. See also Andrea F. Husby, "Birge Harrison: Artist, Teacher and Critic," Ph.D. diss., City University of New York, 2003, p. 203.

6. Henry W. Ranger, "A Basis for Criticism on Painting," *Collector* 6 (November 15, 1894), p. 25.

7. Birge Harrison, "The 'Mood' in Modern Painting," *Art and Progress* 4, no. 9 (July 1913), p. 1015.

8. Harrison, *Landscape Painting*, pp. 155–56.

9. For Harrison, see Husby, "Harrison: Artist, Teacher and Critic," p. 16. For Murphy, see Francis Murphy, *J. Francis Murphy: The Landscape Within, 1853–1921*, exh. cat. (Yonkers, N.Y.: Hudson River Museum, 1982), p. 8.

10. Nicolai Cikovsky, Jr. discusses Inness's theoretical system in his essay "George Inness and Tonalist Uncertainty" in this catalogue. See also Adrienne Baxter Bell, *George Inness and the Visionary Landscape* (New York: George Braziller, 2003).

11. Harrison, *Landscape Painting*, pp. 229–30.

12. See the essays by William H. Gerdts and Jack Becker in this catalogue for discussions of the Society of American Landscape Painters and the Lotos Club. The Index lists many of the artists who participated in these exhibitions.

13. Ranger, "A Basis for Criticism on Painting," p. 25.

14. Bell, *Art-Talks*, p. 137.

15. Ibid., p. 92.

16. See Tom Wolf, "Art at Brydcliffe," pp. 96–104, in Nancy E. Greene, ed., *Brydcliffe: An American Arts and Crafts Colony* (Ithaca, N.Y.: Herbert F. Johnson Museum, 2004).

17. Tryon to Freer, July 14, 1900, quoted in Linda Merrill, *An Ideal Country: Paintings by Dwight William Tryon in the Freer Gallery of Art* (Washington, D.C.: Freer Gallery of Art; Hanover, N.H.: University Press of New England, 1990), p. 77.

18. Harrison, "The 'Mood' in Modern Painting," p. 1020.

19. See Becker's dissertation, "Studies in American Tonalism," for a more thorough discussion of Ranger, Evans, the Lotos Club, and other aspects of Tonalism.

20. Nor was Harrison ever involved with the Lotos Club group to any extent. After traveling extensively in Europe, Asia, and Australia, he began painting tonal landscapes about 1895. In New York, he was a member of the Century Association. He does not seem ever to have used the word "Tonalist." Instead, he pursued his own path, as he so vigorously advocated in his teachings and writings. See, for example, Harrison, *Landscape Painting*, chap. 15, "The Importance of Fearlessness in Painting," pp. 158–63.

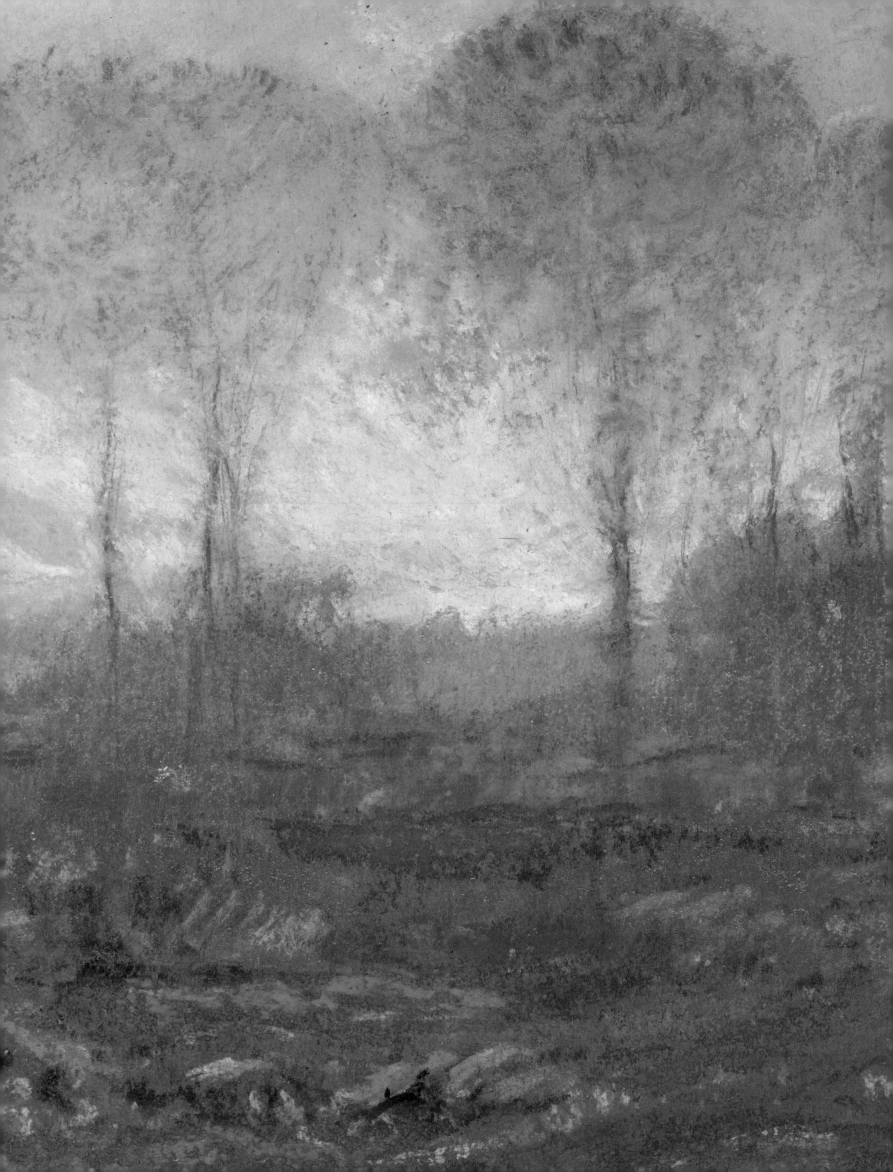

American Tonalism: An Artistic Overview

WILLIAM H. GERDTS

The following essay, reprinted from *Tonalism: An American Experience*, the catalogue accompanying an exhibition organized in 1982 by the Grand Central Art Galleries, Inc., New York, has been edited to conform to the style of the present book and expanded by the author. Square brackets signal editorial or authorial interpolation.

THE TONALIST movement in American art, primarily though not completely pertinent to landscape painting, flourished from about 1880 to about 1915. Of course, intimations of its aesthetics may he found earlier than 1880, and naturally some of the artists involved with the movement lived well beyond 1915 and continued to practice this stylistic mode essentially unchanged. In retrospect, those dates may be significant beyond the setting of a place within a time continuum. Because those years are also those in which historians chart the development and maturity of American Impressionism, Tonalism has often been regarded as, variously, a modified or variant form of Impressionism or a more tentative, less vital, and less progressive approach to landscape than that better-known movement. Neither evaluation is the whole truth.

Almost surely due in part to its relegation to the status of a substyle of Impressionism or, alternatively as we shall see, a late, bloodless extension of American Barbizon painting, Tonalism was quickly dismissed in the years after 1915, its major practitioners by and large forgotten. In a sense the movement was subject to double or triple jeopardy: for champions of Impressionism, Tonalist paintings seemed pallid and unexciting; for those artists, patrons, and critics who preferred the gutsy vitality or the urban Realism of the Ashcan School the Tonalists seemed more old-fashioned and even less concerned with art-for-life's-sake than the Impressionists; and for the proponents of experimental modernism practiced by European-influenced artists, Tonalism was irrelevant.

So the situation remained until 1972 and the M. H. de Young Memorial Museum's *The Color of Mood* exhibition in San Francisco, accompanied by Wanda Corn's groundbreaking catalogue essay. Until then the situation for Tonalism had remained in such obscurity that even in Edgar P. Richardson's encyclopedic *Painting in America* of 1956 the Tonalists were relegated to one footnote in which they were referred to as "completely forgotten." Only—and characteristically—John I. H. Baur, in his *Revolution and Tradition in Modern American Art* of 1951, perceptively recognized "The Tonal School of America." Baur, however, characterized Tonalism as an anemic combination of late Barbizon art and Whistlerian aestheticism. Now, the distinction between anemic and refined is a subtle one, but one must recall also that Baur was writing at the height of the vigor of Abstract Expressionism, against which Tonalism would have appeared pallid. In the last decade [i.e., the 1970s], however, following the successive revivals of specialized thematic material, schools of artists, and individual minor and major masters, the Tonalists have been disinterred, some more successfully than others. The exhibition in San Francisco was not an isolated phenomenon. It had been preceded in 1970 by *Some Quietist Painters*, a show held at Skidmore College [in Saratoga Springs, New York], and the Wickersham Gallery in New York City mounted a related *Quiet Moments in American Painting* in the 1970s. Really more significant, the Tonalists began to appear, both singly and as a group phenomenon to be reckoned with, in broader surveys of American art. Probably the most important of these exhibitions was *American Art in the Barbizon Mood*, organized by Peter Bermingham and held at the National Collection of Fine Arts in 1975, but Tonalist considerations informed shows and catalogue essays as distant as *Artist and Place*, held at the Museum of Art at Washington State University in Pullman, in 1978.

Tonalism's strong showing in *American Art in the Barbizon Mood*, however, suggests the critical and historical dilemma a study of the movement has posed. If, on the one hand, it has been perceived as an alternative to Impressionism, on the

Opposite:
Dwight William Tryon
Twilight (detail of Cat. 36)

other hand, Tonalism has often been described as an offshoot of American Barbizon. Almost all the major figures of American Tonalism swore their primary allegiance either directly or indirectly to the Men of 1830, as the French Barbizon masters were often termed, and specific stylistic characteristics can be found in the work of some of the major Tonalists that derive from their European mentors. Still, the Tonalists were later painters, concerned for the most part with the American landscape, and their work is easily distinguishable from such European counterparts, as contemporary critics almost invariably acknowledged.

Tonalism's seeming inability to stand firmly as an independent movement has only exacerbated a critical problem that has plagued a good deal of art historical consideration since the days of Julius Meier-Graefe and his writings on modern art at the beginning of the twentieth century. This has been the supposed need to evaluate all artistic movements on the criterion of their contributions, or lack of same, to progressive—that is, modernist—developments. This has not only been the partial cause of the neglect of Tonalist art until recently, but it has also affected the regard that Tonalism has generated among its recent champions. Thus, Wanda Corn's otherwise incisive, perceptive essay is seriously flawed by the almost total emphasis on what she, as writers before her, refers to as first-generation Tonalists. Corn relegates the slightly younger, second-generation Tonalists, such as J. Francis Murphy and Henry Ward Ranger, to a mere mention—again in a footnote. The reasons are evident in her essay and its historical compactness. As long as Tonalism is considered as an extension of Barbizon painting, dominating one approach to landscape in the late nineteenth century, it can be seen not only as a further development away from the factual naturalism of the Hudson River School, but in its emphasis on poetic mood often achieved through veils of atmosphere, it can also be shown to run parallel to, and even be influential on, avant-garde approaches to photography. And photography constituted a major portion of this very original and very beautiful exhibition.

The choice of painters to be included was, on a smaller scale, similar in the earlier Skidmore exhibition, and its avant-gardiste point of view was clearly revealed in the subtitle of the show, *A Trend toward Minimalism in Late Nineteenth-Century Painting*. Again, except for Ernest Lawson who was almost never a Tonalist in any case, the artists represented in the Skidmore exhibition were nineteenth-century masters. In fact, however, Tonalism, as an art movement, was primarily of the early twentieth century. The concept of Tonalist art must necessarily be distorted when the leader of the movement, Henry Ward Ranger, is eliminated from

consideration or representation, as was the case in both the San Francisco and the Skidmore exhibitions. And a leader Ranger certainly was. He was Tonalism's spokesman, and his primacy was noted by a good many writers of the period.

One cannot be sure when the term "Tonalist" was first applied to a cohesive approach to modern landscape painting, but its widespread use in contemporary artistic jargon may also be traceable to Ranger. He discussed the meaning of "tone" in *Art-Talks with Ranger*, published by Ralcy Husted Bell in 1914, in which Ranger said that "Tonality to us means just one thing and but one thing. If you were to give it an arbitrary definition you might say, harmonious modulations of colour." Other writers of the time and later have distinguished two separate meanings of "tone" as applicable to the American Tonalist movement, by no means mutually exclusive. On the one hand, a "tonal" painting might be one in which a single color dominated but was not, of course, the sole color used; on the other hand, a "tonal" painting might be one in which forms were perceived through an overall colored atmosphere or mist, which produced an evenness of hue throughout.

In regard to the former meaning, the choice of predominant color in Tonalist painting is limited. If many of the artists favored an overall gray tone, blue evening and night scenes were particularly prevalent, a disposition shared by such diverse figures in Europe as [Claude] Monet, especially in the late 1890s and early 1900s, [James McNeill] Whistler, and the early [Pablo] Picasso. [In 1906,] Clara Ruge pointed out that, whereas the traditional artist mixed his paints on his palette before applying them to his canvas, and the Impressionist let his colors rest side by side without making any attempt to blend them, the Tonalist usually mixed his colors after he had applied them to canvas, which accounted for the concern for an active but harmonious paint surface—and surface was a major preoccupation of Tonalist artists and their critics.

The Tonalist painters eschewed the grandiose, often wilderness, landscapes of the Hudson River School, preferring the cultivated, civilized landscapes of the Barbizon School, but the Tonalists went on to prefer truly fragmentary bits of nature, most often empty, intimate segments of sometimes flat and marshy or at most gently hilly scenes. The favorite time of day suggested might be dawn, early morning, dusk, twilight, or evening, while the seasons of the year were most often depicted were later autumn, winter, or, at the latest, early spring, seasons of emptiness and bareness. Just as noontime light was avoided, so did the more intensely colored foliage of late spring and summer seldom figure in Tonalist painting.

The artists of the movement were concerned not with transcription but with poetic evocation, suggesting in pure landscape the feelings of reverie and nostalgia, psychological states often associated with and induced by evening and night particularly. These were achieved partly through specific technical methodology. Ranger, in his *Art-Talks*, greatly emphasized the utilization of colored glazes, often using varnish rather than oil as a medium, a technique he learned in France as one practiced by Jean-Baptiste Camille Corot. The Tonalists were not plein-air painters; rather, regarding outdoor painting as much as mixing pigments, they were somewhere in between the traditional and the Impressionist. Unlike the older landscape painters of the Hudson River School, the Tonalists not only sketched but also painted outdoors. But in turn, their outdoor paintings were "sketches"—that is, studies done on the spot to be worked up into the large, finished exhibition paintings in their (usually New York) studios. This was important, for, to the Tonalists, nature seldom presented a "perfect picture"; nature was to be reacted to and improved on. Some of the Tonalists, even after sketching in nature, claimed to disregard those sketches for the most part and created their finished works from memory, from the experience of the earlier immersion in the landscape. They were eloquently *not* Realists.

"Tone," of course, has been a commonplace term in the vocabulary of art, but its ubiquitousness has always been accompanied by a lack of clarity or, conversely, even a multiplicity of meaning. It is significant that during the time Tonalism developed as a distinct, recognized movement, one of the leading art historians and theoreticians of the time, John C. Van Dyke, felt compelled to present a lecture to his students at Rutgers College in New Jersey on the subject of "Tone and Light-and-Shade," published in 1893 in his *Art for Art's Sake*. Van Dyke stated that "you will find a beautiful haziness of thought and indefiniteness of meaning in the use of the word among all classes and nationalities of painters." In fact, he distinguished the interpretations of the term among American, British, and French artists. In America, he pointed out, "tone" meant a prevailing or dominant color in a picture; in England, a proper or harmonious diffusion of light throughout a painting; and in France, as taught in the various *écoles*, the *enveloppe* or harmonious values in the atmospheric makeup of the picture. In actuality, all three of these interpretations were to become standards by which American Tonalist art would be judged.

A radically different view of Tonalism was expressed by Leigh Hunt in the *Art Collector* in December 1898, the first of a series of articles relating to the new movement that continued in that magazine into 1899. Hunt denied that Tonality meant "harmonious color" or, as a writer in the fourth and last article to appear defined it in February 1899, "harmonious modulations of color." Hunt insisted that, while George Inness was a magnificent colorist, he was not a Tonalist; Alexander Wyant, by contrast, was. Nor did atmosphere constitute "tone." He stated further that a work painted in a dominant key could still lack tone. Hunt listed as Tonalists such diverse artists as Rembrandt, [Pierre] Puvis de Chavannes, Josef Israëls, and the contemporary Americans Louis Dessar and Arthur B. Davies. He also recognized a common aesthetic found in other arts, not only in music but in the prose writings of [the late-nineteenth-century] Walter Pater and the poetry of Robert Herrick [from the seventeenth century]. Hunt summed up his conception of a tonal painting, admittedly difficult to define, as simple, even severe in style, soft and gentle, often with a coloristic emphasis on grays or bluish grays. For Hunt, the intrinsic characteristic of Tonalist art was elegance and fineness.

Variant terms for Tonalism have been applied to the movement under consideration, just as in America both Luminist and Luminarist were popular variants for Impressionist. (The first of these has acquired in our time a very different art historical meaning.) "Intimist" is one term that has been given to the movement and, as the Skidmore exhibition clearly indicates, "Quietist" has also been found to be appropriate; indeed, Richardson refers to these artists as sharing the Quietist concerns of some of the American Impressionists, John Twachtman, Robert Vonnoh, and others. Here matters of terminology are more than just problems in semantics, for while Tonalism in its various meanings relates to matters of technical creativity, both Intimism and Quietism are related to the psychological and spiritual emanations of the finished work. This was implied by Corn also, for whom *American Tonalism* was a subtitle; *The Color of Mood*, a suggestion of poetic essence, was the title as well as the theme of her exhibition.

By the last decade of the nineteenth century, Tonalism was recognized and discussed [and] had its champions and its outlets. Mention has already been made of the series of articles that appeared in the *Art Collector* in 1898–99. The seminal article on the movement by Clara Ruge, which appeared in *International Studio* in January 1906, referred to an exhibition of Tonalist paintings organized by Ranger fifteen years earlier for the Lotos Club in New York City. So early an exhibition and designation of Tonalist work is possible, of course, but in her enthusiasm for the movement, Ruge may have been exaggerating the early origins of Tonalism. She may well have meant the show of Tonalist painting that took place at the club in March 1897

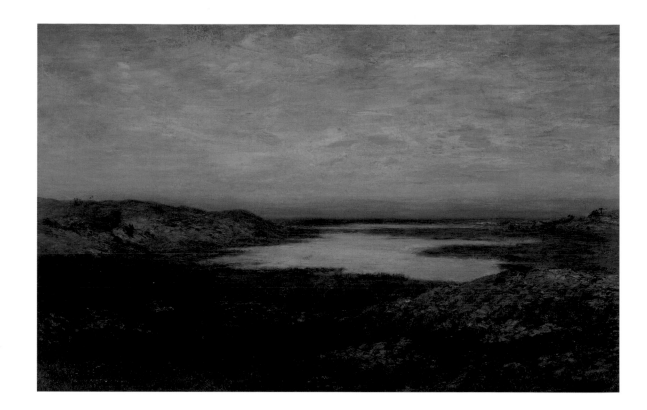

or, even more likely, the exhibition *American Landscape Painters* that opened in March 1896 at the club, in which were represented Ralph Blakelock, George Bogert, Bruce Crane, Charles Melville Dewey, Charles Warren Eaton, Arthur Hoeber, William Lathrop, Robert Minor, J. Francis Murphy, Henry Ward Ranger, and the deceased "masters" of Tonalism, George Inness, Alexander Wyant, and Homer Dodge Martin (Fig. 1)—a veritable roster of the Tonalist movement. In December of the same year another show of the same title held at the Lotos Club featured an equally strong galaxy of Tonalist painters. It was that year, 1896, that the great collector of American art William T. Evans assumed the exhibition chairmanship at the Lotos Club, when Henry Ward Ranger was the club's secretary. Given the particular enthusiasms of such members as Evans, George A. Hearn, and others, the Lotos Club became an exhibition center for the display of Tonalism.

In November 1902, before the Ruge article, Leila Mechlin had written in the *International Studio* of the state of contemporary American landscape painting and clearly distinguished between the Impressionists and the Tonalists such as Ranger, who preferred to explore more decorative effects. However, she also recognized a group in between them, whom she allied with the Impressionists, men such as Dwight Tryon, J. Francis Murphy, Bruce Crane, and Leonard Ochtman, whom she saw as exploring more subtle effects of light—artists we would now see as primarily within the Tonalist

camp. Mary Muir, in her 1978 master's thesis for the University of Utah, referred to this basic approach as "Tonal Impressionism."

Muir, in her thesis, provides a broad survey of the development of "tone" in Western painting, beginning with the artists of the Venetian Renaissance. More immediately, she explored the sources for Tonalism in the nineteenth century in the earlier art of both Europe and America, recognizing an affinity between the Tonalists and the poetic landscapes painted by Washington Allston in Boston and Cambridgeport in his later American career, from 1818 until his death in 1843. Such a heritage is remote and indirect, and somewhat misleading in the attempt to identify the Tonalists with Allston because of a shared New England context. In actuality, although many of the Tonalists did paint on the Connecticut coast, their finished works were usually studio conceptions done in New York, while others had studios in the Catskills and elsewhere. As regional studies are extended, we are finding Tonalists active in the Midwest and as far away as California. Yet, a link between early-nineteenth-century Romanticism and the poetic mode of Tonalism can be identified in the emphasis on memory evocation in the art of both Allston and the Tonalists, and in the posthumous admiration for Allston's work among such New England painters as George Fuller, and the generally favorable reception for Barbizon art there, guided by the enthusiasm of William Morris Hunt.

Fuller and Hunt, however, were primarily figure painters, the latter predominantly influenced by

Jean-François Millet among the Barbizon artists; except for Fuller and Thomas Wilmer Dewing (Fig. 2), the artists associated with Tonalism were all landscapists. The Tonalists looked directly toward examples of French Barbizon landscape painting. Indeed, one of the advantages for developing artists of this aesthetic inclination was the availability of French Barbizon painting in this country in the 1870s, when painters such as Tryon and Ranger were beginning to emerge. In his autobiographical *Art-Talks*, Ranger, while bemoaning the lack of commercial patronage of native American painters in New York about 1873—the leading dealers, Goupil and Schaus, displaying and selling European works, exclusively—nevertheless found it fortunate that he had been able to study Corot's work to a great extent and with good effect, having far better opportunities in fact than he found in Paris on his subsequent student voyage abroad. Direct contact with the major French Barbizon masters was not possible for most of the Tonalists since they emerged after the deaths of many of the Men of 1830, but some of them did become acquainted with Charles-François Daubigny and with some of the later, if perhaps lesser, Barbizon men, particularly Henri Harpignies. One might expect the aesthetic of Tonalism to be informed by the particular nature of the art of the still active French Barbizon painters but, in fact, Ranger's mature painting corresponds most to the more dra-

matic pictures of Théodore Rousseau and the wood interiors of Narcisse-Virgile Diaz [de la Peña], while over the entire movement hovers the ephemeral spirit of the late work of Corot. This, in fact, is not surprising, for these were the paintings imported in great numbers (and faked in great numbers) to this country and thus were available to young American artists as artistic models, both before and after the usual period of study abroad.

One of Muir's most perceptive points is the significance of Dutch Barbizon art for the Americans. This phenomenon is not recognized in America today, but it was in the late nineteenth century, and numerous articles on Dutch art and life appeared in the 1880s, 1890s, and the early years of the present [twentieth] century in American periodicals. Perhaps significantly, the earlier ones were published in the general magazine *Century*, the later in one of the two finest art magazines of the period, *International Studio*. These articles dealt with the artists of The Hague School, Josef Israëls, Anton Mauve, the Maris brothers, and numerous others, in their studios in The Hague, or among the peasant community of Laren, near Hilversum and outside Amsterdam. Henry Ward Ranger contributed an article on Laren to *Century* in March 1893. Laren was to Holland what Pont-Aven was to France, an artists' colony with studios occupied for all or part of the year by the leading landscape and genre painters of the Netherlands,

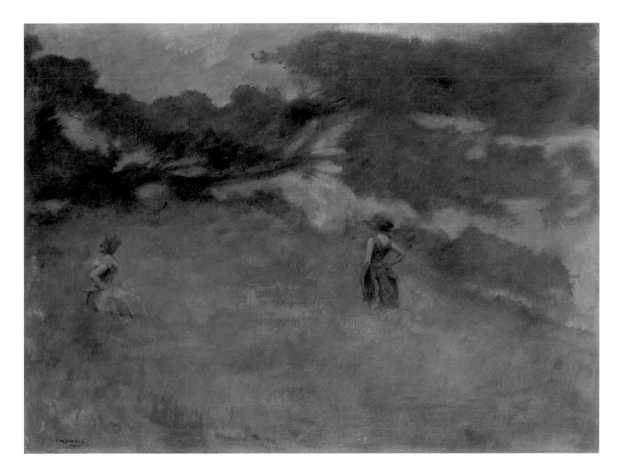

Fig. 2.
Thomas Wilmer Dewing
The Hermit Thrush, 1890
Oil on canvas
34⅝ × 46⅛ inches
Smithsonian American
Art Museum, Washington,
D.C., Gift of John Gellatly

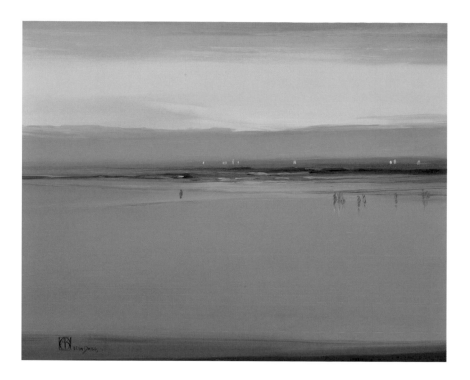

Fig. 3.
Leon Dabo
Low Tide, Oak Point, n.d.
Oil on canvas
24 × 30 inches
Florence Griswold
Museum, Old Lyme,
Connecticut, Gift of The
Hartford Steam Boiler
Inspection and Insurance
Company

with an admixture of artists from many Western nations. Laren, in fact, continued to be an artists' colony of significance for many decades and continued to attract American artists into the twentieth century, as the activity there of such painters as William Singer and Martin Borgord attests.

Laren might be referred to as the "Dutch Barbizon," and indeed the aesthetics of the French movement were paramount in the work of the landscape painters there, but the Dutch artists had their own sensibilities. Israëls was the patriarch of the Dutch painters, though the bleak and tragic outlook of such major works as his *Alone in the World* would restrain enthusiasm even while the sincerity of its sentiment was admired, for instance, when it was shown at the Columbian Exposition in Chicago in 1893. In any case, it was the masters of landscape, or of outdoor genre, who particularly inspired American enthusiasm and even emulation. Anton Mauve was especially admired, and Ranger was fortunate to have known him well shortly before his death in 1888. A description of Mauve's style in particular, taken from one of the articles of the period on Dutch art, could well describe many a Tonalist painting: a landscape illuminated by a diffused light, the trembling foliage bathed in an atmosphere of fine transparency, the skies lightly colored, aerial, and silvery. In general, the characteristics of the Dutch landscape of The Hague and Laren are pertinent to many American Tonalist paintings and do, in fact, differ from French Barbizon works; to quote Elizabeth Champney in an article from *Century* published in July 1898: "the subtler refinements of soft, diffused light . . . the silvery

green of the moist meadows—nature in her more pensive and poetic moods."

The other major influence from Europe in the development of American Tonalism was that of Whistler. Whistler's aesthetic found a ready reception among Americans, in part because he was at least partially an American artist, despite his very deliberately nonspecific cosmopolitanism. Whistler was also nonspecific in his landscapes; his eschewing of naturalistic detail to project a mood offered kinship to the Tonalist aesthetic. "Tone" is as much a musical term as it is a visual one, and Whistler's adoption of a musical terminology in titling his paintings as Harmonies and Symphonies underscores the affinity between his art and that of the American landscapists. Yet, the alliance perhaps should not be pushed too far. Whistler was far more concerned with the primacy of pictorial creation—truly an art for art's sake—while the Tonalists aimed at the projection of a mood induced by their experience in nature. Whistler's aesthetic certainly laid the groundwork both for the art of the Tonalist painters and for the appreciation of their work by patrons and critics. As specific influence, however, it was felt by such as Leon Dabo (Fig. 3) and the Californians Xavier Martinez and Charles Rollo Peters much more than by the "core" artists of Tonalism. In this sense, Muir is correct to emphasize a New England tradition. The major Tonalists, many of them active much of the year in New England, derived particularly from the traditions of French and Dutch Barbizon art, whereas a number of those working elsewhere assimilated Whistler's innovations more easily. The two strains, however, were sufficiently compatible for the greatest of all Tonalist collections, that of Charles Lang Freer of Detroit, to encompass great holdings of Whistler's work; of one of the leading Tonalist landscapists, Dwight Tryon; and of the major Tonalist figure painter, Thomas Dewing.

Until the last ten or fifteen years, the common view of late-nineteenth-century American painting emphasized the unqualified superiority of a group of artists considered genuinely native in their artistry: Thomas Eakins, Winslow Homer, and Albert Pinkham Ryder. Some recognition was given to the landscape achievements of George Inness, and after the publication in 1958 of Alfred Frankenstein's *After the Hunt* came a grudging appreciation of the technical wizardry in the still-life painting of William Michael Harnett and his followers. Today we are rapidly coming to appreciate the tremendous diversity of the period, above all the results of the cosmopolitanism actively pursued by the literally thousands of artists who hied to the art schools of Paris, especially, but also those of Munich and Antwerp, and occasionally still London and Düsseldorf, to immerse themselves

more fully in the art styles and achievements of their European peers. In fact, we recognize now that Homer and Ryder are the exceptions, the relative loners, in the vastly complex tapestry of American art of the period, and that even they, let alone Eakins, were not so divorced from European connections.

Thus, the multiple relationships of Tonalist painting to European art are not surprising and not unusual, and not necessarily contradictory. Yet, the Tonalists were *American* artists, as they and their critics were often at pains to point out, and their place in an American landscape tradition should not be ignored. Whether or not any of the Tonalist artists ever saw one of Allston's poetic landscapes cannot really be verified. By the last decades of the century, Allston's reputation was at something of a low ebb, his pictures relatively rarely exhibited except for his mammoth *Belshazzar's Feast* at the Museum of Fine Arts in Boston (which was not likely to inspire a poetic landscape); his works that were still occasionally admired were his "dreamy women." The landscapes, few in number in any event, were not visible. The Hudson River School tradition was partially discredited by the last quarter of the nineteenth century. The term itself was introduced as one of opprobrium by Clarence Cook in the *New York Tribune*. While today we may admire the reverence for God's creation expressed through delineation of every stone and blade of grass, to the art lover of the late nineteenth century the landscape of fact seemed to ignore the inherent poetry of nature. In general, sensitivity to the effects of light and the transparent veils of colored atmosphere—which we recognize today as characteristic of the Luminist painters within the Hudson River School—were not often distinguished from the more factual, sometimes more prosaic work of the school. The hot, sulphur tones of a Sanford [Robinson] Gifford were not to everyone's taste; still, the clarity of atmosphere and reduction of forms in the work of John F[rederick] Kensett, for instance, spelled welcome relief for some from the gigantic extravaganzas of Frederic [Edwin] Church and Albert Bierstadt. The phenomenal admiration these two masters enjoyed in the 1850s and 1860s was of relatively brief duration, being replaced by increasingly virulent disparagement just when the future Tonalists were seeking role models.

It is true that within the broadest parameters of American landscape painting, no greater diversity can be imagined than between Church or Bierstadt's giant "machines" and a bit of empty marshland by J. Francis Murphy. Yet the Hudson River School's devotion to the American scene, and especially the Luminist concern with colored light and atmosphere (an emphasis on the more transient elements of nature rather than the solid

and enduring)—however technically hard, precise, and self-effacing in their lack of "signature" paint application—prefigure Tonalist concerns. The Barbizon tradition, however, was to displace the Hudson River School in all its manifestations, whether that of Asher B. Durand and Jasper [Francis] Cropsey, the Luminists, or Church and Bierstadt.

George Inness was one of the first to become fired by the Barbizon aesthetic, as early as the 1850s, and William [Morris] Hunt introduced it successfully, in both French and American examples, in the following decade. These two were the leading American Barbizon painters. Hunt died tragically, in 1879. The year before, Inness had settled in Montclair, New Jersey, and began to develop his final pictorial manner, Barbizon-derived but increasingly distinct from his paintings of the 1850s and 1860s, such as the paradigmatic *Peace and Plenty* (Metropolitan Museum of Art, New York) of 1865, with its massive, sharply defined forms, its clearly identified light source, and its radiantly optimistic view of the agrarian American landscape. Inness replaced these characteristics with a soft veiling of colored light, which shrouded and blurred forms of foliage and figures in a soft penumbra. Increasingly, Inness's foliage became frail and wispy, compared to the solidity of trees and forests in his earlier work, his aesthetic development paralleling that of Corot, although coming a generation later. However, a number of his late works done in the early 1890s center on a massive oak, which anchors the composition, a format that surely inspired a number of Ranger's greatest works done shortly thereafter.

Inness was, in fact, the earliest Tonalist landscape painter. His own oft-declared disdain for Impressionism is a significant articulation of the gulf between the two movements, although Inness more than most artists was reluctant to admit to aesthetic relationships. In his development of Tonalism, he was joined by Alexander Wyant and, to some extent, Homer Dodge Martin, as well as by the figure painter George Fuller; he preceded those landscape painters whom we identify really only as Tonalists, such as Tryon, Murphy, and Ranger, but not by very many years. All of these, after all, were finding their way in the 1880s. By the following decade they were working within a Tonalist aesthetic to which Freer's patronage of Tryon, Ranger's activity at the Lotos Club, and Murphy's development of a landscape style similar to that of Wyant (his Catskill neighbor at Arkville) all testify.

But in the diversity and multiplicity of late-nineteenth-century art, Tonalism was not the only or even the dominant mode. If, in the mid-1880s, Impressionism was a misunderstood and frequently criticized, foreign-derived art form, by 1893 it had triumphed at the Columbian Exposition

at Chicago and become the dominant style, even an "official" one in this country, having been more quickly accepted here than in its native France. To reiterate: just as Barbizon art in America did not displace Luminism or the grandiloquent approach to landscape of Church and Bierstadt, but rather developed at the same time and competed and/or coexisted with it, so Tonalism was not a forerunner of American Impressionism but paralleled its development almost exactly.

The question then arises, was Tonalism in fact a conservative mode of landscape interpretation? If it is examined in the light of succeeding European movements and against the background of contemporaneous Impressionist art in America, it would seem to be so, since it derives from the Barbizon precedent and was partially an extended and refined derivation of Barbizon practice. Certainly by the turn of the century, Inness, Wyant, and Martin, all of whom had died in the 1890s, were still revered as they had been previously. Yet their art and that of artists whose painting appeared similar seemed to represent a historical mode, while Impressionism was avant-garde modernism, though a modernism that was fast taking on almost official status in its public and critical acceptance and its breadth of popularity.

But to perceive Tonalism as more than an extended form of Barbizon painting, more than a rarefied version of an aesthetic that itself had just about run its stylistic course, one should ask what Tonalism had to offer those who patronized and championed the movement, in conscious preference to Impressionism. For Tonalism did have its supporters. Its collectors included a number of the leading patrons of the time: Thomas B. Clarke, Charles Lang Freer, William T. Evans, and George A. Hearn. Of course, patronage need not have divided between support for the Barbizon and Tonalist painters on the one hand and that for the Impressionists on the other, though it did do so to some extent. Among the critics the division was not that sharp, and both Royal Cortissoz and Eliot Clark could champion artists of both movements, Clark, for instance, writing laudatory articles about almost all the leading Impressionists in *Scribner's Magazine* and *Art in America* and also publishing a book about Murphy the Tonalist in 1926. Other writers, however, evinced a decided preference for Tonalism. In addition to Leila Mechlin and Clara Ruge already mentioned, Charles H. Caffin was particularly a champion of Tonalist art among the painters of his own time. One of the artists about whom he wrote in 1903 was Arthur Hoeber. The Tonalist movement was fortunate in that two artists whose aesthetics were related were also the leading landscape painter–writers of their time, Hoeber and Birge Harrison. Of the two, Harrison's

work was the more unequivocally Tonalist-related. His concern with craftsmanship and sound construction was elucidated in his book, *Landscape Painting*, published in 1909, and through his teaching at the Art Students League summer school in Woodstock from 1906, where he perpetuated his own "moonlight and mist" landscape aesthetic. Hoeber's preferred flat, marshy landscapes were sometimes tinged with Impressionist colorism, and he, unlike Harrison, wrote enthusiastically about some of the American Impressionist painters.

Tonalism and Impressionism were not mutually exclusive; contemporaneous movements, they shared a concern with the more ephemeral elements of nature, with light and atmosphere, with effects of weather, with the times of day and seasons of the year. But at the same time, Tonalist paintings appeared very different from Impressionist ones as, indeed, they are, and for a good many reasons.

First, Tonalism was regarded as more American. To a writer such as Clara Ruge, Tonalism provided "a national school of landscape painting," and although she acknowledged the specific Americanism of the earlier Hudson River School, she declared that the Tonal School was the first "destined to leave a mark in the history of art." In 1906 this could only be interpreted as a comparison to French-derived Impressionism. This is not the place to examine the roots of such statements in the constant critical call that began to appear a hundred years earlier for a truly American art, and the varied responses and reactions to that summons by artists and writers who reflected the vicissitudes of different periods. The champions of American Impressionism went to great lengths to emphasize how American artists had transformed Impressionism into a native expression, whether by individual technique and/or application to native subject matter. To complicate or confuse the issue further, some of this stylistic "transformation" of Impressionism into a native expression involved a more poetic approach to landscape, using Tonalist formal or interpretative means, such as J. Alden Weir's more single-toned palette or John Twachtman's more intimate focus on the landscape, in contrast to the orthodox Impressionism of Monet or Childe Hassam. While the Barbizon heritage of Tonalism was, after all, just as French-inspired as was Impressionism, its antecedents went back farther in history and had long since been "Americanized." And in fact, writers such as Ruge and others may not be totally incorrect. At least it can be said that European parallels of Tonalist painting—of the pictures of Tryon, Murphy, and Ranger, for instance—are not as easy to summon up as parallels for those of Hassam or Theodore Robinson.

A more important question by the first years of the twentieth century, however, was the charge that Impressionism did not have "soul," while Tonalism had it in abundance. This was an unarguable issue, though writers could, and did, point out that some of the American Impressionists, such as Twachtman, did infuse their studies of landscape with the necessary spiritual content. From artists such as George Inness to influential critics such as Alfred Trumble, the editor of the *Collector*, the charge against the French Impressionists and often against their American followers was a lack of spiritual value; as Trumble wrote in his magazine in May 1893, "The great weakness of this school, if one may call it a school, is that it is simply and solely materialistic."

"Soul" in landscape was to be found in the artist's ability to awaken or heighten an emotional reaction on the part of the viewer, one that reflected his or her own perception, a perception involved, not in the physical aspects of seeing the colored lights and purple shadows of Impressionism, but in sensing the spiritual. Ruge quoted Inness concerning the purpose of art: "Its aim is not to instruct, not to edify, but to awaken an emotion. . . . Its real greatness consists in the quality and force of this emotion." Such emotion was found—often totally—wanting in Impressionism, but it ws abundant in Tonalist art, including, as Ruge stated, that of "George Inness, who displayed in his later manner some of the qualities that became the boast of the succeeding school."

Another quality dear to the heart of Tonalist artists and critics was craftsmanship. Impressionist painting appeared unformed and unfinished; its aesthetic betrayed the heritage of the sketch, a *premier coup* that was now accepted as an end in itself. The materiality of the impastoed surface was, of course, only further proof of the materialistic basic of the art, while this "signature" methodology of the artist stood for egocentric idiosyncrasy rather than the respect for the primacy of the power of the landscape to inspire emotional response. Tonalism, on the other hand, was still a "modern" movement in which the manipulation of paint on the surface of the canvas was essential to the basic aesthetic, and the blurring of forms with its concomitant suppression of detail produced landscapes no longer bound by the triviality of detail that characterized the outmoded approach of the discredited Hudson River School.

Instead, Tonalism could trace its sources far more respectably, much farther back in time. Essential to the poetic effects of Tonalist art was the technique of glazing, that is, successive application of thin washes of pigment suspended in oil or varnish, though light could penetrate these layers to an undercoat of more solid pigment and be reflected back. This tradition had been intensely, if uniquely, investigated earlier in America by Allston, but it was really the heritage of the revered Venetian Renaissance. Such was the source and heritage of Tonalist craftsmanship.

The use of glazes, whether thin films of paint of similar hues, as in Tryon's pictures, or strong contrasts of color and chiaroscuro with attendant dramatic paint manipulation, as in Ranger's work, led to still more agreeable and harmonious surface effects. Tonalist paintings are not glassy smooth; their surfaces display vitality, though to a controlled degree. They avoid the choppy and craggy qualities of much Impressionist painting, which appeared to its critics as unfinished and disagreeable, the opposite extreme from the impersonal smoothness of academic finish.

Impressionism, in fact, was criticized in its own time for its emphatic Realism, and if we recall its origins in the paintings of Édouard Manet, that charge is not difficult to fathom. In its sources in the art of Whistler, in its blurring of recognizable forms, Tonalist art seemed the painting of the present if not the future. That is, without denying its sources in the natural world, the Tonalist landscape veered toward the abstract and away from reality, as did much of the art of the 1890s. On multiple levels, artists of this decade renounced the intense Realism of the previous period and instead emphasized formal aesthetic relationships over concerns derived from subject matter, often with attendant simplifications. Though sharing nothing of the sometimes arcane and occult, often sensual, predilections of European Symbolism, Tonalism's poetic emphasis and concern with suggestion rather than definition were parallel to that contemporaneous movement.

Lastly, Tonalist landscapes were seen as decorative, as Impressionist ones were not, the adjective used in a nonpejorative sense. This was the outcome of their concern with the abstract rather than the realistic and, indeed, a measure of the limit of abstraction to which they were willing to take their manipulation of natural forms. As Samuel Isham wrote about a group of Tonalist painters and their works: "They all paint the decorative landscape, rather low in key, rich in color, and with the paint laid on solidly and with a pleasant, though varied, surface." The emphasis on decoration, in fact, allies the Tonalists with that artist who was perhaps the most admired of all French contemporary painters at the end of the nineteenth century, Pierre Puvis de Chavannes. If we review the qualities that distinguished Tonalism from other approaches to landscape painting of the time, and which were so admired, they are amazingly consistent with the bases of admiration for Puvis: emanation of the

spiritual, concern for craftsmanship, abstract simplification, and a penchant for the decorative.

Was Tonalism a school? Not really. Ranger was the first to "discover" Old Lyme, Connecticut, in 1899, although he had been directed there by the enthusiasm of his fellow painter Clark Voorhees. He induced other like-minded artists to join him in successive summers. For a while he succeeded in making Old Lyme a kind of outpost of late Barbizon, that is, Tonalist, landscape painting, but Childe Hassam's appearance in 1903 quickly changed the dominant mode practiced there to Impressionism. Ranger settled, instead, nearby in Noanck; Leonard Ochtman was not far away in Mianus. Frank Du Mond brought the Art Students League to Old Lyme for a summer session in 1904, but expenses soon forced a removal to another location, which resulted in the establishment of the summer school at Woodstock, New York, under Birge Harrison.

If Tonalism was not a school except, perhaps, in the restricted sense that it dominated the teaching of Tonalist artists (some of whom, like Harrison, held official positions), it was certainly a style of landscape with a cohesive formal approach and recognizable pictorial and emotional values, though still conducive to individual expression. For a while Tonalism was more; it was a movement. We can discount excessive encomiums and claims made by such champions of Henry Ward Ranger as Ralcy Hosted Bell, who called Ranger in 1914 "for more than forty years . . . the militant leader of a group of painters known as 'Tonalists,'" and Clara Ruge, who indicated that Ranger not only was the leader of the movement but had given it its "Tonal" appellation as early as 1890 or 1891. The Tonalist painters coalesced into a movement about 1896. This was the year they became a dominant force in the exhibitions held at the Lotos Club, supported by Ranger and their principal patron, William T. Evans. The following year, the "rival" group of artists, the Impressionists, seceded from the Society of American Artists and formed their own exhibiting group which became known as the Ten American Painters. This organization held its first exhibition in 1898. Almost surely spurred on by the cohesiveness of this predominantly Impressionist-oriented group, the late Barbizon-Tonalist painters formed their own organization, the Society of Landscape Painters, which had its first exhibition in 1899. For a few years this group of twelve artists exhibited effectively together, holding annual exhibitions in such galleries as those of the American Art Galleries and M. Knoedler & Co. in New York and at the Art Institute of Chicago. Their last formal showing appears to have been at Knoedler's in 1904.

The Society of Landscape Painters included a good many of the artists dealt with in this essay and

exhibition [of 1982]. George Inness, Jr. was one of these; his father was of course already deceased, he whom Ruge perceptively observed had provided inspiration for the movement. The art of Inness, Sr., too, suggests the parameters of Tonalism, from the density of Ranger's pictures to the frail ethereality of Tryon's. The work of some of the Tonalists even verged occasionally on a modified Impressionism, just as some of the Impressionists, such as Weir and Twachtman occasionally, at least, produced semi-Tonalist pictures. Tonalists such as Bruce Crane, for instance, or even Dwight Tryon, might indulge in the variegated chromatics more usually associated with Impressionism when painting summer scenes, though their more usual autumnal subjects tended toward a muted, austere palette.

Tonalism dominated the turn-of-the-century exhibitions of the Society of Landscape Painters and also those of the Lotos Club over approximately the same period, just as it figured importantly in some of the major New York and Brooklyn collections of American art owned by such Lotos Club members as Evans and Hearn. Many of the Tonalists, indeed, were members of that club, and certainly the 1901 exhibit of the work of artist members offered a wide display of the various Tonalist approaches to landscape. The movement prevailed again that same year in a showing of American paintings from the collection of George A. Hearn. Tonalism was featured prominently in the Comparative Exhibition of Foreign and American Arts held late in 1904 at the Fine Art Gallery on Fifty-seventh Street in New York City, organized by the Society of Art Collectors, a group in which William T. Evans was a prominent and influential figure. It was an interesting concept and an interesting exhibition. If the foreign pictures were predominantly French Barbizon paintings, there was greater diversity to the American section, but the American Barbizon and Tonalist pictures could be compared to the movement to which they traced their origins. The European pictures necessarily represented an earlier artistic stage, one that had already been "historicized."

Tonalism was soon to become history, also. The reviews of the exhibitions of the Society of Landscape Painters suggest the reasons for the demise of the movement, and perhaps ultimately of the style itself. Basically, it was seen as attractive and poetic—but also somewhat monotonous. Though the artists were able to express their individuality and their styles are not—and were not—confused, there was still a great deal of "sameness" in their work. Ultimately, Tonalism was perhaps *too* aesthetic, lacking the sparkle and color of Impressionism, and, being landscape without figures, also too devoid of life, especially in comparison to the vivaciousness of the Ashcan School,

which was just then beginning to appear. Birge Harrison, in fact, was to paint a number of fascinating and beautiful New York views in the Tonalist manner in an attempt to urbanize the movement, but these, too, were concerned with effects aimed at achieving a special beauty. Basically, Tonalism was not a truly public art, nor did it have public appeal, and the very factors that led to cohesion may have led to the disintegration of the movement. Faced with the urban emphases of the Ashcan School and the controversial, exciting drama of the inroads of European modernism, Tonalist art must have looked frail, indeed. Poetry and "soul" and even traditional craftsmanship were all too soon to be replaced by the crude vigor of a younger generation, who reveled in a lack of that very harmony that was a hallmark of the Tonalists. That was eight [sic] decades ago. Today the suggestive beauty of the work of these artists offers us a realm of suspended reality in which we may wish to seek a gratification in the emotive powers of nature and the empathetical gestures of artists who responded to them. As Leigh Hunt wrote in regard to Tonalism in the *Art Collector* in December 1898:

> Tone is the spirit of a picture—the technique, the letter; and that frame of mind is not always to be deplored which justifies the means to the end. If necessary, we can dispense with many a *tour de force* of drawing or daring color-scheme if we can give the true, artistic inwardness of a scene or incident—an inwardness which is half veiled and half revealed by the indefinite and mystical "tone."

[*The following section constitutes the recent expansion to this essay*]

WITH ONE very significant exception, to be discussed shortly, the Tonalist painters were concentrated in the Northeast—along the Hudson River Valley, and especially in Connecticut and western Massachusetts.[1] Sense of place, of course, was seldom a factor for the Tonalists, who were far more concerned with expressing nature's moods and in conveying their reactions to those moods, often in minimal, sometimes austere, terms. Thus, unlike the paintings of the earlier Hudson River School, the titles the Tonalists gave their pictures concentrated on weather conditions and times of day or year (dawn, twilight, sunset, moonrise, and moonlight being especially prominent).[2] This is not to suggest that the Tonalists did not travel farther afield. Among Charles Davis's finest works, painted early in his career and certainly his most Tonalist, are evening scenes painted in Fleury, outside Barbizon in France, but for the most part, Davis's work was something of an exception to the rule, for

Tonalist painting is, by and large, not associated with pictures created abroad. There are other foreign manifestations, such as George Bogert's Dutch scenes and the pictures painted by Charles Warren Eaton in Holland and especially in Bruges, Belgium. And on this side of the Atlantic, Birge Harrison created the most beautiful Tonalist paintings during his travels, from Quebec in Canada, to Charleston, South Carolina, and indeed, Harrison's pictures do capture qualities distinctive to those very different environments—the dramatic, dark swirls of the Canadian skies and the sometimes soft, sometimes vivid blues of Charleston's harbor and town.

Still, despite the continuing celebration of Harrison's tonal cityscapes of New York, the great majority of his Tonalist landscapes were probably created in and around Woodstock, New York, while Paul Cornoyer, too, made a specialty of painting tonal landscapes of New York City. Henry Ward Ranger's finest works were created in Old Lyme and later in Noanck, Connecticut, and Bruce Crane also painted around Old Lyme. Also working there was Louis Dessar, perhaps the major American painter of Tonalist farm scenes, who was identified with that movement in his lifetime.[3] Leonard Ochtman created beautiful scenes in Mianus, across the river from the predominantly Impressionist colony of Cos Cob in Connecticut. Charles Warren Eaton, who in 1888 had settled in Bloomfield, New Jersey, near George Inness in neighboring Montclair, painted his best-known Tonalist pictures of tall dark pines silhouetted against sunset and moonlit skies in Thompson and then Colebrook, Connecticut. Leon Dabo worked in a Whistlerian manner along the Hudson River, and Ben Foster drew his subject matter primarily from New England. J. Francis Murphy was based in Arkville, New York, and Dwight Tryon around Northampton, Massachusetts, where he was associated with Smith College—this to identify the artists today considered among the leaders of the Tonalist movement. Again, however, geographic identification is seldom a concern in the paintings of these artists.

Elsewhere in the United States, Tonalism appears rarely and spasmodically, and again, with the following exceptions, few artists have become especially associated with the movement. Among the painters of the Brown County art colony in Indiana, the most important such colony in the Midwest, Impressionism was the dominant aesthetic, though there are paintings by Adolph Shulz, one of the founders of the colony, such as his 1918 *Turkey Roost* (Indianapolis Museum of Art), that utilize a soft, minimal palette, achieving a muted lyricism. One might expect some flowering of Tonalism among artists in and around Chicago,

Fig. 4.
Charles Rollo Peters
Moonlit Landscape, n.d.
Oil on canvas
19 × 25 inches
Oakland Museum of
California, Gift of Mr. and
Mrs. Herbert M. Stoll, Jr.

since George Inness was especially well patronized there and the Tonalists exhibited often at the Art Institute of Chicago; in fact, the first exhibition of the primarily Tonalist group the Society of Landscape Painters (discussed elsewhere in this catalogue) traveled, albeit in somewhat reduced form, to the Art Institute in 1899. There is, however, presently no evidence of a midwestern Tonalist movement, though further investigation of Illinois art may reveal some outcropping there.[4] Isolated examples of the work of several midwestern artists are known, of course, and their degree of commitment to Tonalism may enrich our understanding, as the art of these painters is studied further. In Minneapolis, Robert Koehler, originally a dramatic naturalist, especially during his long years abroad in Munich, created some Tonalist works; his best-known Minneapolis painting, *Rainy Evening on Hennepin Avenue* (ca. 1910; Minneapolis Institute of Arts) would quality as such, a rare Tonalist genre picture featuring the artist's wife and son, and recalling the artist's admiration for Whistler, whom he had met earlier in his career.[5] Probably the most significant midwestern artist to adhere to the Tonalist aesthetic was Edmund H. Wuerpel, one of the leading landscape painters in St. Louis in the late nineteenth and early twentieth century. This direction taken in his art was surely due, at least in part, to his friendship with Whistler,

about whom he wrote several times. Wuerpel's own painting probably bears closest comparison with that of Charles Warren Eaton, his eastern contemporary.[6] In the South, the artist who produced the most Tonalist work is probably Alexander Drysdale, though his impressive, if somewhat repetitive bayou landscapes owe their aesthetic, to some degree, to his technique of using an oil wash—that is, a dilute mixture of oil and kerosene.[7]

Where Tonalism really flowered, however, and in fact became the dominant aesthetic at the end of the nineteenth and the early twentieth century was in Northern California, where, as Harvey Jones has written, "Artists active in the San Francisco Bay Area and in Monterey/Carmel embraced an aesthetics of a subjective interpretation of nature rendered in muted colors and soft contours that evoked a quiet, contemplative mood."[8] The artists of the southern part of that state, with its warm climate, brilliant sunlight, and varied landscape of broad beaches, seaside cliffs, forested valleys, and high mountains, were almost all Impressionist-oriented, but in the north, Tonalism triumphed. This was due, in part, to the influence of both George Inness, who had traveled to and worked in California in 1891, and Whistler, as well as to the local temporal conditions—to the fog and haze often characteristic of the climate of the Bay Area. Also of primary significance here was the authority

of Arthur Mathews, not only one of the leading artists of the region but the head of the San Francisco School of Design (later the Mark Hopkins Institute of Art in 1893, and, after the great earthquake and fire of 1906, the San Francisco Institute of Fine Arts).

Studying in France in 1885–89, Mathews was influenced both by the murals of Pierre Puvis de Chavannes and by the work of Whistler. Once back in California, Mathews created beautiful reductive landscapes in closely related tones and was followed in this manner by his students, the short-lived Arthur Atkins, who died at age twenty-six, Giuseppe Cadenasso, Gottardo Piazzoni, and Francis McComas, the latter even better known for his watercolors than his oils. Some of Piazzoni's landscapes are among the most reductive of all Tonalist works, but unlike his eastern counterparts, the forms of land, foliage, sea, and sky are always clearly delineated in his pictures.[9] Today one of California's best-known painters is the deaf-mute Granville Redmond, still another of Mathews's students, celebrated especially for his wonderfully colorful paintings of vast fields of California poppies. Redmond himself, however, was more drawn to his very different and distinct, moody Tonalist landscapes, paintings of fog, haze, sunset, and moonlight.[10] Mathews was also an outstanding figure painter in both murals and easel works, incorporating Symbolist elements into his Tonalist visions in a manner unlike that of his eastern counterparts with the exception, perhaps, of Arthur B. Davies. *The Wave* (The Oakland Museum), probably Mathew's most celebrated painting, is a fascinating mixture of Tonalism, Symbolism, and Art Nouveau.[11]

In California, Charles Rollo Peters created a large series of vivid, dark blue "nocturnes" in Monterey (Fig. 4), in emulation of the paintings of Whistler, who is reported to have said that Peters was the only artist other than himself who could paint nocturnes. Peters's darkly modulated tones led him to be dubbed "the Prince of Darkness," the subtitle of the major study of his life and art.[12] Monterey, in fact, became the alternative setting for Tonalist painting in California, after so many San Francisco artists settled there, some temporarily, some permanently, after the earthquake. There, in 1907, a group of San Francisco artists, including Mathews, Piazzoni, Peters, and Xavier Martinez, made an arrangement with the Del Monte Hotel to hold prestigious exhibitions of their work and that of other Tonalist artists, though Impressionists, both local and some from the south, also participated. Piazzoni, Peters, and Martinez also followed Mathews in creating Tonalist figurative works, often with Symbolist and sometimes overtly religious subject matter. Martinez was another of Mathews's students, also influenced greatly by

Whistler. Perhaps that artist's best-known work is his *Afternoon in Piedmont* (Fig. 5) of about 1911, an homage to Whistler's famous portrait of his mother, but Martinez was working in a Tonalist mode even during his years of study in Paris, as attested by his *Notre Dame* (The Oakland Museum).[13]

The Tonalist mode would seem to have been initiated in Northern California about the same time as in the northeastern United States and was more firmly entrenched there, since Impressionism made few inroads in the Bay Area, despite the occasional showing of European and American Impressionist works. As Harvey Jones has noted, the Tonalist aesthetic "looked backward for its traditional subject matter and its quiet sentiment at the same time as its reductive vocabulary of visual elements with emphasis upon art for its own sake looked forward to the modernist impulses of twentieth-century painting."[14] But, just as in the east, by about 1930 those modernist movements, along with Social Realism, supplanted the tranquility and pure aestheticism of Tonalism in both the American east and west.

Fig. 5.
Xavier Martinez
Afternoon in Piedmont (*Elsie at the Window*), ca. 1911
Oil on canvas
36 × 36 inches
Oakland Museum of California, Gift of Dr. William S. Porter

NOTES

1. The excellent catalogue by Jeffrey W. Andersen, *Old Lyme: The American Barbizon, Old Lyme, Connecticut*, exh. cat. (Old Lyme, Conn.: Lyme Historical Society and the Florence Griswold Museum, 1982), deals with both Barbizon and the related Tonalist painters working in that art colony. Many of the works exhibited and discussed were painted in the colony's heyday as the major Barbizon-Tonalist center in this country, before Impressionism took over in 1903, but some of the artists continued to work in the alternate aesthetic even after that. Andersen discusses Tonalism on p. 9 of his essay.

2. In the exhibition *The Light Beyond: Paintings and Prints from the Permanent Collection Depicting Dawn, Twilight and Moonlight*, exh. cat. (Duxbury, Mass.: The Art Complex Museum, 1996), the majority of the paintings included were Tonalist works.

3. William B. McCormick, "Louis Dessar, Tonalist," *International Studio* 79 (July 1924), pp. 295–97.

4. My thanks to Joel S. Dryer, Director of the Illinois Historical Art Project, for his discussion with me concerning the possibility of Tonalism in Chicago and Illinois. Neither a Barbizon nor a Tonalist aesthetic made much impact in Chicago generally. Dryer suggested that some of Albert Krehbiel's easel paintings might be designated as Tonalist, yet Krehbiel is best known as a muralist, and he worked primarily in a colorful, Impressionist manner and has been linked to that movement. Still, some of his winter landscapes are "Tonalist," in a manner not unlike those of the great Cos Cob Impressionist John Twachtman. For a fairly impressive publication list on Krehbiel, see, most significantly Robert Guinan, *Krehbiel: Life and Works of an American Artist* (Washington, D.C.: Regnery Gateway, 1991).

5. Rena Neumann Coen, *Minnesota Impressionists* (Afton, Minn.: Afton Historical Society Press, 1996), pp. 63, 66.

6. Edmund H. Wuerpel, "My Friend Whistler," *St. Louis Mirror* 13 (28 January 1904), pp. 18–20; Wuerpel, "Whistler—the Man," *American Magazine of Art* 27 (June 1934), pp. 312–21. For Wuerpel, see *Edmund H. Wuerpel Retrospective Exhibition*, exh. cat. (St. Louis, Mo.: St. Louis Artist's Guild, 1988).

7. Howard A. Buechner, *Drysdale (1870–1934), Artist of Myth and Legend* (Metairie, La.: Thunderbird Press, 1985); for Drysdale's method, see especially pp. 44–46, and chap. 8, "Technical Characteristics of Drysdale Paintings," pp. 86–93.

8. The standard work on California Tonalism is Harvey L. Jones, *Twilight and Reverie. California Tonalist Painting, 1890–1930*, exh. cat. (Oakland, Calif.: Oakland Museum, 1995). The title alone points to the dominant themes of the California Tonalists. See also the discussion of this exhibition by Kate Rothrock, "Tonalism: The Softer Side of Light," *The Museum of California* 19 (Winter 1995), pp. 17–21.

9. Piazzoni has yet to be the subject of a major monographic study, but see *Gottardo Piazzoni: Painter of the California Landscape, 1872–1945*, exh. cat. (San Francisco: Museo ItaloAmericano, 2000). In recent years, the murals he began to create in 1929 for the Main Library in San Francisco's Civic Center, *The Land and the Sea*, were the subject of controversy concerning their removal in order to facilitate the transformation of the structure into the Asian Art Museum of San Francisco. They are scheduled to be reinstalled in the M. H. de Young Memorial Museum.

10. The definitive study of Redmond is by Mary Jean Haley, *Granville Redmond* (Oakland, Calif.: Oakland Museum, 1988). One might expect a chronological distinction between Redmond's Tonalist and his more Impressionist paintings, but this does not seem to be the case. Rather, he seems to have worked in both, quite distinct, manners at much the same time; perhaps market considerations were involved in his choice of artistic strategies.

11. The most significant study of Mathews is Harvey L. Jones, *Mathews Masterpieces of the California Decorative Style* (Oakland, Calif.: Oakland Museum, 1972; new ed., with color, 1985).

12. Megan E. Soske, "Charles Rollo Peters: 'The Prince of Darkness,'" master's thesis, University of Indiana, Bloomington, 1992.

13. For Martinez, see George W. Neubert, *Xavier Martinez (1869–1943)* (Oakland, Calif.: Oakland Museum, 1974).

14. Jones, *Twilight and Reverie*, p. 11.

Championing Tonal Painting: The Lotos Club

Jack Becker

During the second half of the nineteenth century, a number of private clubs—the Century, Lotos, Union League, Colonial, and Engineer's—featured displays of American and European paintings. These clubs helped to shape the taste and buying habits of collectors and potential collectors, and the club members who organized these exhibitions became arbiters of taste; by including specific pictures or works by certain favored artists, they sanctioned artists and styles of painting. Frequently these shows were reviewed in newspapers and magazines, and non-members visited the exhibitions. These exhibitions might contain only a dozen or two works, and many artists came to believe that their paintings were displayed to better advantage in these more intimate settings. In January 1897 the noted dealer and promoter of American art William Macbeth opined, "The small, choice exhibitions given by the clubs ... offer to picture lovers the best opportunity for properly studying the work of individual groups or schools of painters."[1] As a result of these exhibitions, clubs stimulated the growing interest in American art after the Civil War, helping to further the careers of many artists through encouraging collecting and sales.

Despite the large number of clubs offering exhibitions, the Lotos stands out within the field of American art during the 1890s and first few years of the twentieth century for its support of what became identified as Tonalist painting.[2] Since its establishment in 1870, the Lotos had attracted a wide range of professionals who participated in its activities, which included hosting art exhibitions for its growing membership. During the 1890s, however, the Lotos Club expanded its exhibition schedule and became a major presence in the New York art scene, largely under the leadership of the collector William T. Evans.[3]

Evans joined the Lotos in December 1892, nominated by the Tonalist painter Henry Ward Ranger.[4] Evans's position with the dry-goods firm Mills & Gibb, where he began as financial manager and rose to president, provided him with the funds to purchase art.[5] Also a member of the Salmagundi Club and the National Arts Club, he displayed works from his collection at those two venues.

Within two years, fellow Lotos Club members had appointed him chairman of the art committee, and for the next eighteen years he used this position to exert his control and his taste in the wider arena of the New York art world. Working closely with Ranger and other members of the club, Evans promoted American art by organizing exhibitions, forming a club collection, and nominating collectors, dealers, and artists as members. During the early 1890s a number of other important collectors joined the club, beginning with George A. Hearn, whom Evans nominated in December 1892.[6] Ranger, who also played an important role in the art life of the club, nominated the future collectors of American art Frederick Bonner in 1891 and Alexander Humphreys in 1894.[7] Ranger also proposed Henry Chapman, Jr., a collector from Brooklyn, late in 1893.[8]

In 1894 the club established a new policy toward exhibitions, which were all held in the clubhouse at 556–558 Fifth Avenue, on the west side of the avenue south of Forty-sixth Street, their headquarters since 1892. As John Elderkin recounted in his 1895 history of the club, "A strong committee, composed of Edward Moran, Henry W. Ranger, William T. Evans, W. Lewis Fraser, and Henry T. Chapman, Jr. took things to charge. These gentlemen planned a series of monthly exhibitions, each to be under the management of a member of the committee, to be devoted to a branch of art especially favored by him."[9] This policy marked a decided shift. Previously only artists had constituted the committee, but beginning in 1894, except for Ranger and Moran, the art committee members were collectors.[10] Over the following years the committee membership changed, but collectors, not artists, dominated the planning of the exhibition program. As a result, collecting and connoisseurship received greater emphasis.

The new exhibition program allowed each member of the committee an opportunity to represent his own taste and expertise as a connoisseur. As revealed by an 1894 review, "The club will aim to have each art exhibit during the season distinctive and representing a definite purpose in collectorship."[11] By 1899, several years after the

implementation of this new program, a writer for the *Art Collector* reflected that the Lotos

> has gone ahead of other organizations, with larger resources, until, in the minds of the painters at least, it now stands at the head of exhibiting clubs, a result due to intelligent management and an intelligent policy. The method of conducting its exhibitions is original and worth giving for the instruction of other clubs, and consists in arranging its display to illustrate certain schools, or certain men, or certain departments of art.[12]

The redirected program opened in February 1894 with an exhibition of drawings and paintings executed in black and white, many lent by the Century Company.[13] For March, Evans organized a display of landscapes and marines by the American artists George Bogert, William Coffin, Charles Melville Dewey, Henry Dearth, George Inness, Homer Dodge Martin, Robert Minor, Thomas Moran, Edward Moran, Leonard Ochtman, Henry Ward Ranger, Albert Pinkham Ryder, Abbott Thayer, Dwight Tryon, J. Alden Weir, and Alexander Wyant. Most, and perhaps all, the paintings were from Evans's own collection. This exhibition, possibly the first arranged by Evans, foreshadowed the type of displays he would organize at the Lotos for the next two decades. Preferring a certain group of American painters closely identified with a muted palette rather than with the bright colors and broken brushwork of Impressionism, Evans favored landscapes over figurative pieces and paintings that conveyed a poetic interpretation of the natural world. A distinguishing feature of Evans's collection was the fact that most of the works were by living American artists or painters who had only recently passed away. Paintings by three landscape painters who worked in a Tonalist style, George Inness, Homer Dodge Martin, and Alexander Wyant, figured prominently in his collection.

The next month Henry T. Chapman, Jr. organized an exhibition of eighteenth-century English art. A banker and stockbroker, Chapman was one of the first Americans to purchase Barbizon paintings.[14] Although Chapman's collection of American paintings did not compare with his European holdings, he supported American art by financially backing William Macbeth during that dealer's early years.[15] Correspondence between the two men suggests that Chapman liked the work of Ralph Blakelock, Arthur B. Davies, Charles Warren Eaton, William Howe, George Inness, Robert Minor, J. Francis Murphy, Henry Ward Ranger, Carleton Wiggins, and Alexander Wyant.[16] That William Evans collected the paintings of these same artists further demonstrates a shared taste among the members of the Lotos Club's art committee.

George A. Hearn assembled the club's final exhibition for the spring 1894 season. He presented works by Dutch masters of the sixteenth and seventeenth centuries, drawing largely on his own collection. Hearn had begun acquiring European art in the 1870s and turned his attention to American work only in the 1890s, his taste for the latter perhaps being influenced by his involvement with the art committee.[17] Not surprisingly, he purchased a large number of paintings by many of the artists most popular at the club, including Ralph Blakelock, George Inness, Dwight Tryon, Horatio Walker, and Alexander Wyant.

The fall 1894 season opened with an October exhibition of old masters of the early English and Continental schools.[18] The following month Evans organized an exhibition of American figurative paintings, an impressive number of which had received notice already: five Columbian Exposition medals, three Thomas B. Clarke Prizes and a first Hallgarten Prize from the National Academy of Design, and a Shaw Fund Award from the Society of American Artists.[19] The highlights of the exhibition included Eastman Johnson's *Nantucket School of Philosophy* (Walters Art Museum, Baltimore, Maryland), Theodore Robinson's *In the Sun*, Winslow Homer's *Eight Bells* (Addison Gallery of American Art, Andover, Massachusetts) and two unidentified works by Thomas Dewing.[20] Evans garnered praise for the high quality of the paintings he chose, and because he installed the canvases "in a way to let them act as foils to each other and by close contrast accentuate their several values."[21]

In January 1895 the club held an exhibition of European old master paintings from George Hearn's collection. In February Evans organized a show of American landscapes that included six works by George Inness, who had died a few months before and whom critics considered the leader of American landscape painting during this era.[22] Chapman assembled the March exhibition, *Epochs of French Art*, which provided a lesson in the history of French painting during the eighteenth and nineteenth centuries.[23] In keeping with contemporary taste, this exhibition included several Barbizon landscapes, an important precursor for American painters working in a Tonalist style.

During the late 1890s, as the Lotos Club continued its active exhibition schedule, the press and art committee began to use the terms "tonal" and "tonalist" with increasing frequency in descriptions of its shows. In 1896 and 1897, only a few years after the new exhibition program was instituted, two important shows identified what constituted Tonalism in a painting.

The first, organized by Evans with Ranger's assistance, opened in February 1896; it was called *Some Tonal Paintings of the Old Dutch, Old English, Barbizon, Modern Dutch, and American Schools*. The content of the forty-picture exhibition illustrated the close relationship of these two men as well as their shared aesthetic.[24] The oldest works included a Jan van Goyen, a Meindert Hobbema, and a Rembrandt. English artists on view included Thomas Gainsborough, Richard Wilson, John Constable, and Old Crome. The Barbizon painters were well represented, as was the Hague School, a group of Dutch painters inspired by the Dutch countryside and the Barbizon tradition. The eight American painters were Albert Blakelock, George Bogert, George Inness, Homer Dodge Martin, Robert Minor, Albert Pinkham Ryder, Henry Ward Ranger, and Alexander Wyant.

In contrast to previous exhibitions at the club devoted to a particular school, this one brought together the art of the past with the art of the present and in so doing provided an opportunity to understand how these collectors defined a Tonalist aesthetic. A delighted reviewer wrote:

> As a showing of tonal pictures it is beautiful, the various paintings holding together in a manner altogether delightful. Not everything in the collection is of equal merit, but it is on the whole a homogeneous exhibition of paintings in which tone is the feature and the raison d'etre.[25]

Evans and Ranger interspersed works by American painters among those by European artists, allowing viewers to examine the stylistic affinities of American painters with the generally older Dutch, French, and English artists. For example, one of Ranger's two landscapes hung next to a work by the early-nineteenth-century English painter John Constable.[26] This integrated arrangement helped delineate the shared tonal quality of the paintings while also asserting that American-born artists were the equals of their European counterparts. As one critic noted, the exhibition was large enough "to demonstrate the kinship existing between these early painters and certain painters of to-day."[27]

The members of the art committee displayed a keen interest in educating other members about the history of art. Accordingly, they followed this show with several smaller thematic exhibitions that critics described as "tonal." In January 1897 two men, George Hearn and Catholina Lambert, organized an exhibition of paintings from the "early English school," drawing largely from their own collections and those of private dealers. The installation was applauded by a critic:

> To enter the gallery where these pictures are hung is to be made sensible of a color charm and harmony which affect the mind like a low, deep-toned musical chord. While the pictures owe something to the hand of time, which has ripened them to a beauty beyond that which the painters gave them.[28]

The following month, John Elderkin, the club's president, organized an exhibition of works painted by the Barbizon School, demonstrating the appeal of these artists for members of the Lotos.

Following the English and Barbizon exhibitions, Chapman presented a show that combined the historic European art of the past two exhibitions with contemporary American painting in a second Tonalist exhibition, *Tonal Paintings: Ancient and Modern*. In keeping with the collecting taste of the art committee, this exhibition included many works by the same European painters that had been displayed in the previous Tonalist exhibition; of American painters only Blakelock was omitted and Arthur B. Davies and Dwight Tryon were added.

During the late 1890s not everyone understood the characteristics of Tonalist painting as displayed at the Lotos Club. One frustrated reporter hinted at the confusion by attempting to provide a clear definition based on the works in this exhibition:

> The term tonalist is used so glibly by many writers and lecturers on art topics that it is to be feared the general art public is not always entirely certain of its meaning. A study of any or all of the admirable and superior canvases Mr. Chapman has selected would soon make clear to the art students and lovers that tone in the simplest sense means that harmonious adjustment and blending of values and color which gives sentiment, richness, and artistic value to a picture. There are tonal figure works, as well as landscapes, and to say that a picture lacks tone is to say that it is hard in color, unpleasant in effect, and devoid, as a rule, of true artistic quality.[29]

After giving this rather general definition of a Tonalist painting, the critic went on to say that "many American painters—Homer Martin, George Inness, Minor, Tryon, and A. P. Ryder—who have been, and are, such students and interpreters of tone in painting, as to make them tonalists par excellence."[30] Ranger's depictions of the Connecticut woods were typical of some of the paintings popular with Evans, Hearn, and other collectors associated with the Lotos (Fig. 6). Employing muted, harmonious colors, Ranger was most interested in the effect of glazes, a very thin layer of transparent paint that tints and modifies the color of the layer below, rather than covering

Fig. 6.
Henry Ward Ranger
Connecticut Woods, 1899
Oil on canvas
28¼ × 36¼ inches
Smithsonian American Art
Museum, Washington, D.C.,
Gift of William T. Evans

it up completely. In addition, Ranger set great store in varnish and firmly believed in applying a final thick coat to each picture. He also employed painting techniques that allowed his pictures to "ripen" with age, in an attempt to make them harmonize with the works of the old masters. William Macbeth believed that Ranger "always bore in mind time's effect on his pigments. He always declared that passing years, mellowing and ripening them, would greatly enhance the beauty of his pictures."[31]

Many of the American artists on view in the Tonalist exhibition were younger than the majority of these European painters, many of whom were associated with the Barbizon and Hague Schools, suggesting that the Americans were the heirs to a European tradition. At least one critic agreed with this tacit assessment: "The men have been selected with considerable care, particularly from the list of our native painters who have strong affiliations with the veterans of the past, for whom tone and quality were most important factors in the construction of a work of art."[32] The organizers of the two Tonalist exhibitions were, in effect, claiming that Tonalist works by Americans were equal to their European counterparts and that American artists were continuing the European tradition.

In March 1897 two exhibitions outside the Lotos added to the enthusiasm for Tonalist landscapes: Daniel Cottier's show of paintings by Horatio Walker, frequently referred to as the "American Millet" because of his scenes of farmers working in the dim light of evening or morning; and William Macbeth's exhibition of thirty-five paintings by Robert Minor, a painter who is virtually unknown today.[33] The *Collector* praised the pic-

tures by Minor, saying, "They invest the room in which they are with a singularly penetrating atmosphere of dreamy color and of tender harmony of tone. . . . There is not one which one would wish away, or which unbalances the harmony of the whole."[34] The writer placed Minor among that group of artists that maintained "its attitude of sincerity, devotion to its ideals, and disdain of the fantastic fashions of the day, the seeds it sows will germinate and flower even as the weeds decay."[35] The phrase "fantastic fashions of the day" was perhaps a thinly veiled reference to Impressionism, which Minor had indeed eschewed. Instead, he had based his paintings on ideals derived from his study of the Barbizon School and through his personal knowledge of the painter Narcisse-Virgile Diaz de la Peña. Diaz had influenced his style, as had the art of his friend and fellow American painter Alexander Wyant.

In the early 1890s critics and reviewers began sporadically using the terms "tone" and "tonal"; by the late 1890s they had dramatically increased their use of these words,[36] despite the fact that the style they described had been prevalent in American art for more than a decade. Inness developed his mature version of the Tonalist idiom in the 1880s, and Tryon had perfected a distinct Tonalist style of painting, in which he employed horizontal compositions and a limited palette, by the late 1880s and early 1890s (Fig. 7).[37] Wyant and Martin also had developed their personalized styles during the late 1880s. Even Ranger was creating seascapes that display an overall gray tonality and simplified composition in the late 1880s. However, it took nearly a decade for critics to dub these landscapes, painted with a muted palette, as "tonal."

To understand the significance of the need to arrive at a label for these subdued paintings, it is necessary to appreciate the somewhat negative impact of Impressionist art.[38] New Yorkers had opportunities to see the works of the French Impressionists in the mid-1880s; the dealer Paul Durand-Ruel, for example, displayed approximately 290 pictures of this kind in 1886. The American version of this style by such painters as Theodore Robinson, Childe Hassam, and John Twachtman, in turn, appeared in the late 1880s and early 1890s. Although a large number of American painters eventually began working in an Impressionist style, American audiences did not immediately accept Impressionism. Indeed, during the 1890s and the first decade of the twentieth century, some of the leading collectors of American painting resisted the style. Instead, they purchased the muted landscapes of Inness, Martin, Wyant, and a rising younger generation of painters such as Murphy, Ranger, and Louis-Paul Dessar, who continued to

work in subdued tones. By identifying the works of these artists as "tonal" or "tonalist," these collectors were announcing that there was an alternative to Impressionism. That one of the most active among them was William T. Evans, chairman of the Lotos Club art committee, meant that the club had become identified as a center for Tonalist painting. As one critic observed about an American figurative exhibition organized by Evans in 1897:

> The Lotos Club shows, as everyone who follows such things is aware, have been definitely, almost aggressively, devoted to aiding and abetting the reaction against advanced impressionism and naturalism generally. . . . It follows that the present display is not over rich in work that opposes this tendency. To be sure Mr. F. W. Benson's beautiful *Summer* has been loaned by Mr. W. T. Shaw, and several other things could be mentioned that are still outside the bondage of bitumen, but on the whole the display is consciously given over to works that secure "tone" at all hazards.[39]

Few if any of the collectors of the Lotos Club took to the bright colors and broken brushwork of contemporary Impressionism. Instead, they sought to legitimize their preference for American paintings in subdued tones through comparison with the works of the Barbizon and Hague Schools.

A number of critics and reviewers supported the Lotos Club's aesthetic agenda. Before praising the 1897 autumn exhibition at the Lotos Club, one critic lauded the club's exhibitions: "In small shows it is feasible to accept only those pictures whose methods and aims are near enough alike to insure absence of clash. Not only must every canvas be in tone but the whole collection must be in tone."[40] Those who assembled the exhibitions strove for an overall harmony of effect. Reviewers of these shows frequently commented on the installation, which suggests that Evans and other members of the art committee gave great attention to the matter. One reviewer of an 1896 landscape show that Evans organized attributed the exhibition design to the collector: "to his taste, it is probable, is due the fact that the present collection is tonal, and in respect of its tonality very agreeable."[41] But Evans was not alone in creating tonal ensembles. Hearn also had "selected his pictures, not only for individual excellence but for aesthetic kinship and harmonic relation."[42] Both men believed that creating exhibitions and collections with an overall tonality reinforced the tonal quality of each painting.

Some critics also discerned a kind of therapeutic quality of "rest" in the exhibitions that Evans organized for the Lotos Club. A reviewer of an 1896 show wrote, "The rich and restful effect of the present exhibition of paintings at the Lotos Club is due to the careful selection by the art committee of canvases of harmonious tone, without a strict regard for the other virtues of picture-making."[43] Three years later another critic commented: "Almost every exhibition contains something that might be dispensed with for the sake of harmony, but this collection is nearly above reproach in this respect. The sense of rest one experiences on glancing around the gallery is a tribute to the ripe knowledge of the chairman [Evans]."[44] In the 1890s

Fig. 7.
Dwight William Tryon
Sunrise: April, 1897–99
Oil on wood panel
20 × 30 inches
Freer Gallery of Art,
Smithsonian Institution,
Washington, D.C., Gift of
Charles Lang Freer

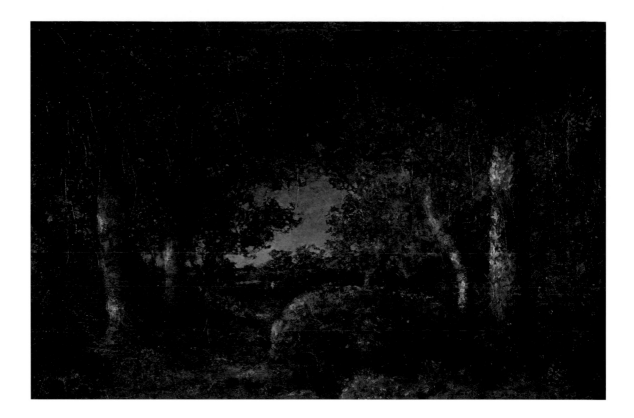

ig. 8.
Ralph Albert Blakelock
Woods at Sunset, n.d.
Oil on canvas
16 × 24 inches
Montclair Art Museum,
Montclair, New Jersey,
Gift of William T. Evans

an individual picture was considered to convey a sense of rest if it displayed harmonious gradations of color, and so could entire exhibitions, if the paintings were properly combined.

Although Evans became closely identified with Tonalist painting through shows at the Lotos Club, he nevertheless purchased paintings by American Impressionists—though in small numbers when compared with his Tonalist purchases. Most of the Impressionist works Evans purchased were created during the first decade of the twentieth century, and by then, American Impressionists had fashioned their own style that was frequently more muted than that of the European Impressionists. Even when Evans gradually began to acquire paintings by American Impressionists, most of them were by Twachtman, an artist who created almost monochromatic pictures that showed allegiance not only to Impressionism but also to Tonalism.[45]

Evans's distinct interest in Tonalist paintings was evident in displays of his collection at other venues as well. In 1906 seventy works from the Evans collection inaugurated the new quarters of the National Arts Club in Gramercy Park. The exhibition included ten works by Wyant, six by Martin, five by Blakelock (Fig. 8), four by Ranger, three each by Inness, Minor, Murphy, Walker, and Williams, and two each by William Gedney Bunce, Dessar, George Fuller, Walter Shirlaw, Tryon, and Twachtman. Although the exhibition included one Impressionist painting, *Isle of Shoals* by Childe Hassam, the show was constituted

largely of Tonalist works.[46] Critics recognized what sort of painting appealed to this collector:

> Perhaps the adjective that characterizes this individual taste best would be "tonal." Mr. William T. Evans seems instinctively to have rejected pictures with severe outlines and sharply accentuated colors. Little by little he has acquired color-poems of greater or, less distinctiveness, and even when figure pieces are introduced these are more ideal than realistic, more romantic than classical.

The reviewer concluded, "The same general impression of love of color rather than of form—of an art which in its widest sense approaches music in its intangible and undefinable qualities of sentiment and feeling."[47] The exhibition confirmed that Evans's reputation as a collector of Tonalist landscapes extended well beyond his efforts at the Lotos.

Although Evans was active in other clubs and venues, he remained at the helm of the art committee through the first decade of the twentieth century, and many of the exhibitions organized during these years at the Lotos Club were similar in approach to those of the previous decade, showcasing private collections and the work of artist members. As a result, the connection between Tonalist painting and the Lotos Club continued well into the first decade of the twentieth century. For example, in March 1901 Hearn presented an exhibition of his growing American art collection. Previously he had shown various facets of his European holdings and, occasionally, works by American painters.

The fifty-four paintings included examples by Blakelock, Dessar, Inness, Martin, Tryon, Walker, and Wyant. His close involvement with the Lotos may have contributed to his interest in collecting contemporary American art and probably shaped his taste for Tonalist pictures.

Two years later, Alexander C. Humphreys, president of the Stevens Institute in Hoboken, New Jersey, presented his collection of American art for the first time at the club. His holdings paralleled those of Evans in that he owned paintings by Blakelock, Dessar, Inness, William Langson Lathrop (Fig. 9), Martin, Murphy, Ochtman, Ranger, Tryon, Walker, Williams, and Wyant, all of whom used a Tonalist rather than an Impressionist approach. The *New York Times* reported that the pictures

> reflect a distinct taste for the landscape in its rich, quiet phase at nightfall and by moonlight, with occasional examples of brighter day dreams to lighten the general tone of somberness that prevails. Here are no paintings by the devotees of dissolved sunlight and vibratory color effects in the strong shining day.[48]

In keeping with the policies of the club, Evans had designed the exhibition and probably even selected the works.[49]

Also in 1903 John Harsen Rhoades, a relatively new collector of paintings, exhibited thirty-eight works at the club.[50] After making his fortune in the dry-goods business, Rhoades, who belonged to the Lotos as well as other clubs, began collecting American art. He purchased canvases by Blakelock, Davis, Davies, Dessar, Dewey, Paul Dougherty, Homer, Inness, Martin, Minor, Murphy, Ranger, Tryon, Walker, Williams, and Wyant. The 1903 exhibition was his first show, and it was reviewed in a daily newspaper. "The large exhibition puts him at once among the serious and discriminating buyers and declares a genuine feeling for color on the part of him who brought the pictures together."[51] Another reviewer opined, "The collection is one of colorists and tonalists without the aid of any of the more notable open-air landscape painters. As they reflect a divided taste for pictures in one department, the gallery offers a very harmonious appearance; indeed, one may say that there is not a single discordant note on the walls."[52]

Artist-member exhibitions also flourished at the club when the art committee was under Evans's direction. In general after 1900, there were fewer exhibitions of European art, and the program became increasingly devoted to American art with emphasis given to shows of works of artist-members. These succeeded because they met the needs of two elements of the membership: the artists and the collectors. At the urging of Ranger and Evans,

an increasing number of artists joined the Lotos: more than 120 between 1886 and 1912.[53] This led to ever-larger artist-member shows. In 1901 the artist-members had "suddenly become so plentiful that it was necessary to appropriate the room adjoining the regular gallery to accommodate the increased numbers of contributions."[54] The works displayed at these exhibitions were frequently for sale, and members could purchase pieces directly from the artists, their fellow members. This arrangement benefited both the artists and the collectors.

Exhibitions devoted to the work of a single artist remained rare at the Lotos Club. There were two one-man shows devoted to the work of Albert Blakelock (1900 and 1902); a posthumous show for Robert Minor; and monographic exhibitions on Homer Dodge Martin, Alexander Wyant, and John Twachtman.

Although American Impressionists including Childe Hassam, Robert Vonnoh, and J. Alden Weir joined the club, it appears that the Tonalists dominated the program. For example, one 1902 review was headlined, "Lotos Club Shows Pictures by Thirty-nine of Its Members—Tonal Men and Others in Evidence."[55] The critic quipped that "of the 'tonal' men, Mr. Ranger, Mr. Dessar and Mr. Bogert are represented by landscapes, in which the search after a swimming atmospheric envelope has in each case led to exaggeration of personal manner."[56] A review of a 1904 member exhibition described the increase in artist membership and the continued interest in Tonalist painting, "there is a goodly number of 'Lotos Club landscapes,' showing the usual affected handling and the accustomed unctuous tonal effects."[57] The label "Lotos Club landscapes" provides further evidence that a certain kind of

Fig. 9.
William Langson Lathrop
The Muskrat Hunter, 1908
oil on canvas
30 × 40 inches
Reading Public Museum,
Reading, Pennsylvania,
Museum Purchase

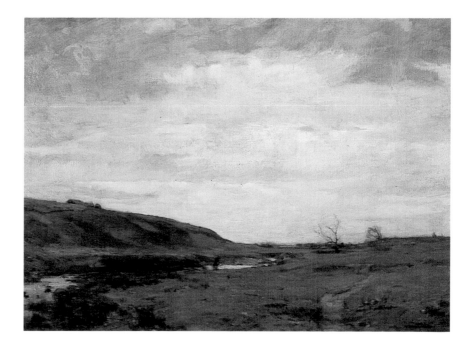

picture found favor at the club. The popularity of this style may well have encouraged less talented artists to make imitations that capitalized on the preference for muted landscapes.

The preference for Tonalist pictures at Lotos Club exhibitions continued unabated. In 1908 the painter Charles Harold Davis, responding to a request from Evans for a painting for a forthcoming annual exhibition of works by artist-members at the Lotos, wrote to his dealer William Macbeth about which picture to send:

> How would it do to send my "Sunset Clouds" there? I hesitated between it and the summer subject of same size—one of the new ones sent down early in the season and which may be called "Midsummer"—The former may be a little more Lotos Club & stand less chance of being hung in some outside overflow place it being quite properly tonal in character. If Mr. Evans or one of the powers that be should happen in, a choice between the two might be left to the potentate.[58]

That Davis described a tonal painting as "a little more Lotos Club" reflects the appeal of these pictures for members of the club.

After moving to 110 West Fifty-seventh Street in 1909, the Lotos continued its exhibition schedule. But change was in the air. Many of the more active members of the Art Committee passed away during the decade beginning in 1910: Hearn in 1914, Ranger in 1916, and Evans in 1918. Although the Lotos Club's position within the New York art world had dramatically diminished by the time of World War I, before that conflict broke out it had played a vitally important role in the promotion of contemporary American art. From its inception in 1870, the club and its members encouraged the work of American artists. However, it was the transformation of the art committee in 1894 by key collectors that made the club an important venue for a major current in contemporary American painting for more than a decade. Leading collectors including William T. Evans, Henry T. Chapman, George A. Hearn, Alexander Humphreys, and John Harsen Rhoades refined their taste through their active involvement with the club's Art Committee. As a result of these men, the public and the art critics came to associate the Lotos Club in the late 1890s with pictures that displayed Tonalist harmonies. It could be said that the club's ambitious exhibition program was in some measure responsible for the preoccupation in the critical press during the 1890s with the terms "tonal" and "tonalist".

NOTES

1. William Macbeth, *Art Notes*, January 1897, p. 34.

2. The Lotos Club possesses a series of scrapbooks of newspaper clippings that record club-related activities, including exhibitions as well as a member book. I would like to thank Dr. William I. Homer for bringing these archival resources to my attention. Lotos Club Member Book, Lotos Club, New York City.

3. For a more thorough discussion of Tonalist painting and its relation to the Lotos Club and the collector William T. Evans, see Jack Becker, "A Taste for Landscape: Studies in American Tonalism," Ph.D. diss., University of Delaware, 2002.

4. For a more complete discussion of Henry Ward Ranger, see Jack Becker, *Henry Ward Ranger and the Humanized Landscape*, exh. cat. (Old Lyme, Conn.: Lyme Historical Society, 1999).

5. For a complete discussion of William T. Evans, see William Truettner, "William T. Evans, Collector of American Paintings," *American Art Journal* 3 (Fall 1971), pp. 50–79.

6. Lotos Club Member Book.

7. Ibid.

8. Ibid.

9. John Elderkin, *A Brief History of the Lotos Club* (New York: The Lotos Club, 1895), p. 122.

10. *Lotos Club Exhibition of Paintings Saturday Evening, November 4 Monday Afternoon, November 6, 1893*. This 1893 catalogue lists only Moran and Ranger as members of the art committee. In 1887 the art committee consisted of Edward Moran, Charles Graham, and Chandos Fulton. *Lotos Club Loan Exhibition of Paintings by American Artists, Saturday Evening, November 26th, Monday Afternoon, November 28th, 1887*. In 1888 Henry Ward Ranger and Bruce Crane joined the committee. *Lotos Club Loan Exhibition of Oil Paintings Saturday, Feb. 25th, Monday, Feb. 27th, 1888*. In 1891 the committee of Moran, Ranger, and C. Harry Eaton constituted the committee. *Lotos Club Loan Exhibition of Paintings by American Artists, Saturday Evening, Jan. 17th, Monday Afternoon, Jan. 19th, 1891*. All, Lotos Club Archives, Lotos Club, New York City.

11. *New York World*, October 23, 1894, clipping, Lotos Club Scrapbooks.

12. *Art Collector* 9 (January 1, 1899), p. 73.

13. For a complete listing of the contents of the exhibition, see the accompanying catalogue, Archives of the Lotos Club.

14. "Col. H. T. Chapman Dies," *New York Times*, September 8, 1912. "The Chapman Gallery," *Collector* 2 (August 1, 1891), p. 202.

15. Linda Skalet, "The Market for American Painting in New York: 1870–1915," Ph.D. diss., Johns Hopkins University, 1980, p. 173.

16. Ibid.

17. For a more complete discussion of Hearn, see Doreen Bolger, "William Macbeth and George Hearn: Collecting American Art, 1903–1910," *Archives of American Art Journal* 15 (1975), pp. 9–15.

18. Lotos Club Archives.

19. *New York Mail and Express*, November 23, 1894, clipping, Lotos Club Scrapbooks.

20. Ibid.

21. Ibid.

22. *New York Sun*, February 22, 1895, clipping, Lotos Club Scrapbooks.

23. Lotos Club Archives.

24. "Pictures at the Lotos Club," ca. February 1896, unidentified clipping, Lotos Club Scrapbooks. The review reads, "Henry W. Ranger, to whom is due much of the success of the present exhibition."

25. *New York Sun*, ca. February 1896, clipping, Lotos Club Scrapbooks.

26. "A picture by Constable cheek by jowl with the very modern Henry W. Ranger"; unidentified clipping, ca. February 1896, Lotos Club Scrapbooks.

27. Unidentified clipping, possibly ca. February 1896, Lotos Club Scrapbooks.

28. Unidentified clipping, possibly ca. January 1897, Lotos Club Scrapbooks.

29. *New York Times*, March 27, 1897, clipping, Lotos Club Scrapbooks.

30. Ibid.

31. William Macbeth, *Illustrated Catalogue of the Completed Pictures Left by the Late Henry Ward Ranger, N.A. and his Collection of Works by Some of his Contemporaries* (New York: American Art Galleries, 1917).

32. Unidentified clipping, dated February 29, 1896, Lotos Club Scrapbooks.

33. Skalet, "The Market for American Paintings," p. 298.

34. *Collector* 3 (15 March 1897), p. 145.

35. Ibid.

36. In January 1890 one critic claimed, "Mr. Tryon is an excellent example of the tonalists." "Native Landscape in Art. The Union League Club Exhibition," *Tribune* January 10, 1890, clipping, Thomas B. Clarke Papers, Archives of American Art, Smithsonian Institution, Washington, D.C., microfilm roll N597.

37. Linda Merrill, *An Ideal Country: Paintings by Dwight William Tryon in the Freer Gallery of Art* (Washington, D.C.: Freer Gallery of Art, Smithsonian Institution, 1990).

38. For an overview of Impressionism as practiced in America, see William H. Gerdts, *American Impressionism* (New York: Abbeville, 1984). For a more recent discussion of American attitudes toward the French Impressionists, see Kathleen A. Pyne, *Art and the Higher Life: Painting and Evolutionary Thought in Late Nineteenth-Century America* (Austin: University of Texas Press, 1996).

39. Unidentified clipping, May 3, 1897, Lotos Club Scrapbooks.

40. *New York Mail and Express*, December 15, 1897, clipping, Lotos Club Scrapbooks.

41. *New York Sun*, March 31, 1896, clipping, Lotos Club Scrapbooks.

42. Eliot Clark, "The Late George A. Hearn Was Always a Firm Believer in the Future of American Art," *Scribner's Magazine* 63 (May 1918), p. 640.

43. "Pictures at the Lotos Club," February 1896, clipping, Lotos Club Scrapbooks.

44. *Art Collector* 9 (April 1, 1899), p. 163.

45. For a complete breakdown of the paintings Evans owned by each artist and when he may have purchased them, see Truettner, "William T. Evans," pp. 72–79.

46. For a complete listing of the contents of this exhibition, see *National Arts Club Opening Exhibition American Paintings from the Collection of Mr. William T. Evans, November 8 to 18, 1906* (New York: National Arts Club, 1906).

47. "Evans Loan Collection Extraordinary Beauty of the Tonal Pictures at the New Arts Club," clipping, Florence N. Levy Papers, Archives of American Art, microfilm roll D45.

48. *New York Times*, ca. March 1893, clipping, Lotos Club Scrapbooks.

49. Ibid.

50. *Lotos Club Exhibition of American Paintings from the collection John Harsen Rhoades, Saturday evening January 31, 1903* (New York: Lotos Club, 1903).

51. *New York Mail and Express*, January 30, 1903, clipping, Lotos Club Scrapbooks.

52. *New York Times*, January 31, 1903, clipping, Lotos Club Scrapbooks.

53. Lotos Club Member Book.

54. "Lotos Club Pictures," February 22, 1901, clipping, Lotos Club Scrapbooks.

55. *New York Mail and Express*, February 2, 1902, clipping, Lotos Club Scrapbooks.

56. Ibid.

57. *New York Evening Post*, probably February 1904, clipping, Lotos Club Scrapbook.

58. Davis to Macbeth, February 2, 1909, as quoted in Bolger, "William Macbeth and George Hearn," p. 13.

The Society of American Landscape Painters

WILLIAM H. GERDTS

LATE IN 1897 a group of ten American painters seceded from the Society of American Artists, the organization that had originated in New York City two decades earlier. Their primary aim was to exhibit and celebrate the more advanced aesthetic tendencies that had been absorbed by the younger painters who had trained in Europe (in Paris and Munich, especially) and who either had returned to develop their careers in this country or had remained expatriates. This society served as an alternative exhibition venue to the much earlier and increasingly conservative National Academy of Design, founded in 1825. By the 1890s, however, the distinction between the works shown at the annual exhibitions of the two organizations seemed increasingly negligible. These secessionists, acknowledging themselves simply as the Ten but critically soon identified as the Ten American Painters, concluded that their interests were best served in smaller and more compact exhibitions in which their work would appear in harmonious relationship with one another. They wanted to distance themselves from what they felt was the heterogeneous and often mediocre work shown at the society, and indeed, the society and the National Academy were to merge in 1906.[1] The Ten were almost immediately identified as an organization of Impressionist painters. Seen as celebrating the most modern art movement then finding increasing favor among American collectors, a number of these artists, in fact,—Thomas Dewing and Edward Emerson Simmons among them—could only partially or tangentially be identified as Impressionist.[2] Their annual shows, which took place in New York City over a period of twenty years, usually traveling to Boston and occasionally other cities as well, were critically well received, particularly during the early years.

Yet Impressionism was not universally accepted in the United States. A significant group of critics and collectors continued to espouse the more lyrical, even spiritual landscapes of the painters who were still working in the mode initiated by the French Barbizon artists and practiced by such American landscapists as George Inness. Inness died in 1894, and during his last years, beginning in the late 1880s, he introduced a more reductive aesthetic,

using a limited landscape vocabulary often dominated by a single overall tone, which was aptly labeled Tonalism. The Barbizon and Tonalist painters who confronted the rising tide of Impressionism, which was deemed too materialistic, as it was pereceived as concerned solely with depicting things of the physical world, enjoyed the critical support especially of the magazine *The Collector*, which began publication in 1889 under its editor and publisher, Alfred Trumble, who, significantly, in 1895 authored the first full-length biography on the recently deceased Inness.

But by the end of the nineteenth century, although the National Academy proved receptive to showing the work of the Tonalist artists, they did not have their own organization as did the Ten, who were predominantly oriented toward Impressionism. To rectify this, and certainly in emulation of the latter painters, early in 1898 twelve Barbizon and Tonalist artists formed a now little-remembered organization called the Society of American Landscape Painters (the name would soon change to the Society of Landscape Painters) and held annual exhibitions in New York.[3] Not only did these artists share an aesthetic philosophy, but they mixed in a congenial social atmosphere at the Lotos Club, where many of them had already exhibited together, most notably in the club's exhibition, of *American Landscape Painters*, on view in March 1896.

The appearance of this group caused nothing like the stir of critical controversy that had greeted the appearance of the Ten a year before. This difference was surely due, in part, to the radical—"modern"—identification of the Impressionists, as opposed to the more traditional nature of the new group. Also, the members of the Society of American Landscape Painters, while well recognized professionally, had not established the distinct and sometimes distinguished reputation of many of the members of the Ten, such as Childe Hassam, nor were they celebrated as leading art teachers of the period, as were Edmund Tarbell and Frank Benson in Boston or, a few years later, William Merritt Chase. Chase, in fact, became the eleventh member of the Ten when, in 1905, he assumed the place vacated by John Twachtman, who had died

Opposite:
Bruce Crane
Late Autumn
(detail of Cat. 1)

39

in 1902. Furthermore, the twelve artists of the Society of American Landscape Painters did not secede from the Society of American Artists but continued to exhibit with the older group. Yet the new society may have had an effect on the earlier one, for in a review of the 1899 annual exhibition of the Society of American Artists, the critic for the *Art Amateur* noted, "The practical secession of a number of the landscapists to form the new Society of Landscape Painters may account for the comparatively small display made in that department of art."[4]

A writer for the *Art Amateur* commented on the overlap between the groups: "The organization of artist associations goes on apace. The latest is a 'Society of American Landscape Painters,' whose object is to give a yearly 'group' exhibition of landscapes only. The members of Messrs. G. H. Bogert, W. Clark, W. A. Coffin, Bruce Crane, R. Swain Gifford, F. W. Kost, R. C. Minor, J. I. [*sic*; J. F.] Murphy, L. Ochtman, W. L. Palmer, H. W. Ranger, and C. Wiggins. None of them intend to resign from any organization to which he belongs, nor to discontinue sending pictures to other exhibitions."[5] This differentiated the society from the Ten American Painters, whose members did indeed resign from the Society of American Artists; nevertheless, a parallel with the Ten was specifically made in a review of the group's fourth annual exhibition held in April 1902. The critic for the *New York Times* wrote of the Landscape Painters: "They form a little group like the Ten American Painters, with a similar purpose, an exhibition outside the regular shows of the Academy and the Society of American Artists. Like the Ten, they are more or less in sympathy with views of tone, so that a room full of their contributions is really more harmonious than is many a one-man show."[6] One critic noted that the formation of this group as independent from the exhibitions of the Society of American Artists had aroused criticism but pointed out that it was not a breakaway organization. Rather, its purpose was twofold: "to give the dignity of distinctiveness to the landscape department of American painting and to gain for each member a more extensive and uninterrupted showing of his work with the probability of making larger sales." Still, this writer criticized the new group as being too exclusive, recommending that it "should have embraced many more men, and it should have made it clear from the start that the membership would be extended as occasion required."[7] The *American Art Annual* for 1898 listed the members of the group, correcting the identification of J. Francis Murphy, and noted that it was limited to twelve members and had no officers. It was also pointed out that arrangements had already been made with the American Art Association, later called American Art Galleries, on Madison Square at 6 East Twenty-third Street for the first exhibition to be held in March 1899.[8]

A full explanation of the purposes of the new society was published in the New York *Sun* in March 1898: "With the idea that with no jury or hanging committee, but each artist selecting the works he wishes to show and arranging them on the walls in a space allotted to him, an exhibition comprising several groups of pictures might be both interesting and attractive to the public, a number of New York landscape painters have formed a society for the purpose of holding such exhibitions." Already the four galleries on the two main floors of the American Art Galleries had been reserved for this show. The writer for the *Sun* understood that their number might be increased to fifteen by the election of three more members, or some other artists might be invited to exhibit with the society, "this being a matter depending on the amount of line space each member will want to have at his disposition." The critic stated that the members of the new society disclaimed any intention of pretending to be the landscape painters of the American school, but simply put forth the announcement that they have associated themselves in a formal organization "for the purpose of giving what they think will be an interesting exhibition, and declare that they will continue them if the first venture proves successful." He pointed out, too, that neither watercolors nor pastels would be shown. Unlike the Ten, with its contingent of three Boston members and with

Fig. 10.
George Henry Bogert
October Evening, 1904
Oil on canvas
28 × 36⅛ inches
The Hudson River Museum, Yonkers, New York, Gift of Mrs. Louis Laidlaw Backus

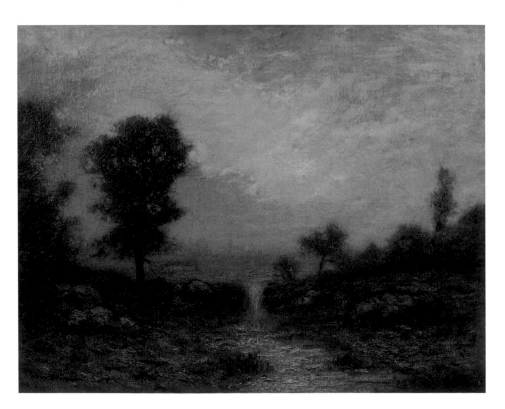

J. Alden Weir and John Twachtman based in Connecticut, the members of the Society of American Landscape Painters were primarily based in New York, despite the fact that several of its members worked in rural Connecticut and Palmer lived and worked in Albany. And while the *Sun's* writer did not suggest the homogeneity of the Barbizon-Tonalist style among the twelve members of the society—only Palmer and, to a degree, several of the Connecticut-based artists painted landscapes utilizing some strategies of Impressionism—he concluded his discussion with a brief notice of the opening of the first exhibition of the secessionist artists of the Ten the following day, suggesting both comparison and contrast with the primary subject of his article.[9]

By 1899 all the members of the new society were quite well-known landscape painters, and all of them were noted for their dedication to this single genre, again in contrast to the Ten, many of whom were equally adept and celebrated for their figural work. Yet, even by the time of the group's first exhibition in March 1899, the membership had changed. Henry Ward Ranger had withdrawn, and, keeping the number to twelve, the group had added Charles Harold Davis, who lived in Mystic, Connecticut.

George Henry Bogert (1864–1944) had studied in France with several masters, including Eugène Boudin, though he credited his success to his colleague in the society Carlton Wiggins. Bogert had begun showing his work at the National Academy in 1884, and many of his landscapes had been done at European art colonies—St. Ives in England, Étaples in France, and Katwijk in Holland. He began to have one-artist shows in New York in 1893, won the National Academy's Hallgarten Prize in 1899, and became an associate of the academy as well as a member of the Society of American Artists that same year, having won the Webb Prize of that society in 1898. He would go on to win medals at several international expositions and, not surprisingly, showed his work at the Lotos Club, where he also organized exhibitions.[10] His landscapes often depicted sunset and moonlight scenes, dominated by a single tone (Fig. 10).

Walter Clark (1848–1917) was an older artist who had studied architecture and sculpture as well as painting. He was greatly influenced by George Inness, renting a studio next to the master in the Holbein Building on Fifty-fifth Street in New York, enjoying Inness's criticisms, and subscribing to the Tonalist aesthetic in landscapes done along the northeast coast.[11] William Anderson Coffin (1855–1925) exhibited landscapes regularly at the National Academy from 1881 and become an associate academician in 1898, but he was equally known for his art criticism, being the art editor for

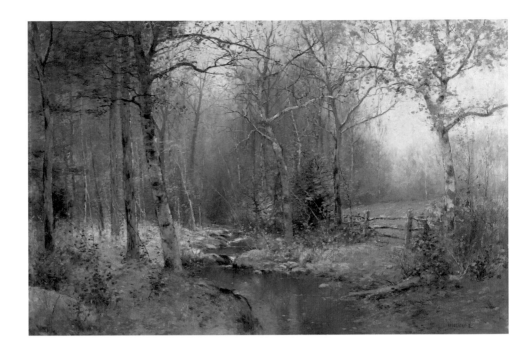

the *New York Evening Post* from 1886 to 1891 and the New York *Sun* from 1896 to 1901. This latter position probably accounts for the *Sun's* enthusiastic reception of the new society, cited above. Coffin was also involved with the organization of the Pan-American Exposition held in Buffalo in 1901, and the Panama-Pacific International Exposition in San Francisco in 1915.[12]

Better known today is Bruce Crane (1857–1937), who has always figured as one of the primary artists in the Tonalist movement (Fig. 11). Crane studied with Alexander Wyant, like Inness one of the founders of the Tonalist movement, and then spent a good deal of time in Grez-sur-Loing in France, an artists' colony on the edge of the Forest of Fontainebleau, where many American artists, including Coffin and other members of the new society, had worked in a Barbizon-Tonalist mode. Crane was a member of the Society of American Artists in 1881 and became an associate of the National Academy in 1897, achieving full academician status four years later. Just before the founding of the Society of American Landscape Painters, Crane wrote: "To me the highest work is the subjective or imaginary. Inness, Corot, and Millet were of this school. No more careful students of nature ever lived; they knew their grammars perfectly, but all their interpretations were colored with the exquisite poetry and feeling of these wonderful imaginations."[13]

Charles Harold Davis (1856–1933) had studied at the School of the Museum of Fine Arts, Boston, and then in Paris, painting distinctly Tonalist landscapes even in the French countryside at Fleury, near Barbizon. On his return, he became a member of the Society of American Artists in 1886 but

achieved associate academician status at the National Academy only in 1901; he, too, was a member of the Lotos Club. A decade earlier he had settled in Mystic, Connecticut, becoming the leading figure in the artists' colony there; ironically, he began moving away from a distinct Tonalist mode, through a less austere and even more colorful aesthetic, with more robust brushwork, which eventually blossomed into full-blown Impressionism with his landscapes featuring "cloudscapes."[14]

Robert Swain Gifford (1840–1905) was one of the oldest members of the new society and had won a gold medal at the Centennial Exhibition in Philadelphia in 1876. He was a founding member of the Society of American Artists in 1877 and became a full national academician in 1878, but his reputation as a landscape painter, both during his lifetime and today, has been overshadowed by his mastery of printmaking techniques, wood engraving and especially etching. He was also an instructor and then director of the art schools of the Cooper

Union in New York.[15] If Gifford was one of the best-known artists of the new organizations, one of the more obscure of the group, then and now, was Frederick W. Kost (1861–1923), though he became a member of the Society of American Artists in 1889 and an associate of the National Academy in 1900. Kost received some instruction from George Inness and, predictably, was a member of the Lotos Club, specializing in Tonalist paintings based on motifs near his home in Brookhaven, Long Island.

The oldest member of the society was Robert Crannell Minor, Sr. (1839–1904), whose ten years abroad, from 1863 to 1873, included working with the French Barbizon master Narcisse-Virgile Diaz de la Peña; on his return to New York, Minor became one of the leading American exponents of Barbizon landscape painting, first known for his dense forest interiors similar to those of Diaz, and then specializing in very softly rendered landscapes of quiet, misty mornings and autumnal moods (Fig. 12). He often painted near the home of his friend Alexander Wyant, in Keene Valley in the Adirondacks; Minor later bought a home in Waterford, Connecticut, in 1894. A national academician only in 1897 and a member of the Lotos Club, where a memorial exhibition took place in 1904, Minor created many paintings particularly reminiscent of the work of George Inness. In addition, he was a proficient master of the etched landscape.[16]

While Minor's reputation has faded today, that of J. Francis Murphy (1853–1921) has remained known and appreciated (Fig. 13). Murphy's country studio was established in Arkville, in the Catskill Mountains, near that of Alexander Wyant. A national academician in 1887, a member of the Society of American Artists in 1901, and, of course, a member of the Lotos Club, in his own day Murphy sometimes enjoyed exceedingly high prices for his works.[17]

The primarily self-taught Leonard Ochtman (1854–1934) was born in the Netherlands, and his family settled in Albany, New York, in 1866. Ochtman became a member of the Society of American Artists in 1891 and an associate of the National Academy in 1898, achieving full academician status only in 1904. He, too, was a member of the Lotos Club. While maintaining a studio in New York City until about 1914, Ochtman is best known today for the works he painted in Greenwich, Connecticut, close to the artists' colony in Cos Cob. These are usually softly rendered, atmospheric landscapes, which sometimes incorporate a wider color range than the paintings by most of his colleagues in the Society of Landscape Painters.[18] But while Ochtman may have absorbed more of Impressionism than his colleagues did, he maintained the importance of

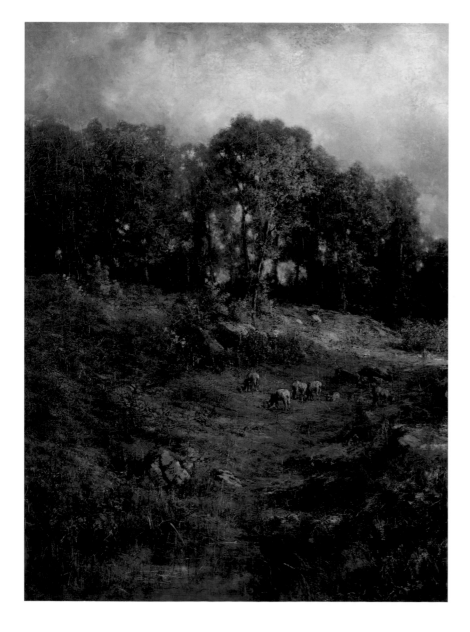

Fig. 12.
Robert Crannell Minor, Sr. *A Hillside Pasture*, n.d. Oil on canvas, 30¼ × 22¼ inches, Smithsonian American Art Museum, Washington, D.C., Gift of William T. Evans

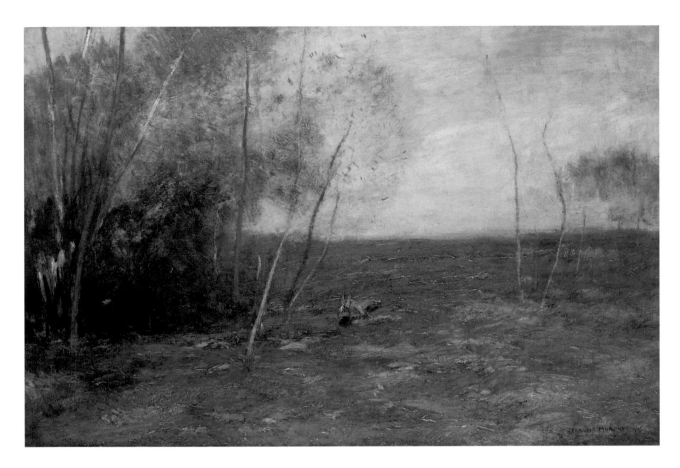

Fig. 13.
J. Francis Murphy
The Sprout Lot, 1915
Oil on canvas
27⅛ × 41¼ inches
Smithsonian American Art
Museum, Washington,
D.C., Gift of John Gellatly

memory and urged his students to rely on that faculty, with the assistance of outdoor oil studies, and to create their finished works in the studio.[19] Earlier, he was known as the "Keats of landscape," due to his "bewitching moonlights, his early morning effects, and pictures of calm days when the autumn mists hang over the hills."[20]

Just as the Tonalist figure paintings of Thomas Wilmer Dewing must have appeared distinctive in the annual shows of the Ten, so the glistening, often quite colorful landscapes of Walter Launt Palmer (1854–1932) must have stood out in the otherwise usually muted displays of the Society of Landscape Painters. Palmer was the son of the Albany sculptor Erastus Dow Palmer, who was, until his death in 1904, the leading figure in the Albany art world, and it was there that his son lived his entire life, with the exception of a few years, 1878–80, in New York's Tenth Street Studio Building. Walter Palmer studied under the portraitist Charles Loring Elliott and the landscape painter Frederic Edwin Church before going to Paris in 1874 to study with Carolus-Duran. Although based in Albany, Walter Palmer exhibited at the National Academy throughout his lifetime, becoming an associate academician in 1887 and a full academician a decade later; earlier, in 1881, he became a member of the Society of American Artists.[21] Palmer was especially noted for his views of Venice and even more for his

sparkling, crisp winter scenes in which blue, violet, and purple shadows contrast with the gleaming white snow.[22] In 1899, the year of the first exhibition of the new society, Palmer and his wife toured Japan and China.

Of all the founding members of the society, Henry Ward Ranger (1858–1916) is probably most recognized as one of the leading figures in the Tonalist movement and most appreciated today. The reasons for his withdrawal from the society have not been determined. Though based in New York, Ranger was the founder and leading figure in the first phase of Old Lyme, Connecticut, as a Barbizon and Tonalist art colony from 1899 to 1903, the same years that the Society of Landscape Painters was active.[23] Bruce Crane and Carleton Wiggins were among the members of the new society who painted with him in Old Lyme at this time.[24]

Carleton Wiggins (1848–1932) painted with Ranger both in Old Lyme and later at Noank, also in Connecticut, where Ranger had moved about 1905, close to his replacement in the society, Charles Davis, in Mystic. Wiggins studied with George Inness in the late 1860s, and then in the early 1880s he worked in Barbizon in France. He subsequently settled in New York, becoming a member of the Society of American Artists in 1887 and a National Academy associate in 1890; he, too, was a member of the Lotos Club. Turning from

pure landscape, Wiggins was known particularly for his painting of cattle in bucolic landscapes. Wiggins painted principally in Connecticut but also in East Hampton on Long Island. He moved permanently to Old Lyme in 1917, but in his later years, Wiggins's career was overshadowed by that of his son, Guy C. Wiggins, famous for his impressionistic snow scenes of New York City.[25]

The new society had dropped the national identification "American" from its name by the time the first annual exhibition opened on Friday, March 24, at the American Art Galleries on Madison Square South, a show that ran through April 5. It was accompanied by a sixty-three-page catalogue listing 184 works, considerably more than ever appeared in the shows of the Ten. It included an illustration of one work by each of the twelve artists. Despite the earlier assertions that only oils would be shown, more than sixty of the pictures were listed as watercolors and sketches. Bogert had the largest number of works, twenty including his sketches. The great majority of the paintings carried generic titles referring to woodlands, brooks, and valleys or to weather conditions, times of day, and seasons of the year. Relatively few were concerned with defining locales, though almost all of Bogert's paintings were identified with Dutch locations, and the sites of Kost's paintings ranged from Staten Island and New Jersey to Long Island and Massachusetts locales. Palmer included one of his Venetian scenes, a theme for which he was as celebrated as he was for his winter landscapes. The subject matter was drawn primarily from the American Northeast, though Wiggins, as with Bogert, showed a Dutch scene and also one done in Cornwall, England. All the pictures in the exhibition were landscapes with the exception of some of Kost's that included figures, including *Old Dock, New Dorp, Staten Island* (location unknown), which was his illustrated work, and the bovines in some of Wiggins's paintings.

Critics took notice of this new exhibiting group with reviews that were, by and large, favorable. The writer for the *Artist* seemed to prefer the paintings by Crane and Davis but concluded that the show was one "that all landscape-lovers will make a point of seeing."[26] Not surprisingly, the writer for the *Art Collector* (formerly the *Collector*), the most vigorous proponent of Barbizon and Tonalist aesthetics, called the exhibition as "the best show of the year." He particularly championed the work of J. Francis Murphy and compared the work of Kost to that of the French Barbizon artist Théodore Rousseau. He also noted that Minor was "the last of the old Barbizon guard," with one of his paintings bearing affinity with the paintings of Jean-Baptiste Camille Corot. Charles Davis's Impressionism was recognized by the writer, who was not sympathetic

to the strategies of that movement.[27] The *Brooklyn Eagle*, too, commended the show of this new organization, proud that "Two of them, George H. Bogert and Carleton Wiggins, are Brooklyn men."[28] The size of the exhibition, however, was discomfitting to some, for it was indeed a good deal larger than any of the annual exhibits of the Ten. The writer for the *New York Tribune*, for instance, found the show only "pleasing to a certain extent, but the painters have made the lamentable mistake of making their exhibit too large. This would be a pardonable fault if all the pictures were good, but unfortunately there is a great deal displayed which is not in the least interesting. Hence the repose and salience of your true 'group' exhibit is inevitably lost." The critic suggested that viewers concentrate on only a few of the finest works of each artist.[29]

The success of the exhibition, in terms of sales, has not been determined, but certainly the most celebrated of the paintings shown was Erastus Dow Palmer's *The Sentinels* (location unknown), the picture by him reproduced in the catalogue, which had been purchased by Mrs. Theodore Roosevelt, the governor's wife, for the State of New York in December 1898, just before the exhibition opened. Palmer sold four of his paintings at the opening of the exhibition.[30]

The writer for the *Mail and Express* pointed out the advantages offered by this group in comparison to the annual show of the Society of American Artists, which was on view at the same time. He noted that the latter "consists of pictures by many different artists, of varying purpose and artistic attitude . . . hung with as much regard to harmony as the necessity of giving fair positions to the several sorts of work will permit. The fault common to nearly every such aggregation of pictures is the lack of a large, guiding principle in their choosing and in their hanging." In contrast, the pictures of each of the Landscape Painters "has a place by itself, the wall space having been divided by lot. . . . In this way it has been found possible to give every man a chance to stand tolerably in the estimate of visitors, by the canvases of his neighbors." Yet even here, the limitations of the group were recognized, for though "The result is interesting; it would be more so were the twelve artists more even in power and more sympathetic in idea."[31] And the writer for the *Art Amateur* found that the exhibition of the group "did not show that the twelve artists represented in it have any common and peculiar artistic aim in view."[32] By contrast, the writer for the *New York Journal* noted that "A slight thread unites them like pearls of a necklace. The men of the society are at one in the thought that the artist must love life and show us that it is beautiful."[33]

Ochtman had been assisting with the schools of the Art Institute of Chicago when the first exhibition was being organized, and through his influence the society sent its exhibition to be shown at the Art Institute, the only time that this occurred. It was fortuitous, paralleling the regular appearance of the exhibitions of the Ten at Boston's St. Botolph Club, after an initial showing in New York. Not all of the New York show appeared in Chicago, but enough to make a serious impression. The writer for one of Chicago's leading art magazines, *Brush and Pencil*, was obviously taken with the work of Ochtman and Davis when he wrote, "if there were more studios in Connecticut instead of in New York City, the collection would be none the worse for it," bemoaning "the number of good things in this display of landscapes which are studio pictures that never saw the benign light of an out-door sky." The critic went on to discuss the importance of out-of-doors painting directly from nature, of which he was a proponent. He recognized the aesthetic distinctions within the exhibition, speaking of the gray—that is, Tonalist—work of Murphy, the "Barbizon School revisited" in the work of Minor, where "We find the earmarks of Diaz, his master, Corot, and others." But the works of Davis—his "dash, freedom, interest, personality, nature, charm"—and the delicacy and poetic sentiment of Ochtman were for this writer the highlights of the exhibition. Admiring, if to a lesser extent, the work of Clark and Palmer, he noted that the latter's painting, *The Sentinels*, which was illustrated in the article, had already been sold from the exhibition in New York.[34]

Although the exhibition of the Society of Landscape Painters in Chicago, from April 15 to May 14, 1899, was smaller than their initial showing in New York—119 pictures as compared to 184—it was still a substantial exhibition, accompanied by a catalogue in a very similar format, with the same work by each artist illustrated. It is not possible to determine whether the smaller showing in Chicago was due to a necessary diminution of the show to accommodate the galleries in the Art Institute or reflected successful sales in New York that were refused for further travel; very likely, both reasons were in play.

By and large, the critics in Chicago were enthusiastic, both because so substantial an exhibition had been brought from New York and because of the specific works included. Lorado Taft, the dean of Chicago artists, found the exhibition "not only interesting in itself, but a valuable index of the progress of landscape in this country."[35] The writer for the *Chicago Standard* deemed that "The group idea is excellent, both as applied to the subjects of the pictures, and the works of the artists. One may judge landscapes the more justly, and enjoy them

more fully, if they are not scattered among figures and buildings; while one may also the more satisfactorily judge the artist's work when he is able to study it in a dozen or more examples."[36] Not unlike some of the New York critics, both these Chicago writers preferred the work of Charles Davis and Leonard Ochtman, though Taft also commended Palmer, finding his snowy woods "strangely real," with "nature's true blend of tenderness and strength." The writer for the *Chicago Post*, too, was especially receptive to Davis's work, though actually on the basis of what would seem Impressionist, rather than Barbizon or Tonalist, qualities; he referred to Davis as "an apostle of purple shadows" and much admired three pictures that emphasized sky and cloud studies over glorious colors.[37] The most extensive, albeit the least sympathetic, review appeared in the *Chicago Times Herald*, where the critic was enthusiastic about only two or three canvases rather than the large numbers submitted by each of the twelve exhibitors, though he recognized the dominance of the Barbizon aesthetic. Here again, preference was voiced for the work of Davis and Ochtman, surely the "hits" of the society's first exhibition.[38]

The society's second exhibition, again held at the American Art Galleries, from May 2 to May 26, 1900, was slightly smaller than the first, with 155 pictures on view, ninety-four finished oil paintings and the rest watercolors and sketches. The same twelve artists exhibited, with all the works for sale except for one *Landscape* by Murphy that was owned by the major New York collector George A. Hearn. Exhibited this time were probably more views of locales both foreign and farther afield in the United States. Bogert showed scenes from England, France, and Holland; Crane exhibited a scene on the Brandywine River, where Walter Clark also painted, as well as views from Maine, Massachusetts, and France; Gifford showed a Florida view, while Kost had scenes of Staten Island, New Jersey, Pennsylvania, Rhode Island, and Long Island; Palmer showed five of his Venetian scenes; and Wiggins exhibited two French views from Barbizon and several from Laren in Holland. The collection, not surprisingly, consisted of landscapes, though Coffin also showed a flower piece, *Rhododendrons*.

The 1900 exhibition appears to have accrued even more extensive criticism than the previous one. The writer for the *Art Amateur* thought the show a distinct advance on the first, with the watercolors and studies making a clearer note than the oils themselves, though he found these, too, finer works than those shown in 1899.[39] The writer for the *New York Times* mentioned the exhibition on four separate occasions, the first of two detailed reviews noting that American landscape painting

was very much alive and well in 1900 despite the recent death of the great old name in the field, Frederic Edwin Church. He also considered the show to be at the same time independent and original and yet not without some reflection of both Barbizon and "Giverny" influences. The *Times* writer, in fact, thought Bogert's painting much improved and commended the work of all the other members of the society, with only that of William Coffin having "fallen off."[40] An even more in-depth analysis of the show appeared two days later.[41]

One of the difficulties in assessing the contents of the exhibitions of the new society is the very general nature of their entries, as indicated by their titles. It would be difficult to reconstruct any of these shows, since the titles of the works were usually so nonspecific, and because later writings on these sometimes still fairly obscure painters and even what few memoirs exist offer little assistance in locating their current owners. Likewise, contemporary reviews of the shows seldom reproduced works; one of the few exceptions is an *Art Interchange* review of the second show in which eight paintings were reproduced. The eight included four distinctly Tonalist pictures, *Morning* by J. Francis Murphy, *Cloudy October* by Robert Minor, *The Moonlit Road* by Leonard Ochtman, and *Peace at Night* by Bruce Crane; the presumably more Impressionist *Morning after the Snow* by Walter Launt Palmer; two more Barbizon-oriented works, *The Marsh* by Walter Clark and *Mountain Farm, Twilight* by Charles Davis; and the very Barbizon sheep picture, *Three Oaks* by Carleton Wiggins.[42]

Yet, as much as many of the critics paid lengthy attention to the exhibition, a number of them demurred as to both the quality of the work shown and the success of the show as a whole. The writer for the *International Studio*, for instance, who offered perhaps the most comprehensive view of the exhibit, noted that "face to face with the exhibition, after due consideration thereof, some modifications arise. Though the first visit to the gallery verifies all we have said about freshness of touch and freedom in the use of color, we search in vain for a canvas that appeals to us as a complete performance; there are parts or mere fragments suggestive of some great whole, but unsatisfying, like the fragments of codiciles which the archaeologists are now finding in the Orient." This writer, too, for better or worse, continued to find the influences of other painters in the works of these modern landscapists, both American and European: Inness, John Constable, and Charles-François Daubigny in Crane's pictures; Inness again, as well as Fritz Thaulow and Jean-Charles Cazin in Ochtman's; that of the later Hudson River artists in Gifford's pictures; the French painter Georges Michel in

Bogert's work; the monotony of Alexander Wyant passed into that of Murphy; Diaz's impact on Minor; and the French animal painter Emile Van Marke on Wiggins.[43]

The writer for *Harper's Bazaar* made a similar comment: there was "not one painting which arrests attention with the grip of a masterly achievement." Nonetheless, the finest works were those of Davis, Ochtman, and Palmer.[44] The writer of the brief review in the *Art Interchange*, while acknowledging that "no one familiar with the current landscape painting of European countries could question the superiority, sincerity, and originality of this display," actually found a "lack of uniform strength and a falling off" from the previous show. He more seriously repeated what had been written a year earlier: "The painters are certainly representative of much that is best in current art, but there are some others that might equally well be included in the number to the advantage of the Society."[45] And the writer for *Harper's Weekly*, even while giving the society a spread of four illustrations, was more specific. He commended the limitations inherent in the society's shows in their concentration only on landscape, in that it "has the advantage of being limited in extent and more choice in selection. Nearly everything will repay study, and the gross application demanded is not too exhausting." But he echoed his colleagues in pointing out that "one must be careful to note that this little group of twelve men neither exhaust the number of our prominent landscapists nor is even representative of all the best tendencies of landscape art in this country. It represents nothing except its individual members; therefore the visitor to the exhibition must avoid drawing any general conclusions as to anything beyond what he actually sees upon the walls."[46] Certainly some of the members of the society had risen to the pinnacle of their profession in 1900 when eleven of them— all but Wiggins—were included in the 1900 Paris Exposition Universelle, with bronze medals awarded to Bogert, Crane, and Davis and honorable mentions to Kost, Murphy, Minor, and Palmer.[47]

Florence Levy, in the *American Art Annual, 1900–1901*, noted the second annual show and reported that "The Third Annual Exhibition will be held in the spring of 1901."[48] That exhibition did indeed take place in April 1901, but it appears to have received very little attention in the press, and, to date, no catalogue for the show has come to light. This is especially unfortunate, since both the nature and the expectations of the society underwent radical change between 1900 and 1902, and understanding these modifications would be facilitated by learning if they had begun with the 1901 show. In any case, that display took place, not with the American Art Association, but at the Clausen

Galleries in New York. The makeup of the society also underwent a change. Walter Launt Palmer was no longer an exhibitor, his place being taken by George Inness, Jr. He was an obvious choice for the society, as Inness, Jr. was the well-established artist-son of the most celebrated of all the Barbizon-Tonalist American landscape painters, a movement of which Inness, Sr. was the leading progenitor.[49] And while Coffin remained a member, his position as Director of Fine Arts for the Pan-American Exposition held in Buffalo that year necessitated his being represented by a single picture. The exhibition also changed in size from the previous shows. It was reported that there were about sixty finished paintings and about thirty studies, by no means an insignificant number but far diminished from the previous years.

The writer for the *Sun* admired the craftsmanship of the works exhibited and repeated the praise of previous years for the effectiveness of the separate hangings of the submissions of each artist, but he not only suggested the presence of some monotony in the show but also bemoaned any sense of the feeling of the out of doors, of spaciousness, of nature's atmosphere and sunshine.[50] Another writer echoed this criticism. While admiring the artists' sketches shown in Clausen's lower galleries, he criticized the finished pictures upstairs: "The work in there was technically good, but they had not been painted under the effects of the fresh air tonic with which the sketches had been dashed off. The impressions had staled somewhat, and thought had given way to impulse."[51] More seriously, the critic for the *New York Times* offered what appears to be a reversal of the original rationale for the establishment of the society, suggesting that the artists would do better "to hold their little show in the Autumn," rather than compete with the annual spring exhibitions of the National Academy of Design and the Society of American Artists. "The members of the society can hardly be expected to keep their best for the Landscape exhibit, so long as the Academy or the Society of American Artists will take it. The large general exhibitions naturally have their pick, and what is left over appears at this particular show. Some method will have to be found to overcome this point or the little society of landscape painters will never thrive." Even while still admiring the work of Davis and Ochtman especially, and noting the appearance of Inness, Jr., particularly a view of Niagara Falls, the critic concluded that the oil sketches were generally superior to the finished paintings.[52] The choice and involvement of the Clausen Galleries for this exhibition remain unexplained, though Charles Harold Davis appears to have profited from the association, enjoying a well-received one-artist show there the following February.

Whatever the causes for the decline of the society, the fourth annual exhibition, held April 1–5, 1902, at M. Knoedler & Company at 355 Fifth Avenue in New York, was a vastly reduced affair, comprising only twenty-two paintings by eleven artists; Inness, Jr. remained in place of Palmer as he had the previous year, and in this display Murphy was absent, as the critics noted.[53] Bogert, Davis, Gifford, Inness, Jr., and Wiggins exhibited only one work each, Clark, Coffin, and Crane, two pictures, and Kost and Ochtman, three. Only Minor had a substantial representation with five paintings. As in previous years, Kost's were the only works to emphasize regional identification, each repeating his preferred painting locations—Brookhaven, Long Island, the New Jersey coast, and Florida, though the most "exotic" of locations was Clark's painting of Lake Louise, in Canada. Otherwise, the society's preference for generic titles featuring time of day, time of year, or weather conditions continued to be upheld.

Reviewers took notice of the decline in size and scope of the society's exhibition, and they noted a decline in quality also. The single painting by both Gifford and even Davis met poor reception on this occasion, while the brief mention in the *Evening Sun* referenced the pictures as mere repetitions of what had been on view in shows earlier that year.[54] The painter to emerge with special plaudits in this case was Frederick Kost, especially his picture *Off Long Branch, N.J.*, admired precisely for its "true sense of the outdoors," a quality that critics had found lacking in the work of many of his colleagues during the run of the society's annual shows.[55] The writer for the *Morning Sun* commented that "The society, which made its debut in a spacious gallery with an imposing array of pictures, has gradually narrowed its showing until now a small room is amply sufficient for the modest complement of twenty-three canvases."[56] The fact would seem to prove that this separate organization does not "'fill a long-felt want' on the part of the painters, or lead to very marked financial results on the part of the public." He went on to analyze the creation and question the value of these separate, if not secessionist, organizations, in more general terms: "The one-man show is an intelligible and altogether acceptable affair; so, also, the exhibition organized by a handful of painters for particular presentment of their work. But the centrifugal policy of forming little independent societies is another matter. More or less it must impair the authority and value of the older societies and does not seem to benefit to a considerable extent the little asteroids. They begin with something of a meteoric display and drop off into insignificance."[57]

The society's fifth and final exhibition took place again at M. Knoedler & Company, opening

on April 15, 1903, and running until April 29. So far no catalogue has been located, but a gallery inventory suggests that the show included twenty-seven works, a slightly larger number than the previous year. The number of exhibitors, though, was reduced to nine: Bogert, Clark, Crane, Coffin, Gifford, Inness, Jr., Kost, Ochtman, and Wiggins, with Davis and Minor joining Murphy in absentia, Minor almost surely because of the increasing illness that would lead to his death the following year.[58] Fewer exhibitors meant that the majority of these nine artists had a somewhat fuller representation than in 1902—from three to five paintings, with only Inness, Jr. and Crane showing a single example of their art. The subject matter of the landscapes was much as before, with Kost again identifying his favorite regions of Florida and the Jersey coast and Bogert showing at least one Dutch scene of Amsterdam.

Several of the critics found the exhibition quite praiseworthy and better than some of its predecessors. The writer for the *Art Interchange* offered a carefully detailed review in which he discussed each painting in more or less glowing terms. "With a charming variety in the paintings there is a certain homogeneity of aim which made the exhibition an agreeable unit. Moreover, and this is of vital importance, the majority of the artists were represented by works which displayed not alone individual characteristics and merits, but scope and versatility."[59] Likewise, the critic for the *New York Times*, who admired many of the pictures and enjoyed the evenness of quality, found the justification for the exhibition to lie, not in presenting the best landscape painting of the past year, but in the aesthetic harmony among these particular painters, thus avoiding the "companionship of work which is out of sympathy in coloring and method."[60] The writer for the *Mail and Express* put it more firmly: "The Society of Landscape Painters has reduced the size of its annual shows until the upper room at the Knoedler galleries easily contains all the canvases sent. If with the compression had come a corresponding gain in quality, nothing but good would have resulted. Frankly, however, the exhibitions have become unimportant. One does not look to them for the expression of new ideas or for that experimental and enterprising quality that is one of the chief arguments for the absence of a jury of admission."[61]

With the closing of its fifth annual exhibition at the end of April 1903, the Society of Landscape Painters appears to have dissolved; no further notice has been found of this short-lived organization. In the annals of American art, the society can be said to have attained only brief recognition and fame, and while its first two exhibitions held in 1899 and 1900 were impressive displays, even they

did not constitute any groundbreaking aesthetic territory. But that, in fact, is the primary importance of this little-known group. Its significance lies, not so much in the five shows it mounted, either individually or collectively, or the impact they may have had on the thirteen artists involved, but rather in their commitment to the principles, both ideological and aesthetic, of the poetic landscape, carrying these into the twentieth century in the face of the ever-increasing popularity of Impressionism. Furthermore, the society's demise after 1903 was fortuitous. The following year would see the first significant appearance of those urban realists appearing in a show at the National Arts Club, the group whose activities would culminate in February 1908 with its exhibition of the Eight at the Macbeth Galleries, signaling a very different critical estimation of the directions that our artists would and should assume in interpreting the American environment. The vigorous figurative paintings of Robert Henri, John Sloan, and their colleagues are worlds apart from the contemplative, lyrical landscapes of J. Francis Murphy and his associates in the society—the one portraying the contemporary world with in-your-face strategies, the other offering a timeless retreat into a world both introspective and reflective, one whose gentle beauty retains its appeal today, just as it did at the turn of the previous century.

NOTES

1. The basic study of the Ten, or the Ten American Painters, is William H. Gerdts et al., *Ten American Painters*, exh. cat. (New York: Spanierman Gallery, 1990). See also Ulrich W. Hiesinger, *Impressionism in America: The Ten American Painters* (Munich: Prestel-Verlag, 1991).

2. Edgar P. Richardson, one of the major historians of American art in the mid-1900s, for instance, continued to affirm that "The Ten formed a kind of academy of American Impressionism." E. P. Richardson, *Painting in America from 1502 to the Present* (New York: Thomas Y. Crowell Company, 1954), p. 306.

3. The Ten had also solicited Abbott Handerson Thayer and Winslow Homer to join the group, but both had refused. Had these artists accepted, both new exhibition groups would have consisted of a dozen members. The Society of Landscape Painters has gone virtually ignored in recent studies of the period. I discussed the society briefly in 1982 in my essay for the Grand Central Art Galleries, reprinted with additions in the present publication (pp. 15–29). It was also noted in A. Everette James, Jr., *A Collection of Tonalism and Nocturnes* (n.p., 1990), p. 5; and in Kevin Avery, "Impressions of Mood: American Tonalism," in Avery and Diane P. Fischer, *American Tonalism: Selections from the Metropolitan Museum of Art and the Montclair Art Museum*, exh. cat. (Montclair, N.J.: Montclair Art Museum, 1999), p. 8.

4. "The Society of American Artists," *Art Amateur* 40 (May 1899), p. 117.

5. *Art Amateur* 38 (May 1898), p. 131.

6. "The Landscape Painters," *New York Times*, April 3, 1902. The Robert C. Minor Papers, Archives of American Art, Smithsonian Institution, Washington, D.C., contain numerous reviews of the 1902 exhibition.

7. *Artist* 24 (April 1899), p. lv.

8. "The Society of American Landscape Painters," *American Art Annual, 1898* (New York: MacMillan Company, 1899), p. 295.

9. "Art Notes," *New York Sun*, March 29, 1898, p. 6.

10. There is no modern study of Bogert's work. A brief but interesting early article on him—misidentifying his first name—is "Mr. Charles [sic] H. Bogert," *Art Amateur* 35 (October 1896), p. 85.

11. Richard H. Love, *Walter Clark and Eliot Clark: A Tradition in American Painting*, exh. cat. (Chicago: R. H. Love Galleries, 1980).

12. Again, there is no contemporary study of Coffin's life, art, or art criticism. An interesting early piece on him is "William Anderson Coffin," followed by "Talks with Artists. IV.—Recollections of Mr. W. A. Coffin of Bonnat's Life School," *Art Amateur* 17 (September 1887), p. 75.

13. Bruce Crane, "Objective and Subjective Painting," *Art Amateur* 36 (May 1897), p. 114. The literature on Bruce Crane is quite extensive, but see particularly Charles Teaze Clark, "The Touch of Man: The Landscapes of Bruce Crane," in *Bruce Crane: American Tonalist*, exh. cat. (Old Lyme, Conn.: Florence Griswold Museum, 1984).

14. Davis was the subject of numerous articles in art periodicals during his lifetime and a memorial tribute after his death by Louis Bliss Gillet, "Charles H. Davis," *American Magazine of Art* 27 (March 1934), pp. 105–12. The only recent study is Thomas L. Colville, *Charles Harold Davis N.A., 1856–1933*, exh. cat. (Mystic, Conn.: Mystic Art Association, 1982). Frances Davis, the artist's widow, produced an unpublished typescript biography of her husband in 1940.

15. *R. Swain Gifford, 1840–1905*, exh. cat. (New Bedford, Mass.: Whaling Museum, Old Dartmouth Historical Society; Yonkers, N.Y.: Hudson River Museum, 1974), with an introduction by Elton W. Hall. Gifford's etchings, almost all landscapes, were surveyed by David G. Wright, *R. Swain Gifford: A Catalogue of Etchings, 1865–1891*, exh. cat. (New Bedford, Mass.: New Bedford Whaling Museum, 2002). Gifford's landscapes, all in a Barbizon mode, can be surveyed in the *Works in Oil and Water Colors by the Late R. Swain Gifford, N.A.*, exh. cat. (New York: American Art Galleries, 1906).

16. Bibliography on Minor is scarce. See the essay by Thomas P. Bruhn in *The Landscape Etchings of Robert C. Minor (1839–1904)*, exh. cat. (Storrs, Conn.: William Benton Museum of Art, University of Connecticut, 1987). See also "Robert C. Minor," *Collector* 2 (March 15, 1891), p. 115; "Robert G. Minor's Success," *New York Times*, Saturday Review section, February 10, 1900, p. 90; and the introductory essay by Frank Millet in the auction sale *Paintings by the Late Robert C. Minor, N.A.* (New York: American Art Galleries, January 18, 1905).

17. The basic study of Murphy is by the painter-son of his fellow society member, Walter Clark: Eliot Clark, *J. Francis Murphy* (New York: privately printed, 1926). A full survey of his work was offered for sale in *Paintings and Drawings by J. Francis Murphy* (New York: American Art Association, exact date? 1926). For a more recent survey of his work, see *J. Francis Murphy: The Landscape Within, 1853–1921*, exh. cat. (Yonkers, N.Y.: Hudson River Museum, 1982), with an essay by Francis Murphy (no relation to the artist). Many articles were published on Murphy's art during his lifetime. The most detailed study of Murphy's life and art is the unpub-lished manuscript by the Albany physician Dr. Emerson Crosby Kelly, "J. Francis Murphy, N.A., 1853–1921: 'Tints of a Vanished Past.'" This manuscript, together with a mass of manuscript material by Murphy and his artist-wife, Ada, accumulated by Dr. Kelly, who died in 1977, was donated by Kelly's widow, Sydney, to the Archives of American Art, Smithsonian Institution, Washington, D.C. The title of Kelly's undated manuscript is taken from the painting by Murphy that won the Hallgarten Prize at the National Academy of Design in 1885. The late Dr. Kelly had acquired the artist's papers and studio collection.

18. Like Murphy, Ochtman was the subject of many articles in art periodicals during his lifetime. The most significant modern study is Susan Larkin, *The Ochtmans of Cos Cob*, exh. cat. (Greenwich, Conn.: Bruce Museum, 1989). See also Diana Dimodica Sweet, "Leonard Ochtman (1854–1934): Interpreter of Nature's Tonal Hues and Moods of Lyrical Sentiment," *Illuminator*, Summer 1981, pp. 12–16.

19. Leonard Ochtman, "A Few Suggestions to Beginners in Landscape Painting," *Palette and Bench* 1 (July 1909), pp. 231–32; (August 1909), pp. 243–44.

20. "Art and Artists," *Graphic* (Chicago), 9 (September 9, 1893), p. 216.

21. Palmer was an especially successful painter and much written about during his lifetime and, like his father, celebrated as one of the leading figures in Albany's art world. While his reputation declined during the decades after his death, there has been an upsurge of interest in his work in recent years. The major study of Palmer is Maybelle Mann, *Walter Launt Palmer: Poetic Reality* (Exton, Pa.: Schiffer Publishing, 1984).

22. Palmer wrote of painting snow in his article "On the Painting of Snow," *Palette and Bench* 2 (February 1910), pp. 90–91. In 1901 Palmer's winter scenes were compared and contrasted with those of John Twachtman and Claude Monet in Robert Jarvis, "Snow Scenes in Oil-Painting," *Art Amateur* 44 (March 1901), pp. 99–100.

23. Old Lyme became known at this time as "the American Barbizon"; see Grace L. Slocum, "An American Barbizon: Old Lyme and Its Artist Colony," *New England Magazine* 34 (July 1906), pp. 563–71. For a modern consideration of this development, see Jeffrey W. Andersen, *Old Lyme: The American Barbizon*, exh. cat. (Old Lyme, Conn.: Lyme Historical Society, Florence Griswold Museum, 1982).

24. Ralcy Husted Bell, *Art-Talks with Ranger* (New York and London: G. P. Putnam's Sons, 1914), which was dedicated "To the American Tonalists Living and Dead," is an invaluable treatise not only on Ranger but on Tonalism generally. Ranger's art was much discussed in the press in his time. The most important modern treatment of Ranger is Jack Becker, *Henry Ward Ranger and the Humanized Landscape*, exh. cat. (Old Lyme, Conn.: Florence Griswold Museum, 1999). See also Estelle Riback, *Henry Ward Ranger: Modulator of Harmonious Color* (Fort Bragg, Calif.: Lost Coast Press, 2000).

25. Bibliography on Carleton Wiggins is scarce. See Charles B. Ferguson, *Paintings by Three Generations of Wiggins*, exh. cat. (Windsor, Conn.: Loomis Chaffee School; New Britain, Conn.: New Britain Museum of American Art, 1979); and Anne Cohen DePietro, *Wiggins, Wiggins and Wiggins: Three Generations of American Art*, exh. cat. (New York: Joan Whalen Fine Art, 1998). A significant article that appeared in Wiggins's lifetime is that by George Parsons Lathrop, "The Bucolic Mood in Painting," *Monthly Illustrator* 4 (second quarter 1895), pp. 305–9. See also "Art and Artists," *Graphic* (Chicago), 9 (September 16, 1893), p. 235.

26. "First Annual Exhibition of the Society of Landscape Painters," *Artist* 24 (April 1899), pp. lxi–lxiv.

27. Leigh Hunt, "The Landscape Painters," *Art Collector* 9 (April 1, 1899), p. 165.

28. "The Landscape Painters," *Brooklyn Eagle*, March 28, 1899, p. 5.

29. "Society of Landscape Painters," *New York Tribune*, March 25, 1899, p. 9.

30. Mann, *Walter Launt Palmer*, p. 69. My thanks to Mary Alice Mackay of the Albany Institute of History and Art for confirming that Mrs. Roosevelt purchased the work before the opening of the Society's exhibition.

31. "Two Picture Shows," *New York Mail and Express Illustrated Saturday Magazine* 1 (April 1899), p. 2.

32. *Art Amateur* 40 (May 1899), p. 117.

33. "Twelve Landscape Painters," *New York Journal*, undated clipping of 1899, Charles Harold Davis Papers, courtesy of Thomas Colville.

34. "The Society of Landscape Painters," *Brush and Pencil* 5 (May 1899), pp. 114–26.

35. Lorado Taft, *Chicago Record*, May 6, 1899. My enormous thanks to Amy Galpin, who delved deeply into the available records on the Chicago exhibition at the Art Institute and elsewhere, locating both exhibition reviews and the catalogue for the Chicago exhibition.

36. *Chicago Standard*, May 13, 1899.

37. "Exhibitions Next Week," *Chicago Post*, April 15, 1899.

38. *Chicago Times Herald*, April 16, 1899.

39. "Exhibitions," *Art Amateur* 43 (June 1900), pp. 12–13.

40. "Landscape Painters Display," *New York Times*, May 3, 1900, p. 9.

41. "The Week in Art," *New York Times*, May 5, 1900, p. BR12.

42. "Landscape Exhibition," *Art Interchange* 44 (June 1900), pp. 132, 142.

43. "American Studio Talk," *International Studio Supplement* 10 (June 1900), pp. xiii–xvii.

44. John J. a'Becket, "The Spring Art Exhibitions," *Harper's Bazaar* 33 (June 2, 1900), p. 317.

45. "Landscape Exhibition," *Art Interchange* 44 (June 1900). p. 133.

46. Charles H. Caffin, "The Society of Landscape Painters," *Harper's Weekly* (June 2, 1900), p. 512.

47. Diane P. Fischer, "Constructing the 'American School' of 1900," in *Paris 1900: The "American School" at the Universal Exposition*, ed. Fisher (New Brunswick, N.J., and London: Rutgers University Press, 1999), p. 210 n. 121.

48. Florence N. Levy, "The Society of Landscape Painters," *American Art Annual, 1900–1901* (Boston: Noyes, Platt & Company, 1900), p. 164.

49. Inness, Jr.'s career has been long overshadowed by that of his famous father and has received little attention except for his paintings hanging in the Church of the Good Shepherd in Tarpon Springs, Florida. See the pamphlets, one by Louis J. Richards, *George Inness, Jr. Man and Artist an Appreciation* (n.p., n.d.); and the other by Mrs. Louis J. Richards, *Interpretations of The Paintings of George Inness, Jr.* (Tarpon Springs, Fla.: Leader Press, n.d). For a brief, but more general, discussion of the painter, see Anne Louise Booth, "The Art of George Inness, Jr.," *Fine Arts Journal* 33 (December 1915), pp. 548–51.

50. "The Society of Landscape Painters," *New York Sun*, April 16, 1901, p. 6. The writer, who obviously favored the aesthetics of Impressionism, nonetheless acknowledged that most of the members of the society were concerned with the poetry of landscape to be found in the *paysage intime*.

51. "Palette and Brush: Exhibition of American Landscape Painters," unidentified clipping of April 18, 1901, Charles Harold Davis Papers, courtesy of Thomas Colville.

52. "Society of Landscapists," *New York Times*, April 5, 1901, p. 5.

53. "In the Galleries," *Art Interchange* 48 (May 1902), p. 111. This critic noted that there were twenty-four paintings on view, but the catalogue lists only twenty-two.

54. "Fine Arts," *Brooklyn Eagle*, April 4, 1902, p. 5; "Mr. Robert Henri and Some 'Translators,'" *New York Evening Sun*, April 6, 1902, p. 4.

55. "Art," *New York Mail and Express*, April 8, 1902, p. 5; "Art Notes," *Boston Herald*, April 13, 1902, p. 33.

56. "Around the Galleries," *New York Sun*, April 6, 1902, sec. 2, p. 8. The writer may have been mistaken in enumerating the works as twenty-three, rather than twenty-two as in the catalogue; however, he mentions a painting by William Coffin, *The Brook*, which is not listed in the catalogue. This may have been an addition to the show or a substitution for Coffin's *An August Evening*, which is listed, but which the critic did not reference.

57. "Around the Galleries," *New York Sun*, April 6, 1902, sec. 2, p. 8.

58. *The American Art Annual* for 1903–4 acknowledged Murphy's departure from the group, though Davis and Minor were still listed as regular members. Florence N. Levy, ed., *American Art Annual, 1903–1904* (New York: American Art Annual, 1903).

59. "The Society of Landscape Painters," *Art Interchange* 50 (May 1903), p. 119; see also "Gleaning from American Art Centers, *Brush and Pencil* 12 (May 1903), pp. 149–50.

60. "The Landscape Painters," *New York Times*, April 19, 1903, p. 8.

61. "Art," *New York Mail and Express*, April 17, 1903, p. 4.

George Inness and Tonalist Uncertainty

Nicolai Cikovsky, Jr.

Two sources that became the wellsprings for American Tonalism developed independently, and on opposite shores of the Atlantic Ocean: the first, in London, in the form of the *Nocturnes* that the American-born James McNeill Whistler (1834–1903) began painting in the early 1870s; and the second, several years later, in America by George Inness (1825–1894). Of the two, Inness had the more potent influence on Tonalism. That was because Whistler, although he toyed with returning home, never actually did. Even though Americans had several ways of knowing of him and his art—by his somewhat controversial international reputation, by such of his words and ideas as traveled to America, and at firsthand by paintings and etchings that were exhibited here—he was inevitably only a distant and attenuated presence, and a presence, in any case, one that was felt most strongly in this country only after his death in 1903. Inness, by contrast, beginning about 1880, exerted his influence directly, as a palpable presence, until his death in 1894 and remained actively influential through the art and reputation that survived him well after that. Even though he never used the word "Tonalism" to describe his art, Inness was considered one of its originators by the group of younger painters who did. Therefore, the term can readily serve to characterize his art and philosophy in the final decades of his life.

Inness's Tonalist style—or signs of it—became discernible about 1875, when a *New York Times* critic called his paintings "suggestive";[1] or when one for the *Nation* (published in New York) used the term "synthesis" in the way it often would be used, to describe both the generalized appearance of Inness's aesthetic and the means or mechanism by which it was obtained;[2] or when, in 1880, a Chicago critic (as the *New York Times* reported) called Inness "the high priest of the indefinite";[3] or when a critic for the *New York Evening Post* in 1882 complained that he "never gives us a decisive form, never a well-defined contour," and that "everything with him is softened and is, as it were, melting away";[4] or when a writer in the *Boston Advertiser* that same year described one of his paintings as "hardly more than the ghost of a landscape."[5]

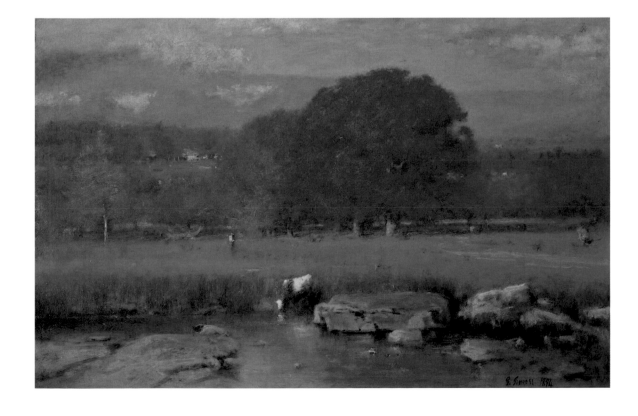

Fig. 14.
George Inness
Morning, Catskill Valley, 1894
Oil on canvas
35⅜ × 53¼ inches
Santa Barbara Museum of
Art, California, Gift of
Mrs. Sterling Morton to
the Preston Morton
Collection

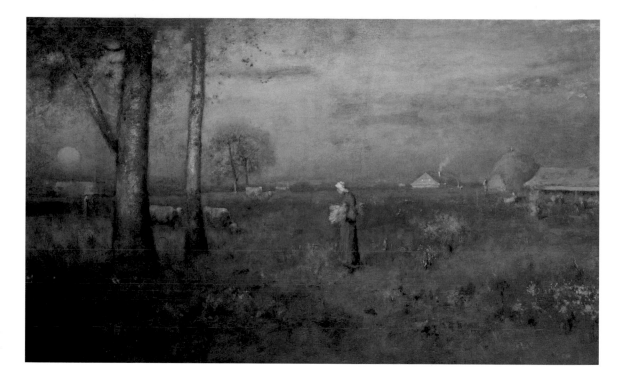

Fig. 15.
George Inness
Sundown, 1894
Oil on canvas
30⅝ × 45 inches
Smithsonian American Art
Museum, Washington, D.C.,
Gift of William T. Evans

Fig. 16.
George Inness
October, 1886
Oil on canvas
19¹⁵⁄₁₆ × 29⅞ inches
Los Angeles County
Museum of Art, California,
Paul Rodman Mabury
Collection

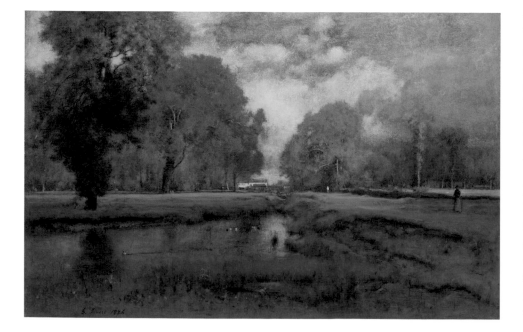

Indefiniteness and blurred softness of form were by the early 1880s among the generally agreed-upon traits of Inness's style. But there were others, such as the critic of the *Cincinnati Commercial* who commented in 1875 on Inness's "exquisite relations of tones,"[6] or the reviewer for the *New York Evening Post* who in 1884 described his "absolute harmony of tint,"[7] who saw that Inness's art consisted not only of suggestive softness of form but also, and as much, of close and often (but not always by any means) subdued harmonies of color. Tonal painting did not necessarily mean colorism to everyone, but it undoubtedly did to Inness: "The painter," he said in 1878, when he was beginning to fashion his individualistic style, "must be a colorist."[8] From the

beginning color was for him the essential expressive medium of painting—"Colors are words to him," a critic wrote. "He makes them speak from soul to soul"[9]—and, still more, its principal and even defining attribute. In some of his last paintings (Fig. 14) Inness used color almost for its own sake, without the obligation to depict anything other than itself.

By the early 1880s critical commentary on Inness had, on the whole, reached agreement on the Tonalist character of his stylistic language and the mixture of indefinite and suggestive form and rich but subdued coloration that constituted it. By 1884 a critic (the one for the *New York Evening Post* quoted above) could say categorically—in one of the earliest uses of the term in its present meaning—that "Mr. Inness . . . must be considered as a tonalist."[10] Toward the end of that decade Inness's "generalizations of nature" had achieved such conspicuous and compelling authority that they attracted a number of "votaries," including the budding Tonalists Charles Warren Eaton, Elliott Daingerfield (who later would become Inness's chief disciple and interpreter), Walter Clark, Frederick W. Kost, Dwight W. Tryon, Francis De Haven, and J. Francis Murphy.[11]

Although signs of Tonalism had been visible in Inness's art since the mid-1870s, it took him at least a decade to arrive at an assured, clearly developed—and, because of that, nameable—Tonalist style. It took that long because while Tonalism was commonly, in its means and meanings, a reductive style in which more was left out (sometimes to the point of emptiness) than put in, his conception of what his new style was and what it did—or, more

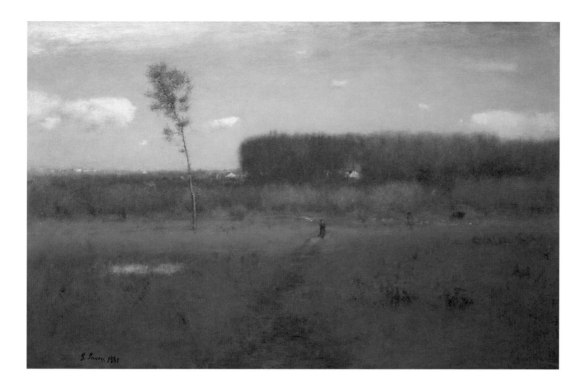

Fig. 17.
George Inness
October Noon, 1891
Oil on canvas
30⅝ × 44⅝ cm
Fogg Art Museum, Harvard
University Art Museums,
Cambridge, Massachusetts,
Bequest of Grenville L.
Winthrop

exactly, as we will see, what in his mind it had to be and do—was more richly inclusive than exclusive.

Inness, who spoke of "the difficulties necessary to be overcome in communicating the substance of his idea,"[12] struggled for years with the often complex problems of form and content this inclusiveness required a contest whose traces are sometimes preserved in the compositional changes and crawling, overworked surfaces of his paintings (Fig. 15). Someone once described the problem Inness confronted as his attempt to combine "philosophical and aesthetic discernment," to fuse "the relations of subjective and objective" by "a sort of religious fervor,"[13] or, as Inness himself put it, to reach pictorially a synthesis of "subjective sentiment—the poetry of nature—and the objective fact." (Figs. 16–22)[14] He aimed to unite the two most fundamental but diametrically different conditions of artistic attention: inwardness and outwardness, feeling and fact. More difficult by far to achieve than to conceive, the realization of this unity of opposites must at times have seemed to Inness impossibly out of reach, and even beyond human creative abilities altogether. But because it was a condition of artistic perfection too desirable to be forsaken out of mere mortal fallibility, Inness invented an artistic persona or alter ego that was more capable of attaining it. He did this by joining two radically different contemporary personifications of style, Ernest Meissonier's "careful reproduction of details with Jean-Baptiste Camille Corot's more suggestive inspirational powers" into a single one to form a "very god of art" who would have the power to accomplish what Inness's human person, even in a "religious fervor," could not always succeed in doing.[15]

While he struggled with the painterly means and methods of Tonalism, Inness was also, as a friend of his in the mid-1870s reported, "much occupied with theories of . . . painting."[16] A paper Inness read that he titled "The Logic of the Real, Aesthetically Considered" in the spring of 1875 and a "work on art" he was said to be engaged on that fall were both probably attempts to find words—no easy matter for Inness—for his thoughts and theories. Neither survives, but something of the thrust and content of, as a critic called it, his "mental labor,"[17] must be reflected in material published a little later in *Harper's New Monthly Magazine* (in 1878, as "A Painter on Painting") and the *Art Journal* (in 1879, as "Mr. Inness on Art-Matters"). Appearing in this public fashion at the same time he was working intensively to shape his new style, Inness's theories provide insight into his working methods and ambitions—although it must quickly be said that Inness was too impulsive and erratic to be an orderly, disciplined thinker or coherent writer, so that a good deal of interpretative reordering is needed to give what he thought and wrote about some usable sense. The "masses of manuscript" he left at his death were, someone who saw them reported, mostly "incoherent and unreadable" (they have since disappeared),[18] and his published remarks, even after the editorial polish they must have been given, are not always easily made sense of.

The thoughtfulness that lay behind and directed Inness's Tonalism, disorderly as it may often have been, nevertheless gave it a texture of form and weight of meaning that other, more ordinarily conceived, and less cerebrally guided

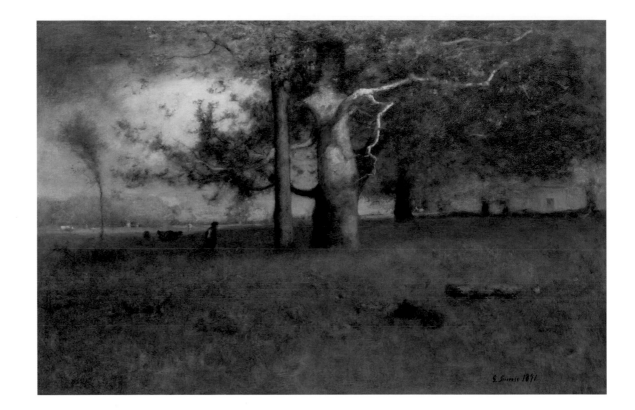

forms of the style did not have. For that reason—though perhaps, because no other artist thought or said as much about the mode of painting that has come to be called Tonalism as he did, only by default—Inness was Tonalism's chief theoretician.

If Inness's theory of art was inconsistent and contradictory, that state cannot be ascribed solely to intellectual and verbal ineptness. Instead, different aspects or states of Tonalism, as he formulated it, needed to be described and explained in different ways. (Though inconsistency, stemming as Inness said it did from intellectual openness and flexibility—"as I do not care about being a cake, I shall remain dough subject to any impression which I am satisfied comes from the region of truth"[19]—was not a fault but a virtue.)

Tonalism's outward expressive condition was reached by a broad and impetuously spontaneous

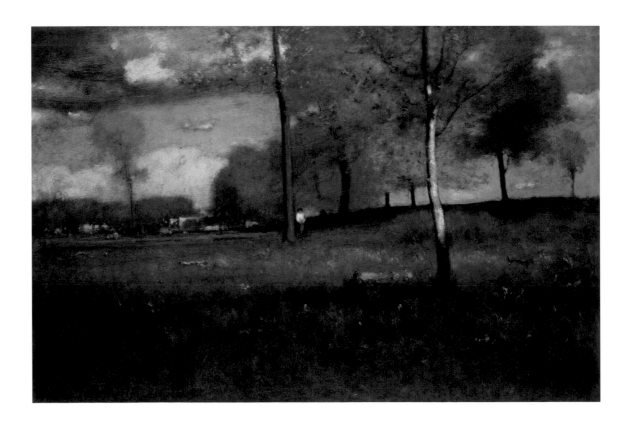

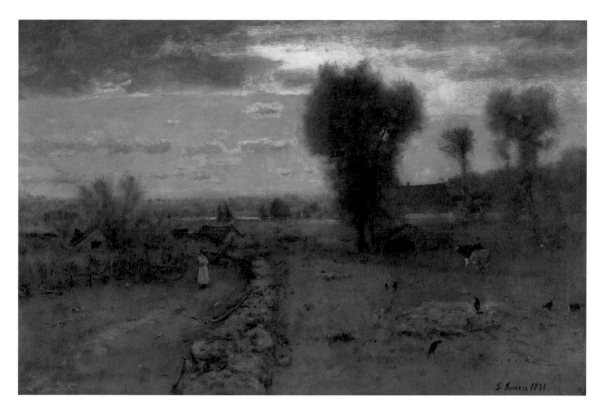

Fig. 20.
George Inness
The Clouded Sun, 1891
Oil on canvas
30⅛ × 45¼ inches
Carnegie Museum of Art,
Pittsburgh, Purchase

style, the greatest impediment to the accomplishment of which was pedantic, painstakingly descriptive literalness: "The [true] artist reproduces nature not as the brute sees it, but as an idea partaking more or less of the creative source from which it flows."[20] As he explained:

> We find men of strong artistic genius, which enables them to dash off an impression coming, as

they suppose, from what is outwardly seen, may produce a work, however incomplete or imperfect in details, of greater vitality, having more or less of that peculiar quality called "freshness," either as to color or spontaneity of artistic impulse, than can other men after laborious efforts.[21]

> The unlabored spontaneity by which unity was obtained—Inness himself, we know, painted

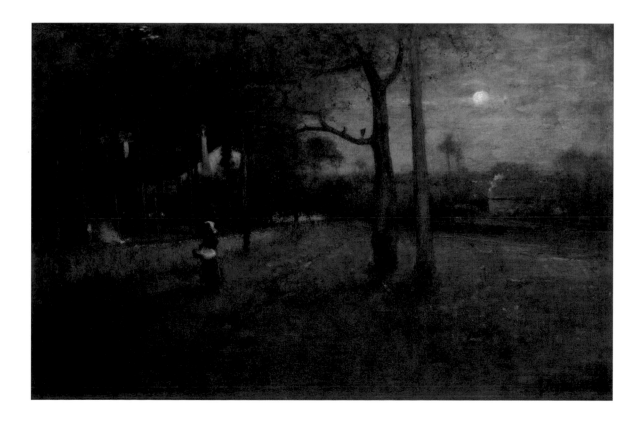

Fig. 21.
George Inness
*Moonlight, Tarpon
Springs*, 1892
Oil on canvas
30 × 45½ inches
The Phillips Collection,
Washington, D.C.

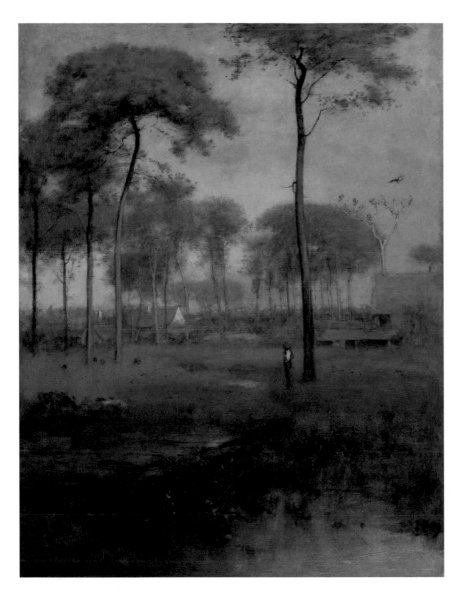

Fig. 22.
George Inness
*Early Morning, Tarpon
Springs*, 1892
Oil on canvas
42³/₁₆ × 32³/₈ inches
Art Institute of Chicago,
Edward B. Butler
Collection

with impulsive intensity—accounts for much of
the appearance and expressive effect of his
Tonalist style.

But Tonalism had other properties, internal and
realist ones, for which another theoretical account
needed to be given. "You must suggest to me real-
ity—you can never show me reality,"[22] Inness said,
by which he meant that Tonalist suggestiveness was
not only the result of an abbreviation of form that
rapid, impulsive painting inevitably produced, but
that it took that form because reality, true reality,
could be depicted in no other way. Reality, as Inness
conceived it, was not "a fixed material condition"
but a "living motion,"[23] an always changing and
therefore "indefinable"[24] thing that, in its very nature,
can only be suggested and never, as by firm contours
and surfaces or objects immovably attached, shown
in any fixed and final configuration of form.

But if Inness thought of and possibly to some
extent even experienced reality as something
unfixed and unfixable, and if, consequently, it could
only be suggested but never directly shown, it
was not at the same time something ineffable and

insensible. He objected to having paintings, his
own and those of others, called "poetic" (as they
often were to characterize their allusiveness)
because doing so evoked the insubstantial and
wishy-washy ineffability he found objectionable.
Inness's conception of reality was of something
more sturdily unpoetic and prosaic. "There is," as
he explained, "a notion that objective force is
inconsistent with poetic representation. But this
is a very grave error. What is often called poetry is
a mere jingle of rhymes—intellectual dishwater.
The poetic quality is not obtained by eschewing
any truths or facts of Nature which can be included
in a harmony of real representation."[25] Inness
believed the purpose and power of art was to clothe
meaning, an idea, "in a form fitted to material
comprehension,"[26] and that was something poetic
vagueness could not do. Almost as a parable of
his conception of the experience of art, he said
emphatically: "When John saw the vision of the
Apocalypse, he *saw* it. He did not see emasculation,
or weakness, or gaseous representation. He saw
things, and those things represented an idea."[27]

Inness was deeply religious, for much of his life
a devoted follower of Emanuel Swedenborg—one
among many in the nineteenth century (Ralph
Waldo Emerson, for instance, included Swedenborg
among his "representative men").[28] Swedenborg
claimed to have been admitted bodily into the spir-
itual world. His descriptions of what he purported
to have seen there told of a world that was in its
topography, botany, and zoology, even in the "con-
jugal delight"[29] to be experienced there, very like
the natural, material world (which, for the reli-
giously skeptical, scientifically positivist, and mate-
rialistically inclined nineteenth century, must have
been a large element of Swedenborg's appeal):

> Lands, mountains, hills, valleys, plains, fields,
> lakes, rivers, springs of water are to be seen
> there, as in the natural world; thus all things
> belonging to the mineral kingdom. Paradises,
> gardens, groves, woods, and in them trees and
> shrubs of all kinds bearing fruit and seeds; also
> plants, flowers, herbs, and grasses are to be seen
> there; thus all things pertaining to the veg-
> etable kingdom. There are also to be seen there
> beasts, birds, and fishes of every kind; thus all
> things pertaining to the animal kingdom. Man
> there is an angel or spirit.[30]

Nor were angels and spirits "mere puffs of air"
but "substantial men, and like men in the natural
world live together in spaces and times."[31]

But if in these respects the spiritual world
resembled the natural, in essence it was different:

> Since angels and spirits see with eyes, just as
> men in the world do, and since objects cannot

be seen except in space, therefore in the spiritual world where angels and spirits are, there appear to be spaces like the spaces on earth; yet they are not spaces but appearances; since they are not fixed and constant, as spaces are on earth; for they can be lengthened or shortened; they can be changed or varied.[32]

Swedenborg, in other words, described a realm like the real world, except that in it matter had the quality of substance, space the quality of appearance, and nothing was fixed and settled in form or position. This comes very close to describing the pictorial effects of Inness's Tonalist paintings. It is certainly possible that a longtime student of Swedenborg, such as Inness undoubtedly was, might, perhaps unknowingly, have carried Swedenborgian images of the spiritual world about with him—particularly because Swedenborg's imagery and philosophy interested Inness more than his theology.[33]

If so, however, he surely did not think of his paintings only or even primarily as illustrations of or scenes from Swedenborg. As an adjunct to literary narrative, illustration is a form of literature, and because literature was, Inness believed, nothing more than "the influence upon us of what we have heard or read of things we have not seen,"[34] it was too remote to interest him as a source of either meaning or experience, both of which it contained only secondhand. Meaning and experience had to be more directly and immediately knowable, which, for Inness, meant visually knowable, that is, by and through the formal properties and devices of painting: "A story told by a painter," Inness said, "must obey the laws of pictorial art."[35] Charles de Kay, one of Inness's most sensitive critics, writing in the *Century* magazine in 1882, said Inness "hides" religious meaning in artistic form.[36] Inness himself suggested this construction when he told de Kay, "the symbolization of the Divine Trinity is reflected in the mathematical relations of perspective and aerial distance."[37] The two men imply, it seems (for both are somewhat elliptical about it), that religious meaning was contained—"hidden" was the term they used—in and experienced through coherently and even mathematically ordered pictorial arrangements. "Back of the landscapes, in whose confection rules founded on logic that can be expressed in mathematical terms have been strictly followed," de Kay explained, "lies the whole world of immaterial spirits, of whom Swedenborg was the latest prophet."[38] "Does [Inness] try to express religion?" he added. "We should say no. It is rather the methods by which he does [his landscapes]," he explained, "that are governed in his mind by religious ideas."[39]

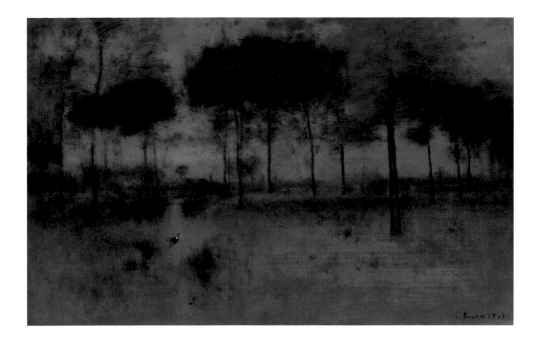

Fig. 23.
George Inness
The Home of the Heron, 1893
Oil on canvas
30 × 45 inches
Art Institute of Chicago, Edward B. Butler Collection

Religion was not experienced as "gaseous representation" but, as Inness said emphatically, by "*things*" that were convincingly real, sensibly and sensuously apprehensible. Inness has never been thought of as a realist, nor did he think of himself as one. He always placed imaginative freedom and the expression of subjective feeling above the realist's responsibility to depict accurately and faithfully the objective configurations of particular places, and severely derided the close imitation of nature: "[I]n Holland [in the seventeenth century] we find Art imitating natural objects more closely than ever before or since. Lower than this, Art could not go."[40] Imitation was deception. It represented only the shadow or shallow surface of reality, not its substance (which is why he objected to the deceptive trompe l'oeil illusionism of William Michael Harnett's *After the Hunt*: "[I]t is not real. It is not what it represents. It is a lie").[41] "What is seen is not reality," Inness said.[42] Reality consisted instead of what he called "the logic of the real" (Inness was "piques himself on logic," de Kay said[43]), the truth that underlay and structured appearance and was what, Inness said, "the organized mind endorses as reality."[44] A pupil who observed him at work reported that all the while he "talked on structural forms, dimensions, distances, spaces, masses, and lines.... One might have thought he was an architect laying out a large structure."[45] His paintings are replete with the designed symmetries, parallelisms, plotted intervals, and echoed accents that that sort of methodical, carefully plotted visual thinking produced and that—more than landscape, which was only the medium of its visibility—made the religious meaning that was the true subject of his great Tonalist paintings available through the senses to the

Fig. 28.
James McNeill Whistler
*Grey and Silver—
Liverpool*, ca. 1883–85
Watercolor on paper
$5\frac{7}{8} \times 10\frac{11}{16}$ inches
Freer Gallery of Art,
Smithsonian Institution,
Washington, D.C., Gift of
Charles Lang Freer

pictures in oil, watercolor, and pastel, none larger than the lid of a cigar box, hung in flat gold frames on walls tinted a subtle shade of rose. Although they represented a variety of subjects, the figural works were generally discounted by the critics, who preferred Whistler's "most delightful little impressions of sea beaches, covered with crowds or dotted with single figures" and the "small oil sketches of landscape, which are veritable jewels of art."[24] As those descriptions suggest, Whistler's so-called Notes (another musical term that could easily be misconstrued) were regarded more as preliminary studies than fully developed works of art—"dainty trifles" or "brilliant little memoranda in color."[25] Consequently, Whistler's grandiloquent declaration of aestheticism, titled "L'Envoie" and printed in the catalogue, struck some critics as out of place. Having read the artist's definition of a "masterpiece," one writer expected works more magisterial than the simple little sketches on display.[26] The *New York Tribune* offered a thoughtful synopsis of Whistler's theory but wondered whether anyone would bother to understand it, since the pictures were perfectly comprehensible on their own.[27]

Whistler's aestheticism, then, informed the exhibition but did not impede an appreciation of the art. As usual, the titles provided the key of color for each composition, but critics judged that information incidental, if not irrelevant. On the whole, the paintings were "not only simply treated, but of very simple subjects": the watercolor *Green and Blue—The Fields—Loches* (Fig. 27), for example, portrayed nothing more elaborate than "an expanse of meadow, a low green hill, with some trees upon it and a single large tree to the left."[28] Despite their apparent simplicity, or perhaps because of it, the landscapes appealed to Americans as a balanced presentation of material fact and artistic arrangement, exactly like the best of Whistler's work in portraiture. "It would be difficult to find

another living artist," one critic concluded, "who in work so slight . . . could give us half so true a report upon the outside world, half so fascinating a report upon the personality of the mind which had surveyed it."[29]

Moreover, just as Whistler's understated portraits were considered a pleasing contrast to Sargent's bravura performances, his Notes were regarded as an antidote to Impressionism, which many Americans had long regarded with distaste. "I never in my life saw more horrible things," the young J. Alden Weir wrote in 1877 about certain modern paintings in Paris. "They do not observe drawing nor form but give you an impression of what they call nature," by which he must have meant "what they call an impression of nature"— an impression primarily optical and scientific.[30] Whistler's "impressions," on the other hand, were anchored in the intellect. As Theodore Child explained, the artist had "evolved a preconceived way of looking at nature," imposing order on the randomness of eyesight long before he touched a canvas with his brush.[31] Although Whistler and the Impressionists were alike in attempting to capture elusive effects of light and atmosphere, the Impressionist manner resulted in "brutal materialism," in the words of the *Collector*, "rasping the nerves by violence of contrast and treatment." Whistler's works were anything but "shrill," another adjective used to describe the Impressionist effect.[32] One critic remarked that he "seemed averse to experiments with the primary or even the secondary colors," and the titles alone of the works listed in the Wunderlich catalogue confirm that the dominant tone of the exhibition was gray.[33]

It might be argued that Whistler's partiality to shades of silver had to do with the climate of his adopted country, and rain and fog do figure largely in these tiny landscapes. *Grey and Silver—Liverpool* (Fig. 28), for example, is one of several works in which sea and sky dissolve into a single tonality, "a foggy day . . . with a wonderfully rendered misty atmosphere."[34] The only other American artist whose works, in the 1880s, approach the austerity of these images is William Merritt Chase, who had practiced Whistler's principles under the guidance of the master himself.[35] But American landscape paintings were already tending toward the dull and dreary, and the absence of sunshine in Whistler's anti-Impressionist Harmonies seems to have struck a chord that sounded through American art around the turn of century. At the New York Water Color Club's exhibition in 1897, Caffin noticed the prevalence of heavy weather in the landscapes on display:

> For the most part the sentiment of the pictures is in the minor key, and it is the sob in nature

to which the artist has responded. It may be going too far to say that this is a characteristic of modern American landscape generally, but it certainly seems to be the phase of nature which our artists paint best. Is it because of the *sturm und drang* of American life that they fly for relief, not to the joyous or stirring modes of nature, but to that still small voice which can only be caught by listening long and quietly? Perhaps it is so, for on analyzing one's own pleasure in these pictures one finds that their sweet sadness brings to light all sorts of little fragments of memory of younger days long stowed away in nooks and crannies of the mind, dusty and forgotten.[36]

In the same way, Whistler's low-toned Notes— if bereft of the nostalgia that settles like a fog over Tonalist paintings—seemed to embody the "still small voice" that could induce a wistful mood. One of their titles, *Grey and Brown—The Sad Sea— Dieppe*, even hints of the pathetic fallacy, which might have encouraged critics to consider all of Whistler's spare and understated works "as full of feeling as they are of skill."[37]

The title of the Wunderlich show, *"Notes"— "Harmonies"—"Nocturnes,"* implies a range of subjectivity corresponding to the scale Caffin created to measure American approaches to portraiture: the vibrant sketches called Notes, which appear closely related to nature, occupy the objective end of the spectrum, with the Nocturnes falling at the other extreme, where, as Caffin might say, the portrait is lost in the picture. Two Nocturnes are named in the Wunderlich catalogue—*Nocturne in Black and Gold: The Falling Rocket* (1875; The Detroit Institute of Arts) and *Nocturne: Black and Gold—The Fire Wheel* (ca. 1872–77; Tate Gallery, London)—but neither is mentioned in any of the published reviews. This can only be explained by their absence, for those pyrotechnical paintings would have been impossible to overlook; presumably, they were among the eighteen works that arrived in New York too late for the opening, if they were ever included in the exhibition at all.[38] *The Falling Rocket* was already notorious as the work John Ruskin had maligned as a "pot of paint" flung at the public. It was during the ensuing trial of *Whistler v. Ruskin* that Whistler had defined a Nocturne, according to the account published in the *New York Times*, as "an arrangement of lines, form, and color, with some incident or object of nature in illustration of my theory."[39] This may be a garbled transcription of Whistler's actual testimony, but the syntax suitably suggests that "theory" takes precedence over any "incident or object of nature." Unlike the Notes, which proved accessible even to those with no feeling for art for art's sake, the

Nocturnes were designed to be incomprehensible to the uninformed and unsympathetic. "In them he carried his theories to their ultimate conclusion," as Royal Cortissoz observed, "eschewing all tangible facts, and aiming at his effect almost as though he had no pictorial intention at all."[40]

In England during the 1870s and 1880s, the Nocturnes had been the works that cast doubt on Whistler's sincerity as an artist; but by the 1890s, when they became known in the United States, Whistler's professional reputation had become almost unassailable. The French government purchased *Arrangement in Grey and Black: Portrait of the Painter's Mother* for the national collection late in 1891, just over a year before *Nocturne: Blue and Gold—Valparaiso* (Fig. 29) made its premier American appearance among six of Whistler's works at the World's Columbian Exposition in Chicago in 1893. American critics tended to confine their

Fig. 29.
James McNeill Whistler
Nocturne: Blue and Gold— Valparaiso, 1866/ca. 1874
Oil on canvas
29¾ × 19¼ inches
Freer Gallery of Art, Smithsonian Institution, Washington, D.C., Gift of Charles Lang Freer

Fig. 30.
Childe Hassam
Rainy Midnight, late 1890s
Oil on canvas
22¼ × 18¼ inches
The Museum of Fine Arts,
Houston, Texas, Gift of
Mrs. Langdon Dearborn

Fig. 31.
Dwight William Tryon
*The Rising Moon:
Autumn*, 1889
Oil on panel
20 × 31⅝ inches
Freer Gallery of Art,
Smithsonian Institution,
Washington, D.C.: Gift of
Charles Lang Freer

His special gift of playing with a single tone, as a great violinist may draw music from a single string, is just what is needed by a painter of "nocturnes." Whistler varies his tint by the mere play of the brush; by the less or more pigment that he puts on the canvas; by the nearer or more remote juxtaposition of two nearly similar tones. We believe he might, if he wished, paint a whole picture out of the one pot of pigment, and it yet would not appear to be monochrome.

Other artists, he said, lacking Whistler's "special gift," frequently failed in their attempts to capture that elusive nocturnal effect.[41]

As it happened, there were scores of American paintings to afford such a comparison—"Moonlights," "Moonrises," "Twilights," and "Evenings" by artists who would later be linked to the Tonalist School, including George Bogert, Charles H. Davis, Charles Melville Dewey, Charles Warren Eaton, Robert C. Minor, and Leonard Ochtman.[42] In fact, the prevalence of night scenes at the fair confirms that the theme was well established in the United States even before Whistler's renditions became widely known—presumably under the influence of Inness, who himself exhibited works titled *Nine O'Clock* and *Twilight*.[43]

Whistler's was the only Nocturne, in name or spirit, but it would not take long for American

comments to the portraits, which were comparatively familiar, but a writer for the *Art Amateur* took up the Nocturne's challenge. Recognizing it as an artful evocation of "the mysterious beauty of night," the critic analyzed the aesthetics of *Nocturne, Valparaiso* in terms conditioned by the American preoccupation with Tonalist painting:

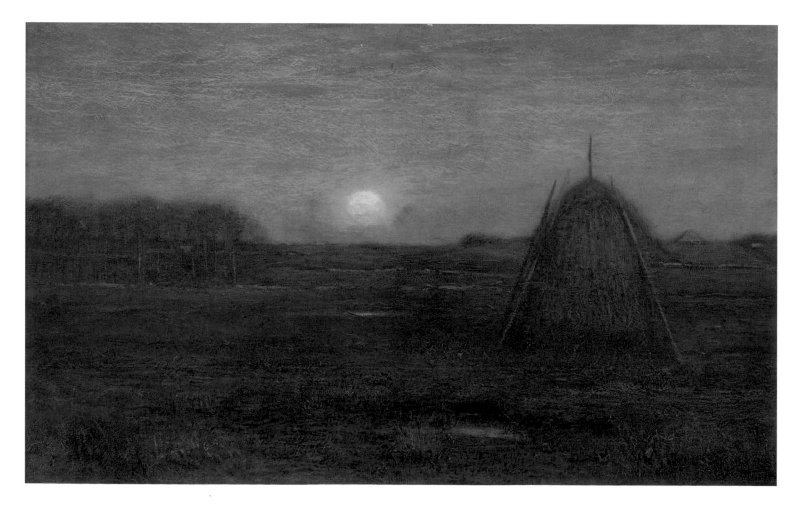

renditions to become ubiquitous. The majority were painted by artists associated with American Impressionism, including J. Alden Weir and Willard Metcalf, for whom elements of Whistler's style served to soften the rough edges of the French manner; and by such California painters as Charles Rollo Peters and Charles Walter Stetson, who were already geographically removed, as William H. Gerdts has suggested, from the freighted tradition of New England landscape painting.[44] Whistler's nocturnal approach proved particularly effective in muting the clamor of urban life, and many of the finest American nocturnes portray scenes of New York City (Fig. 30). But like the earlier experiments in Whistler's decorative portraiture, these works tend to be more animated than their paradigm, sacrificing the silence of aesthetic distance for the pulse of human life. It is telling that Birge Harrison, one of the leading practitioners of tonal painting, if not technically a Tonalist, credited Inness with introducing him to the peculiar beauties of the cityscape, an aesthetic "discovery" usually regarded as Whistler's signal contribution to nineteenth-century art.[45]

In retrospect, we can trace the divergence of Tonalism from Whistler's aestheticism back to Chicago, where gold medals were awarded both to Whistler and to Dwight William Tryon, an exemplary first-generation Tonalist. Indeed, it would be difficult to imagine an American painting more completely "in the Barbizon mood," to borrow Peter Bermingham's phrase, than Tryon's award-winning *The Rising Moon: Autumn* (Fig. 31).[46] The quiet scene of haystacks in a moonlit meadow intentionally recalls the *paysages intimes* of Henri Harpignies and Charles-François Daubigny, masters of the Barbizon School whom Tryon felt privileged to have known during his student days in France. Like *Nocturne, Valparaiso*, Tryon's *The Rising Moon* was probably painted from memory in the studio, not *en plein air*. The practice of portraying a scene at some remove from experience was fundamental to the Tonalists' approach, one of the factors distinguishing their art from Impressionism. Indeed, both Tryon's crepuscular haystack and Whistler's nocturnal seascape can be seen as conscious counterpoints to French Impressionism, essays in the value of artistic interpretation. Nevertheless, Tryon's painting—the later of the two by more than a decade—appears deeply conservative and rooted in the Western tradition, while Whistler's, imbued with an Asian sensibility, hovers on the edge of modernism.

Significantly, *The Rising Moon* belonged to Charles Lang Freer, a Detroit collector who eventually acquired *Nocturne, Valparaiso* as well. Shortly after the fair, Freer wrote to Whistler that his works "of course completely overshadowed everything in

the Fine Arts Department."[47] To Thomas Dewing, another of the artists whose paintings he was beginning to amass, Freer declared that his art (along with Tryon's and Abbott Handerson Thayer's) shared with Whistler's the distinction of being "the most refined in spirit, poetical in design and deepest in artistic truth of this century."[48] Consequently, Freer decided to dispose of *The Home of the Heron* (Fig. 32), an intimate landscape by Inness, even though he ranked it among the artist's masterpieces. "Poor Inness is sure to be forgotten while Tryon will live forever," Freer predicted with customary confidence, attributing Tryon's superiority to the "greater refinement " of his art.[49] Indeed, at that time Tryon was working in the most "refined" manner of his career. Having completed a cycle of decorative paintings to adorn Freer's house, he went on to paint a number of extraordinarily delicate landscapes such as *Twilight: Early Spring* (Fig. 33), a pronounced departure from the Barbizon-inflected *Rising Moon*. Recognizing "something of the charm of Whistler" in Tryon's *Twilight*, Guy Pène du Bois noted that "its refinement runs rampant."[50] Another critic observed that beside such

Fig. 32.
George Inness
The Home of the Heron, 1891
Oil on canvas
42 × 37 inches
Princeton University Art Museum, New Jersey, Gift of Victor Stephen Harris, Class of 1940, and David Harris, Class of 1944, in memory of their father, Victor Harris

ethereal paintings, "Whistler looks crisp and declaratory and realistic."[51]

But Tryon did not linger in this decorative, or Whistlerian, phase. Years later, he renounced the super-subtle compositions of the early 1890s as shallow and unsatisfying, works that failed to "stir the emotions as deeply," he thought, as the "richer tonal pictures" of subsequent decades.[52] In this abrupt change of direction, Tryon abandoned aestheticism in favor of a philosophy that reflected his profound affection for nature, the tenets of Tonalism as they were emerging in the later 1890s. Significantly, Tryon also demonstrated his unspoken alliance with the artist Freer had deemed insufficiently refined, for it was Inness who maintained that the purpose of art was "to awaken an emotion."[53] William T. Evans, Inness's champion, wrote in 1899 that "unless a thrill is communicated which makes us feel what the artist felt, the effort cannot properly be classed as artistic. In other words, the painter must put some soul into the work."[54] This conviction helps explain why Evans was devoted to Inness (and also to Tryon, to a lesser degree) but was never a serious collector of Whistler's work.[55] Willa Cather put it this way:

> Mr. Whistler's nocturnes in color are ravishingly beautiful things, but they have not the power or the greatness of the old faded frescoes that told roughly of hell and heaven and death and judgment. After all, the supreme virtue in all art is soul, perhaps it is the only thing which gives art a right to be. . . . All prettiness for its own sake is trivial, all beauty for beauty's sake is

sensual. No matter how dainty, how refined, how *spirituelle*, it is still a thing of the senses only.[56]

The insistence on "soul," not only in contrast to physical beauty but also as the seat of human emotion, lies at the heart of the Tonalist ambition. "Any landscape has a soul as well as a body," Birge Harrison wrote. "The true artist is he who paints the beautiful body informed and irradiated by the still more lovely and fascinating spirit—he who renders the *mood*."[57]

To recognize and adequately represent the "moods" of nature, an artist would have to possess (as someone said of Tryon) "a sympathetic feeling for the poetry of out-of-doors."[58] Whistler decidedly did not. "For dullness, this place is simply amazing!" he wrote one year from the Cornish countryside. "Nothing but Nature about—and nature is but a poor creature after all . . . poor company certainly—and, artistically, often offensive."[59] Moreover, the notion that art should convey a mood, its own or the artist's, would have been dismissed by him—and any true follower—as "clap-trap." How, then, could Whistler's American contemporaries, including the critics most acutely attuned to the soulful strains of Tonalism, persist in their unqualified admiration for his art?

One reason is that the poetic device Whistler exploited to best effect was ambiguity, which by definition accommodates a range of interpretation. As Wanda Corn noted, in this country Whistler's work was often seen "as if through the eyes of Inness"—or, one might say, as if Inness had produced it.[60] "Let no one say there is no emotion in

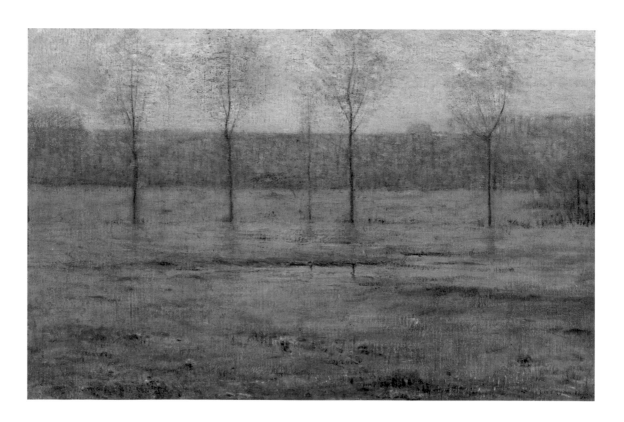

Fig. 33.
Dwight William Tryon
Twilight: Early Spring, 1893
Oil on canvas
22 × 33¼ inches
Freer Gallery of Art, Smithsonian Institution, Washington, D.C.: Gift of Charles Lang Freer

Whistler," wrote Annie Nathan Meyer in 1904. "His night pieces are the very quintessence of emotion. Only a highly strung, exquisitely responsive modern could have seized the very soul of the night and made it his own."[61] This peculiarly American method of discerning "soul" in the formal detachment and subtle coloration of Whistler's work pervades art criticism around 1900, when his art was regularly interpreted as spiritually restorative. *Nocturne: Blue and Silver—Bognor* (Fig. 34), for example, was said to exert an "almost supernatural influence . . . upon the imagination" and extolled as "a scene of exquisite refreshment to the spirit, mysteriously etherealized, the artist being so absorbed with the spiritual presence of the summer night that his own soul echoes in its very heartbeats."[62] It is a remarkable work, one that stands alone in the Nocturne ensemble, and even Whistler acknowledged its mysterious aura—but to him, the wonder was all in the miracle of its production.[63] From the perspective of Aestheticism, the "*painter's* poetry" (Whistler's emphasis) was not a conduit to profound emotion or spiritual enlightenment but "the amazing invention that shall have put form and colour into such perfect harmony, that exquisiteness is the result."[64]

The second reason Americans could revere Whistler's work without ever assimilating his aestheticism is that he was perceived as sui generis, inimitable and apart. "Whistler now is about the only living artist who may be written down as uncopiable," one critic wrote in 1893. "He is his mighty self, individual and alone."[65] Accordingly, Whistler's work was thought to require a place to itself, isolated from its contemporaries, if it were to be properly appreciated. In 1904, for example, at the Comparative Exhibition of Native and Foreign Art, Whistler's ten paintings hung separately from the others—despite the comparative purpose of the show—as if to suggest, Jack Becker pointed out, that he existed "outside the domain of both American and European painting."[66] Freer, who lent several of those works and had a hand in their arrangement, regularly insisted on special conditions for the exhibition of Whistler's art.[67] He even tried to set those considerations in stone by establishing a national museum to house his incomparable Whistler collection, together with works by Asian and American artists that he considered aesthetically compatible. But even at the Freer Gallery of Art, Whistler's works were meant to hang together in designated galleries, aloof from competition.[68]

Whistler's isolation was also related to his ambiguous nationality. Although American-born, he spent his entire professional life abroad, wholly unaffected by the currents of contemporary American art. One critic argued that to include his paintings in an exhibition was to compromise its standing as a "purely American" show, even though the other works on view (including a number by Tryon) were "bone of our bone and flesh of our

Fig. 34.
James McNeill Whistler
Nocturne: Blue and Silver—Bognor, ca. 1875
Oil on canvas
19¾ × 33⅞ inches
Freer Gallery of Art, Smithsonian Institution, Washington, D.C., Gift of Charles Lang Freer

flesh."[69] As Kenyon Cox observed, Whistler's works "had no national accent."[70] Inevitably, then, as American landscape painting grew more nationalistic in subject matter and intent, Whistler's tentative Americanism began to undermine his influence. At the Exposition Universelle in Paris, in 1900, where the American landscapes were said to show a "marked tendency . . . to maintain a tonal arrangement of color," that aesthetic predilection might have been ascribed to Whistler's example, but was not. As the Commissioner General reported, the paintings "connect logically with one another, forming a short chain of tradition from George Inness, the father of the present development of American landscape, through Homer Martin and Wyant, to the men still living."[71] This distinctly American movement (which we can now confidently identify as Tonalism) was considered part of an indigenous artistic tradition; Whistler's art, tended and treasured in a protected environment, was a hothouse flower that could never take root in American soil. "His is not the kind of art that, imposing itself upon men, starts an evolutionary movement," Royal Cortissoz concluded in 1903. "He meant it to exist in and for itself alone, and so it does, like some rare orchid that has no prototype and can have no successor."[72]

NOTES

1. Henry James, "The Grosvenor Gallery" (1878), in *The Painter's Eye: Notes and Essays on the Pictorial Arts by Henry James*, ed. John L. Sweeney (Madison: University of Wisconsin Press, 1989), p. 164.

2. Wanda M. Corn, *The Color of Mood: American Tonalism, 1880–1910*, exh. cat. (San Francisco: M. H. de Young Memorial Museum and the California Palace of the Legion of Honor, 1972). Corn identifies Whistler as a Tonalist but concedes that American paintings "were rarely informed with the same refined estheticism which was found in the master's works" (pp. 4 and 9). William Gerdts names Whistler a "major influence" but cautions that "the alliance perhaps should not be pushed too far." His assertion that Whistler's concern with "the primacy of pictorial creation" diverged from the Tonalists' "projection of a mood induced by their experience in nature" was the starting point for this essay. William H. Gerdts, "American Tonalism: An Artistic Overview," in *Tonalism: An American Experience*, exh. cat. (New York: Grand Central Art Galleries Art Education Association, 1982), p. 22.

3. Clara Ruge, "The Tonal School of America," *International Studio* 27 (January 1906), pp. 57–66. William T. Evans did try to borrow Whistler's *Nocturne: Blue and Silver—Bognor* (Fig. 10) from Charles Lang Freer for a Lotos Club exhibition in 1901, after its exhibition at the Pan-American Exposition in Buffalo. Freer declined to lend it, however, citing Whistler's objection to showing the painting in any but "an important exhibition of his work." Freer to Evans, November 11, 1901, Letter Book 8, Charles Lang Freer Papers, Freer Gallery of Art/Arthur M. Sackler Gallery Archives, Smithsonian Institution, Washington, D.C. (hereafter Freer Papers).

4. The painting was shown at the Union League Club and afterward at the Metropolitan Museum of Art's *Loan Exhibition*, May 1881. For more about these exhibitions, see Linda Merrill, ed., *After Whistler: The Artist and His Influence on American Painting*, exh. cat. (Atlanta: High Museum of Art, 2003), pp. 17 and 100. *The White Girl* was not exhibited with its present title, *Symphony in White, No. 1*, before the Whistler Memorial Exhibition in Boston, in 1904.

5. "The Union League. The Regular Monthly Meeting of the Club and an Exhibition of Pictures [ca. April 10], 1881, unidentified New York newspaper, BP II Presscuttings, vol. 4, p. 61, Special Collections, Glasgow University Library, Scotland.

6. "The American Artists' Exhibition," *Art Amateur* 6 (May 1882), p. 114. The painting exhibited as *Portrait of a Lady* is now titled *Flora (Carrie Mansfield Weir)*, 1882, Brigham Young University, Provo, Utah.

7. John C. Van Dyke, "Retrospective Exhibition of the Society of American Artists," *Harper's Weekly* 36 (December 17, 1892), p. 1211. The painting, later titled *The Blue Dress*, is in the collection of the Freer Gallery of Art, Smithsonian Institution, Washington, D.C. (F1906.67).

8. John C. Van Dyke, *Art for Art's Sake: Seven University Lectures on the Technical Beauties of Painting* (New York: Scribner's, 1893), p. 77.

9. P. G. Hamerton, "Pictures of the Year. IX," *Saturday Review*, June 1, 1867, in *Whistler: A Retrospective*, ed. Robin Spencer (New York: Hugh Lauter Levin, 1989), p. 81; "The Critic's Mind Considered," in James McNeill Whistler, *The Gentle Art of Making Enemies* (London, 1890; reprint, New York: Putnam's, 1904), p. 45.

10. "The Red Rag," in Whistler, *The Gentle Art*, pp. 127–28.

11. On these exhibitions, see Merrill, *After Whistler*, pp. 17–19 and 50–51.

12. W. C. Brownell, "Whistler in Painting and Etching," *Scribner's Magazine* 18 (August 1879), p. 492.

13. Mariana G. Van Rensselaer, "Art Matters," *Lippincott's Magazine* 3 (January 1882), p. 101; Brownell, "Whistler in Painting and Etching," p. 492.

14. "The Society of American Artists," *Critic* 34 (April 22, 1881), p. 119.

15. *Boston Journal,* quoted in "Art Notes," *New York Times,* May 8, 1881, p. 4.

16. "The American Artists' Exhibition," *Art Amateur* 6 (May 1882), p. 114.

17. Charles H. Caffin, "The Loan Exhibition of Portraits at the National Academy," *Harper's Weekly* 42 (December 24, 1898), pp. 1260 and 1262. This particular *Portrait of a Lady* by Dewing, described by Caffin as a lady with dark hair wearing a "gray-white dress" and seated in a "yellow-upholstered chair" against a "green-gold background," has not been positively identified (my thanks to Susan Hobbs for help with this research). One of Mowbray's portraits, *Mrs. Mowbray* (unlocated), is reproduced on p. 1261.

18. Van Dyke, "Retrospective Exhibition," p. 1213.

19. Caffin, "Loan Exhibition of Portraits," p. 1262.

20. "Society of American Artists," p. 119.

21. "The Exhibition of the Pennsylvania Academy of the Fine Arts," *Art Amateur* 30 (February 1894), p. 71.

22. "Mr. Whistler at Home," *Current Literature* 17 (April 1895), p. 304.

23. The New York show reprised Whistler's solo exhibition of the same title held at Dowdeswell and Dowdeswells in London, in 1884. On that exhibition, see Kenneth John Myers, *Mr. Whistler's Gallery: Pictures at an 1884 Exhibition,* exh. cat. (Washington, D.C.: Freer Gallery of Art, Smithsonian Institution, 2003).

24. "Etchings, Drawings, Pastels," *New York Times,* March 3, 1889, p. 5.

25. "Mr. Whistler's Pictures at the Wunderlich Gallery" [March 1889], unidentified newspaper, and "A Whistler Exhibition," *New York Tribune,* March 2, 1889, Whistler Presscutting Book 1, pp. 4–5, Freer Papers.

26. "The Whistler Exhibition at Wunderlich's" [March 1889], unidentified newspaper, Whistler Presscutting Book 1, p. 4, Freer Papers.

27. *New York Tribune,* March 17, 1889, Whistler Presscutting Book 1, p. 5, Freer Papers.

28. "The Whistler Exhibition," *Art Amateur* 20 (April 1889), p. 99.

29. "Mr. Whistler's Pictures at the Wunderlich Gallery."

30. J. Alden Weir to his parents, April 15, 1877, Paris, in Dorothy Weir Young, *The Life and Letters of J. Alden Weir* (New Haven, Conn.: Yale University Press, 1960), p. 123.

31. Theodore Child, "American Artists at the Paris Exhibition," *Harper's New Monthly Magazine* 79 (September 1889), p. 498.

32. Review of 1896 landscape exhibition at the Lotos Club, *Collector* 7 (April 1, 1896), p. 162, quoted in Jack Becker, "Studies in American Tonalism," Ph.D. diss., University of Delaware, 2002, chap. 1, p. 38.

33. *New York Tribune.* Of the 44 works displayed, 26 have "grey" or "silver" in their titles. *"Notes"—"Harmonies"— "Nocturnes,"* exh. cat. (New York: H. Wunderlich & Co., 1889).

34. *New York Sun,* quoted in Margaret F. MacDonald, *James McNeill Whistler: Drawings, Pastels, and Watercolours: A Catalogue Raisonné* (New Haven, Conn.: Yale University Press, 1995), p. 359. This review refers to *Grey and Gold— Off Holland,* which was destroyed by fire by 1937.

35. See, for example, *Seashore* (originally *A Gray Day*), ca. 1888, The Museum of Fine Arts, Houston. On Chase's relationship with Whistler, see Merrill, *After Whistler,* pp. 19–21.

36. Charles H. Caffin, "The Eighth Annual Exhibition of the Water-Color Club," *Harper's Weekly* 41 (November 27, 1897), p. 1174, referring particularly to works by Ben Foster, W. L. Lathrop, and Charles Warren Eaton.

37. "Mr. Whistler's Pictures at the Wunderlich Gallery."

38. "Etchings, Drawings, Pastels." The missing paintings must have arrived in New York eventually, because they were returned to London in November: see G. Dieterlen of H. Wunderlich & Co. to Whistler, November 1, 1889, Glasgow University Library, MS Whistler W1175, in *The Correspondence of James McNeill Whistler, 1855–1903,* ed. Margaret F. MacDonald, Patricia de Montfort, and Nigel Thorp (on-line edition, Centre for Whistler Studies, University of Glasgow, 2003), http://www.whistler.arts.gla.ac.uk/ correspondence (hereafter GUW).

39. "Mr. Whistler, the Artist. The Account He Gave of Himself and His Work in the Ruskin Trial," reprinted from the *Pall Mall Gazette* (London), in *New York Times,* December 8, 1878, p. 9.

40. Royal Cortissoz, "Whistler," *Atlantic Monthly* 92 (December 1903), p. 835, referring specifically to the two Nocturnes that failed to appear at Wunderlich's Gallery in 1889.

41. "American Painting," *Art Amateur* 29 (November 1893), p. 134.

42. A catalogue of works exhibited at the World's Columbian Exposition is published in Carolyn Kinder Carr and George Gurney, eds., *Revisiting the White City: American Art at the 1893 World's Fair,* exh. cat. (Washington, D.C.: National Museum of American Art and National Portrait Gallery, Smithsonian Institution, 1993), pp. 201–383.

43. Both paintings are unlocated, but they are identified and reproduced in Carr and Gurney, *Revisiting the White City,* pp. 267 and 269.

44. Gerdts, "American Tonalism," p. 22.

45. [Gustav Stickley], "The Picturesqueness of New York Streets," *Craftsman* 13 (January 1908), p. 398.

46. Peter Bermingham, *American Art in the Barbizon Mood,* exh. cat. (Washington, D.C.: National Collection of Fine Arts and Smithsonian Institution Press, 1975).

47. Freer to Whistler, January 9, 1894, in *With Kindest Regards: The Correspondence of Charles Lang Freer and James McNeill Whistler, 1890–1903,* ed. Linda Merrill (Washington, D.C.: Freer Gallery of Art and Smithsonian Institution Press, 1995), p. 89.

48. Freer to Dewing, July 19, 1893, quoted in Thomas Lawton and Linda Merrill, *Freer: A Legacy of Art* (Washington, D.C.: Freer Gallery of Art; New York: Abrams, 1993), pp. 153–54.

49. Freer to Wilson Eyre, October 2, 1893, quoted in Linda Merrill, *An Ideal Country: Paintings by Dwight William Tryon in the Freer Gallery of Art* (Washington, D.C.: Freer Gallery of Art; Hanover, N.H.: University Press of New England, 1990), pp. 61 and 62.

50. Guy Pène Du Bois, "Whistler, Troyon [*sic*], Dewing and Thayer Contribute to a Remarkable Collection," February 14, 1910, unidentified New York newspaper, Exhibitions Presscutting Book 1, p. 3, Freer Papers.

51. "National Gallery Pictures," February 10, 1910, Exhibitions Presscutting Book 1, p. 34, Freer Papers.

52. Tryon to Edwin C. Shaw, April 30, 1923, quoted in Merrill, *Ideal Country,* pp. 64 and 118.

53. Quoted in Ruge, "Tonal School," p. 60.

54. William T. Evans, "Fads and Fashions in Art," *Art Collector* 9 (April 15, 1899), p. 136, quoted in Becker, "Studies in American Tonalism," chap. 2, p. 39.

55. William H. Truettner listed one painting by Whistler, *Tatting*, among the works in Evans's collection: "William T. Evans, Collector of American Paintings," *American Art Journal* 3 (Fall 1971), p. 79. There is no record of any painting of that title by Whistler, however, and no evidence of Evans's purchase has come to light. Presumably, he owned an impression of Whistler's etching *Tatting*. As Truettner supposed, another reason that Evans did not collect works by Whistler (or Sargent) may have been his "disapproval of their expatriate circumstances" (p. 71 n. 54).

56. Willa Cather, March 4, 1894, in *The World and the Parish: Willa Cather's Articles and Reviews, 1893–1902*, ed. William M. Curtin (Lincoln: University of Nebraska Press, 1970), vol. 1, p. 37.

57. Birge Harrison, *Landscape Painting* (New York: Scribner's, 1911), pp. 155–56.

58. "Society of American Artists. The Landscapes," *New York Times*, April 4, 1896, p. 4.

59. Whistler to Helen Euphrosyne Whistler (his sister-in-law), [January 1884?], from St. Ives, Library of Congress, Manuscript Division, Pennell-Whistler Collection 3/26/1, GUW.

60. Corn, *Color of Mood*, p. 10.

61. Annie Nathan Meyer, "Comparative Exhibit of American and Foreign Art," *Harper's Weekly* 48 (December 3, 1904), p. 1857.

62. "At the Montross Gallery" [probably March 1901], Exhibitions Presscutting Book 1, p. 3, Freer Papers; Charles H. Caffin, *American Masters of Painting* (New York: Doubleday, 1902), p. 46.

63. See, for example, Whistler to Cyril Flower [July/August 1874], published in Lucy Cohen, *Lady De Rothschild and Her Daughters, 1821–1931* (London, 1935), pp. 198–99, GUW: "Go round one morning to my place and look at a most lovely Nocturne in blue and silver in the Drawing room. It differs from all the others and is perhaps the most brilliant of the lot. . . . Go and see if ever you saw the sea painted like that! And the mystery of the whole thing—nothing apparently when you look at the canvas, but stand off—and I say the wet sands and the water falling on the beach in the blue glimmering of the moon—and the sheen of the whole thing—enfin—then I have exhausted the subject."

64. "Mr. Whistler's Ten O'Clock," in *The Gentle Art*, p. 147.

65. L. K., "The New Salon of Paris," *New York Times*, June 19, 1893, p. 9.

66. Becker, "Studies in American Tonalism," chap. 4, p. 11.

67. On Freer's participation in the scheme, see Becker, "Studies in American Tonalism," chap. 4, pp. 9–11. As Becker suggests, the large number of Whistlers shown at the exhibition—the largest by any single artist—could indicate that Evans "experienced a growing acceptance of this painter," although it might also signify Evans's respect for Freer as a collector.

68. Whistler's works, including the Peacock Room, were meant to occupy five adjacent galleries. The architect's rendering of Freer's scheme is reproduced in Lawton and Merrill, *Freer*, p. 250, fig. 181.

69. "National Gallery Pictures."

70. Kenyon Cox, "Whistler and 'Absolute Painting,'" *Scribner's Magazine* 35 (May 1904), p. 637.

71. *Report of the Commissioner-General for the Unted States to the International Universal Exposition, Paris, 1900*, vol. 2 (Washington, D.C.: Government Printing Office, 1901), p. 552, quoted in Becker, "Studies in American Tonalism," chap. 2, pp. 31–32.

72. Cortissoz, "Whistler," p. 838.

Fig. 34.
James McNeill Whistler
*Nocturne: Blue and Silver—
Bognor*, ca. 1875
Oil on canvas
19¾ × 33⅞ inches
Freer Gallery of Art,
Smithsonian Institution,
Washington, D.C., Gift of
Charles Lang Freer

Whistler," wrote Annie Nathan Meyer in 1904.
"His night pieces are the very quintessence of emo-
tion. Only a highly strung, exquisitely responsive
modern could have seized the very soul of the night
and made it his own."[61] This peculiarly American
method of discerning "soul" in the formal detach-
ment and subtle coloration of Whistler's work per-
vades art criticism around 1900, when his art was
regularly interpreted as spiritually restorative.
Nocturne: Blue and Silver—Bognor (Fig. 34), for
example, was said to exert an "almost supernatural
influence . . . upon the imagination" and extolled
as "a scene of exquisite refreshment to the spirit,
mysteriously etherealized, the artist being so
absorbed with the spiritual presence of the summer
night that his own soul echoes in its very heart-
beats."[62] It is a remarkable work, one that stands
alone in the Nocturne ensemble, and even
Whistler acknowledged its mysterious aura—but to
him, the wonder was all in the miracle of its pro-
duction.[63] From the perspective of Aestheticism,
the "*painter's* poetry" (Whistler's emphasis) was not
a conduit to profound emotion or spiritual enlight-
enment but "the amazing invention that shall have
put form and colour into such perfect harmony,
that exquisiteness is the result."[64]

The second reason Americans could revere
Whistler's work without ever assimilating his aes-
theticism is that he was perceived as sui generis,
inimitable and apart. "Whistler now is about the
only living artist who may be written down as

uncopiable," one critic wrote in 1893. "He is his
mighty self, individual and alone."[65] Accordingly,
Whistler's work was thought to require a place to
itself, isolated from its contemporaries, if it were
to be properly appreciated. In 1904, for example,
at the Comparative Exhibition of Native and
Foreign Art, Whistler's ten paintings hung sepa-
rately from the others—despite the comparative
purpose of the show—as if to suggest, Jack Becker
pointed out, that he existed "outside the domain
of both American and European painting."[66]
Freer, who lent several of those works and had a
hand in their arrangement, regularly insisted on
special conditions for the exhibition of Whistler's
art.[67] He even tried to set those considerations in
stone by establishing a national museum to house
his incomparable Whistler collection, together
with works by Asian and American artists that he
considered aesthetically compatible. But even at
the Freer Gallery of Art, Whistler's works were
meant to hang together in designated galleries,
aloof from competition.[68]

Whistler's isolation was also related to his
ambiguous nationality. Although American-born,
he spent his entire professional life abroad, wholly
unaffected by the currents of contemporary
American art. One critic argued that to include his
paintings in an exhibition was to compromise its
standing as a "purely American" show, even though
the other works on view (including a number by
Tryon) were "bone of our bone and flesh of our

flesh."[69] As Kenyon Cox observed, Whistler's works "had no national accent."[70] Inevitably, then, as American landscape painting grew more nationalistic in subject matter and intent, Whistler's tentative Americanism began to undermine his influence. At the Exposition Universelle in Paris, in 1900, where the American landscapes were said to show a "marked tendency . . . to maintain a tonal arrangement of color," that aesthetic predilection might have been ascribed to Whistler's example, but was not. As the Commissioner General reported, the paintings "connect logically with one another, forming a short chain of tradition from George Inness, the father of the present development of American landscape, through Homer Martin and Wyant, to the men still living."[71] This distinctly American movement (which we can now confidently identify as Tonalism) was considered part of an indigenous artistic tradition; Whistler's art, tended and treasured in a protected environment, was a hothouse flower that could never take root in American soil. "His is not the kind of art that, imposing itself upon men, starts an evolutionary movement," Royal Cortissoz concluded in 1903. "He meant it to exist in and for itself alone, and so it does, like some rare orchid that has no prototype and can have no successor."[72]

NOTES

1. Henry James, "The Grosvenor Gallery" (1878), in The Painter's Eye: Notes and Essays on the Pictorial Arts by Henry James, ed. John L. Sweeney (Madison: University of Wisconsin Press, 1989), p. 164.

2. Wanda M. Corn, The Color of Mood: American Tonalism, 1880–1910, exh. cat. (San Francisco: M. H. de Young Memorial Museum and the California Palace of the Legion of Honor, 1972). Corn identifies Whistler as a Tonalist but concedes that American paintings "were rarely informed with the same refined estheticism which was found in the master's works" (pp. 4 and 9). William Gerdts names Whistler a "major influence" but cautions that "the alliance perhaps should not be pushed too far." His assertion that Whistler's concern with "the primacy of pictorial creation" diverged from the Tonalists' "projection of a mood induced by their experience in nature" was the starting point for this essay. William H. Gerdts, "American Tonalism: An Artistic Overview," in Tonalism: An American Experience, exh. cat. (New York: Grand Central Art Galleries Art Education Association, 1982), p. 22.

3. Clara Ruge, "The Tonal School of America," International Studio 27 (January 1906), pp. 57–66. William T. Evans did try to borrow Whistler's Nocturne: Blue and Silver—Bognor (Fig. 10) from Charles Lang Freer for a Lotos Club exhibition in 1901, after its exhibition at the Pan-American Exposition in Buffalo. Freer declined to lend it, however, citing Whistler's objection to showing the painting in any but "an important exhibition of his work." Freer to Evans, November 11, 1901, Letter Book 8, Charles Lang Freer Papers, Freer Gallery of Art/Arthur M. Sackler Gallery Archives, Smithsonian Institution, Washington, D.C. (hereafter Freer Papers).

4. The painting was shown at the Union League Club and afterward at the Metropolitan Museum of Art's Loan Exhibition, May 1881. For more about these exhibitions, see Linda Merrill, ed., After Whistler: The Artist and His Influence on American Painting, exh. cat. (Atlanta: High Museum of Art, 2003), pp. 17 and 100. The White Girl was not exhibited with its present title, Symphony in White, No. 1, before the Whistler Memorial Exhibition in Boston, in 1904.

5. "The Union League. The Regular Monthly Meeting of the Club and an Exhibition of Pictures [ca. April 10], 1881, unidentified New York newspaper, BP II Presscuttings, vol. 4, p. 61, Special Collections, Glasgow University Library, Scotland.

6. "The American Artists' Exhibition," Art Amateur 6 (May 1882), p. 114. The painting exhibited as Portrait of a Lady is now titled Flora (Carrie Mansfield Weir), 1882, Brigham Young University, Provo, Utah.

7. John C. Van Dyke, "Retrospective Exhibition of the Society of American Artists," Harper's Weekly 36 (December 17, 1892), p. 1211. The painting, later titled The Blue Dress, is in the collection of the Freer Gallery of Art, Smithsonian Institution, Washington, D.C. (F1906.67).

8. John C. Van Dyke, Art for Art's Sake: Seven University Lectures on the Technical Beauties of Painting (New York: Scribner's, 1893), p. 77.

9. P. G. Hamerton, "Pictures of the Year. IX," Saturday Review, June 1, 1867, in Whistler: A Retrospective, ed. Robin Spencer (New York: Hugh Lauter Levin, 1989), p. 81; "The Critic's Mind Considered," in James McNeill Whistler, The Gentle Art of Making Enemies (London, 1890; reprint, New York: Putnam's, 1904), p. 45.

10. "The Red Rag," in Whistler, The Gentle Art, pp. 127–28.

11. On these exhibitions, see Merrill, After Whistler, pp. 17–19 and 50–51.

12. W. C. Brownell, "Whistler in Painting and Etching," *Scribner's Magazine* 18 (August 1879), p. 492.

13. Mariana G. Van Rensselaer, "Art Matters," *Lippincott's Magazine* 3 (January 1882), p. 101; Brownell, "Whistler in Painting and Etching," p. 492.

14. "The Society of American Artists," *Critic* 34 (April 22, 1881), p. 119.

15. *Boston Journal*, quoted in "Art Notes," *New York Times*, May 8, 1881, p. 4.

16. "The American Artists' Exhibition," *Art Amateur* 6 (May 1882), p. 114.

17. Charles H. Caffin, "The Loan Exhibition of Portraits at the National Academy," *Harper's Weekly* 42 (December 24, 1898), pp. 1260 and 1262. This particular *Portrait of a Lady* by Dewing, described by Caffin as a lady with dark hair wearing a "gray-white dress" and seated in a "yellow-upholstered chair" against a "green-gold background," has not been positively identified (my thanks to Susan Hobbs for help with this research). One of Mowbray's portraits, *Mrs. Mowbray* (unlocated), is reproduced on p. 1261.

18. Van Dyke, "Retrospective Exhibition," p. 1213.

19. Caffin, "Loan Exhibition of Portraits," p. 1262.

20. "Society of American Artists," p. 119.

21. "The Exhibition of the Pennsylvania Academy of the Fine Arts," *Art Amateur* 30 (February 1894), p. 71.

22. "Mr. Whistler at Home," *Current Literature* 17 (April 1895), p. 304.

23. The New York show reprised Whistler's solo exhibition of the same title held at Dowdeswell and Dowdeswells in London, in 1884. On that exhibition, see Kenneth John Myers, *Mr. Whistler's Gallery: Pictures at an 1884 Exhibition*, exh. cat. (Washington, D.C.: Freer Gallery of Art, Smithsonian Institution, 2003).

24. "Etchings, Drawings, Pastels," *New York Times*, March 3, 1889, p. 5.

25. "Mr. Whistler's Pictures at the Wunderlich Gallery" [March 1889], unidentified newspaper, and "A Whistler Exhibition," *New York Tribune*, March 2, 1889, Whistler Presscutting Book 1, pp. 4–5, Freer Papers.

26. "The Whistler Exhibition at Wunderlich's" [March 1889], unidentified newspaper, Whistler Presscutting Book 1, p. 4, Freer Papers.

27. *New York Tribune*, March 17, 1889, Whistler Presscutting Book 1, p. 5, Freer Papers.

28. "The Whistler Exhibition," *Art Amateur* 20 (April 1889), p. 99.

29. "Mr. Whistler's Pictures at the Wunderlich Gallery."

30. J. Alden Weir to his parents, April 15, 1877, Paris, in Dorothy Weir Young, *The Life and Letters of J. Alden Weir* (New Haven, Conn.: Yale University Press, 1960), p. 123.

31. Theodore Child, "American Artists at the Paris Exhibition," *Harper's New Monthly Magazine* 79 (September 1889), p. 498.

32. Review of 1896 landscape exhibition at the Lotos Club, *Collector* 7 (April 1, 1896), p. 162, quoted in Jack Becker, "Studies in American Tonalism," Ph.D. diss., University of Delaware, 2002, chap. 1, p. 38.

33. *New York Tribune*. Of the 44 works displayed, 26 have "grey" or "silver" in their titles. *"Notes"—"Harmonies"— "Nocturnes,"* exh. cat. (New York: H. Wunderlich & Co., 1889).

34. *New York Sun*, quoted in Margaret F. MacDonald, *James McNeill Whistler: Drawings, Pastels, and Watercolours: A Catalogue Raisonné* (New Haven, Conn.: Yale University Press, 1995), p. 359. This review refers to *Grey and Gold— Off Holland*, which was destroyed by fire by 1937.

35. See, for example, *Seashore* (originally *A Gray Day*), ca. 1888, The Museum of Fine Arts, Houston. On Chase's relationship with Whistler, see Merrill, *After Whistler*, pp. 19–21.

36. Charles H. Caffin, "The Eighth Annual Exhibition of the Water-Color Club," *Harper's Weekly* 41 (November 27, 1897), p. 1174, referring particularly to works by Ben Foster, W. L. Lathrop, and Charles Warren Eaton.

37. "Mr. Whistler's Pictures at the Wunderlich Gallery."

38. "Etchings, Drawings, Pastels." The missing paintings must have arrived in New York eventually, because they were returned to London in November: see G. Dieterlen of H. Wunderlich & Co. to Whistler, November 1, 1889, Glasgow University Library, MS Whistler W1175, in *The Correspondence of James McNeill Whistler, 1855–1903*, ed. Margaret F. MacDonald, Patricia de Montfort, and Nigel Thorp (on-line edition, Centre for Whistler Studies, University of Glasgow, 2003), http://www.whistler.arts.gla.ac.uk/ correspondence (hereafter GUW).

39. "Mr. Whistler, the Artist. The Account He Gave of Himself and His Work in the Ruskin Trial," reprinted from the *Pall Mall Gazette* (London), in *New York Times*, December 8, 1878, p. 9.

40. Royal Cortissoz, "Whistler," *Atlantic Monthly* 92 (December 1903), p. 835, referring specifically to the two Nocturnes that failed to appear at Wunderlich's Gallery in 1889.

41. "American Painting," *Art Amateur* 29 (November 1893), p. 134.

42. A catalogue of works exhibited at the World's Columbian Exposition is published in Carolyn Kinder Carr and George Gurney, eds., *Revisiting the White City: American Art at the 1893 World's Fair*, exh. cat. (Washington, D.C.: National Museum of American Art and National Portrait Gallery, Smithsonian Institution, 1993), pp. 201–383.

43. Both paintings are unlocated, but they are identified and reproduced in Carr and Gurney, *Revisiting the White City*, pp. 267 and 269.

44. Gerdts, "American Tonalism," p. 22.

45. [Gustav Stickley], "The Picturesqueness of New York Streets," *Craftsman* 13 (January 1908), p. 398.

46. Peter Bermingham, *American Art in the Barbizon Mood*, exh. cat. (Washington, D.C.: National Collection of Fine Arts and Smithsonian Institution Press, 1975).

47. Freer to Whistler, January 9, 1894, in *With Kindest Regards: The Correspondence of Charles Lang Freer and James McNeill Whistler, 1890–1903*, ed. Linda Merrill (Washington, D.C.: Freer Gallery of Art and Smithsonian Institution Press, 1995), p. 89.

48. Freer to Dewing, July 19, 1893, quoted in Thomas Lawton and Linda Merrill, *Freer: A Legacy of Art* (Washington, D.C.: Freer Gallery of Art; New York: Abrams, 1993), pp. 153–54.

49. Freer to Wilson Eyre, October 2, 1893, quoted in Linda Merrill, *An Ideal Country: Paintings by Dwight William Tryon in the Freer Gallery of Art* (Washington, D.C.: Freer Gallery of Art; Hanover, N.H.: University Press of New England, 1990), pp. 61 and 62.

50. Guy Pène Du Bois, "Whistler, Troyon [sic], Dewing and Thayer Contribute to a Remarkable Collection," February 14, 1910, unidentified New York newspaper, Exhibitions Presscutting Book 1, p. 3, Freer Papers.

51. "National Gallery Pictures," February 10, 1910, Exhibitions Presscutting Book 1, p. 34, Freer Papers.

52. Tryon to Edwin C. Shaw, April 30, 1923, quoted in Merrill, *Ideal Country*, pp. 64 and 118.

53. Quoted in Ruge, "Tonal School," p. 60.

54. William T. Evans, "Fads and Fashions in Art," *Art Collector* 9 (April 15, 1899), p. 136, quoted in Becker, "Studies in American Tonalism," chap. 2, p. 39.

55. William H. Truettner listed one painting by Whistler, *Tatting*, among the works in Evans's collection: "William T. Evans, Collector of American Paintings," *American Art Journal* 3 (Fall 1971), p. 79. There is no record of any painting of that title by Whistler, however, and no evidence of Evans's purchase has come to light. Presumably, he owned an impression of Whistler's etching *Tatting*. As Truettner supposed, another reason that Evans did not collect works by Whistler (or Sargent) may have been his "disapproval of their expatriate circumstances" (p. 71 n. 54).

56. Willa Cather, March 4, 1894, in *The World and the Parish: Willa Cather's Articles and Reviews, 1893–1902*, ed. William M. Curtin (Lincoln: University of Nebraska Press, 1970), vol. 1, p. 37.

57. Birge Harrison, *Landscape Painting* (New York: Scribner's, 1911), pp. 155–56.

58. "Society of American Artists. The Landscapes," *New York Times*, April 4, 1896, p. 4.

59. Whistler to Helen Euphrosyne Whistler (his sister-in-law), [January 1884?], from St. Ives, Library of Congress, Manuscript Division, Pennell-Whistler Collection 3/26/1, GUW.

60. Corn, *Color of Mood*, p. 10.

61. Annie Nathan Meyer, "Comparative Exhibit of American and Foreign Art," *Harper's Weekly* 48 (December 3, 1904), p. 1857.

62. "At the Montross Gallery" [probably March 1901], Exhibitions Presscutting Book 1, p. 3, Freer Papers; Charles H. Caffin, *American Masters of Painting* (New York: Doubleday, 1902), p. 46.

63. See, for example, Whistler to Cyril Flower [July/August 1874], published in Lucy Cohen, *Lady De Rothschild and Her Daughters, 1821–1931* (London, 1935), pp. 198–99, GUW: "Go round one morning to my place and look at a most lovely Nocturne in blue and silver in the Drawing room. It differs from all the others and is perhaps the most brilliant of the lot. . . . Go and see if ever you saw the sea painted like that! And the mystery of the whole thing—nothing apparently when you look at the canvas, but stand off—and I say the wet sands and the water falling on the beach in the blue glimmering of the moon—and the sheen of the whole thing—enfin—then I have exhausted the subject."

64. "Mr. Whistler's Ten O'Clock," in *The Gentle Art*, p. 147.

65. L. K., "The New Salon of Paris," *New York Times*, June 19, 1893, p. 9.

66. Becker, "Studies in American Tonalism," chap. 4, p. 11.

67. On Freer's participation in the scheme, see Becker, "Studies in American Tonalism," chap. 4, pp. 9–11. As Becker suggests, the large number of Whistlers shown at the exhibition—the largest by any single artist—could indicate that Evans "experienced a growing acceptance of this painter," although it might also signify Evans's respect for Freer as a collector.

68. Whistler's works, including the Peacock Room, were meant to occupy five adjacent galleries. The architect's rendering of Freer's scheme is reproduced in Lawton and Merrill, *Freer*, p. 250, fig. 181.

69. "National Gallery Pictures."

70. Kenyon Cox, "Whistler and 'Absolute Painting,'" *Scribner's Magazine* 35 (May 1904), p. 637.

71. *Report of the Commissioner-General for the United States to the International Universal Exposition, Paris, 1900*, vol. 2 (Washington, D.C.: Government Printing Office, 1901), p. 552, quoted in Becker, "Studies in American Tonalism," chap. 2, pp. 31–32.

72. Cortissoz, "Whistler," p. 838.

"Spiritualized Naturalism": The Tonal-Impressionist Art of J. Alden Weir and John H. Twachtman

LISA N. PETERS

SCHOLARS USUALLY associate the landscape paintings created by American artists at the turn of the twentieth century with either the Impressionist or Tonalist movements, which unfolded concurrently. Nonetheless, two artists are consistently identified as exemplars of both movements: J. Alden Weir (1852–1919) and John H. Twachtman (1853–1902).[1] At times, Weir and Twachtman have also been called "Tonal-Impressionists," primarily in reference to their works of the 1890s in which they synthesized the two styles.[2] Thus, a consideration of their art of this decade allows us to see how these approaches, often thought of as antithetical, could have come together. The Tonal-Impressionist works of Weir and Twachtman reveal that the two styles were indeed compatible; in addition, the blending was frequently viewed as felicitous, as it resulted in works that reflected ideals associated with American art and the American landscape during the era.

The two artists were born one year apart: Weir in West Point, New York, in 1852, and Twachtman in Cincinnati, Ohio, in 1853. Growing up when the Hudson River School had fallen from favor, both joined a cosmopolitan generation of young artists who sought to leave behind the provincialism and didacticism of an earlier American artistic heritage by pursuing travel and study abroad. Following the career trajectory typical of many American artists of their time, both spent about a decade looking to European art for inspiration. In the 1870s and early 1880s they studied in Europe—Weir in Paris and Twachtman in Munich and Paris—and spent time in popular artists' haunts in France, Italy, and Holland. Both had completed the European phases of their careers by the mid-1880s and returned, permanently, to America. Committed to painting the familiar places where they lived and worked, both settled in the countryside of southwestern Connecticut—Weir in Branchville (beginning in 1883) and Twachtman in Greenwich (beginning in 1889)—where they

maintained the friendship they had begun in the late 1870s.[3] The two remained in close contact until Twachtman's early and sudden death at age forty-nine in 1902; Weir lived another seventeen years, passing away at age sixty-seven.

By the mid-1880s Weir and Twachtman were creating landscapes incorporating the sources that were also important for many American artists of their time. The most significant influence for the two artists was the work of the French Barbizon School to which they had been exposed in the late 1870s in both Europe and New York. Weir's admiration for such artists as Jean-François Millet and Théodore Rousseau prompted him to visit the town of Barbizon in 1875, and his respect for their art continued. "To see these works," he wrote to his parents in 1878, "one is really inspired to go to work immediately. The simplicity and truth of these men makes one love art and want to get to work."[4] Weir also knew leading American proponents of the Barbizon aesthetic, including George Inness, whom he had met as a youth through his father, Robert, and whom he had visited in Paris, and Robert Minor, a painter of dark, tonal landscapes.

Weir and Twachtman also became enamored of the art of the Dutch Hague School, which they saw on sojourns in Holland as well as in New York, where it was promoted in the late 1870s by the gallery of Cottier and Company. While in Holland, Weir had visited the Dutch marine painter Hendrik Mesdag, and Twachtman sought out the noted Hague School landscapist Anton Mauve. The works of Jules Bastien-Lepage, a French artist who painted scenes of peasants within naturalistically conceived landscapes, also had a significant impact on the artists. An admirer of Bastien's coalescing of a close observation of outdoor light with an academic approach to composition and the figure, Weir developed a close relationship in Paris with the French painter and became the only American to join his inner circle. Although Twachtman, too, admired Bastien, he

Fig. 35.
John H. Twachtman
Arques-la-Bataille, 1885
Oil on canvas
60 × 78⅞ inches
The Metropolitan Museum
of Art, New York, Morris
K. Jesup Fund, 1968

Although it drew throngs of curious visitors, the exhibition received disparate critical responses that ranged from avid enthusiasm to disgusted revulsion.

Twachtman probably did not attend the exhibition; having returned from Paris to Cincinnati in the winter of 1885–86, he was not yet on the East Coast when it was held. Weir, who in 1881 assisted the collector Erwin Davis purchase paintings by Edouard Manet, may have become less resistant to the new art than he was in 1877, but it is not known if he visited the 1886 show. However, like other American artists of their time, in the years that followed, Weir and Twachtman would have been unable to avoid seeing Impressionist art. It appeared in other exhibitions in New York and spread its influence to their peers. The artists probably also became familiar with Impressionism through their mutual friend Theodore Robinson, who spent time with them between his long stays in the town of Giverny, France, where from 1887 until his permanent return to America in 1892 he was a confidant of Claude Monet.

In the late 1880s and early 1890s, the New York art scene was suddenly flooded with French Impressionist works, causing a rift between American landscape painters. On one end of the spectrum were those artists who enthusiastically embraced the new approach, leaving old stylistic methods behind to emerge from their studios and paint sunlit scenes in the open air. On the other end were those artists who continued to draw from sources that had become prevalent earlier and retained their allegiance to painting in the studio. The former group is exemplified by Childe Hassam, often seen as the most "French" of the American Impressionists, who, after encountering French Impressionism in Paris in 1886, significantly changed his style. Instead of relying on the grays and greens of the Barbizon School, he used vivid, high-key colors and vigorous, broken brushstrokes to portray the world as he directly experienced it. Representing the latter group were such artists as Henry Ward Ranger, J. Francis Murphy, and Bruce Crane, who continued to be influenced by Barbizon and Hague School motifs and techniques as well as those of Whistler. Their role model was Inness, who had attacked Impressionism as early as 1879 for its "skeptical scientific tendency to ignore the reality of the unseen,"[7] and who maintained his aversion to Impressionism until his death in 1894. Retaining earlier practices of painting from memory, the second group concentrated on the portrayal of quiet, rural sites, which they distilled to poetic essences by using blended, low-key tones, glazing that derived from methods used in the Venetian Renaissance, and simplified arrangements that enhanced the sense of quietude and reverie that their images evoked.

was more critical of his work; he wrote to Weir that he found it too materialistic, seldom going "beyond the modern realism which . . . consists too much in the representation of things."[5]

Both artists also derived inspiration from the art of James McNeill Whistler. Weir visited the notorious American expatriate and Aesthetic Movement leader in London in 1877 and again in 1881. Twachtman probably did not meet Whistler but knew of him through his many friends who became close to Whistler in London and Venice. Whistler's "nocturnes," "symphonies," and "harmonies," in which tonal values constituted the subject rather than merely the background, were critical influences on the paintings that Twachtman created of the Normandy countryside in 1884 and 1885, most notably his *Arques-la-Bataille* (Fig. 35), in which the tranquil mood of the riverside setting is expressed through bands of subtly shifting tones of grayish green.

In Paris in 1877 Weir may have been the only American artist to visit the third exhibition of the French Impressionists. The show repulsed him, and he pronounced it "worse than a Chamber of Horrors."[6] It was not until the end of the next decade that French Impressionist art became known in America and began to be acceptable to American artists, including Weir. The catalyst for spreading an awareness of Impressionism in this country was the exhibition brought to New York in the spring of 1886 by the Paris art dealer Paul Durand-Ruel; it consisted of nearly three hundred French Impressionist works as well as some examples by more conservative French painters. The show opened at the American Art Galleries but was so popular that it was relocated to the National Academy of Design.

As elucidated by William H. Gerdts and Jack Becker, it was the latter group that in 1895 became known as the Tonalists.[8] That was the year that New York's Lotos Club and its art committee—in an attempt to retard the spread of Impressionism in America—began to promote such art under this aegis. Indeed, the term "Tonalism" was coined about a decade after the style that it described had been in practice. In exhibitions at the Lotos Club, beginning in the mid-1890s, the art committee hung works by American "Tonalists" next to those by old masters and Barbizon and Hague School artists to demonstrate that Tonalism was connected to the great art traditions of the past. Because of this heritage, they believed that Tonalism represented the point to which art history had evolved. Not only was it the style that would continue into the future, but it was the mode that would demonstrate the achievement of American art and establish its international hegemony. They believed that the poetry and craftsmanship exemplified in Tonalist art were ingredients essential to all art of lasting value. To Tonalist advocates, Impressionism was deficient in both these qualities and was also detached from the historical foundations that underlay Tonalism. For these reasons, they attacked Impressionism as merely a cult or a fad, soon to fade away and suggested that the artists were drawn to it purely for its caché. They denounced the style as superficial and purely scientific. As a reviewer of an 1896 show at the Lotos Club stated, the difference in the two modes could be described as "the presence of sentiment and a melodic rhythm of color, as against mere brushwork in the scientific spirit of the analytic cathode ray."[9]

Within the context of the American art scene in which the two styles were seen to be at odds with each other, Twachtman and Weir were perceived as belonging to the Impressionist camp. This designation makes sense, because they were among the first American artists to be inspired by French Impressionist art. Their earliest forays into Impressionist practices occurred in the pastels they created together in the late 1880s. Working in the outdoors in the hills of Branchville on toned and textured papers, they used the fresh and bright colors of pastels to record their direct observations of nature. In the process they turned from muted tonal palettes to fresher, freer coloristic blends and more vigorous, agile handling (Cat. 38).

Soon the two artists transferred such practices to their oil paintings. This change was quickly recognized by the critics. When both had independent solo exhibitions in New York in 1891, they were pronounced converts to the French style and viewed as leading exponents of Impressionism in America. A critic for the Magazine of Art wrote that Weir had gone "over, bag and baggage, to the disciples of Manet and Monet, with their pinks, blues, and purples."[10] A review of Twachtman's show was entitled, "An Impressionist's Work in Oil and Pastel—Mr. J. H. Twachtmann's [sic] Pictures."[11]

The artists' reputations as preeminent American "Impressionists" were cemented two years later, when their work was featured in a four-person exhibition in New York along with that of Monet and Paul-Albert Besnard, a portraitist who employed a painterly style similar to that of his friend John Singer Sargent. In an article entitled "A Group of Impressionists," the New York Sun announced:

> Here is a treat for the apostles of light and air and the hot vibrations of sunlight in painting: for the devotees of the simple beauty of abstract color and illumination. It is also a fine opportunity to compare with the works of Monet, the most conspicuous of Parisian impressionists, those of two of our own most advanced followers in his footsteps.[12]

The New York Mail and Express stated: "The impressionist school of painting is probably as well represented in the exhibition of pictures at the American Art Galleries in 23rd street as it will ever be in this city. Two Frenchmen, Monet and Besnard, both in the first rank of the style, and two Americans, Weir and Twachtman, are chosen exponents to illustrate the 'plain air' school."[13] Under the title "Some Dazzling Pictures," a critic for the New York Times announced that the collection presented four artists "who are devotees of the latest effort to give the impression either of sunlight in the open, or of the brightest diffused light when the sun is obscured."[14] When a smaller group of works by Weir and Twachtman was sent to the St. Botolph Club in Boston the following November, the Boston Evening Transcript made the pronouncement that "within about three years" the two painters had changed their style radically so as to "proclaim plainly that they believe in a new set of principles, quite different from, if not at variance with, their former theories and practices."[15]

However, the Boston Evening Transcript critic's view—that the artists had not only moved in a new direction but had thoroughly altered the essence of their art—was not reflected in other commentaries of the time. Indeed, many critics took the position that although Weir and Twachtman had become "Impressionists," they nonetheless had not fundamentally changed the nature of their art. By contrast with the Boston Transcript's view, many felt that Weir and Twachtman had simply chosen to integrate Impressionist strategies into aesthetic modes they had developed earlier, blending the old and the new. This synthesis resulted in works by

the two artists that can be termed examples of "Tonal-Impressionism." Although the critics of the time did not refer to these works with this label, they often recognized that the artists had combined the direct observational approach of Impressionism with a lyrical and artistic conception of nature that was often associated with "Tonal Painting" or "Tonalism."

This view of the art of Weir and Twachtman was articulated most succinctly at the time of their 1893 exhibition, in which Monet's vivacity was frequently contrasted with the gentler, more aesthetically pleasing form of Impressionism exemplified by Weir and Twachtman. The *New York Sun* reported:

> While, like Monet, [Weir and Twachtman] have striven toward the expression of Impressions of landscape and figure, they have looked with soberer eyes. There is none of the splendid, barbaric color that distinguishes the works of the Frenchman. They tend to silvery grays modified by greens and blues quite as silvery.[16]

The *New York Evening Post* noted that while Weir and Twachtman "affiliate very naturally with Monet . . . the distinction between them . . . is that Monet pursues the representation largely for truth's sake, while Weir and Twachtman use the represen-

tation for art's sake." In this critic's view, the work by the Americans had a decorative quality often missing in Monet but qualified this statement:

> by "decorative" we do not mean the common reproach of something arbitrary or not serious. We mean in saying a picture is decorative to pay it the very highest compliment in our power. It is the decorative sense that produces art in contradistinction to the realistic sense which produces merely the representation.[17]

Naturally, not all of the art Weir and Twachtman created beginning in the 1890s can be seen as exemplifying Tonal-Impressionism. In the mid-1890s—when the Lotos Club worked hardest to forestall the proliferation of Impressionism—the two artists most completely embraced Impressionist approaches. Perhaps they did so to reinforce their allegiance with the French style, which represented the epitome of modernism at the time. Twachtman created some of his most vigorously dabbed works in which forms dissolve into flickering atmospheres, such as *Hemlock Pool, Autumn* (ca. 1894; private collection), and painted scenes flooded with sunlight, such as *In the Garden* (ca. 1895–1900; private collection). In the mid-1890s Weir, too, more frequently turned to staccato brush handling, higher-key palettes, and flattened designs

Fig. 36.
J. Alden Weir
Lengthening Shadows, 1887
Oil on canvas
20⅛ × 25 inches
Private Collection

inspired by the Japanese prints that he collected (even though he often continued to rely on academic methods to structure his compositions). Probably the best example of his foray into full-fledged Impressionism is his well-known *The Red Bridge* (ca. 1895; Metropolitan Museum of Art, New York). In the 1910s Weir reverted to a Tonalist approach, in landscapes painted with indefinite, blurred forms in subdued, pale tones. By contrast, during the last three years of his life, from 1900 through 1902, Twachtman turned in the opposite direction, in images of Gloucester, Massachusetts, that stand out as among the most vivid, freely rendered American works of the era.

However, during the 1890s and in Weir's case continuing into the next decade or so, the two artists often created images that exemplified the qualities of Tonal-Impressionism, in which they modified Impressionist means in the service of a softer, more poeticized approach. This middle-ground style was frequently viewed at the time and in the early decades of the twentieth century as a more appealing American version of Impressionism. As evidence of this appeal, beginning in 1900 American collectors began to buy works by Weir, Twachtman, and others that exhibited a tonal or more gentle form of Impressionism.

This pattern is exemplified by the gradual shift in the taste of the noted American collector William T. Evans, who had made his fortune in the dry-goods business. When he began to collect art in 1880s, he bought works by both American and European artists, but in 1890 he sold his European holdings and began restricting his purchases to American pictures, both figure paintings and landscapes. In 1892 he was nominated to membership in the Lotos Club by Henry Ward Ranger, and two years later he became chairman of the club's art committee. Many of Evans's landscape paintings were by such artists as George Inness, Dwight Tryon, Robert Minor, and Alexander Wyant, which were done in the style that would become known as Tonalism. Evans supported Tonalism through his efforts at the Lotos Club, by lending his paintings to other private clubs, and by making the galleries in his homes in New York City and Montclair, New Jersey, available for private viewings of his collection.

Despite his involvement with the Lotos Club, which was still antagonistic toward Impressionism in the mid-1890s, Evans gradually began to add works by American artists who were inspired by Impressionism to his private collection. Drawn at first to quieter, softer types of images, he gradually acquired more vibrant and freely rendered works, stopping short, however, of art that represented what was then considered a more extreme form of Impressionism. Other American collectors such as

George Hearn, John Gellatly, and John Harsen Rhoades followed a similar route.

Evans acquired his first work by Weir in 1896, when he bought Weir's *Lengthening Shadows* of 1887 (Fig. 36); he lent it to a show at the Lotos Club the following year. Painted before Weir had adopted Impressionist techniques, *Lengthening Shadows* reflects Weir's absorption of Barbizon and academic influences. After the turn of the century, Evans, along with other Tonalist collectors including Hearn, acquired paintings by Weir that combined Tonalist and Impressionist elements, such as *Upland Pasture* (see Fig. 39), acquired by Evans by 1909, *Midday* (1891; private collection), acquired by Evans by 1908, and the figural painting, *The Green Bodice* (1906; Metropolitan Museum of Art, New York), acquired by Hearn by 1906. Tonalist collectors began to favor Twachtman's art immediately following his death in 1902. Among the organizers of the artist's estate sale in 1903 were Evans, Charles Lang Freer, and Gellatly, all of whom purchased works from the sale; they continued to buy work by Twachtman in the years that followed.

In 1907 the Lotos Club held simultaneous shows of art by Twachtman and Weir, indicating a change in outlook from the mid-1890s. By 1910 the promise of Tonalism had not come to fruition, and the Lotos Club had thrown its support, surprisingly, behind Impressionism. In December 1910 the club held a show entitled *Exhibition of Paintings by French and American Luminists*, which juxtaposed works by Eugène Boudin, Mary Cassatt, Edgar Degas, Hassam, Willard Metcalf, Monet, Camille Pissarro, Robert Reid, Pierre-Auguste Renoir, Robinson, Alfred Sisley, Twachtman, and Weir, that is, the leading French and American Impressionists. The critic for the *Herald* observed: "Doubtless the art committee of the Lotos Club never arranged a show in which it has manifested in a greater degree its sincere appreciation of the works of those men who have striven so well with the subtleties of light and air."[18]

Yet it was also in the early decades of the twentieth century that the nationalism embodied in the promotion of Tonalism was also applied to the works of Weir and Twachtman. Many commentators of the era responded positively to what they perceived as the "American" variant of Impressionism as represented in the two artists' landscapes, viewing them as superior to those of their French counterparts. Calling the works of Weir and Twachtman examples of "spiritualized naturalism," the collector Duncan Phillips summed up this point of view: "These American pupils were to surpass their French masters by making their method more flexible and more spiritual, while retaining all the truth and all the vitality."[19] At

times, Weir's and Twachtman's images were perceived as representing a new American landscape ideal, by merging the rugged, fresh beauty associated with the American outdoors, epitomized by the Hudson River School, with an element of delicate refinement connected to "Anglo-Saxon" traditions and expressive of the tranquility and reassurance that was sought during an age of complexity and anxiety.

Weir's "Idyllic Optimism"

Many of Weir's landscapes of the early 1890s best exemplify a Tonal-Impressionist synthesis and demonstrate how this style came to be seen as representing an American ideal. A clear progression may be seen in his works. In *Lengthening Shadows* (Fig. 36), Weir portrayed the rolling countryside around his Branchville home at the end of the day. His perspective is intimate, showing a path curving up toward the house illuminated by sunlight coming from just over the brim of the hill. However, his carefully constructed composition, clearly delineated forms, and controlled modulation of light and shadow indicate that he painted this work in his studio. By the next year, he had begun to loosen his brushwork and soften the outlines of forms, blending trees into the landscape, but he retained an allover rich green palette. In *The Farmer's Lawn* (Fig. 37), probably created about 1890, Weir further broke up the solidity of the paint surface and introduced a range of brighter

and intermediary tones to express an interplay of sunlight and shadows. With this approach he found a direct way of conveying his joyous response to his familiar surroundings.

The Farmer's Lawn reveals that Impressionism provided Weir with a means of lessening his dependence on academic draftsmanship methods and of imbuing his works with new vitality, while retaining the soft tonalities and the general concerns that had been part of his art earlier. This painting, along with such works as *The Lane* (ca. 1890; Phillips Collection, Washington, D.C.), a similar warm-toned, loosely painted view of the Branchville countryside, *Farm Scene* (Cat. 42), in which a diffused light blurs distinctions among forms while allowing the delicate, calligraphic lines of tree branches and hedgerows to emerge, and *Early Moonrise* (1891; private collection), a typical Tonalist subject rendered with touches of Impressionist broken brushwork, were probably typical of the images in Weir's solo exhibition at New York's Blakeslee Gallery in 1891. Critics were appreciative of Weir's new approach. A critic for the *New York Sun* was especially discerning. While stating that it was "a little startling to see what a total change has come over [Weir's] eye and palette," the writer recognized that Weir's art had not changed in its basic character, noting: "In the essential qualities of his sentiment for the poetic, the suggestive, the undefined in landscape, he naturally remains the same." Acknowledging that although Weir's work had "wholly changed" under the "influence of

Fig. 37.
J. Alden Weir
The Farmer's Lawn
ca. 1888–90
Oil on canvas
20¼ × 29 inches
Private Collection

the impressionistic school," and especially under the influence of Monet, the critic stated that the artist's temperament had remained unaffected, and it was this element that still formed the basis of his art. "Even the strongest outside influence, though it may wash and reset a palette, and even seem to give a new form of vision, cannot make a new artist out of one already developed." The *Sun* critic wondered how Weir should proceed. Asking whether Weir had "done well to abandon old lines for new," he or she was certain that "the low-toned, somewhat melancholy, wholly poetic, if not very spirited, canvases with which he has made us familiar have a personal charm which, if it is to vanish forever from our exhibitions, will be genuinely regretted." At the same time, Weir's new works revealed "a good deal of charm of another kind," demonstrating the "roughly treated, pale-colored, yet still poetic products of his newer brush." The critic further conjectured as to whether Weir would eventually bring more solidity to his art, which might infuse his work with even more poetry: "By this we do not mean necessarily more expression of detail, for it is possible to be very firm and accurate and virile, even when one is frankly synthetical." Approving of Weir's use of Impressionism to enhance the poetic content in his art as well as to help him purge it of elements that were detrimental to it, the writer nonetheless worried that if he went too far, he would lose "personal charm" as well as depart too far from solidity, resulting in "formlessness."[20]

Other reviews of the show expressed a similar point of view. A writer for the *Studio* noted that not one of Weir's works "has not some charm of coloring, some grace of line, or subtlety of composition to draw the eye." The *Studio* writer seems to have put Weir closer to the Tonalist than to the Impressionist camp, commenting that the artist never saw nature "with analytic eyes," instead creating works in which nature is always seen "through a veil." For this critic, Weir's art was also characterized by "charm," a quality that could be defined as "fine observation" combined with "artistic accomplishment."[21]

The *Magazine of Art* similarly approved of Weir's personalized version of Impressionism, stating that Weir was "too good an artist" to allow Impressionism to lead him to the vapid, "sticky and soft jams" of some of his peers. However, perceiving that Weir was "not always happy in the new manner," this critic saw it as more effective in "certain late afternoon effects, landscapes in early spring and twilight views" than in his images of a "lady's portrait in streaks of pale candy" and in a scene attempting to "render crisp American autumn."[22] The subjects that this critic felt most benefited from Weir's Impressionist approach were exactly

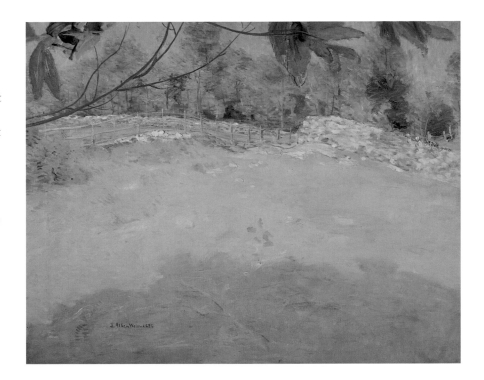

Fig. 38.
J. Alden Weir
*In the Shade of a Tree
(Sunlight, Connecticut)*, 1894
Oil on canvas
27 × 34 inches
Sheldon Memorial Art
Gallery and Sculpture
Garden, University of
Nebraska, Lincoln, NAA-
Nelle Cochrane Woods
Memorial

the motifs that were most popular among artists associated with Tonalism, revealing this critic's view that Impressionism could enhance such poetic images rather than being unsuited to them.

The critic for the *Collector* also saw Weir as creating a gentler form of Impressionism, stating that unlike Sisley, Monet, and Pissarro, Weir had not condescended or forced "himself to the brutality of execution that frequently mars their work, with a suggestion of reckless defiance of the conventions rather than that calm contempt for them which made a [Jean-Baptiste Camille] Corot, and has made a [Jean-Charles] Cazin." This critic felt that Weir's work was "distinguished in nearly every instance by a subtle and dainty loveliness of feeling" and commended Weir for creating art with "the breath of genuineness in it" that exemplified his ability to paint as he sincerely felt. However, this praise was somewhat qualified by the critic's comment that Weir had given "us the poetry of nature in a minor, very minor key, and on a narrow, a very narrow scale," which has "a dainty melodic charm which seduces the weaker senses only, but was incapable of thrilling the eye or stirring the blood."[23]

By the mid-1890s Weir had reinserted into his art some of the solidity that he had eliminated earlier in his images, but he continued to straddle the line between a Tonalist and an Impressionist approach. An example of this type of work is *In the Shade of a Tree* (Fig. 38). Weir's allegiance to Impressionism is demonstrated in the bright golden sunlight spread across the meadow directly before us and the flattened pictorial scheme accentuated by the overhanging leaves in the upper foreground,

Fig. 39.
J. Alden Weir
Upland Pasture, ca. 1905
Oil on canvas
39⅛ × 50¼ inches
Smithsonian American Art
Museum, Washington, D.C.,
Gift of William T. Evans

inspired by Japanese prints. Yet the work's simplicity of design and mood of reassuring serenity associate it with Tonalism. The open-ended composition evokes a feeling of freedom, yet this openness is controlled by the curving stone wall that divides the meadow from the dense forested scrim of trees beyond it and by the shadows in the foreground, whose blended tones create a transitional zone that eases us into the scene. In 1911 the critic Guy Pène du Bois saw in this work "grace of line" and "harmonious color," so different from the kinds of spatial and coloristic incongruities that were often part of French Impressionist art. For du Bois, Weir's art embodied a "subtle quality" of "idyllic peace or optimism" that was "essentially American— American in the refined sense."[24]

After the turn of the century, Weir continued to blend qualities associated with Impressionism and Tonalism, although he tended to treat forms with greater firmness, reinvoking the lessons of his years in Paris and his debt to Bastien-Lepage. This approach is exemplified in *Upland Pasture* of ca. 1905 (Fig. 39). For du Bois, this work had a "rigid reserve" that was "conservative, and yet gloriously and almost boyishly happy." Observing that Weir had "lent himself to that staid old rule of composition—the triangle," du Bois felt that he had yet "given us something new and individual and delightful."[25]

In at least two works in 1910 and 1911 Weir treated a new subject that was amenable to a merging of Impressionism and Tonalism: New York City. Whistlerian-inspired abstract arrangements, *The Bridge: Nocturne* (Fig. 40) and *The Plaza: Nocturne* (Fig. 41) portray aerial, panoramic views of the city

in which the artificial yellows and oranges of street lights and windows penetrate the darkness, creating a range of colored shadows and reflections. The lights set partially visible urban forms aglow, transforming them into objects of mystery and magic.

As noteworthy as Weir's views of New York City are, at the same time they relate to works by other American artists who took a similar approach to New York. Indeed, in the early twentieth century, New York was an extremely popular subject for painters as well as for photographers. The paintings of the city, however, may be divided into two groups. On the one hand were the images of the "urban realists" among the Eight and their followers in the Ashcan School, including such artists as Robert Henri and John Sloan, who captured the gritty and dynamic aspects of New York's streets, harbors, cafés, and tenement districts. These works were usually created in a gestural, painterly style using dark tonalities that recalled the Munich School of the 1870s and its precedents in seventeenth-century Dutch and Spanish painting. On the other hand were the images of artists who often united Impressionist and Tonalist approaches in more distant views of the city. Works in this vein by painters including Paul Cornoyer, Edmund Greacen, Birge Harrison, Hassam, Henri, George Luks, Henry Ward Ranger, Edward Redfield, and Weir showed the city from faraway and overhead vantage points, depicting it partially obscured by mists, the dark of night, or snow-filled atmospheres.[26] These artists often combined flickering Impressionist brushwork with the soft hazes of Tonalism, resulting in images that promoted the beauty of America's premier city, with all of its stress, grit, and discordant elements hidden, forgotten, or seemingly extracted. That such a perspective was viewed as desirable was proposed as early as 1892 by the noted critic Marianna Van Rensselaer, who stated that it is best to see the city as an arrangement of masses and colors, as if seen from a boat, from which

> the abrupt, extraordinary contrasts of its sky-
> line are then subdued to a gigantic mystery; its
> myriad many-colored lights spangle like those
> of some supernaturally large casino; and from
> the east or south we see one element of rare and
> solemn beauty—the sweep of the great bridge,
> defined by starry sparks, as though a bit of the
> arch of heaven had descended to brood over
> the surface of the waves.[27]

Jesse Lynch Williams echoed this attitude in 1899: the city's high buildings by themselves are "vulgar, impertinent 'sky-scrapers,'" but as a group, "they are "fine, with a strong, manly beauty all their own."[28] That a genteel distance rendered the city

in its best light was an opinion often conveyed in the years that followed. John Corbin wrote in 1903 that the "most casual eye may find delight in noting how softly building fades into building in the heart of the town," and that "most beautiful of all are the flurries of snow-flakes, in which the commonest city sights loom vague and mysterious."[29] In 1909 Paul Cornoyer was praised for painting "the city tranquil, not the city of pulsing energy or dramatic contrasts" and for taking a Tonalist stance in his urban scenes of transferring "to canvas the transient impression which is left on the mind by so much that is beautiful."[30]

For his views of New York, Weir purposefully chose a similar approach. He wrote of these images to his friend Charles Erskine Scott Wood: "Of course none of it could be painted direct, having had to make studies—memorandum to use the following day. The thing itself was so beautiful I had to get the big notes which as you know, are terribly subtle."[31] That Weir achieved his objective was recognized by the artist Eliot Clark, who wrote of Weir's New York images in 1920: "Weir has given us a supreme representation of the palpitating mystery of night.... With a delicacy of tonal relations which is almost ethereal, he has rendered in material pigment the immensity and the mystery of night."[32]

Weir's ability to find the perfect stylistic balance between Tonalism and Impressionism in his landscapes, whether of Branchville or of New York City, was emphasized positively in writings about the artist over many years. In 1893 a critic writing for the *New York Times* praised Weir's portrayal of a sunlight that was "hazy and soft" rather than "strong."[33] His friend Childe Hassam commended his works for their "very delicate and rare quality of color on the subtle gray, or muted scale" and his arrangements that revealed a "dignity and a naïve tendency of line."[34] Edward King wrote in 1895: "Seen through the temperament of J. Alden Weir, a rather prosaic New England pasture suddenly takes an interesting—I had almost said a romantic—look." King lauded Weir for softening "the rugged outlines of the low hills," for calling "into service of poetry" "whimsically built fences," and showing "unpromising and hard features" in nature "mellowed in the rich warm light of the artist's fancy, until they seem enchanted."[35] In 1911 Catherine Beach Ely wrote that Weir was able to give "us something new and individual and delightful" that combined "vitality with exquisite sensitiveness."[36] In 1916 the artist Howard Russell Butler remarked that "the lighter key, closer range of values, the purer color, and the pervading tone of the impressionism [were] far more suited to [Weir's] temperament than were the former key, color, and contrasts of previous schools."[37]

Fig. 40. J. Alden Weir, *The Bridge: Nocturne (Nocturne: Queensboro Bridge)*, 1910, oil on canvas mounted on wood, 29 × 39½ inches. Hirshhorn Museum and Sculpture Garden, Smithsonian Institution, Washington, D.C., Gift of Joseph H. Hirshhorn Foundation, 1966

Others commended him for portraying places with an intimate understanding that came from close familiarity, while creating works imbued with a power of transcendence. As Frederic Newlin Price stated in 1922: "When he painted one of [his landscapes] he gave it the delicate visionary loveliness of a dream, yet he left the picture the unmistakable

Fig. 41. J. Alden Weir, *The Plaza: Nocturne*, 1911, oil on canvas mounted on wood, 29 × 39½ inches, Hirshhorn Museum and Sculpture Garden, Smithsonian Institution, Washington, D.C., Gift of Joseph H. Hirshhorn Foundation, 1966

portrait of a place."[38] Du Bois associated Weir's moderated use of color with his personality as well as with a classical ideal of harmony, stating that Weir's "color has not the luxuriance of Delacroix nor the vulgar abundance of Rubens, it has not the coldness of Copley nor yet the extreme warmth of Blakelock. . . . The atoms of the organization of his thought are peculiarly harmonious."[39]

Just before and just after Weir's death in 1919, several writers posited that his balanced art was representative of a "true" America, one that embodied an upper-class ideal of refinement and privilege and that turned a blind eye to the more crass, commercial, or "impure" elements of American life as well as to the decadence of modern art. Ely wrote in 1924 of Weir's preference for the "ordinary (though not repellant) aspects of his own country to the more convenient picturesqueness of foreign lands." She saw him as "a genuine American," because he "represented the fine old tradition electrified by a new civilization." For Ely he had an idealism that countered the materialism of which Americans were often accused. Weir reflected an "aristocracy of spirit," embodying a "fundamentally American viewpoint."[40] Writing in 1916, Butler saw Weir as an artist who, on emerging "into the light of outdoor impressionism," had experienced the "joy of finding the instrument best suited to his theme." Weir soon got "the new method under as great control as the old" because of the way he was "restrained by his fine sense of the artistic to which with him any method will always be subject." To Butler, Weir's art, in contrast to the "debauchery" of the "horde of modernists" working in the styles of "neo-impressionism, cubism, . . . futurism, and a host of other forms, all striving to outdo each other," was "no less up to date, but of an elevating and spiritual character." Butler concluded that the "nobility of [Weir's] inspiration has sobered his technique and kept him from drifting on the rocks against which so many lighter hulks have been shattered."[41]

Duncan Phillips echoed Ely and Butler in seeing Weir's art as exemplifying an American ideal. Euphemistically alluding to the different views that could exist of America, he described Weir's "Americanism" as one of "a special rather than a complete or composite character," and wrote that Weir's "task was to fix the survival of the older America, the Anglo-Saxon America of the founders of our old families, more particularly yet, the America developed in New England and New York."[42] Phillips accused the writers Walt Whitman, Bret Harte, and Mark Twain of being "subject to the lure of a foreign vogue" for a certain "homely Americanism," writing, "the European-minded critics are certain that Old Walt represents what American art is or should be. They insist

that America is not only frank and free and brave, but also vulgar and vain and fond of creating a sensation." Against this view, Phillips saw Weir's art as unconsciously expressing "the reticent, innate idealism which guides and guards the better known materialism of America." He took the view was that it was "an injustice to ascribe to the average American an indifference to that grace of spirit which we call refinement."[43] Using Weir's art as a vehicle for advocating a nationalistic agenda, Phillips suggested that there was a connection between the nature of the country itself and of its people, who exhibited a "chivalry of thought" and an "idealizing love of familiar things" that were "traits of the fundamental, the original American."[44]

Phillips's elitist viewpoint was undoubtedly not that of Weir. A generous, kind, and thoughtful person, whose friends were a "curious aggregation"[45] of individuals from many different backgrounds, Weir had a natural empathy that drew people to him and inspired their trust. As the modernist sculptor John Flanagan noted, "Weir is the kind of a man one would like to have for a father."[46] Weir's images of landscapes mellowed by human use that evoke feelings of freedom within limits were rightly viewed as reflective of this temperament.

Twachtman's "Suggestion of Suspended Animation"

Twachtman and Weir were deriving influences from the same sources in the mid-1880s, and together they turned toward Impressionism at the end of the decade as they explored the medium of pastels side by side in the Branchville hills. However, Twachtman formulated a different path than did Weir, because Twachtman incorporated into his Impressionism elements of the dynamic realist art of his Munich period of the late 1870s. Whereas Weir had to overcome his attachment to academic modes as he moved toward Impressionism, Twachtman was able simply to reinvoke the direct, painterly handling and cursory, sketchy treatment of forms that he had used in the 1870s.

That Twachtman's Impressionist style was consistent with his previous work was acknowledged by critics in the 1890s. As one put it in 1891, the "advent of Monet and his followers" had "emboldened [Twachtman] to use color freely," but he had "not really changed, for these were his methods years ago."[47] Perhaps because of his Munich background, Twachtman felt free to develop a unique Impressionist approach, which involved changing the rhythm and force of his brushwork and the relative density of his pigments throughout an image to express by tactile means the nature of his different motifs. Yet, like Weir, Twachtman mostly veered

away from the bright hues and strong coloristic contrasts of Impressionism, preferring subdued, pastel colors and gradual, tonal transitions. Thus, through his dynamic and expressive application of paint, he imbued his works with Impressionist immediacy, while through his muted palette and his sensitivity to an artful coordination of tones and forms, he evoked the poeticism of Tonalism.

Twachtman's merging of Impressionism and Tonalism was not a simple joining of the aesthetic components of the two styles. Paradoxically, it was through his use of Impressionist means that Twachtman was seen to evoke the metaphysical realm that was usually the domain of Tonalist art. He best achieved this synthesis in his snow scenes. Indeed, Twachtman had a great fondness for snow. He wrote to Weir in 1891: "We must have snow and lots of it. Never is nature more lovely than when it is snowing. Everything is so quiet and the whole earth seems wrapped in a mantle. That feeling of quiet and all nature is hushed to silence."[48] Twachtman was not alone in being drawn to the painting of snow. The subject was extremely popular at the end of the nineteenth century among American artists who worked in both Impressionist and Tonalist styles. For the former, the painting of snow provided an opportunity to explore the coloristic properties on a surface responsive to nuances of fleeting effects of reflected light and shadow. For the latter, it afforded a vehicle for capturing the evocative qualities that could be found in the stillness and serenity of snow-covered landscapes.

However, Twachtman's snow scenes stand out from those of other artists of his time, because instead of painting fresh snowfalls he concentrated on old snow that had been on the ground for some time, that had partially melted, or that had built up in crusted layers (Figs. 42–43). With this approach, he came closer to evoking the physicality of snow than any other American artist of his time. His subjects included depictions of thawing brooks, some stilled under thin layers of translucent ice; moist snow, presumably soft underfoot; encrusted surfaces, hardened and giving way only with effort; landscapes where patches of bare ground and protruding rocks had surfaced; icy hillsides blown clear of new snow; and fields in which melting snow created sinuous looping patterns over muddy ground. Although he mostly refrained from painting newly fallen snow, in his images of falling snow, such as *Round Hill Road* (ca. 1890s; Smithsonian American Art Museum, Washington, D.C.), he showed that he was attentive to such times, capturing a snow so fine that it is indistinguishable from the atmosphere. In *The Last Touch of Sun* (ca. 1893; Manoogian Collection), he portrayed dappled sunshine on

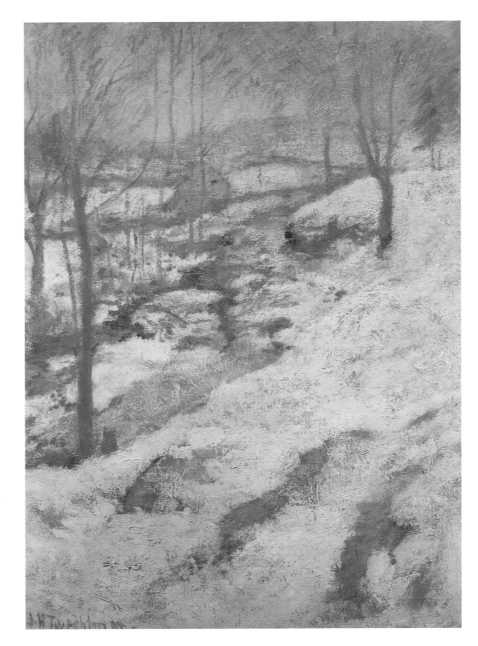

Fig. 42.
John Henry Twachtman
Frozen Brook
ca. early 1890s
Oil on canvas
30 × 22 inches
Private Collection

hard-packed recent snow, but the crisp, form-defining light cast over the scene adds to the feeling of day's chill rather than producing warmth.

The impact of such images was often explored by critics of the day, who suggested that the ability of these pictures to emulate the look and feel of nature provided a means for us to become so engaged in a work that we could detach ourselves from our immediate surroundings and enter a realm of pure feeling and introspection. In 1891 a writer for the *Studio*, describing a painting that may have been similar to Twachtman's *Frozen Brook* (Fig. 42), explained how this process worked:

Here the painter leads you to some quiet spot— you see the damp melting snow,—the bare wet trees, and the swiftly flowing brook, you feel that the air is laden with moisture—it is one of those gray, damp days. You are not restricted to the narrow limits of the canvas; you feel as

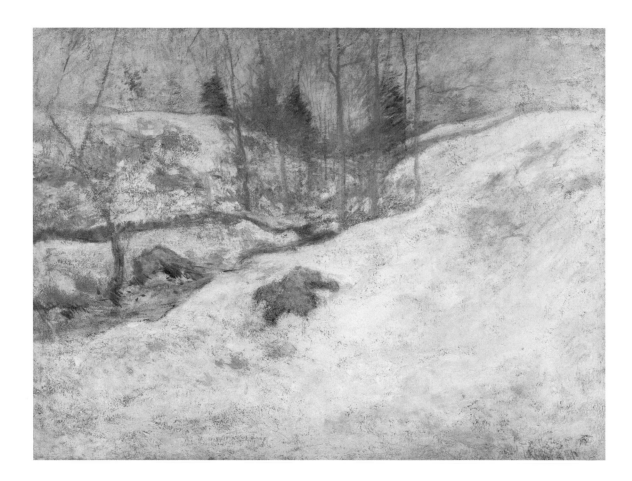

Fig. 43.
John Henry Twachtman
Brook in Winter, ca. 1892
Oil on canvas
36⅛ × 48⅛ inches
Museum of Fine Arts,
Boston, The Hayden
Collection—Charles
Henry Hayden Fund

though you could follow the brook's course far-
ther down, and see way into the distance. This
is the charm about these pictures—they are not
placed before you as facts; they are awakeners of
certain trains of thought; you feel even more
than you see.[49]

Another critic alluded to the same effect, stat-
ing in 1891 that "the exquisiteness with which the
values [of one of Twachtman's wintry views of the
small pool on his property surrounded by hemlock
trees] were rendered would alone make it a great
landscape painting, but there is added to it that
indescribable something which is the spirit of
woodland winter."[50] In 1900 another writer per-
ceived a painting by Twachtman of this subject as
similarly representing winter itself along with the
season's spirit: "In both the broad and rugged
aspects of the scene are faithfully reproduced, and
then stealing over all is the suggestion of suspended
animation, the still torpor of winter."[51]
Twachtman's ability to link the sensuous imme-
diacy of winter with a force greater than its mate-
rial existence frequently led people to compare his
approach with that of the Transcendentalists Ralph
Waldo Emerson and Henry David Thoreau. For
example, Thomas Wilmer Dewing wrote that one
of Twachtman's winter scenes, in which "one feels
the temperature and recalls the scream of the blue
jay, the black-green leaves of the sapling pines

turning gray in the wind," was "like a page from
Thoreau's note books," and commented: "This like-
ness to Thoreau is, of course, due to the fact that
they were both original observers at first hand."[52]
In 1918 the critic Charles de Kay also associated
Twachtman with the Transcendentalists. Noting
Twachtman's close and subtle observations of win-
ter, de Kay proposed that the process of entering
these works was interactive rather than passive,
demanding effort and attentiveness on the part of
the viewer; the very process of looking thus became
one with the elevating experience. Singling out a
work entitled *Frozen Brook* (possibly the painting
known today as *Hemlocks* [Museum of the City
of New York]), de Kay wrote that it "takes one
straight to nature on some quiet windless day." Of
such works in general, de Kay observed:

> Each is a musical strain, a poem. They demand
> your attention, too, a prolonged, close atten-
> tion, for they do not give themselves to the first
> comer; they do not call you with a gay smile;
> they do not flaunt themselves. Not at all. They
> are shy; they are reserved; they are Thoreauish,
> Emersonian. You must wait and let them come
> out of their coverts like the immobile, hushed,
> expectant creatures.[53]

Twachtman also conjoined elements associ-
ated with Impressionism and Tonalism in many
of his other works and especially in images of

landscapes on misty, overcast days. He expressed his fondness these for times an 1892 letter to Weir, writing:

> The weather continues very fine. There has been so much sunshine for months that a grey day is a fine and rare thing. The foliage is changing and the wild-flowers are finer than ever. There is greater delicacy in the atmosphere and the foliage is less dense and prettier. The days are shorter which gives us a chance to see more of early morning effects.[54]

In views of hazy, gray days such as *Autumn Mists* (Spanierman Gallery, LLC, New York), *November Haze* (Cat. 40), and *Misty May Morn* (Fig. 44), Twachtman used the same skills of close observation that are apparent in his snow scenes. Instead of depicting fog or mist by overlays of gray, he captured the specific interaction of air and light on a given day with blended tones and by orienting his forms and compositions so that they echo the feeling evoked by the atmospheres in his scenes. In this way, the artistry in his works seems to exude spontaneously from his subjects. In *Autumn Mists*, the air is heavy, almost stagnant, but it does not obscure landscape forms, and the echoing curved horizontals of the water and land

forms suggest the quiet stillness of such a day. In *November Haze*, diffused sunlight and moist air have fused into a vaporous, luminous atmosphere. Correspondingly, the landscape forms are less defined and seem to flow together, and Twachtman's brushwork has a thick, shiny quality suggestive of the day's humidity. In *Misty May Morn*, a glowing light bathes the landscape. Out of the resulting pale luminosity, the diagonal of the brook and the warm turquoise and green tones in the landscape lend a feeling of animation that also resonates in the spring foliage that emerges jewel-like from the subdued sparkle of the atmosphere.

Misty May Morn was possibly the painting entitled *Misty Morning* that Twachtman exhibited at the 1901 exhibition of the Ten American Painters at New York's Durand-Ruel Galleries. The comments by a critic for the *New York Tribune* suggest how audiences of the time saw Twachtman's art as resolving the dichotomy between the transcriptive approach of Impressionism and the poetic, elevating qualities associated with Tonalism. Twachtman's *Misty Morning*, the critic wrote, with "the trees in the foreground, the rising land in the distance and the stream between," gave "the spectator a refreshing and delightful sense as of being in the presence of the scene itself." "It seems as if the most imagi-

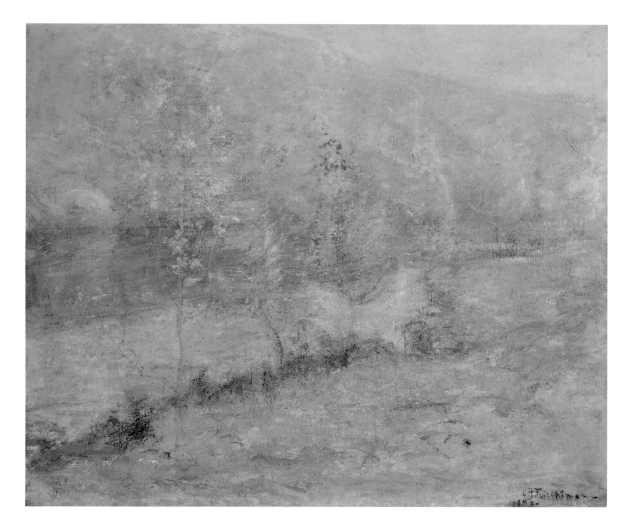

Fig. 44.
John Henry Twachtman
Misty May Morn, ca. 1899
Oil on canvas
25⅛ × 30 inches
Smithsonian American Art
Museum, Washington, D.C.,
Gift of John Gellatly

native of painters could not have achieved a more convincing report of the matter," the critic stated, "but there are strange limitations to the art evidently of great service to the gatherer of material [which] by its very nature . . . is opposed to the selective and constructive ideals which preside over the transformation of raw material into something more beautiful, more artistic." For this critic, Twachtman had overcome such limitations: "the 'Misty Morning' is not only a portrait of a place. It is a picture."

The critic went on to query whether "Mr. Twachtman meant it to be one." His or her answer was that Twachtman did not feel that "a felicitous arrangement of forms and colors" was "incompatible with the notation of an atmospheric effect of a special gleam of light." The critic explained that Twachtman's process was to accept "the compositions nature offers," and, "whether they are good or poor," he used the "pictorial motive" only as subsidiary to the "notation."[55] The critic thereby suggested that Twachtman accepted nature as he found it, and secondarily enhanced what he saw through aesthetic means.

The reviewer of the show for the *Artist* was also drawn to *Misty Morning*. Commenting that it had been hung in the place of honor, where "it attracted the most approval from visitors, and not surprisingly for it was very beautiful," the critic found the painting to provide the same quiet power as Twachtman's winter scenes. It is "just a placid stream, with one bank, covered with a wood, the other dotted with trees and bushes; but the whole was wrapt in early morning mist, giving a dainty radiance and spirituality."[56]

Of all Twachtman's works, *Sailing in the Mist* (ca. 1895; Pennsylvania Academy of the Fine Arts, Philadelphia) is the one that most obviously links the natural and the spiritual. Painted by the artist at the time of the death of his nine-year-old daughter Elsie, this image of a child in a small dory enveloped in a gentle mist as she sails into the unknown suggests Twachtman's sense that art grounded in real experience could express a realm usually represented in art through symbolic means.

As in the case of Weir, in the early twentieth century, many writers claimed that Twachtman's gentle, poetic images were refined, "aristocratic,"[57] and revealing of a "typical New England reserve"[58] that represented an American ideal. Duncan Phillips, who supported Twachtman's art along with Weir's, noted that Twachtman's brush was also "imbued with the candour and elemental directness of our Far West."[59]

However, by the early 1910s Twachtman's art also was seen as related to modernism. At a time when the works of American Impressionists often seemed overly bright and cheerful in the face of the complexities of the modern world, and Tonalist images frequently were viewed as dim, faded, and all too similar, the unique blend that Twachtman achieved was admired for the way it mediated between the natural world and the artist's personal experience of it. The introduction to an exhibition of Twachtman's work at the Albright Academy in Buffalo, New York, in 1913 stated: "His best work . . . has in it the latest modern note of idealism. It represents the effort of the artist to free himself from the encumbrance of the material, by giving expression to the spirit that abides in matter."[60] J. Nilsen Laurvik wrote in 1915 that Twachtman's art was

> profoundly related to that current of poetic mysticism that flows serenely through our hurly-burly life, and in this sense only can it be called modern. . . . He is the one painter who has made the principles of Impressionism wholly subservient to the end in view, hence one is seldom conscious of the means employed. His canvases are never scientific demonstrates of any theory whatsoever.[61]

Twachtman's approach, along with his integrity and commitment to a personal vision, were valued by early-twentieth-century American modernists including Marsden Hartley, Arthur Dove, and Milton Avery. Hartley, who once caught a glimpse of Twachtman, wrote that "he cared too much for the essential beauties to involve them with analyses extraneous to the meaning of beauty," and commented that "his own personal lyricism" surmounted "his interest in outer interpretations of light and movement" so that he "leaves you with his own notion of a private and distinguished appreciation of nature."[62]

In a 1958 retrospective account of Twachtman, Sheldon Cheney stated that whereas Twachtman had once been classified as a "mere impressionist," time had "worked in Twachtman's favour": "Many museums are discovering that in his canvases they have examples of post-impressionist form manipulation, and examples that are deeply moving even while fragile and lovely on the sensuous side."[63]

Indeed, while the merging of Impressionism and Tonalism as demonstrated in the works of Weir and Twachtman was viewed as representing a genteel, more beautiful, American form of Impressionism, the coming together of the two styles also reflected a modernist understanding that a fidelity to nature was not a simple transcribing of details and facts but a capturing of nature as subjectively experienced, whether an artist focused on recording the visual or emotional impact of a scene.

NOTES

1. Both Weir and Twachtman are included in the major sources on American Impressionism and on American Tonalism. Surveys of American Impressionism include Donelson F. Hoopes, *The American Impressionists* (New York: Watson-Guptill, 1972); Richard J. Boyle, *American Impressionism* (Boston: New York Graphic Society, 1974); William H. Gerdts, *American Impressionism* (Seattle: Henry Art Gallery, 1980); William H. Gerdts, *American Impressionism* (New York: Abbeville, 1984); Ulrich W. Hiesinger, *Impressionism in America: The Ten American Painters* (Munich: Prestel-Verlag, 1991); and William H. Gerdts and Carol Lowrey, *The Golden Age of American Impressionism* (New York: Watson-Guptill, 2003). Publications on American Tonalism include Wanda M. Corn, *The Color of Mood: American Tonalism, 1880–1910* (San Francisco: M. H. de Young Memorial Museum and the California Palace of the Legion of Honor, 1972); Joan Siegfried, *Some Quietist Painters: A Trend Toward Minimalism in Late Nineteenth-Century American Painting* (Saratoga Springs, N.Y.: Hathorn Gallery, Skidmore College, 1970); William H. Gerdts, Diana Dimodica Sweet, and Robert Preato, *Tonalism: An American Experience* (New York: Grand Central Art Galleries, 1982); Kevin Avery and Diane Fischer, *American Tonalism: Selections from the Metropolitan Museum of Art and the Montclair Art Museum* (Montclair, N.J.: Montclair Art Museum 1999); and Jack Becker, "Studies in American Tonalism," Ph.D. diss., University of Delaware, 2002. The main monographic sources on Weir are Dorothy Weir Young, *The Life and Letters of J. Alden Weir* (New Haven, Conn.: Yale University Press, 1960); Doreen Bolger Burke, *J. Alden Weir: An American Impressionist* (Newark, Del.: University of Delaware Press, 1983); Hildegard Cummings, Helen K. Fusscas, and Susan G. Larkin, *J. Alden Weir: A Place of His Own* (Storrs, Conn.: William Benton Museum of Art, University of Connecticut; Greenwich, Conn.: Bruce Museum, 1991); and Nicolai Cikovsky Jr. et al., *A Connecticut Place: Weir Farm—An American Painter's Rural Retreat* (Wilton, Conn.: Weir Farm Trust in collaboration with the National Park Service, 2000). The main monographic sources on Twachtman are Lisa N. Peters, *John Henry Twachtman: An American Impressionist* (Atlanta, Ga.: High Museum of Art, 1999); Lisa N. Peters, *John Twachtman (1853–1902) and the American Scene in the Late Nineteenth Century: The Frontier within the Terrain of the Familiar*, Ph.D. diss., City University of New York, 1995 (Ann Arbor, Mich.: University Microfilms International, 1996); Deborah Chotner, Lisa N. Peters, and Kathleen A. Pyne, *John Twachtman: Connecticut Landscapes* (Washington, D.C.: National Gallery of Art, 1989); Richard J. Boyle, *John Twachtman* (New York: Watson-Guptill, 1979); and John Douglass Hale, *The Life and Creative Development of John H. Twachtman*, 2 vols., Ph.D. diss., Ohio State University, 1957 (Ann Arbor, Mich.: University Microfilms International, 1958). See also Susan G. Larkin, *The Cos Cob Art Colony: Impressionists on the Connecticut Shore* (New York: National Academy of Design in association with Yale University Press, 2001).

2. In her 1978 master's thesis, Mary Muir studied the historical evolution of the terms "tone" and "tonal color" as related to the American Tonalist movement, by considering "tonal" works created beginning in the Renaissance. She categorized Twachtman, along with J. Francis Murphy and Bruce Crane, as a "Tonal-Impressionist." She distinguished these three artists from mainsteam Tonalists who clung to Barbizon influences. Mary Margaret Morgan Muir, "'Tonal Painting,' 'Tonalism', and 'Tonal Impressionism,' in the History of Western Art: A Study with Reference to Native American Impressionism," master's thesis, University of Utah, 1978, pp. 180–89. In 1970 Wanda Corn wrote that Tonalist characteristics could be seen in the art of "painters generally identified as American Impressionists." She stated: "In the work of Childe Hassam, Willard Metcalf, or John Twachtman, one finds that Impressionist ideas were decidedly modified by a tonalist approach to nature. Along with the adoption of the high-keyed Impressionist palette and the occasional use of the short, quick stroke, there exist certain misty atmospheric qualities, monochromatic color usages and a fondness for twilight, winter scenes and gray days which clearly fall within the tonalist vocabulary." Corn, *The Color of Mood*, p. 4. William H. Gerdts wrote similarly in 1982 that after Impressionism spread in this country, a trend within it arose in which the style was transformed "into a native expression," which often "involved a more poetic approach to landscape, using Tonalist format or interpretive means, such as J. Alden Weir's more single-toned palette or John Twachtman's more intimate focus upon the landscape, in contrast to the orthodox Impressionism of Monet, or of Childe Hassam." Gerdts, "American Tonalism: An Artistic Overview," in Gerdts, Sweet, and Preato, *Tonalism: An American Experience*, p. 17.

3. The two artists probably met in New York City in late 1878 or early 1879, when both began to show at the Society of American Artists and became members of the Tile Club.

4. Young, *Life and Letters of J. Alden Weir*, p. 143.

5. Twachtman, Paris, to Weir, [New York], January 2, 1885, Weir Family Papers, MSS 41, Harold B. Lee Library, Archives and Manuscripts, Brigham Young University, Provo, Utah.

6. J. Alden Weir to Mr. and Mrs. Robert W. Weir, April 15, 1877, quoted in Young, *Life and Letters of J. Alden Weir*, p. 123.

7. "Mr. Inness on Art-Matters," *Art Journal* (New York), 5 (1879), pp. 374–77.

8. See Gerdts, "American Tonalism: An Artistic Overview," pp. 17–29 (also reprinted in this catalogue, pp. 15–29); and Becker, "Studies in American Tonalism."

9. *Collector* 7 (April 1, 1896), p. 162, cited in Becker, "Studies in American Tonalism," chap. 1, p. 38.

10. "Minor New York Exhibitions," *Magazine of Art* 14 (1890–91), p. xiv.

11. "The World of Art: An Impressionist's Work in Oil and Pastel—Mr. J. H. Twachtmann's Pictures," *New York Mail and Express*, March 26, 1891, p. 3.

12. "A Group of Impressionists," *New York Sun*, May 5, 1893, p. 6.

13. "World of Art," *New York Mail and Express*, May 8, 1893, p. 7.

14. "Some Dazzling Pictures," *New York Times*, May 4, 1893, p. 9.

15. "St. Botolph's Exhibition: Paintings by Messrs. Weir and Twachtman on View in Their Gallery," *Boston Evening Transcript*, November 28, 1893, p. 2.

16. "A Group of Impressionists," *New York Sun*, May 5, 1893, p. 6.

17. "Some French and American Pictures," *New York Evening Post*, May 8, 1893, p. 7.

18. "Colorful Art Show at the Lotos Club," *New York Herald*, December 16, 1910, sec. 2, p. 11.

19. Duncan Phillips, "Julian Alden Weir," in *Julian Alden Weir: An Appreciation of His Life and Works*, ed. J. B. Millet (New York: E. P. Dutton & Company, 1922), p. 27.

20. "Some Questions of Art," *New York Sun*, January 2, 1891, p. 4.

21. "Recent Pictures by J. Alden Weir," *Studio* 6 (January 31, 1891), p. 81.

22. "Minor New York Exhibitions, p. xiv.

23. "Three Special Exhibitions. II. J. Alden Weir," *Collector* 78 (February 1891), p. 78.

24. Guy Pène du Bois, "The Idyllic Optimism of J. Alden Weir," *Arts and Decoration* 2 (December 1911), p. 78.

25. Ibid.

26. Many Tonal-Impressionist scenes of New York by these artists are illustrated and discussed in William H. Gerdts, *Impressionist New York* (New York: Abbeville, 1994).

27. M[ariana] G. Van Rensselaer, "Picturesque New York," *Century Magazine* 23 (December 1892), p. 168.

28. Jesse Lynch Williams, "The Water-Front of New York," *Scribner's Magazine* 26 (October 1899), pp. 391–92.

29. John Corbin, "The Twentieth Century City," *Scribner's Magazine* 33 (March 1903), p. 259, quoted in Gerdts, *Impressionist New York*, p. 155.

30. "A Painter of the City Tranquil," *Current Literature* 47 (July 1909), pp. 54–55.

31. J. Alden Weir to Charles Erskine Scott Wood, January 13, 1911, quoted in Dorothy Weir Young, "Records of the Paintings of J. Alden Weir," 6 vols. [1920s–40s], vol. 4A, p. 409, quoted in in Burke, *J. Alden Weir*, p. 233.

32. Eliot Clark, "J. Alden Weir," *Art in America* 8 (August 1920), p. 242.

33. "Some Dazzling Pictures," *New York Times*, May 4, 1893, p. 9.

34. Childe Hassam, "Reminiscences of Weir," in Millet, *Julian Alden Weir: An Appreciation*, p. 73.

35. Edward King, "Straightforwardness Versus Mysticism," *Monthly Illustrator* 5 (July 1895), p. 31.

36. Catherine Beach Ely, "J. Alden Weir," *Art in America* 12 (April 1924), p. 116.

37. Howard Russell Butler, "J. Alden Weir," *Scribner's Magazine* 59 (January 1916), pp. 129–32.

38. F. Newlin Price, "Weir—The Great Observer," *International Studio* 75 (April 1922), p. 130.

39. du Bois, "The Idyllic Optimism of J. Alden Weir," p. 50.

40. Ely, "J. Alden Weir," p. 118.

41. Butler, "J. Alden Weir," pp. 129–32.

42. Phillips, "Julian Alden Weir," p. 8.

43. Ibid., p. 10.

44. Ibid., p. 12.

45. Joseph Pearson to Dorothy Weir Young, quoted in Young, *Life and Letters of J. Alden Weir*, p. 193.

46. Quoted by Manhonri Young, "J. Alden Weir: An Appreciation," in *J. Alden Weir 1852–1919* (New York: American Academy of Arts and Letters, 1952).

47. "Art Notes," *New York Times*, March 9, 1891, p. 4.

48. Twachtman to Weir, Greenwich, December 16, 1891, Weir Family Papers.

49. "A Criticism," *Studio*, April 25, 1891, 203.

50. "The World of Art: An Impressionist's Work in Oil and Pastel—Mr. J. H. Twachtmann's Pictures." *New York Mail and Express*, March 26, 1891, p. 3.

51. "Third Exhibition of Ten American Painters," *Artist* (May 1900), p. xxviii.

52. Thomas Dewing, "John Twachtman: An Estimation," *North American Review* 176 (April 1903), p. 554.

53. Charles de Kay, "John H. Twachtman," *The Art World and Arts and Decoration* 9 (June 1918), p. 73.

54. Twachtman to Weir, Greenwich, September 26, 1892, Weir Family Papers.

55. "Art Exhibitions," *New York Tribune*, March 6, 1901, p. 6.

56. "Ten American Painters," *Artist* 28 (June 1899), p. xii.

57. J. Nilsen Laurvik, *Catalogue Deluxe of the Department of Fine Arts, Panama-Pacific International Exposition*, 2 vols. (San Francisco: Paul Elder and Company Publishers, 1915), "American Landscape Painters," vol. 1, p. 24.

58. Duncan Phillips, "Twachtman—An Appreciation," *International Studio* 46 (February 1919), p. cvi.

59. Ibid., p. cvi.

60. *Memorial Exhibition of the Works of John H. Twachtman*

61. Laurvik, Catalogue Deluxe, vol. 1, "Chapter X: John H. Twachtman," p. 44.

62. Marsden Hartley, *Adventures in the Arts* (New York: Boni and Liveright, 1921), p. 77.

63. Sheldon Cheney, *The Story of Modern Art* (New York: Viking Press, 1958), p. 431.

Alfred Stieglitz and Tonalism: The Americanization of Pictorial Photography

DIANE P. FISCHER

ALFRED STIEGLITZ (1864–1946) has recently been called "perhaps the most important figure in the history of visual arts in America."[1] This tremendous legacy is primarily due to his contributions to modernism as a gallery impresario, "straight" photographer, publisher, patron, and collector. Scholars have already demonstrated the influence of many nineteenth-century European styles on his work. However, despite the numerous monographs devoted to him, the influence of Tonalism from 1890 to 1907— which we will see is crucial to the development of Stieglitz's aesthetic—has been largely overlooked.[2] During these years Stieglitz adopted the Tonalists'

harmonious monochromatic arrangements, soft focus, simple compositions, spirituality, elitism, craftsmanship, and patriotism, as aspects of his early photography and behavior.

This forgotten connection, however, was originally recognized by contemporary critics, among them Charles H. Caffin and Sadakichi Hartmann; the latter deemed Stieglitz, whom he would credit with changing the course of American photography, "the fanatic champion of the tonal school."[3] Although Hartmann's assertion has an accusatory edge, examining Stieglitz's relationship with Tonalism not only helps us to see the important pervasiveness of the movement across media in the

Fig. 45.
Alfred Stieglitz
Weary, 1890
Platinum print, 1895–96
The J. Paul Getty Museum,
Los Angeles, California,
Estate of Georgia O'Keeffe

last decade of the nineteenth century, but it also reveals much about Stieglitz's early formation as an impresario and modernist artist.

Little has been written about the impact late-nineteenth-century American painting has had on Stieglitz's photography because scholars have only seriously begun to examine such art during the last thirty years, when Stieglitz's reputation was already established. American art was simply neither as well studied nor as fashionable as European art, so it was easy for photographic historians to ignore it.[4] Moreover, in his later years Stieglitz denounced all influences from painting, and this claim has tended to resound in assessments of his work. Yet a closer look clearly shows this to be far from true. For all his innovation, Stieglitz was not as much of a lone maverick as he would have liked us to believe. Rather, during his early career Stieglitz, young and ambitious, took his primary cues from the New York art world, the very milieu he was anxious to join.

Tonalism had itself already absorbed elements from the legacy of nineteenth-century movements. It was also a style whose characteristics could readily be expressed in the photographic image, especially with the subtle artistic, technical interventions explored by Stieglitz—who later abandoned Tonalist strategies in his better-known modernist photographs. Indeed, American Tonalism was quite compatible with Stieglitz's self-proclaimed quest to create and promote a distinctly American form of photography. During this period, his Tonalist ideas are reflected in the articles written or commissioned for Stieglitz's two influential journals, *Camera Notes* (1897–1903) and *Camera Work* (1903–17), and they became linked critically with works of members of the Photo-Secession, a group he formed in 1902.[5] An examination of his work and ideas from this period shows that Stieglitz

assimilated and at times even anticipated the principles of Tonalism in his interpretations of urban landscapes and unconventional viewpoints, often before the movement's own painters had turned to such subject matter.

Stieglitz was born in Hoboken, New Jersey, and as a boy moved with his family to Manhattan in 1871. The son of Jewish German immigrants, he was exposed to art at an early age. Because his father collected art, the young Alfred met artists such as the portrait and genre painter Fedor Encke (1851–1936), who lived with his family for almost a year in 1877.[6] In June 1881 the Stieglitz family sailed to Germany, where they were greeted by Encke, who in turn introduced Stieglitz to the painter Wilhelm Gustav Friedrich Hasemann (1850–1913), a specialist in peasant scenes and landscapes set in the Black Forest. Like many cultured Americans of his time, Stieglitz studied abroad. From 1882 to 1886 he attended the Königliche Technische Hochschule in Berlin, where in 1883 he was introduced to photography. His professor Hermann Wilhelm Vogel (1834–1898) was a well-known scientist who emphasized the importance of aesthetics, chemistry, and optics in photography, ideas that influenced Stieglitz greatly.

About 1887 Stieglitz became interested in Pictorialism, the approach to photography that emphasized softer focus and subjects and compositions borrowed from painting with the aim of creating a more elevated and artistic photograph.[7] Pictorialism was championed by the American expatriate photographer Peter Henry Emerson (1856–1936). His seminal book *Naturalistic Photography for Students of the Art* (1889) was a bible for the movement, whose roots were in British Aestheticism and the early-nineteenth-

century naturalistic landscapes of the French Barbizon painters. In 1887 Stieglitz was awarded first prize for a competition judged by Emerson and sponsored by the English periodical *Amateur Photographer*. The style and subject of his entry, *The Last Joke—Bellagio, a Good Joke* (1887; National Gallery of Art, Washington, D.C.), was reminiscent of Italian genre painting, carrying out Emerson's directive for photographers to appropriate established traditions of painting. It was believed that such an emulation of the styles, subjects, and compositions of traditional painting—but not outright plagiarism— would raise photography to a new artistic level.[8]

Genre painting was also the model for Stieglitz's photograph *Weary* of 1890 (Fig. 45), in which a peasant girl rests on a makeshift pillow of kindling wood after the day's work. The romanticized peasant became a popular subject during the nineteenth century among Barbizon painters and was a prominent Salon subject as well. European peasants were painted by American artists as well, for during the last quarter of the nineteenth century, American artists flocked to Europe, especially France, to gain the technical expertise and exposure necessary to establish their international reputations; in themes and technique their work became virtually indistinguishable from that of their French colleagues.[9] Stieglitz's *Weary* might also be compared to numerous paintings by his compatriots, such as Alexander Harrison's *Castles in Spain* (Metropolitan Museum of Art) exhibited at the Paris Salon of 1882, in which a sleepy urchin dreams of a world inspired by his sand castle. Stieglitz followed these artistic traditions as closely as he could to compensate for his roster of artistic disadvantages: being an American, self-taught in picture making, striving to gain respect as an artist, and lacking the benefit of a large institutional framework for his medium.

Stieglitz was not the only one who was deprived. Photographers in general faced an enormous impediment, not the least of which was the fact that the French academic standard—which had ruled the art world and manifested itself in the École des Beaux-Arts and the Parisian Salons— did not recognize photography as a fine art. Photography, only introduced to the public in 1839, faced stringent artistic prejudices; not only were its images generated by machine rather than by the hand of the artist, but it did not require long years of academic training. Faced with this discrimination, at the end of the century Pictorial photographers aspired to produce work that looked as much like "art" and as little like commercial photography as possible. Accordingly, they emphasized excellence in composition and image quality, and they chose conservative artistic models, since with such a radical medium they could not also afford to

be avant-garde stylistically. In carefully choosing acceptable subject matter, Stieglitz was pursuing his ultimate mission: to establish photography as a fine art by exhibiting his work and that of his circle in "real" art museums.[10]

Although Stieglitz photographed modern aspects of New York after he returned there in 1890, he revisited peasant subjects during a later trip to Europe in the summer of 1894. With his new wife, Emmeline Obermeyer, Stieglitz visited Italy, Austria, Germany, Holland, France, and England. During this trip he pursued traditional subjects even more deliberately, seeking out locations already favored by European and American painters and printmakers—such as Venice, a favorite of the famous American expatriates James McNeill Whistler and John Singer Sargent.

Stieglitz also sought out the art colonies of Gutach, Germany, and Katwijk, Holland, which he wrote about for the *Photographic Times*.[11] In Gutach Stieglitz visited Hasemann and produced bucolic photographs similar to his friend's paintings. Likewise, Stieglitz's photographs of Katwijk are consistent with Dutch paintings of that period. His attraction to Dutch art also had its counterpart in American taste, especially amid the "Holland mania" of the final two decades of the nineteenth century. According to Annette Stott, by the 1890s "the market in the United States for contemporary pictorial interpretations of Holland had grown so strong that it supported six colonies of American artists in the Netherlands," including Katwijk.[12]

Stieglitz's *Coming Boats* of 1894 (Fig. 46), inspired by his Dutch travels that year and reproduced in his article "Two Artists' Haunts,"[13] relates to the painting *Dutch Harbor* of about 1890 (Fig. 47) by Henry Ward Ranger, who would become the leader of the

Fig. 47.
Henry Ward Ranger
Dutch Harbor, ca. 1890
Oil on canvas
24 × 31 inches
Florence Griswold Museum, Old Lyme, Connecticut, Purchase

Tonalist painters. In its extreme horizontal format and overcast dark skies, it refers even more directly to the seventeenth-century Dutch seascape tradition—and American Tonalist paintings—than does Ranger's earlier canvas, which is still Impressionist in its squarish format, asymmetrical composition, full tonal range, and execution with broad, flat brushstrokes. Subjects from Dutch traditions, Barbizon, and the British Aesthetic Movement had been the mainstay of Pictorialist photography at the time, favored by England's prestigious Brotherhood of the Linked Ring, to which Stieglitz was elected in 1894. After he returned to New York, first in 1890 and again in 1894, European subjects were no longer available to him to photograph, so he translated Old World Pictorialism into American terms. Misty landscapes, harbor scenes, and genre themes were the major subjects to be transformed, but there were formal and conceptual issues as well. Furthermore, the desire to reconcile an artistic shift from Europe to the United States was hardly unique to photography.

Painters returning from Europe in the 1890s who were essentially realists also had to adjust their subject matter. Eventually they created a new category of distinctly American themes that featured mostly landscape, urban scenes, and some portraits. Some of these artists, including Ranger, blended aspects of the shadowy woodlands of the Barbizon painters (via George Inness), the refined, simplified compositions of Aestheticism (via Whistler), and the realist subjects of the Dutch tradition to create American Tonalism. Tonalism was characterized by simple compositions, a restricted palette and tonal range, and an aestheticized concept of the image that could evoke an imaginary place or require the imagination to fill out the suppressed details. With these devices Tonalists manipulated and often obliterated any sense of realism from their scenes.[14]

In the early 1890s earlier Pictorialist and newer Tonalist tendencies intermingled in Stieglitz's work. As Geraldine Kiefer has observed, the all-encompassing term for Stieglitz in the 1890s was "tone-rich" or "tonal."[15] In 1892 he asserted that sensitivity to tone was essential for a photograph to become a picture.[16] His early clique included Edward Steichen—Stieglitz's close confidant who had begun his own career as a Tonalist painter—and Gertrude Käsebier, who also had a background in painting. While Tonalism's heritage in earlier art made it seem conservative, its emphasis on mood over precision was quite modern. Because of these factors, Tonalism offered Stieglitz the ideal mixture of tradition and experimentation he needed to pursue his objective, which he later summarized, was to promote "a picture rather than a photograph."[17]

Tonalism, which was firmly rooted in the nineteenth century, generally had familiar rather than exotic subject matter, consisting largely of urban and rural landscapes as well as figural studies. Stieglitz experimented with all of these. His pure landscapes such as *An Impression* of 1894 (Fig. 48) are reminiscent of oil paintings by the Tonalists John Francis Murphy and Bruce Crane. However, more parallels exist between Stieglitz's photographs and watercolors and gouaches, such as Crane's *Snow Scene* (Fig. 49) because of their shared delicacy as works on paper. The generality of *An Impression* makes it seem familiar and intimate, allowing viewers to fill in details based on their own perceptions and memories. This was a central quality of Tonalist paintings, drawings, and prints: the viewer could escape the reality of modern life and enter the more agreeable world of the imagination. While genre scenes and landscapes such as these constituted a large part of Stieglitz's earliest work, since the 1890s Stieglitz's primary subjects were street scenes of New York—a

Fig. 48.
Alfred Stieglitz
An Impression, ca. 1894
From George Davidson, "American Amateur Photographer Special Prize Competition, 1894," *American Amateur Photographer* 7 (Febrary 1895), p. 55. General Research Division, The New York Public Library, Astor, Lenox and Tilden Foundations

Fig. 49.
Bruce Crane
Snow Scene, ca. 1889–94
Watercolor and gouache on
blue-gray wove paper
10⅞ × 18¹¹⁄₁₆ inches, The
Metropolitan Museum of
Art, New York, George A.
Hearn Fund, 1968

theme he would return to throughout his career. In
those urban scenes we see some of Stieglitz's most
remarkable contributions as a Tonalist photographer.

For example, a Tonalist aesthetic is quite appar-
ent in Stieglitz's celebrated *Winter—Fifth Avenue* of
1893 (Fig. 50). The image is self-consciously
American; Stieglitz inscribed on the verso of
another version of this print at the National
Gallery of Art in Washington, D.C., "This photo-
graph is the basis of so-called American photogra-
phy." The motif of the carriage in the blizzard
could be compared to city scenes by the American
Impressionist Childe Hassam such as *Winter in
Union Square* of 1892 (Fig. 51), and the emphasis
on weather conditions continued a long nine-
teenth-century tradition of treating such effects.
This photograph's simple composition is expressed
through areas of restricted tonal range, whose large
planes of compositional massings in limited gray
tones are in the spirit of Whistler's images. In the
early 1890s painters were not yet making city
scenes with a Tonalist sensibility, so Stieglitz broke
new artistic ground. In Stieglitz's aestheticism of
the city street he adopted another Tonalist charac-
teristic—the artistic manipulation of the view to
render it "poetic" (to use a favorite adjective in
Tonalist literature). As Stieglitz observed, "Metro-
politan scenes, homely in themselves, have been
presented in such a way as to impart to them a per-
manent value because of the poetic conception of

the subject displayed in their rendering."[18] If it
were not for his elevated viewpoint and etherealiz-
ing of the urban subject, this photograph has the
sensibility of a Tonalist snow scene such as Inness's
Home at Montclair of 1892 (Sterling and Francine
Clark Art Institute, Williamstown, Massachusetts),
in which soft snow obscures the scene.

Although Stieglitz and other turn-of-the-century
Americans were eager to celebrate their nation's
recent urban accomplishments such as skyscrapers
and bridges, for the most part they still could not
abandon the romantic notion that art should be
picturesque. Like later Tonalist paintings of the city
by Ranger, Birge Harrison, and Edward Willis
Redfield, Stieglitz's pioneering urban photographs
from this period are aestheticized, with misty
atmospheres of weather or tenebrous effects trans-
forming grimy realism into a mysterious, urban
dreamland. When seen through Stieglitz's Tonalist
aesthetic, even a frigid, slushy street scene is meta-
morphosed into a coolly refined paradise.

Winter—Fifth Avenue was exposed with a bor-
rowed four-by-five-inch detective's camera—an
amateur's camera—an informal, spontaneous, and
commonplace device, which is thus stereotypically
American. But it is clear that this camera's less pre-
cise focus—which was well-suited to Pictorialism—
is what Stieglitz was after. He further manipulated
the image by cropping out more than half of the
negative to make a vertical composition, removing

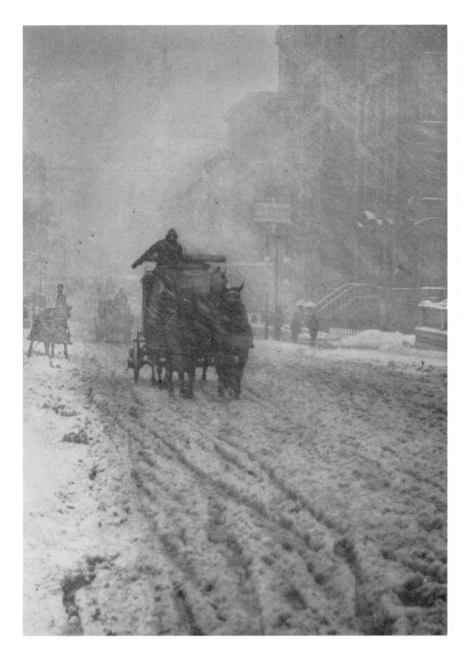

Fig. 50.
Alfred Stieglitz
Winter—Fifth Avenue, 1893
Carbon print
George Eastman House,
Rochester, New York

to Inness's home in Montclair, New Jersey: While looking at the land surrounding him, the elderly Inness, with failing eyesight, exclaimed, "I wish I could have seen this in my youth as I do now!"[20] Soft focus, of course, was a stylistic component of Pictorialist photography. Emerson's theory of naturalistic photography was also guided by Helmholtz and an attempt to replicate the actual process of seeing, which he was attuned to as a medical doctor.[21]

Stieglitz's use of selective focus can be seen some fourteen years later in his collaboration of 1907 with Clarence White. *Experiment No. 27* (Fig. 52) is one of a series of investigations into Tonalist iconography and execution using different lenses to evoke poetic moods. While Stieglitz suggested poses and most likely the placement of the camera, White focused the camera and developed the negatives. The negatives were then printed using a variety of processes, such as platinum, gelatin silver, and gum bichromate over platinum, sometimes "coaxed to yield every nuance of gray," as Weston Naef has observed.[22] If the woman in white in *Experiment No. 27* evokes a Symbolist typology, it is of a specifically American Tonalist variety. As a softened, remote, ethereal, virginal type, it has immediate American counterparts in the work of Whistler and the Tonalist painter Thomas Wilmer Dewing, such as the nebulous women in his *In the Garden* (Fig. 53), which was reproduced in *Camera Work* in April 1905. Just as with the landscapes, here the viewer fills in the details to create an "ideal" woman. From Whistler, artists and photographers—Dewing, Stieglitz, and Steichen—learned how to dematerialize the contours of their figures so that the subject seemed to be one with its atmosphere.[23] These fragile American Virgins, cousins of the Gibson Girl and Henry James's ingenues, stood in stark contrast to the world-weary Europeans.[24]

After Stieglitz returned from his 1894 trip to Europe, he revisited American subjects and Tonalist photography, again as urban scenes, pushing further the artistic effects of limited tone. In his *Reflections—Night (New York)* of 1896 (Fig. 54), he also experimented with technically challenging night photography.[25] Again, a string of evocative night paintings through the history of art could be cited as his sources, but one would scarcely have to look further than Whistler's *Nocturnes*, for example, his *Nocturne: Blue and Gold—Valparaiso*, 1866 (Freer Gallery of Art, Smithsonian Institution, Washington, D.C.), for an immediate precedent. This photograph of the Savoy Hotel anticipates later nocturnal Tonalist paintings of the city, such as Henry Ward Ranger's *High Bridge, New York*, 1905 (Metropolitan Museum of Art). With its overall dark tonality with some light highlights and few middle tones, *Reflections—Night (New York)* is also similar to Edward Steichen's paintings, such

railroad ties from the lower left—a workaday detail that detracted from the universal simplicity of the scene. He then enlarged and retouched the negative and made a carbon print—which prints a warm brown—on textured watercolor paper to further soften the effect.[19] All these deliberate choices—of tone, softness of image, and simplicity of composition—were expressly Tonalist strategies.

The nineteenth-century sources of Tonalism in painting could be traced through Jean-Baptiste Camille Corot's dreamy late *Souvenirs* and the work of the Impressionists, whose paintings were inspired by what was known about the optics of the eye. In 1867, Hermann von Helmholtz's *Handbook of Physiological Optics* furthered this knowledge. Of course, George Inness's misty atmospheres most directly inspired the Tonalists. With at least some irony, Hartmann perpetuated the myth that Inness's superior aesthetic vision was the inverse of his ocular function, when he recalled a trip he took

as *Night Landscape*, from about 1905 (Whitney Museum of American Art, New York).

Stieglitz's Tonalist inclinations were reinforced by the influential contemporary art critics Charles H. Caffin and Sadakichi Hartmann, who were major advocates of the movement. Both initially wrote about Stieglitz in 1898.[26] Their books and essays, including those Stieglitz commissioned for his journals *Camera Notes* and *Camera Work*, were essential to the success of Stieglitz and his group. During this period both critics discussed Tonalist painting and photography simultaneously, which is remarkable, considering that Stieglitz has not been examined in this context at length until now.

Caffin, for example, observed that "Side by side with the latter phases of this development [of American Barbizon painting and the art-for-art's-sake doctrine of Aestheticism] has grown up the pursuit of artistic photography, influenced at every stage of its progression by the example of the painters."[27] Elsewhere he went so far as to assert that the photographers were better Tonalists than the painters were because of the monochromatic nature of their craft. As Caffin explained:

> The painter . . . varies his hues, but the artist in black and white, including the photographer, has practically only one at his disposal. He creates his illusion by varying the intensity of this one color; in fact, by graduating its tone. So tone becomes one of the qualities which distinguish[es] a pictorial photograph; a method of approximating towards nature, and at the same time of producing an effect that is in itself beautiful.[28]

Like Caffin, Hartmann also advocated both Photo-Secessionism and Tonalism. In 1901 he claimed that it was in "tone compositions" that "our artistic photographers celebrate their greatest triumphs."[29] In fact, Hartmann considered some of the photographers to be "extreme tonalists" because they worked with fewer harmonious tones than the painters.[30] While Hartmann thought tone

Fig. 51.
Childe Hassam
Winter in Union Square
1889–90
Oil on canvas
18¼ × 18 inches
The Metropolitan Museum of Art, New York, Gift of Miss Ethelyn McKinney, in memory of her brother, Glenn Ford McKinney, 1943

an essential ingredient of any work of art, he also believed that "it is merely one of the elements that enters into the making of a picture, and not the whole thing."[31] Actually, Hartmann preferred more contrast, as found in the "light and shade" compositions Stieglitz had produced in Europe.[32] Hartmann explained that the extreme Tonalists, or Secessionists (he used the terms interchangeably), employed two or three tints when most pictures have six or seven.[33]

For example, Stieglitz's *Snapshot—from My Window, New York*, 1902 (Fig. 55), which has only a few tones, is more reductive than his earlier *Winter—Fifth Avenue* and is even sparer than Tonalist paintings by Dewing, Dwight Tryon, and Leon Dabo. Stieglitz was well aware of his subtle manipulations of tone, advising photographers to "be familiar not only with the positive, but also with the negative value of tones."[34]

However, in Stieglitz's earliest twentieth-century Tonalist photographs, not only did he reduce the number of tones and suppress details, but he further simplified his compositions so that they, like Tonalist paintings, would contain only a very few

elements, leaving the viewer's mind unencumbered to allow the photograph to elicit a quiet mood. As Stieglitz had claimed in 1892, "simplicity . . . is the key to all art—a conviction that anybody who has studied the masters must arrive at."[35] And, as Sadakichi Hartmann later explained in his 1909 book *Composition in Portraiture*, in which he used both paintings and Pictorial photographs to instruct photographers: "Tonal composition consists largely of a right sense of proportion, to understand the beauty of different degrees of tonality, the relation of tone in regard to size and shape against each other, and to bring all these possibilities into full play in each new effect."[36] Tone and compositional proportion were thus mutually bound.

Snapshot—from My Window, New York also exemplifies how Stieglitz's early New York photographs are reduced compositionally, arranged as an angular geometry of pale planes, in accordance with principles drawn from the Tonalist aesthetic. This work, another instance of Stieglitz's constant experimentation, was taken from a window of his apartment at 1111 Madison Avenue. This ephemeral, ghostly image, which in its pale subtlety is reminiscent of Whistler's sheer, rarefied pastels, is an example of what Hartmann considered to be "extreme" Tonalism. Borrowing the high window views of Impressionist painters, and emphasizing that physical height with an emotional distance resulting from the image's minimal tones and composition, Stieglitz has veiled the reality of the city with a certain faraway magic. New York becomes a dreamland bathed in an ethereal light—an ideal city for the new century.[37]

Stieglitz also used a very spare Tonalist composition to express the modernity of New York in *The Flatiron* of 1903 (Fig. 56). The wedge-shaped twenty-one story skyscraper built at the narrow corner of Broadway, East Twenty-third Street, and Fifth Avenue in 1902, the Flatiron Building was a popular subject for artists; skyscrapers—an American phenomenon—were symbolic of American technological supremacy. Stieglitz's asymmetrical composition reveals his awareness of Japanese woodcuts, as filtered through Whistler and Arthur Wesley Dow. He has used the building's unique shape, which defied the massive volumes of other tall buildings, as a tonal experiment in flat forms. Rather than focusing on the novel architectural sliver of the north corner—so favored by commercial photographs and postcards of the time—Stieglitz's slightly oblique angle also emphasizes the building's sheetlike broad facade, setting up the first of three simple, flat, sheer tonal planes—the pale horizontal froth of the trees, the slim, dark tree trunk that frames the photograph on the left. His continued refinement of features that were so thoroughly ensconced in the vocabulary of the Tonalist aesthetic would ultimately offer a powerful transition to the

Fig. 52.
Clarence White and
Alfred Stieglitz
Experiment No. 27, 1907
Platinum print
9⁷⁄₁₆ × 7⁷⁄₁₆ inches
The Metropolitan Museum
of Art, New York, Alfred
Stieglitz Collection, 1933

Fig. 53.
Thomas Dewing
In the Garden, ca. 1889
Oil on canvas
20⅝ × 35 inches
Smithsonian American Art
Museum, Washington, D.C.,
Gift of John Gellatly

abstract art that Stieglitz, Caffin, and Hartmann would later embrace.

The Tonalists were remarkably modern in their belief that the experience of a painting should not be limited to sight. This is apparent in the indistinct late landscapes of Inness, for example, in which the viewer's imagination must fill in the details; in 1894 Ranger professed that painting has the same principles as the "arts of music, literature, or drama."[38] Similar invitations to ambiguity remind us of the Romantic movement and especially the French and Belgian Symbolists, who used all forms of artistic expression,[39] and with whom the Photo-Secessionists had direct contact.[40]

In turn-of-the-century New York, the analogy between the visual arts and music was especially pronounced. In his article "Tonality" in *Camera Notes* (whose title itself is a musical reference) Joseph Keiley, a lawyer and Photo-Secessionist, wrote that the photographer "must be as entirely at home with lights and shades as the musician is with notes, or the poet with numbers."[41] Similarly, Caffin proclaimed that the "tone of color affects us in much the same way as tone of sound."[42]

Using music as his guide, William Murray in *Camera Notes* outlined a theory of correspondences between the celestial and terrestrial realms that recalls the writings of the Christian mystic Emanuel Swedenborg, who heavily influenced Inness.[43] In 1904, writing about a concert he had just attended conducted by the composer Hermann

Hans Wetzler, Murray told Stieglitz: "Seemed to me that Herr Alfred Stieglitz was leading the orchestra and even if you drop the editor's pen and take to conducting I shall expect to behold the same combination of minute shades of detail with, at the same time, large breadth in your readings."[44] Stieglitz, who played the piano and enjoyed the music of Richard Wagner and Ludwig van Beethoven, embraced the idea of the spiritual association of nature with music (and by extension the other arts), which he later explored in his photographs of clouds including the *Songs of the Sky* and the *Equivalents* of the 1920s and 1930s.[45]

Stieglitz's desire to transcend reality places him among late-nineteenth-century advocates of the "higher life," including intellectuals, poets, and artists—many of them Tonalists—who attempted to accelerate the evolutionary progress of American society.[46] For the most part, advocates and collectors of Tonalist art were urban businessmen, who appreciated Tonalism for its escapist qualities. In keeping with the tenor of the McKinley administration, Tonalism was elitist and nationalistic. For example, in the article "Tonality," Leigh Hunt implied that tone can be appreciated only by "an elect few," meaning connoisseurs.[47] Another critic, writing about the Tonalist-oriented Society of Landscape Painters, was similarly exclusionary when he commented that we are "not fighting the Philippinos [during the Spanish-American War of 1898] but the

Philistines." In a statement about the Photo-Secession, Stieglitz struck a similar chord, railing against both the Philistines and the masses.[48] Stieglitz, who had begun his career as an amateur, gradually assumed an elitist attitude as his reputation grew,[49] and his circle of photographers and critics became their own esoteric realm.

Tonalism's exclusivity was in part a reaction against quick advances in technology, the influx of immigrants, and the shoddy workmanship that permeated turn-of-the-century urban life. High-quality craftsmanship was valued among the cultural elite, a trend that, originating with William Morris in England's Arts and Crafts Movement of the mid-nineteenth century, had spread throughout Europe and the United States. In America it coincided with Tonalism on many levels. Ranger, an avid technician who experimented with glazes and heavy textures, claimed that sound craftsmanship was "one of the secrets of the Tonalist's success."[50] The Photo-Secessionists also valued craftsmanship, creating "prints" that were often virtually indistinguishable from contemporary etchings and mezzotints—as printmaking, too, was a major component of the Arts and Crafts Movement.[51]

Stieglitz's mastery of technical skills could be seen at his retrospective exhibition at the Camera Club of New York in 1899, which included photographic prints in five processes—platinum, photogravure, carbon, gum bichromate, and gelatin-silver toned with platinum.[52] This attention to the technical aspects of the craft of photography in turn made the image a unique work of art. Stieglitz frequently printed multiple variations from the same negative, experimenting with numerous combinations of processes, papers, textures, focuses and other painterly—and therefore unique—treatments. This attention to individuating each image paralleled techniques of history's finest artist-printmakers, whose painstaking treatments of each plate and sheet elevated an engraving, etching, or lithograph to a fine, often singular, work of art. In other examples, Stieglitz would print an image only once, with customized treatments or processes that made the photograph as individual as a painting. During his Tonalist period he experimented with subtle colorations specific to the various processes, imparting a warm old master burnish or a grainy finish to the softly rendered photograph, in strong contrast to the cooler, more neutral hues of more conventional silver or platinum prints.

Stieglitz's devotion to quality workmanship extended to his careful presentation of his and his colleagues' photographs. In addition to ordinary halftone reproductions, *Camera Work* also included exquisite exhibition-quality hand-pulled photogravures, most of which were printed on Japan tissue, tipped in to the volume.[53] Stieglitz's Little Galleries of the Photo-Secession, which opened in 1905, were decorated in a very refined manner,

Fig. 54.
Alfred Stieglitz
*Reflections—Night
(New York)*, 1896
Gelatin silver print
3⅛ × 4⅝ inches
Museum of Fine Arts,
Boston, Gift of Miss
Georgia O'Keeffe

featuring an olive-toned burlap wall covering. This aesthetic type of installation, which has been regarded as an example of Stieglitz's modernity, actually had many precedents, including the exhibitions of the Ten American Painters beginning in 1898, which were themselves influenced by Whistler's exhibition designs of a decade earlier.[54] Burlap walls had also already been used in the Sixty-seventh Street Cooperative Building, where Ranger and other Tonalists had studios.[55] The coloring was also similar to the olive-sage walls of the American paintings exhibition at the Universal Exposition of 1900, which Stieglitz must have seen during his trip to Paris that summer.

But no ideology, not even craftsmanship, was as important for Tonalism as nationalism. Stieglitz was also obsessed with nationalism in his goal to establish an American photography that would surpass European work. In his 1892 article "A Plea for American Photography," he opined, "There is no reason why the American amateur should not turn out beautiful pictures by photographic means as his English brethren across the long pond."[56] Three years later he made a patriotic resolution personally to "sacrifice time and money to bring about a revolution in photographic exhibitions in the United States."[57]

Indeed, at the Paris Universal Exposition of 1900, the nationalistic qualities of Tonalism came to the fore. It was the style the United States contingent self-consciously promoted to assert the parity of the American school of art with those of the Europeans.[58] With Caffin and Hartmann among its primary supporters, the campaign was successful, as the predominantly French judges awarded the new American School more medals than any national school except their own. Tonalism was thus considered an American invention whose Barbizon roots gave it a pedigree that pleased conservative critics, while its native themes were undeniably American. At this time, the pervasive nationalism of the art world was especially manifest during international competitions and expositions. With its predilection for American subject matter, Tonalism was inherently patriotic, a theme that is also reflected in its literature. At the exposition, for instance, Caffin (a naturalized citizen from Britain) was one of many critics preoccupied with identifying national traits. In his review of the American paintings installation, Caffin defined the "national characteristics" as "tending towards an art which is elevated in feeling, reticent, and earnest"—all aspects of Tonalism.[59]

Yet, in an unfortunate turn, while Tonalist painting was represented at the exposition, Stieglitz's Tonalist photography was not. After American photography had made the great strides that were due largely to his efforts, Stieglitz was invited to showcase it at the Paris Exposition of

Fig. 55.
Alfred Stieglitz
Snapshot—from My *Window, New York,* 1902
Carbon or gum print
Philadelphia Museum of Art: Gift of Carl Zigrosser, 1966

1900. However, this tremendous opportunity was lost, for, when he learned that photography would be exhibited, not as a fine art, but as a liberal art, Stieglitz boycotted the exposition.[60] Instead, the international debut of American photography was made, not by Stieglitz, but by his rival, the Bostonian F. Holland Day, at London's Royal Photographic Society in 1900. This triumphant exhibition, the *New School of American Photography,* then traveled to Paris. Although Day did not include Stieglitz's work in the show, Stieglitz's Tonalist influence on the other photographers was palpable. Encapsulating reviews of the London exhibition, Margaret Harker has observed:

> The chief tendencies of the American school were said to be the sacrifice of almost all detail for strength of effect, the reduction of tonal gradation to as few tones as possible, very free use of deep shadow with proportionally small space of light, very limited use of the middle tonal range and emphasis on strong rather than graceful lines of composition.[61]

Harker adds that American influence on British art from the *New School* exhibition also extended to the "simplification of subject matter, a greater

Fig. 56.
Alfred Stieglitz
The Flatiron, 1903
Photogravure
(from *Camera Work* 4,
October 1903, pl. 1)
Philadelphia Museum
of Art: Gift of Carl
Zigrosser, 1966

appreciation of pattern as an element of design and concentration of the broader aspects of material selected for representation." These comments indicate not only how much American photography had progressed in eight years, but also just how Tonalist it had become.

Soon after the *New School* exhibition, Stieglitz became increasingly involved with organizing American photographic representation in European exhibitions.[62] He also continued his quest to establish photography as a fine art in projects including the Photo-Secession, *Camera Work*, and the Little Galleries of the Photo-Secession. Another major accomplishment for the cause was Caffin's 1901 book, *Photography as a Fine Art*, which proclaims the status of photography as a legitimate art form that "stands along side of etching."[63] In other words, even Caffin—one of Stieglitz's staunchest supporters—clung to the notion of the hierarchy of media, in which painting was superior to printmaking. In 1908 the National Arts Club exhibited paintings and photographs side by side for the first time in the United States.

At this exhibition, the photographs were frequently confused with works in the other paper media. As the art critic J. Nilsen Laurvik observed:

> That [the photographers] held their own and "made good," so to speak, was amply proven by the unusual interest these prints aroused, despite the fact that many mistook them for mezzotints at first glance, only to discover to their amazement and mortification that these were merely photographs they had been admiring.[64]

Even with this commendation (in which Laurvik used the word "merely" ironically), Stieglitz's dream to exhibit photography in an art museum was not realized until the *International Exhibition of Pictorial Photography* at Buffalo's Albright Art Gallery in 1910, where the Photo-Secessionists dominated.

Despite Stieglitz's enormous achievement of exhibiting photography in an art museum, his self-conscious attempt to incorporate photography into the existing art world was tenuous at best. Indeed, the very establishment Stieglitz emulated would not fully accept him and his group, which, in any case, was dwindling in numbers. Ultimately, artists who had spent years perfecting their drawing skills were still reluctant to accept an "art" dominated by amateurs, who with the mere push of the button that operated a camera shutter created work eerily similar to their own.[65] According to an interview Hartmann conducted with a number of famous American artists, they viewed photography with "amused condescension."[66] These painters included ones Stieglitz had admired—Hassam, whose work inspired his early New York scenes; William Merritt Chase, who frequently judged photography exhibitions; and the Tonalists Dwight Tryon and Dewing, whose paintings Stieglitz reproduced in *Camera Work*. Among the artists interviewed, only Daniel Chester French, who as a sculptor was not threatened by the photographers, supported their art.

By 1907 Stieglitz was discouraged. As Caffin sympathized, "It is one of the sadnesses of my own life that you suffer so."[67] Realizing that they had exhausted their options to convince most of the art establishment that photography was a fine art, Caffin advised Stieglitz to "shift your attack." By this time, Stieglitz was in the position to do something radical: that year he recognized modernism. In doing so, he stridently avenged the New York art world by making it seem old-fashioned.

However, it was only because Stieglitz understood the American art world that he could so successfully undermine it. By co-opting the multifaceted style of Tonalism he was able to declare independence from European Pictorialism and create a style of making photographic images that was not only uniquely American but was recognized as

art, acclaimed, and promoted by leading art critics. Stylistically, thematically, and conceptually, Stieglitz was indeed a "fanatic" Tonalist for a while—even if he never admitted it. This relatively short-lived affiliation, however, strengthened his early alliances with critics and painters and gave him valuable experience operating in the art business. Indeed, it was during his Tonalist phase that Stieglitz accomplished his initial goals—at least with a limited audience—of promoting photography as a fine art and of instituting an internationally recognized American school of photography. Stieglitz's brief but critical Tonalist period also made him sensitive to the beauty of spare composition and abstract design, which would help him embrace modernism. Ultimately, however, it helped him to launch his own alternative modernist empire that welcomed both painting and photography. This experience not only gave him the wherewithal to have American photography be recognized as a legitimate school, it was also an important rung in his ascent to secure photography's place alongside painting in the modernist avant-garde worldwide.

NOTES

1. Richard Whelan, comp., *Stieglitz on Photography: His Selected Essays and Notes* (Millerton, N.Y.: Aperture, 2000), p. ix.

2. See, for example, Sarah Greenough, *Alfred Stieglitz: The Key Set; The Alfred Stieglitz Collection of Photographs*, 2 vols. (Washington, D.C.: National Gallery of Art; New York: Harry N. Abrams, 2002); and Katherine Hoffman, *Stieglitz: A Beginning Light* (New Haven, Conn., and London: Yale University Press, 2004), who mention Stieglitz's American influences but not Tonalism specifically. In more general studies, Stieglitz has been linked to Tonalism but not in detail. See Wanda M. Corn, *The Color of Mood: American Tonalism, 1880–1910*, exh. cat. (San Francisco: M. H. de Young Memorial Museum and the California Palace of the Legion of Honor, 1972); Naomi Rosenblum, *A World History of Photography* (New York: Abbeville Press, 1984), pp. 229–301; and Kevin J. Avery and Diane P. Fischer, *American Tonalism: Selections from The Metropolitan Museum of Art and The Montclair Art Museum*, exh. cat. (Montclair, N.J.: The Montclair Art Museum, 1999).

3. Sadakichi Hartmann, *Landscape and Figure Composition* (New York: Baker and Taylor Company, 1910; reprint, New York: Arno Press, 1973), p. 52.

4. Modernist biases against late-nineteenth-century American art had only begun to be quelled in the 1970s. For example, it was not a photographic historian but rather an art historian, Wanda Corn, who restored the link between Tonalism and American photography in *The Color of Mood*, which was also the first serious examination of Tonalism.

5. Influenced in part by European associations, such as the Brotherhood of the Linked Ring in London and the Munich Secession exhibition of 1898 (which included photographs with painting, sculpture, and printmaking), Stieglitz and his group broke ties with the conservative Camera Club of New York. Hoffman, *Stieglitz: A Beginning Light*, pp. 202–203.

6. Ibid., p. 23.

7. This describes Pictorial photography in the most general sense. Specifically, Pictorialism as a historical tendency began with the Victorian photographer Henry Peach Robinson's book *Pictorial Effect in Photography* of 1869 and the amateur photographic movement that ensued. In the 1880s Peter Henry Emerson ushered in the second wave of Pictorialism, which will be addressed in this essay.

8. See, for example, Sadakichi Hartmann, "On Plagiarism and Imitation," *Camera Notes* 3 (January 1900), pp. 105–108; reprinted in Harry W. Lawton and George Knox, eds., *The Valiant Knights of Daguerre: Selected Critical Essays on Photography and Profiles of Photographic Pioneers by Sadakichi Hartmann* (Berkeley, Calif.: University of California Press, 1978), pp. 64–67.

9. See H. Barbara Weinberg, *The Lure of Paris: Nineteenth-Century American Painters and Their French Teachers* (New York: Abbeville Press, 1991), p. 8.

10. Ulrich F. Keller, "The Myth of Art Photography: A Sociological Analysis," *History of Photography* 8 (October–December 1984), p. 256. This article is essential to understand the underpinnings of Stieglitz's agenda in his early New York period.

11. Alfred Stieglitz and Louis H. Schubart, "Two Artists' Haunts," *Photographic Times* 26 (January 1895), pp. 9–12; Whelan, *Stieglitz on Photography*, pp. 51–55.

12. Annette Stott, *Holland Mania: The Unknown Dutch Period in American Art and Culture* (Woodstock, N.Y.: Overlook Press, 1998), p. 12.

13. Stieglitz and Schubart, "Two Artists' Haunts," pp. 9–12, reproduced on p. 12.

14. See William H. Gerdts, "American Tonalism: An Artistic Overview," in *Tonalism: An American Experience*, exh. cat. (New York: Grand Central Art Galleries, 1982), p. 19; This essay has been reprinted with changes, in this catalogue, pp. 15–29.

15. Geraldine Wojno Kiefer, "The Leitmotifs of *Camera Notes*, 1897–1902," *History of Photography* 14 (October–December 1990), p. 351.

16. Alfred Stieglitz, "A Plea for Art Photography in America," *Photographic Mosaics* 28 (1892), pp. 135–37; Whelan, *Stieglitz on Photography*, pp. 29–30.

17. Editorial statement, *Camera Notes* 1 (July 1897), p. 1.

18. Alfred Stieglitz, "Pictorial Photography," *Scribner's Magazine* 26 (1899), p. 537.

19. See Greenough, *Key Set*, p. xvii.

20. Sidney Allan [Sadakichi Hartmann], "The Influence of Visual Perception on Conception and Technique," *Camera Work* 3 (July 1903), pp. 23–26.

21. Hoffman, pp. 36 and 87. It is also worth noting that Stieglitz studied with Helmholtz in Germany.

22. Naef, p. 490.

23. Kathleen A. Pyne, *Art and the Higher Life: Painting and Evolutionary Thought in Late Nineteenth-Century America* (Austin: University of Texas Press, 1996), p. 134. See also Nicolai Cikovsky, Jr. , "Whistler and America," in Richard Dorment and Margaret F. Macdonald, *James McNeill Whistler* (London: Tate Gallery Publications, for National Gallery of Art, 1995), p. 38.

24. Diane P. Fischer, ed., *Paris 1900: The "American School" at the Universal Exposition* (New Brunswick, N.J., and London: Rutgers University Press; Montclair, N.J.: The Montclair Art Museum, 1999), pp. 53–56.

25. Greenough, *Key Set*, p. 148.

26. Geraldine Wojno Kiefer, *Alfred Stieglitz: Scientist, Photographer, and Avatar of Modernism, 1880–1913* (New York: Garland, 1991), pp. 235–44. Hartmann and Stieglitz probably met in the fall of 1897.

27. Charles H. Caffin, "The Development of Photography in the United States in Art Photography. With Selected Examples of European and American Work," *Studio* (Special Summer number 1905), p. 1.

28. Charles H. Caffin, "The New Photography," *Munsey's Magazine* 27 (August 1902), p. 735.

29. Sadakichi Hartmann, "On Composition," *Camera Notes* 4 (April 1901), pp. 275–62.

30. Hartmann, *Landscape and Figure Composition*, p. 52.

31. Sidney Alan [Sadakichi Hartmann], "The Ideal Average—Charles H. Davis," *Wilson's Photographic Magazine* 43 (January 1906), p. 8.

32. Hartmann, *Landscape and Figure Composition*, p. 52.

33. Sidney Allan [Sadakichi Hartmann], *Composition in Portraiture* (New York: Edward L. Wilson, 1909; reprint, New York: Arno Press, 1973), p. 105.

34. Alfred Stieglitz, "Pictorial Photography," *Scribner's Magazine* 26 (1899), p. 530; reprint, Whelan, *Stieglitz on Photography*, p. 105.

35. Alfred Stieglitz, "A Plea for Art Photography in America," *Photographic Mosaics* 28 (1892), p. 136; Whelan, *Stieglitz on Photography*, p. 30.

36. Allan, *Composition in Portraiture*, 104.

37. Diane P. Fischer, "Constructing the 'American School' of 1900," in Fischer, *Paris 1900*, p. 88.

38. Henry Ward Ranger, "A Basis for Criticism on Painting," *Collector* 6 (November 15, 1894), p. 24.

39. Charles C. Eldredge, *American Imagination and Symbolist Painting*, exh. cat. (New York: Grey Art Gallery and Study Center, New York University, 1979), p. 16.

40. See, for example, Colleen Denney, "The Role of Subject and Symbol in American Pictorialism," *History of Photography* 13 (April–June 1989), pp. 109–28. Both Hartmann and Steichen were associated with Stéphane Mallarmé's circle in Paris, and Steichen also knew the Belgian poet Maurice Maeterlinck.

41. Joseph Keiley, "Tonality," *Camera Notes* 2 (April 1899), p. 136.

42. Charles H. Caffin, "The New Photography," *Munsey's Magazine* 27 (August 1902), p. 735.

43. W[illiam] M. Murray, "The Music of Colors, the Color of Music, and the Music of the Planets," *Camera Notes* 1 (January 1898), pp. 67–69.

44. William M. Murray to Alfred Stieglitz, January 27, 1904, Alfred Stieglitz/Georgia O'Keeffe Archive, Yale Collection of American Literature, Beinecke Rare Book and Manuscript Library, Yale University, New Haven, Connecticut.

45. Hoffman, *Stieglitz: A Beginning Light*, pp. 44–45. Stieglitz was enamored with the redemptive work of Wagner and the notion of the *Gesamtkunstwerk*—or total work of art—which unites all media. This concept, in which the imagination was more important than the medium itself, enhanced Stieglitz's argument for the validity of photography as a fine art.

46. Pyne, *Art and the Higher Life*, p. 3ff.

47. Leigh Hunt, "Tonality," *Art Collector* 9 (December 1, 1898), p. 36, as analyzed in Becker, "Studies in American Tonalism," chap. 1, p. 41.

48. Alfred Stieglitz, "The Photo-Secession," *Bausch and Lomb Souvenir*, 1903; Whelan, *Stieglitz on Photography*, p. 155.

49. Ulrich F. Keller, "The Myth of Art Photography: A Sociological Analysis," *History of Photography* 8 (October–December 1984), pp. 257ff.

50. Ralcy Husted Bell, *Art-Talks with Ranger* (New York: G. P. Putnam's Sons, 1914), p. 1.

51. On pictorial photography's connection with the Arts and Crafts Movement, see Christian A. Peterson, "American Arts and Crafts: The Photograph Beautiful," *History of Photography* 16 (Autumn 1992), pp. 189–234.

52. Weston J. Naef, *The Collection of Alfred Stieglitz: Fifty Pioneers of Modern Photography* (New York: The Metropolitan Museum of Art, 1978), p. 66. Naef notes that such experimentation was out of character with Stieglitz's purism between 1894 and 1897. Stieglitz later shunned manipulated prints entirely in favor of straight prints.

53. Marianne Fulton Margolis, ed., *Alfred Stieglitz Camera Work: A Pictorial Guide* (New York: Dover Publications; Rochester, N.Y.: The International Museum of Photography at the George Eastman House, 1978), p. ix.

54. William H. Gerdts, *American Impressionism* (New York: Abbeville Press, 1984), p. 175.

55. Becker, "Studies in American Tonalism," chap. 3, p. 40.

56. Stieglitz, "A Plea for Art Photography in America," pp. 135–36, quoted in Sarah Greenough and Juan Hamilton, *Alfred Stieglitz: Photographs and Writings* (Washington, D.C., National Gallery of Art, 1983), p. 182.

57. Alfred Stieglitz, "A Plea for a Photographic Art Exhibition," *American Annual of Photography and Photographic Times Almanac*, 1895, p. 28, quoted in Beaumont Newhall, *The History of Photography* (New York: The Museum of Modern Art, 1982), p. 156.

58. See Fischer, "Constructing the 'American School' of 1900."

59. C[harles] H. C[affin], "American Art in Paris," *New York Evening Post*, August 11, 1900, p. 5.

60. See Alfred Stieglitz, letter, "Why American Pictorial Work Is Absent from the Paris Exposition," *Amateur Photographer* 35 (July 5, 1900), p. 44.

61. Margaret F. Harker, *The Linked Ring: The Secession Movement in Photography in Britain, 1892–1910* (London: Heinemann, 1979), p. 111.

62. Naef, *The Collection of Alfred Stieglitz*, p. 106. The first of these was the Glasgow International Art Exhibition of 1901.

63. Charles H. Caffin, *Photography as a Fine Art*, (New York: Doubleday, Page, 1901); reprint, New York: Morgan and Morgan, Inc., 1981, p. 12.

64. Nilsen Laruvik, "New Tendencies in Art," *Camera Work* 22 (April 1908), p. 33.

Uniting the Fine and Decorative Arts: Tonalism and American Art Ceramics

ELLEN PAUL DENKER

THE YEARS 1890 to 1910, or perhaps more broadly 1880 to 1915, are the dates usually given to bracket the heyday of Tonalist painting; those years also coincide with the American Arts and Crafts Movement in the decorative arts. In addition to chronology, the two movements share a subdued palette and simplified compositions and motifs. It is tempting to posit influences or instances of overlap between the work of the painters and those whose media were wood, clay, fiber, and copper at the turn of the twentieth century. As is often the case when generalizations are subjected to careful scrutiny, however, the actual situation was more complex.

Those active in the Arts and Crafts Movement wanted to revive the historical relationship between artist and object, wherein the artist is intimately involved with every step of production, thereby restoring human dignity to the making of objects intended for domestic use. This approach was nonetheless transgressed regularly in decorative arts workshops, where most operations were quasi-industrial at best, depending on the efficiencies inherent in the division of crafts rather than their unification in the hands of an individual artist. Most so-called art pottery, for example, was made in industrial settings where each step of the process of making a vase was carried out by a different specialist, the clay mixer, turner, kiln man, and decorator. The "art" in most potteries of the time was defined by the education of the decorator. Those who had been exposed to instruction by painters in art academies were thought to make the best decorators, and they were given some latitude in developing decorative expressions within the narrow boundaries that defined the style of a particular brand. For example, the managers of the Rookwood Pottery early on established a "Standard" glaze palette that defined their wares in the marketplace. As time went on, Rookwood's artist-decorators adhered to this standard, painting a variety of subjects in the same colors, and developed new products and standards, called glaze lines, to meet the demands of the marketplace. The fact that many of these decorators had formal art training should have ensured a close correlation between the fine and decorative arts. In reality, this relationship

existed as a progression from close to distant, and it is often difficult today to determine where a particular artist rests on this continuum, as the appearance of an object is often misleading.

Anita Ellis's excellent paper "American Tonalism and Rookwood Pottery"[1] is virtually the only research to date on the correspondence between Tonalist landscape painting and American decorative arts. Artists working in glass, wood, or metals rarely introduced landscape motifs into their work in this period, but ceramic artists often incorporated landscape or its elements, such as flowers

Fig. 57.
Edward Timothy Hurley
Vase, 1908
Semi-porcelain
9 inches (height) ×
5¼ inches (diameter)
Rookwood Pottery
Company, Cincinnati, Ohio
Collection of Dr. and
Mrs. William E. Heil

and trees, as surface decoration. With Ellis's paper as a model, it is incumbent on the researcher of a topic that interprets decorative arts in terms of the fine arts to demonstrate that the decorative artists under investigation actually knew what they were doing. In other words, before anointing the work of this or that decorative artist as "Tonalist," the modern scholar must first show that the artist him- or herself had been consciously working in a mode suggested by painting. Ellis's method, developed to demonstrate the relation of Rookwood Pottery to American Tonalism, can thus be used as a model in assessing the correspondence between other decorative artists and this particular kind of painting.

Ellis determined that the artist's motivations are paramount in making a valid association between ceramics and Tonalism. Following Ellis, this essay will examine the output of two corporate potteries and one individual to assess whether the term "Tonalist" can rightfully to applied to the ceramics they produced. Rookwood's artists, having full knowledge of Tonalist painting, knowingly produced their own versions of Tonalist landscapes in varicolored slips under a translucent matte glaze. By contrast, Newcomb's artists, working within a limited color palette and subject matter, responded to the larger marketplace, that is, with economic rather than artistic imperatives at the fore. They produced a distinctive product to challenge Rookwood's wares without, however, understanding the aesthetic foundations of Rookwood's aesthetic. Charles Volkmar, the final example presented here, was a painter and etcher before taking up ceramic art. Although he continued to paint and etch, he explored a wider range of artistic expression, some of it Tonalist in nature, as a ceramic artist working in the highly charged art arena of New York City from 1880 to 1910, the same years that the Tonalist painters were active.

Rookwood's Tonalism

Ellis's paper defines the elements of Tonalism in landscape painting, describes the appearance of the landscapes on Rookwood Pottery painted under the vellum glaze, and then demonstrates that the decorators who painted these landscapes understood that they were interpreting nature in the same way as Tonalist landscape painters did (Fig. 57).

The Rookwood Pottery (active 1880–1967) was founded by Maria Longworth Nichols,[2] granddaughter of the wealthy Cincinnati collector and art patron Nicholas Longworth[3] and new wife of the art critic George Ward Nichols. Nichols's significant book, *Art Education Applied to Industry*, included a review of the work presented at the 1876 Centennial Exhibition in Philadelphia and challenged American manufacturers, especially potteries, to make artistic, rather than purely utilitarian, wares.[4] From the beginning Rookwood Pottery was recognized as an art industry. The University of Chicago professor Oscar Lovell Triggs described Rookwood as an "Ideal Workshop," an art industry in the new industrialism that ideally combined a factory with a school for training workers and producing goods, thereby transforming the handicraft revival into a positive force for industrialization that took advantage of machines, but not at the cost of human dignity.[5] The workforce assembled by Maria Nichols was similar in many ways to those of other potteries at the time. The ordinary tasks of pottery making—clay mixing, turning, firing, and so forth—were accomplished by skilled artisans who might have worked at any Ohio pottery. However, the decorating of the ware was done by artists who had been educated under a fine arts curriculum at the Art Academy of Cincinnati[6] that included instruction by fine artists in life drawing and painting, as well as landscape.

Fig. 58.
Sara Sax
Vase, 1913
Semi-porcelain
9¼ inches (height) ×
4½ inches (diameter)
Rookwood Pottery
Company, Cincinnati, Ohio
Collection of Judge and
Mrs. Norman A. Murdock

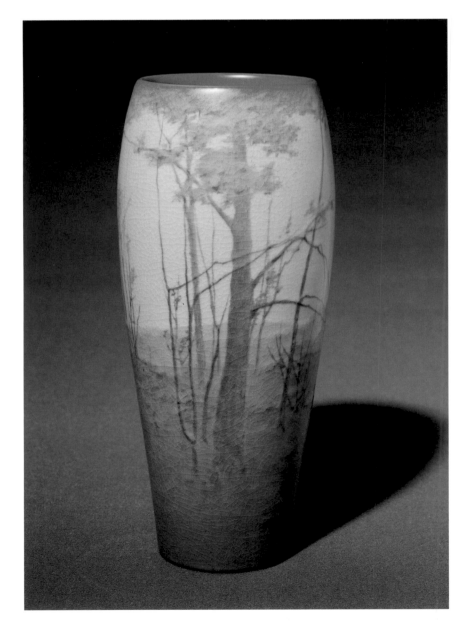

Fig. 59.
Lorinda Epply
Edge of the Forest
(framed plaque), 1913
Semi-porcelain
4½ × 8¼ inches
Rookwood Pottery
Company, Cincinnati, Ohio
Cincinnati Art Museum,
Jane Herschede
Memorial Fund

Technically, the practice at Rookwood was to paint with slips (naturally occurring colored clays mixed with water) directly on the damp clay body that had been previously formed, but not fired in a kiln. The artistic qualities of the ware were emphasized by allowing the artists to sign their work with a monogram or other identifiable device and periodically publishing a list identifying the artists with their signatures. The first popular decorative idiom practiced at Rookwood was referred to as the "Standard" glaze, a mahogany-colored background, often shading from dark to light, decorated with a variety of subjects using a palette of ochers. Flowers were probably the most popular motifs, but the Rookwood decorators also painted such subjects as Indian portraits, animals, birds, and fruits and vegetables. These embellishments were displayed under a brilliantly reflective transparent overglaze, similar in effect to the varnishes used by painters on canvas to finish their work.

In contrast, Rookwood's vellum glaze gives a translucent, matte effect. Stanley Burt, Rookwood's chemist, began experiments in 1900 to develop this glaze, and a line of ware using it was introduced at the 1904 Louisiana Purchase International Exposition in Saint Louis. The glaze derived its name from the fact that its look and feel had "the qualities of old parchment."[7] Because this matte glaze was translucent, the embellishments painted with slip under the glaze could be seen through it. At the exposition, the achievement was rewarded with two grand prizes, and at least one observer commented that "the mat glaze on pottery could develop no further."[8]

Before the the vellum glaze was developed, the Rookwood decorators had been using a lighter palette of slips in a line called the Iris glaze, similar in many ways to the work being produced in porcelain by Royal Copenhagen in Denmark. The lighter colors lent themselves to floral subjects, and the first landscape under vellum glaze, painted by Albert Valentien, appeared only in 1905. The landscape compositions were extraordinarily complicated to develop because the slips that were used were very different in color before firing. Often many trials were required before the desired effect was achieved. After the ware was decorated with slips, it was fired, then dipped in the vellum overglaze and fired a final time. As landscape techniques became more assured, the number of floral subjects diminished and the vellum glaze was used almost exclusively for landscapes.

Ellis crucially shows that Rookwood's decorators intended to paint Tonalist landscapes on vases and plaques. After discussing the art education that the decorators received as students at the Art Academy of Cincinnati, she demonstrates that Rookwood artists traveled at company expense to visit artists' studios and receive additional instruction in the United States and abroad. The Cincinnati Art Museum played a large role in the education and careers of Rookwood artists. According to Ellis, there were no fewer than ten exhibitions of contemporary art at the museum between 1895 and 1922 that included works by, among others, John White Alexander, Ralph Blakelock, William Merritt Chase, Willard Metcalf, Birge Harrison, Childe Hassam, George

Inness, John Twachtman, and James McNeill Whistler.[9] Pictorialist photography by Edward Steichen, Alfred Stieglitz, and Clarence H. White could also be seen in the exhibitions at the museum. Painting and sculpture by such Rookwood artists as Matt Daly, Anna Bookprinter Valentien, Albert Valentien, Edward Timothy Hurley (Fig. 57), Irene Bishop, and John Dee Wareham were frequently exhibited alongside work of contemporary artists from across the country in the museum's Annual Exhibition of American Art held in the spring from 1894 to 1941. The Society of Western Artists, which staged eighteen exhibitions at the Cincinnati Art Museum between 1897 and 1911, often showed Rookwood vellum objects.

Ellis insists that the background of Rookwood's artists "did not consist of apprenticeships in china painting. It was their art backgrounds and their undeniable familiarity with tonalism that enabled them to transfer that aesthetic to ceramics. Once the vellum glaze was developed, it took barely a year for the artists to realize its tonalist potential"[10] Clinching her argument, she cites the Rookwood artist Ed Diers calling a vase "a fine tone piece."[11]

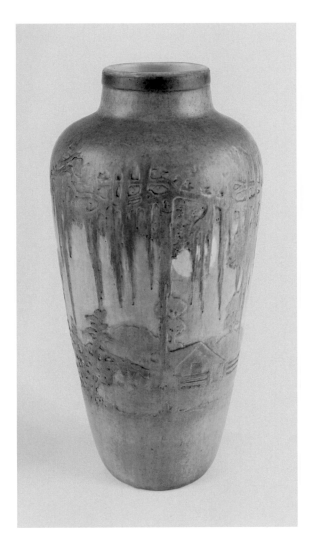

Fig. 60.
Sadie Irvine
Vase, 1922
Earthenware
11½ inches (height) ×
5½ inches (diameter)
Newcomb Pottery,
New Orleans, Louisiana
Rago Arts and Auction,
Lambertville, New Jersey

Tonalist vellum objects continued to be made at Rookwood well after the taste for paintings in the style had passed. As long as there was a market for these objects and artists who could make them, Rookwood, understandably, continued to produce and sell them. Edward Hurley, the last artist to be employed at Rookwood who had come of age during the heyday of Rookwood's Tonalist vellums, painted the final one in 1948, the year he retired.

Rookwood produced both vases and framed plaques decorated with vellum landscapes (Fig. 58). The plaques, though much smaller, were similar in format to Tonalist paintings on canvas. The artists signed the plaques on the front, as painters sign their canvases, and the plaques were fitted with oak frames (Fig. 59). In addition, the plaques were given titles, just as paintings were, and the title was typed on a paper label that was attached to the back. The vases, by contrast, were presented in a wholly different format. Unlike the flat, rectangular format of a painting, photograph, or plaque, vases were painted continuously around their exterior without artificial interruption. Thus, the reading of a Tonalist landscape as painted on a vase is continuous; it neither begins nor ends.

Ellis concludes that "Rookwood's vellum landscapes were not merely a by-product of American tonalism, they were very much a part of it. They were not a secondary manifestation of the aesthetic, but integral to it. Rookwood's tonalism was produced by artists working in the same culture and incited by the same philosophy that produced the paintings on canvas. It was a vital part of American tonalism that unified the fine and decorative arts."[12]

Newcomb Pottery

The Newcomb Pottery (active 1895–1940) was operated in New Orleans as an adjunct program to Newcomb College's School of Art and produced a commercially successful line of landscape-decorated vases in a transparent matte glaze with a subdued palette of blues and grays. Newcomb's matte glaze, however, was not developed until 1910–11, some years after Rookwood's was introduced.[13] Furthermore, landscape decoration evolved from Newcomb's emphasis on the use of local flora as inspiration for decoration that was incised or worked in low relief and painted with a limited palette of colors. While patterned treescapes had been used as motifs as early as 1902, the scenic oak trees with the moon shining through hanging moss was introduced at Newcomb only sometime between 1908 and 1915. This quintessential landscape was promptly commended: "In examining the pottery department one is struck immediately by the fact that designs on the articles are reproductions of the scenery of [the South]. There are no views of mountains or of

rolling country, but the vases and other articles bear finely wrought designs of moss draped live oaks and cypresses growing along the banks of the bayous."[14]

When Newcomb's landscape vases were exhibited in New York at the National Society of Craftsmen in January 1916, the work was described as "simple, dignified and quiet, with a feeling for the South where it was made."[15] William P. Jervis, an English potter working in America who wrote extensively about ceramics at the beginning of the century, mentioned Newcomb Pottery's landscapes in 1911: "The colors are mostly grays and neutral greens, and the painting being on the biscuit an extreme softness, a restfulness to the eye, and an air of repose results."[16]

Sadie Irvine, one of Newcomb's prominent decorators, became in later years an authority on the history and processes of Newcomb Pottery (Fig. 60). In a series of letters she wrote of being "accused of doing the first oak tree decoration, also the first moon. I have surely lived to regret it. Our beautiful moss draped oak trees appealed to the buying public but nothing is less suited to the tall graceful vases—no way to convey the true character of the tree. And oh, how boring it was to use the same motif over and over."[17] Irvine also described the method of making these moody landscapes: "First the clay shape is turned and brought to the decorators who draw in the design. . . . Then with a steel tool the design is cut in. Clay is never added to the surface to bring out the relief; nothing but cutting is used. The process really approximates sculpture."[18]

While the source of the moss-draped oak landscape can be traced to antebellum Louisiana, the romance of the view derives from the "haze of retrospect" that enveloped the South after the Civil War. Even so, the origins of this decoration on Newcomb pottery have been found in a contemporary event.[19] Although the campus was home to fifty-five live oaks in the early twentieth century, the evocative scenes on Newcomb Pottery vases probably derived from the work of Arthur Wesley Dow, a small selection of which was shown in the college's art gallery in March 1914. Dow's work was described as "melancholy" and "sensitive" by a local reviewer of the exhibition.[20]

The critic and teacher Dow had a profound influence on the decorative work at the Newcomb Pottery following the 1899 publication of his book *Composition*, in which he advocated the study of Japanese aesthetic principles and demonstrated their application to Western art and design.[21] Between 1900 and 1906 nine of Newcomb's decorators and managers attended Dow's summer school at Ipswich, Massachusetts, and the decorative emphasis on the pottery shifted quickly from the ornamental style derived from the design theories of the Englishman Christopher Dresser to the use of *notan* (an abstract analysis of the patterns of dark and light) espoused by Dow.[22]

The matte-glazed landscapes helped make the Newcomb Pottery's products popular at a time when commercial interest in art pottery was waning. Paul Cox, chief chemist for Newcomb in the early years of the twentieth century, remembered the popularity of the matte-glazed landscapes and flowers:

> Matt glazes were introduced and the pottery became much more popular, with sales of wares increasing noticeably. Large kilns were added and production developed on an improved mechanical basis. . . . No arts and crafts show was complete without a display of ware from Newcomb College and the products were sent to all parts of the world. . . . Naturally, the enjoyment of ample business caused the artists to hold to the character of output that recorded the best sales.[23]

Variations on the moonlit moss-draped oak were repeated on vases and bowls from about 1910/15 until the pottery closed in 1940.

Although observers at the time noted that the decoration on Newcomb's pieces tended toward the tonal, there is no evidence that the artists consciously saw their work as part of the larger movement. They were merely following a style made popular by others, in this case Arthur Wesley Dow and the Rookwood Pottery. The subject matter—Southern flora—had long been established by the administration of the school and pottery, and the Tonalist treatment of the subject was driven by a desire to keep pace with the marketplace.

Charles Volkmar

Because Charles Volkmar was an individual artist, his relation to Tonalism and ceramics differs from those of the corporate potteries examined up to this point. He came to appreciate ceramic art after he had already established himself as a landscape painter and etcher. In his work and through his networks, he sought to unite the fine and decorative arts rather than advocate a preference for one over the other. Aspects of his work can be seen as Tonalist, and his efforts to unify the fine and decorative arts echo the activities at Rookwood. In addition, his practice as an artist working alone or with one or two assistants mimicked the fine artist's working method.

Charles Volkmar, Jr. (1841–1914) was born in Baltimore, Maryland, to Charles and Ann Volkmar, both natives of Germany. His father was a portrait painter but made a significant portion of his living as a restorer of paintings. His grandfather was an

Fig. 61.
Charles Volkmar
Charger, ca. 1880
Earthenware
20 inches (diameter)
Brooklyn, New York
Rago Arts and Auction,
Lambertville, New Jersey

engraver "of considerable prominence."[24] Young Volkmar drew at an early age and, following in the footsteps of his forebears, became a painter and an etcher. He spent several years studying and painting in Paris and Barbizon at a relatively young age, but his sojourn abroad had more to do with the looming Civil War at home than an immediate desire to study in Europe. In his "Reminiscences," Volkmar explained that a misunderstanding of his role in a minor political uprising on the streets of Baltimore necessitated his leaving the country in 1861. Volkmar's father arranged to have young Charles taken to Europe and pursue his artistic career abroad while the war raged at home.[25]

In Paris, Volkmar studied with Antoine Barye, "the famous sculptor in Jardin des Plantes zoological gardens"[26] in the mornings, drew from casts at the government drawing school in the afternoons, and attended the Swiss school in the evenings to draw from life. He and his compatriots also kept abreast of the war at home.

Volkmar returned to Baltimore briefly in 1864 to see his family and brought pictures to sell. He was so successful that he made an arrangement with an art dealer to "send pictures each month for [a] regular amount of money."[27] In the following spring, after his return to Paris, Volkmar and his fellow Americans "decided to go to Barbizon to make some spring sketches. The place was one long street bordered by dwellings and studios. Nearly opposite the hotel was the home and studio of Jean Francois Millet." While in Barbizon, Volkmar also observed the working methods of Emile A. Breton, Charles Jacque, and the Englishman DeLucy (first name, unknown), among others.

About 1870 Volkmar returned to Baltimore a second time, bringing more of his pictures, which he again sold successfully. He set up a studio in

New York City and in the spring sketched from nature in Pennsylvania pictures he exhibited in the following season. Just after the Franco-Prussian War ended early in 1871, he returned to Paris with his wife (Nettie Welch, whom he married in 1869) and infant son, saddened by the "ruins of the many fine buildings that were largely destroyed" during the siege of that city. He was accepted as a student of Henri Harpignies. After some initial work together in Paris, Volkmar "went to the country with him and worked from nature with him." Volkmar, whose artistic interests tended toward landscape, was pleased with his choice of teacher.

After some months study with Harpignies, Volkmar rented a furnished house in Montigny, very near an art pottery.

I made the acquaintance of artists who were decorating articles there and through them became interested in Pottery work. Later two of them started a small place in a neighboring town and desired me to help in decorating their wares. I gladly accepted their offer. It was some time before they got into working order. We had failure after failure firing the kilns but kept up our courage and [were] eventually successful. This proved a great object lesson to me as I assisted in every part of the processes.

. . . After working there and alternately sketching outside I went to Paris where I found encouragement of getting work in two similar establishments. Here I found myself surrounded by some of the most talented men in Paris. The decoration of the vases or panels was all piece work which was well paid. Each artist had a section of the studio as his own. Next to me was the now celebrated [Jean-Charles] Cazin, modeling lion heads to answer as handles on large jardinières. . . . I divided my time between Chas Oury and Gille, two important potteries. The processes in each were different, thus giving me wider and more thorough experience. At Gilles [*sic*] I had as a neighbor Eugene Carriere [*sic*]. He struggled a long time painting Cupids and Children as decorations on pottery, but not with unqualified success. The fine details disappearing in the firing which left a vague mystic quality which [was] not of great commercial value, [although it] was very artistic in quality. He saw the possibilities of this method and applied them [*sic*] to his oil paintings.

Volkmar continued by noting that many French artists, such as Narcisse Diaz de la Peña, Constant Troyon, Henri Harpignies, Félix Braquemond, and others "used pottery decorations to enable them to pursue Art in other directions."[28]

For the Paris Exposition Universelle of 1878, Volkmar submitted a painting that was displayed in

the American section and showed some pottery in the French section.[29] Several of his pots were purchased by the French government. Having stumbled on a form of art that he found completely fascinating, Volkmar chose to bring these new methods of decorating to the United States when he returned in the late 1870s. "Hearing that there was great interest in the decorative arts [in New York City] and receiving an invitation from the Society of that name to become an instructor—to take charge of the classes in underglaze painting—I accepted and returned home." In 1879 Volkmar succeeded John Bennett as an instructor of ceramic painting at the Society of Decorative Art in New York City.

He first built a kiln in Greenpoint, Brooklyn, which had been the historical home to many potteries of the early and mid-1800s. In 1880 the Salmagundi Club exhibited a fireplace that had been designed and painted by club members in a "Limoges style" under the direction of Volkmar, who was appointed potter of the club shortly thereafter. The so-called Limoges style refers to the painterly art ware made by Haviland and Company of Limoges, France, which pioneered the technique of painting impasto glazes on ceramics. Haviland's large exhibit of this work at the 1876 Centennial

Exhibition in Philadelphia was widely admired and is the technique that inspired the Rookwood decorators to paint with slips on greenware. Volkmar's technique, however, was quite different. He embraced the French method of painting with thick, colored slips on the once-fired biscuit. Both Rookwood and Volkmar finished their ware with a glossy, transparent glaze (Fig. 62).

By 1882 Volkmar had moved to Tremont in the Bronx, where he built a larger kiln and established his studio, salesroom, and home, staying there for several years. Although he had to adjust to new materials, he began making mantel and bathroom tiles, plaques, and vases. He was very successful, hiring George W. Maynard, a genre and landscape painter, to paint the tiles for him in a limited palette of yellow, orange, light and dark blue, red, pink, light and dark browns, some greens, and black. Volkmar became well known for his tile work during this period and received commissions for such important installations as William Rockefeller's mansion in Tarrytown, New York, designed by Carrere and Hastings; the ceiling of the Boston Public Library; and the Market and Fulton National Bank Building in New York City.[30]

Volkmar was long known for painting landscapes on ceramic plaques. The *American Art*

Fig. 62.
Charles Volkmar
Pair of Vases, 1881
Earthenware
12⅝ inches (height)
Greenpoint (Brooklyn),
New York
Brooklyn Museum of Art,
New York, Gift of Leon
Volkmar

Fig. 63.
Charles Volkmar
Tile, ca. 1910
Earthenware
7¾ × 7½ inches
Volkmar Kilns,
Metuchen, New Jersey
Newark Museum, New
Jersey, Gift of William B.
Kinney, 1911

Fig. 64.
Charles Volkmar
Tile, ca. 1910
Earthenware
8⁵⁄₁₆ × 8⅜ inches
Volkmar Kilns,
Metuchen, New Jersey
Collection of R. A. Ellison

Journal referred to them "simply" as "pictures painted and burnt on clay."[31] But his painter colleagues did not always understand what he was trying to do. Volkmar reported in his "Reminiscences" conversations with several of his friends on the subject of his plaques that were displayed at the Salmagundi Club in 1887: "[The plaques] were beautiful and interesting, but were not appreciated by the public and consequently met with no sales as the compliments which I received will show. Swayne [*sic*; R. Swain] Gifford said 'Volkmar they look like first class pictures.' Carleton Wiggins remark was 'Volkmar if I was you I would make a lot of those things and copy them in oil' thus showing how little he understood the merits of the things or the difficulties of making them."[32] The art critic J. B. Townsend saw Volkmar's Salmagundi exhibition differently:

> To those who have not yet visited the Salmagundi display it may seem odd to place in juxtaposition illustrative drawings and paintings on pottery and yet we are confident that the high artistic quality of Mr. Volkmar's work when seen will remove any impression of a lack of the sense of fitness on our part. Each and every one of the panels, framed as canvases would be, shows a sympathy with nature and an ability to translate her moods only found among a few of our painters on canvas. This artistic quality inheres in Mr. Volkmar's work, apart from the technical ability which has enabled him, after long years of effort, to produce, through the uncertain medium of the fire, paintings possessed of rare wealth of color, richness of quality and depth of tone. All these attributes make these tiles far more than mere decorative effects, and give to them a lasting and high value.[33]

In 1888 Volkmar moved his pottery operation to Menlo Park, New Jersey, where he was in partnership with J. T. Smith in the Menlo Park Ceramic Company. This arrangement was curtailed in 1893, when Volkmar organized the Volkmar Ceramic Company, also in Menlo Park.[34] By 1895 he was back in Greenpoint, Brooklyn, making art tile. It was here that he made Old Delft ware, decorating plaques, loving cups, and beer steins in underglaze blue. Later that year he partnered with Kate Cory, a landscape painter and muralist. Establishing Volkmar & Cory in Corona, Queens, they continued to make Old Delft ware.

Volkmar's real artistic breakthrough followed the dissolution of his partnership with Cory toward the end of 1896. He carried on alone at the same location, styling his new company the Crown Point Pottery. He abandoned the Old Delft style to make new work, which he described as having "rich but

Fig. 65.
Volkmar Kilns
Vase, ca. 1910
Earthenware
6⅛ inches (height) ×
5¼ inches (diameter)
Metuchen, New Jersey
Collection of the Newark
Museum, New Jersey,
Museum Purchase, 1911

delicate color qualities, subdued in tone; such effects are only possible to secure in the underglaze treatment of pottery."[35] Jervis, in his 1911 *Pottery Primer*, noted that by 1900 Volkmar had "turned his attention to mat glazes [at Corona], which he now seems to have entirely under control. . . . Landscapes in mat glazes do not sound very attractive, and yet with these unwieldy materials he has produced some landscape slabs which are really remarkable for their atmospheric quality."[36] Volkmar's use of matte glazes with landscape painting on tiles and plaques made in the mid-1890s at Corona predates Rookwood's vellum landscape vases and plaques, introduced in 1904 at the St. Louis World's Fair, by almost a decade. He was proud of his new line, and his work found places in the city's leading clubs (Fig. 63).

In an 1897 letter to the writer and editor Henry Clayton Hopkins, in which he recounted his artistic biography and some of his achievements, Volkmar notes that "One of my most successful ceramic panels belongs to the Lotos Club N.Y."[37] In 1901 the *Brooklyn Daily Eagle* noted that most of Volkmar's tiles "will decorate the superb rooms of New York clubs,"[38] suggesting that the Lotos Club may have been only one of many clubs that took an interest in his work.

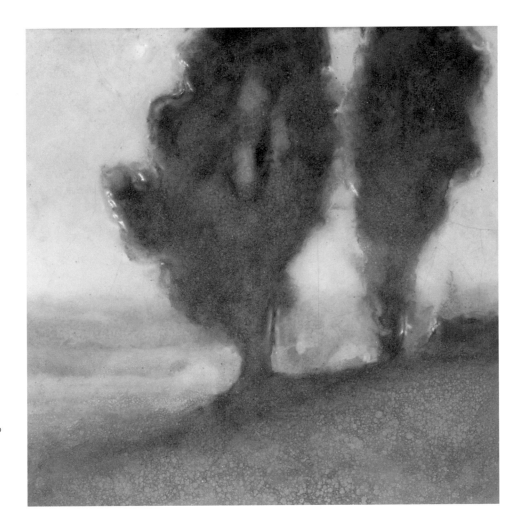

Fig. 66.
Henrietta Ord Jones
Framed Plaque, ca. 1905–10
Glazed porcelain
8¼ × 8¼ inches
The Saint Louis Art
Museum, Gift of Peggy
Ives Cole

Volkmar's solo exhibition in the Pratt Institute Gallery in the fall of 1900 received many notices, although the most thoughtful came from the pen of the art critic for the *Brooklyn Daily Eagle*: "This product of the Corona kilns is unique. It is, fortunately, not a copy of anything else. There is not even an attempt to imitate the solid colors of the Chinese porcelains. . . . Each piece is a satisfaction. It could be placed in a cabinet or on a shelf and it would not quarrel with anything else. It rests the eye, instead of distracting it. . . . a mug of rich green, yellow and brown shows a harmony such as may be found in some of the wood interiors of Diaz and Rousseau."[39] The critic's reference to the Barbizon painters Diaz and Théodore Rousseau was not idle. Volkmar's relationship with this French landscape school would have been well known in the New York art circles of his day. The fact that the critic had discovered the connection between the fine and the decorative arts in this simple mug is testimony to Volkmar's efforts to unite the two in his work.

In 1903 Volkmar moved to Metuchen, New Jersey, at the urging of his son Leon, with whom he commenced a partnership. Here, they continued making the tiles and simple utilitarian wares for which Volkmar was already known (Fig. 64). A 1905 notice in *International Studio* emphasized the "simplicity" of their work: "the Volkmars avoid all florid or realistic effects, maintaining a conventionalism which, while formal, is graceful and decorative."[40] Although Leon moved on in 1910, Volkmar remained in Metuchen until his death in 1914. One of the last reviews his work received was for a display of his work at the 1909 exhibition of the New York Society of Keramic Arts. The reviewer noted Volkmar's panel paintings of landscapes in matte glazes, remarking that it "seems almost unbelievable that such atmosphere could be obtained with such unwieldy material. They are veritable pictures and most delightful as well as wonderful in technique"[41] (Fig. 65).

Like the artists of the Rookwood Pottery, Charles Volkmar was able to transfer his skills from canvas to clay. As a painter, he kept abreast of the nuances of the contemporary art scene and adapted them to his clay work. Evidence of his knowledge of the Tonalist painters can be inferred from his vital role as potter for the Salmagundi Club and from his relation to the Lotos Club in the 1890s, when the exhibition committee there was focused on exhibiting the work of American Tonalist painters. His adherence to the artistic principles of Tonalism is shown by his own descriptions of his

work and the assessments made by others. As he moved toward his mature style at the Crown Point Pottery, he referred to his new work as having "rich but delicate color qualities, subdued in tone."[42] Reviewers of his work during this period and later in Metuchen repeatedly mention its "atmospheric quality," especially in tiles. Thus, Volkmar's mature work in clay rightfully belongs among the landscape paintings of the Tonalists.

The strength and appeal of his mature work is confirmed by the work of his students. Volkmar was a generous artist, ever anxious to share his knowledge, and his role as the first potter-teacher of Adelaide Robineau and the Byrdcliffe ceramicists Edith Penman and Elizabeth Hardenbergh is well known.[43] But it is in the work of his unsung students that the strength and value of his style are seen most clearly. Later an instructor in ceramics at Washington University School of Fine Arts in Saint Louis, Henrietta Ord Jones (1859–1934) had studied painting there as an art student, but gradually developed an interest in ceramics. She studied with Volkmar in the late 1890s, "where she learned everything about pottery 'from the ground up'— clays and enamels and firing the pieces, and such sculpture as was necessary for designing and making varied and beautiful forms for her creations."[44] Returning to St. Louis in 1900, she became head of the ceramic department of the St. Louis School of Fine Arts, where she remained until her retirement in 1927. Comparison of the framed plaque by her with Volkmar's mature tile painting shows that artist and student had developed similar expressions (Fig. 66).

When the fine and decorative arts from this period are most clearly united, shown here in the work of the Rookwood decorators and Charles Volkmar, the closest connections to Tonalist painting may be observed. While tiles can be seen as canvas paintings carried out on clay, Rookwood's vases present the Tonalist expression continually in three dimensions, and Volkmar's later vessels abstract that expression by focusing on color without motif. These artists, however, are probably not the only ones to articulate Tonalist ideas in clay. As new names are added to the list, care should be taken to understand the artist's view of her or his work as well as the opinions of critics and reviewers of the time. As shown here, the Tonalist tendencies observable in the vases of the Newcomb Pottery were the result of market forces rather than an attempt to understand the ideas embraced by painters working in a similar style. The contextual references in the work of Volkmar and Rookwood's decorators further reveal that the aesthetics of American Tonalism transcend material expression and represent deep-seated connections between reality and perception at the turn of the last century.

NOTES

1. Anita J. Ellis, "American Tonalism and Rookwood Pottery," in *The Substance of Style: Perspectives on the American Arts and Crafts Movement*, 1990 Winterthur Conference, ed. Bert Denker (Winterthur, Del.: The Henry Francis du Pont Winterthur Museum, 1996), pp. 301–15.

2. For more on Maria Longworth Nichols, see Nancy E. Owen, *Rookwood and the Industry of Art: Women, Culture and Commerce, 1880–1913* (Athens, Ohio: Ohio University Press, 2001).

3. Longworth is credited with giving Alexander Wyant financial support for study in New York. See Jack Becker, "Studies in American Tonalism," Ph.D. diss., University of Delaware, 2002, p. 97.

4. George Ward Nichols, *Art Education Applied to Industry* (New York: Harper & Brothers, Publishers, 1877), see esp. chap. 17.

5. Oscar Lovell Triggs, "Rookwood: An Ideal Workshop," in *Chapters in the History of the Arts and Crafts Movement* (Chicago: Bohemia Guild of the Industrial Art League, 1902), pp. 160ff.

6. The Art Academy of Cincinnati was originally the School of Design of the University of Cincinnati. In 1884, the School of Design was transferred to the Cincinnati Art Museum. In 1887, the school was renamed the Art Academy of Cincinnati.

7. Ellis, "Tonalism," p. 304.

8. "Louisiana Purchase Exposition Ceramics," *Keramic Studio* 6 (January 1905), p. 193; for an extensive discussion of the vellum glaze, see Anita J. Ellis, *Rookwood Pottery: The Glorious Gamble* (New York: Rizzoli, 1992), pp. 56–57.

9. Ellis, "Tonalism," p. 307.

10. Ibid., pp. 307–8.

11. Ibid., p. 308, citing company memoranda about pieces in vellum.

12. Ibid., p. 315.

13. For more on the Newcomb Pottery, see Jessie Poesch, *Newcomb Pottery: An Enterprise for Southern Women, 1895–1940* (Exton, Pa.: Schiffer Publishing, 1984).

14. "The Newcomb Gallery to Show Art Work of the Students," (New Orleans) *Times-Picayune*, May 8, 1915.

15. Annie M. Archer, "The National Society of Craftsmen Ninth Annual Exhibition," *American Magazine of Art* 7 (February 1916), pp. 150–52.

16. W. P. Jervis, *A Pottery Primer* (New York: O'Gorman Publishing Company, 1911), p. 180.

17. Letter, October 25, 1968, quoted in Robert W. Blasberg, "The Sadie Irvine Letters: A Further Note on the Production of Newcomb Pottery," *Magazine Antiques* 100 (August 1971), pp. 250–51.

18. Ibid.

19. Poesch, *Newcomb Pottery*, p. 67.

20. "Art Exhibit at Newcomb Completed," (New Orleans) *Times-Democrat*, March 27, 1914.

21. For more information on Dow, see Nancy E. Green et al., *Arthur Wesley Dow: His Art and His Influence* (New York: Spanierman Gallery, 1999).

22. Poesch, *Newcomb Pottery*, pp. 21–28, explains these influences and the transition from one to the other. For a discussion of the ornamental style advocated by Dresser, see Ellen Paul Denker, "The Grammar of Nature: Arts and Crafts China Painting," in Denker, *The Substance of Style*, pp. 297–99.

23. Paul E. Cox, "Potteries of the Gulf Coast," *Ceramic Age* 25 (1935), pp. 8–9.

24. Edwin AtLee Barber, *The Pottery and Porcelain of the United States*, 3rd ed. rev. and enl. (New York: G. P. Putnam, 1909), p. 377.

25. Charles Volkmar, Jr. "Reminiscences" manuscript and typescript, n.p. Smithsonian Institution, Archives of American Art, reel 4391. Details of Volkmar's life given in the text are taken from this source.

26. Volkmar, "Reminiscences," n.p.

27. Volkmar, "Reminiscences," n.p.

28. Volkmar, "Reminiscences," n.p. Volkmar's references to Gille and may be to the Paris porcelain maker Jean Gille (d. 1868), who promoted the use of porcelain for interior decoration, and his sometimes partner Charles Baury, a modeler. See Elisabeth Cameron, *Encyclopedia of Pottery and Porcelain: The 19th and 20th Centuries* (London: Faber and Faber, 1986), p. 140. Contemporary writers on American art pottery have assumed that Volkmar worked in Haviland's art studios, but more definitive research is needed to identify the potteries in which he gained his knowledge of ceramic techniques.

29. United States Commission to the Paris Exposition, Thomas Pickering, comp., *Official Catalogue of the United States Exhibitors* (London, 1878), p. 259, lists Charles Volkmar of Montigny showing "#110. Landscape with Cattle."

30. Barber, *Pottery and Porcelain*, pp. 378–80.

31. "Charles Volkmar: Painter, Etcher and Ceramist," *American Art Journal* (April 14, 1888), p. 416.

32. Volkmar, "Reminiscences."

33. Undated clipping, *New York World*, Archives of American Art, Smithsonian Institution, Washington, D.C., reel 4391. Townsend's remarks were also quoted in "Charles Volkmar: Painter, Etcher and Ceramist," p. 416.

34. According to the ceramic historian Paul Evans, there is no indication that Volkmar's Menlo Park operation ever got under way. See Evans, *Art Pottery of the United States: An Encyclopedia of Producers and Their Marks* (New York: Charles Scribner's Sons, 1974), p. 312.

35. Quoted in Margaret C. Whiting, *The House Beautiful* 8 (October 1900), p. 616.

36. Jervis, *Pottery Primer*, p. 181.

37. Charles Volkmar to Henry Clayton Hopkins, October 29, 1897, on Crown Point Pottery letterhead, Archives of American Art, reel 4391. Recent research has failed to turn up the panel or a photograph of it.

38. *Brooklyn Daily Eagle*, March 17, 1901, p. 28.

39. "Art Notes," *Brooklyn Daily Eagle*, October 19, 1900, p. 9.

40. "Notes on the Crafts and Industrial Arts," *International Studio* 25 (1905), p. xi.

41. "Exhibition of the New York Society of Keramic Arts," *Keramic Studio* 11 (June 1909), p. 39.

42. Quoted in Whiting, *House Beautiful*, p. 616.

43. Regarding Robineau, see Peg Weiss, "Adelaide Alsop Robineau: Syracuse's Unique Glory," in *Adelaide Alsop Robineau: Glory in Porcelain* (Syracuse, N.Y.: Syracuse University Press, 1981), p. 14; regarding Penman and Hardenbergh, see Ellen Paul Denker, "Purely for Pleasure: Ceramics at Byrdcliffe," in *Byrdcliffe: An American Arts and Crafts Colony*, ed. Nancy E. Green (Ithaca, N.Y.: Herbert F. Johnson Museum of Art, Cornell University, 2004), p. 110.

Adelaide Crapsey: A Tonalist Life in Letters

William H. Gerdts

Artists give us not conclusions but evidence.

—Adelaide Crapsey

WHEN WE originally conceived of this exhibition, we wanted to find a literary counterpart to the Tonalist movement. After all, many poems had been written during the eighteenth and nineteenth centuries to and about both large oil portraits and more sentimental miniatures. Not only do parallels exist between Hudson River School landscapes and the nature poetry of such writers as William Cullen Bryant, but a number of Asher B. Durand's finest landscapes were directly inspired by Bryant's poems. Links have been drawn over and over between the work of the turn-of-the-century American Realists of the Ashcan School and the writings of Frank Norris and Theodore Dreiser—Dreiser actually wrote about the Ashcan School—and correspondences between modernist art and writing are manifest. And this does not take into account the voluminous poems and essays composed by artists themselves, from the writings of the leading Hudson River landscapist, Thomas Cole, to the shelf of literature by the major American Neoclassic sculptor, William Wetmore Story.

To our surprise, we located almost no literary counterparts for the evocative, sensitive imagery of such painters as J. Francis Murphy, Dwight Tryon, Birge Harrison, and countless others, so esteemed in their own time. We were aware, however, of the beautiful poetry of the early-twentieth-century writer Adelaide Crapsey (1878–1914) (Fig. 67). Much celebrated during her brief lifetime, Crapsey has not gone unnoticed in modern scholarly circles: she has been the subject of a dissertation, two master's theses, four books, and numerous articles and notices in poetry anthologies. Yet Crapsey remains what even her champions usually acknowledge, "a minor poet," often identified as a short-lived successor to Emily Dickinson.[1] The often perceptive and admirable scholarship devoted to Crapsey, beyond a study of her exceptional personal history, has been devoted almost exclusively to the development of her poetry and the integration of that achievement with her life and particularly her

Fig. 67.
Photograph of Adelaide Crapsey, Department of Rare Books and Special Collections, University of Rochester Library, New York

illness and death at the age of thirty-six. Scholars have also debated her role as possibly either a precursor to or a member of the Imagist group of poets, which included Ezra Pound, T. S. Eliot, and Amy Lowell. The irony here is that the American poem that offers the most complete analogy with the Impressionist movement—the aesthetic converse

to Tonalism—is Lowell's well-known "An Impressionist Picture of a Garden" (1919).

Nonetheless, Crapsey's art outlines an analogy between the work of the Barbizon painters and the Tonalists. Writers on Crapsey have noted that "the possibility of spiritual transcendence is never completely abandoned or denied." Like the Tonalists, she refused to "soften crag edges of despair with vague appeals to the immortality of the soul or similar Romantic sentiments. It is this power that makes them modern, prophetic, and that emphasizes the extent to which Crapsey's poetic voice, like Emily Dickinson's several decades earlier, was unique to its time and place (America)."[2] Just as Tonalist work has been distinguished from that of even mature Barbizon painting and certainly the earlier Hudson River School, Crapsey's poetry has been defined as "a retreat from the rhetorical excesses associated with the Georgian poets, excesses of emotion as well as language. The neoclassic grace of understatement, which had always reflected Crapsey's personality . . . appeared essential as a pioneer method for exploring heightened states of consciousness not normally given to understatement."[3]

Study of Crapsey's poetry has generally centered on the unique nature of her finest creation, the cinquain (a poem of five lines), of which she produced only a limited number in the few years between 1911 and 1913. For the most part, the cinquains bear the closest similarity in theme and style to the work of the Tonalist painters, who were active—perhaps not coincidentally—at much the same time. Yet, similarities between Crapsey's poetry and Tonalist painting occasionally go beyond the cinquains. One poem for instance, "The Sun-Dial"—possibly an embryonic cinquain—suggests the motifs and mood of many a Tonalist painting:

Every day,
Every day,
Tell the hours
By their shadows,
By their shadows.

Crapsey's poetry is tinged with her own sense of loss and bitterness, so that the Tonalist aesthetics are often combined with personal recollections, revelations, and predictions that are foreign to their pictorial counterparts. Take, for instance, her very early poem "Loneliness" (not a cinquain), written in response to the death of her sister Ruth:

The earth's all wrapped in gray shroud-mist,
 Dull gray are sea and sky,
And where the water laps the land
 On gray sand-dunes stand I.
Oh, if God there be, his face from me
 The rolling gray mists hide;
And if God there be, his voice from me
 Is kept by the moan of the tide.[4]

Despite the brevity of her life, Crapsey enjoyed a vigorous and remarkable career, though one plagued by tragedy and death, qualities only hinted at in some of the more melancholy Tonalist paintings. Crapsey was the third of nine children of the Reverend Algernon Crapsey, whose stormy career within the Episcopal church ended in a revolt against some of its rituals and his eventual expulsion from the clergy. Close to and supportive of her father, Adelaide shared his individuality. Crapsey grew up in Rochester, New York, but was sent to Kemper Hall in Kenosha, Wisconsin, where she began to write, though initially expressing herself in prose rather than poetry. At Kemper Hall her monochromatic wardrobe was noticed. She was known for wearing neutral colors, gray being her favorite, though brown also was common—the colors we now associate with Tonalist painting.[5] Crapsey's valedictory address at Kemper in 1897 contained imagery that brings to mind some of the imagery of Tonalist landscapes: "The road stretches out before us and our feet are set therein. The wind of the morning blows against our foreheads, and with buoyant steps we renew the journey. Deep in our hearts has sunk the image of the land we are leaving, in all its serenity and beauty."[6]

In 1897 Crapsey went to Vassar College, in Poughkeepsie, New York, where her friendship with Jean Webster, a niece of Mark Twain, led to a mutual admiration for poetry. Crapsey published short stories in the *Vassar Miscellany* beginning in 1897 and began to publish her poetry in that periodical the following year. Florence Keyes, one of her Vassar instructors, characterized Crapsey as lacking in concreteness, her treatment of things being rather diffuse, a harbinger of Tonalist characteristics.[7] The year 1898 brought a devastating blow to Crapsey's personal life with the death of her eleven-year-old sister, Ruth, from undulant fever. Three years later, her older sister, Emily, died of appendicitis. Emily, the sister against whom she had constantly measured herself and striven to excel, was her most cherished intimate. Her grief, exacerbated by the guilt of sibling rivalry, was overwhelming.[8]

In 1902 Crapsey returned to Kemper Hall to teach. She also began work on *A Study in English Metrics*, which she left incomplete at her death. She continued to write poetry, not necessarily tinged with the melancholy and presentiment of death that would later enter her work, but nature poems that share the spirit of the more buoyant Tonalist paintings, such as her "Bob White."

Bob White! Bob White:
On brink of night,
On edge of day,
While dawn is grey
In eastern sky,

I hear your cry
Bob White! Bob White!

Bob White! Bob White!
As dawn grows bright,
You sing, you sing,
On bough a-swing.

What do you say,
Bob White, Bob White?
That sun is come,
That it's light, light, light.

That it's time to be up,
Up, up, and away,
For day is here,
The glorious day!

All this you say,
Bob White, Bob White,
In sweet of day
While dawn grows bright.[9]

Crapsey sailed for Europe in 1904. In Rome she studied at the School of Classical Studies but was far more interested in nature than in the galleries of art. As one of her biographers has written: "Despite her saturation in architecture and statuary, Crapsey's Rome did not consist of monuments but of birds and sun."[10] She returned the following year to attend her father's ecclesiastical trial for heresy in Batavia, New York; in 1906 she taught literature and history at Miss Lowe's Preparatory School in Stamford, Connecticut, but left the position in December 1908, owing to failing health. At the end of that decade she made her second trip abroad; on her return, she accepted an appointment in the English department faculty at Smith College in Northampton, Massachusetts, teaching courses on poetics and verse beginning in 1911. There, her students remarked on her love of beauty for beauty's sake. In an unconscious analogy to the chromatic preferences of the Tonalists, Crapsey was conspicuous in dressing completely in gray. Her dresses, coats, and hats were all gray, and she sometimes completed this monotone with a thin, fully sharpened gray pencil.[11]

Crapsey taught at Smith for a year and a half until a diagnosis of tuberculosis forced her to surrender her position. She could not possibly have avoided some intercourse with the great Tonalist painter Dwight Tryon, who had taught at Smith since 1886. His works were on view at the college to offer inspiration to students, faculty, and visitors alike.

Karen Alkalay-Gut, Crapsey's most recent biographer, has written:

When the old poetic answers do not satisfy the hunger for a relationship between poetry and life, a new approach is needed, and the cinquain provides this approach. . . . allowing

no space for poetic images, poetic language, and the looseness or sentimentality of [Crapsey's earlier poetry] but only descriptions, contrast, and a sparseness that leaves room for the reader. The contrast is intentional, and the lack of commentary encourages the reader's innovation, the biographer's suppositions, the relating of parallel events.[12]

Surely here, again, are parallels to the aesthetics of Tonalist painting.

The evolution of Crapsey's cinquains devolved in part from her mastery of French, which led to her reading Michel Revon's 1910 translations from the Japanese in his *Anthologie de la littérature japonaise des origines au XXe siècle*. Such reading apparently acquainted her with the Japanese forms of haiku and tanka (thirty-one-syllable poems popular in Japan for over 1300 years) poetics, which bore directly on the development of her cinquains. Even one of the translations Crapsey copied from Revon—in this case a tanka by the ninth-century poet Korenori—she shaped into an image that reverberates with Tonalist aesthetics:

At daybreak,
Seeming to my eyes almost
Like the moon of dawn,
The white snow falls
On the village of Yoshino.[13]

These poems with their abbreviated forms, particularly the haiku, led to Crapsey's terse, five-line poetic constructions as well as her syllabic emphasis (the mark of the syllable pronounced slightly louder and longer than other syllables in a word). The form finds parallels both in the simplicity and austerity of Tonalist painting and in their serial emphasis on certain motifs—Tryon's repeated curtain of transparent treetops, the spare growths of J. Francis Murphy's marshes, Charles Warren Eaton's rows of stately pines, and the staccato movement across the picture plane of Arthur B. Davies's hypnotic nudes. The placement of these features often replicates the syllabic emphases within Crapsey's five-line poems, interrupting the seamless flow of a Tonalist composition with carefully chosen accents. As Crapsey envisioned her poems, they drew on the haiku's taught compression of emotion into a single striking symbol or metaphor.[14] As Susan Sutton Smith has explained, the roots of Japanese poetics, on which Crapsey drew heavily, also characterize what we view as the basis of so much Tonalist painting, itself akin to Japanese pictorial art: "What Japanese poets have most often sought is to create with a few words, usually with a few sharp images, the outline of a work whose details must be supplied by the reader, as in a Japanese painting a few strokes of the brush must

suggest a whole world."[15] Even the sheets on which Crapsey wrote her cinquains sometimes appear in general outline to echo the format of a Tonalist picture—their constantly expanding horizontals, only to end tersely at the bottom, and the broad surrounding nothingness of the blank paper. See, for instance, the photograph of her manuscript for her poem "Amaze"[16]

Before she had been long at Smith, Crapsey's health, always delicate, began deteriorating rapidly after she was diagnosed with tuberculosis. She entered a sanatorium at Saranac Lake, New York, where she died in 1914. Her volume *Verse* appeared posthumously later in 1915, with a touching preface by her old friend and associate from Rochester, Claude Bragdon; a second edition came out in 1922 with an additional preface by Jean Wallace. Marsden Hartley wrote a loving tribute to Crapsey in a essay he published in his *Adventure in the Arts*, while Carl Sandburg had already written a tribute poem to her.[17] Numerous editions of *Verse* appeared in 1926, 1929, 1934, and 1938. Bragdon later provided a telling description of the deceased poet: "she was secretive, shy, inwardly burning with unavowed admirations and secret scorns. . . . Her eyes were blue grey; her hair was ashen blond; her mouth was large and mobile, and her teeth extraordinarily regular and white. She was so swift and silent in all her movements that she seemed never to enter a room, but to appear there, as at the stroke of some invisible clock. She dressed mainly in grey, with some cloud of gossamer bewitchment wrapped about or trailing after her, for she was a true daughter of Astarte: "Mistily radiant, clad like the moon,"[18] truly a Tonalist image.

This essay concludes with a selection of Crapsey's cinquains that are most closely allied to the aesthetics of Tonalism. Note, however, the variations she injected into the poetic expression, from the fatality of *Triad* and *Winter* to the exaltation of nature in *Snow*.

> *Fate Defied*
> As it
> Were tissue of silver
> I'll wear, O Fate, thy grey,
> And go mistily radiant, clad
> Like the moon.

> *Anguish*
> Keep thou
> Thy tearless watch
> All night but when blue dawn
> Breathes on the silver moon, then weep!
> Then Weep!

Moon-Shadows
Still as
On windless nights
The moon-cast shadows are,
So still will be my heart when I
Am dead.

Snow
Look up . . .
From bleakening hills
Blows down the light, first breath
Of wintry wind . . . look up, and scent
The snow!

November Night
Listen . .
With faint dry sound,
Like steps of passing ghosts,
The leaves, frost-crisp'd, break from the trees
And fall.

Triad
These be
Three silent things:
The falling snow . . the hour
Before the dawn . . the mouth of one
Just dead.

Refuge in Darkness
With night's
Dim veil and blue
I will cover my eyes,
I will bind close my eyes that are
So weary.

Night Winds
The old
Old winds that blew
When chaos was, what do
They tell the clattered trees that I
Should weep?

Winter
The cold
With steely clutch
Grips all the land . . alack,
The little people in the hills
Will die!

Arbutus
Not spring's
Thou art, but hers,
Most cool, most virginal
Winter's, with thy faint breath, thy snows
Rose-tinged.

Epigraph: Unattributed quotation copied by Crapsey in her commonplace book. Susan Sutton Smith, ed., *The Complete Poems and Collected Letters of Adelaide Crapsey* (Albany, N.Y.: State University of New York Press, 1977), p 45.

1. Books: Mary Elizabeth Osborn, *Adelaide Crapsey* (Boston: Bruce Humphries, 1933); Smith, *The Complete Poems*; Edward Butscher, *Adelaide Crapsey* (Boston: Twayne Publishers, 1979); Karen Alkalay-Gut, *Alone in the Dawn: The Life of Adelaide Crapsey* (Athens: University of Georgia Press, 1988). Theses and dissertations: Mary Edwardine O'Connor, "Adelaide Crapsey: A Biographical Study," master's thesis, University of Notre Dame, 1931; Walter C. Loescher, "The Personality and Poetry of Adelaide Crapsey," master's thesis, University of Rochester, 1947; Susan Sutton Smith, ed., "The Poems of Adelaide Crapsey: A Critical Edition with Introduction and Notes," Ph.D. diss., University of Rochester, 1972.

2. Butscher, *Adelaide Crapsey*, pp. 15–16.

3. Ibid., p. 75.

4. "Loneliness," *Vassar Miscellany* 28 (November 1898), p. 71.

5. Alkalay-Gut, *Alone in the Dawn*, p. 60.

6. *Kemper Hall Kodak* 4 (June 1897), p. 5.

7. Horace Gregory and Marya Zaturenska, *A History of American Poetry, 1900–1940* (New York: Harcourt, Brace and Company, 1942), p. 93.

8. Alkalay-Gut, *Alone in the Dawn*, p. 106.

9. *Kemper Hall Kodak* 9 (January 1902), pp. 1–2.

10. Alkalay-Gut, *Alone in the Dawn*, pp. 136, 138.

11. Osborn, *Adelaide Crapsey*, p. 87; Alkaly-Gut, *Alone in the Dawn*, p. 251.

12. Alkalay-Gut, *Alone in the Dawn*, p. 310.

13. Smith, *The Complete Poems*, p. 26.

14. Butscher, *Adelaide Crapsey*, p. 76.

15. Smith, *The Complete Poems*, p. 35.

16. Ibid., p. 57.

17. Marsden Hartley, *Adventures in the Arts* (New York: Boni and Liveright, 1921), pp. 207–14; Carl Sandburg, "Cornhuskers," in *Collected Poems* (New York: Harcourt, Brace and Jovanovich, 1970), pp. 101–2.

18. Claude Bragdon, *More Lives Than One* (New York: Alfred A. Knopf, 1938), pp. 258–59.

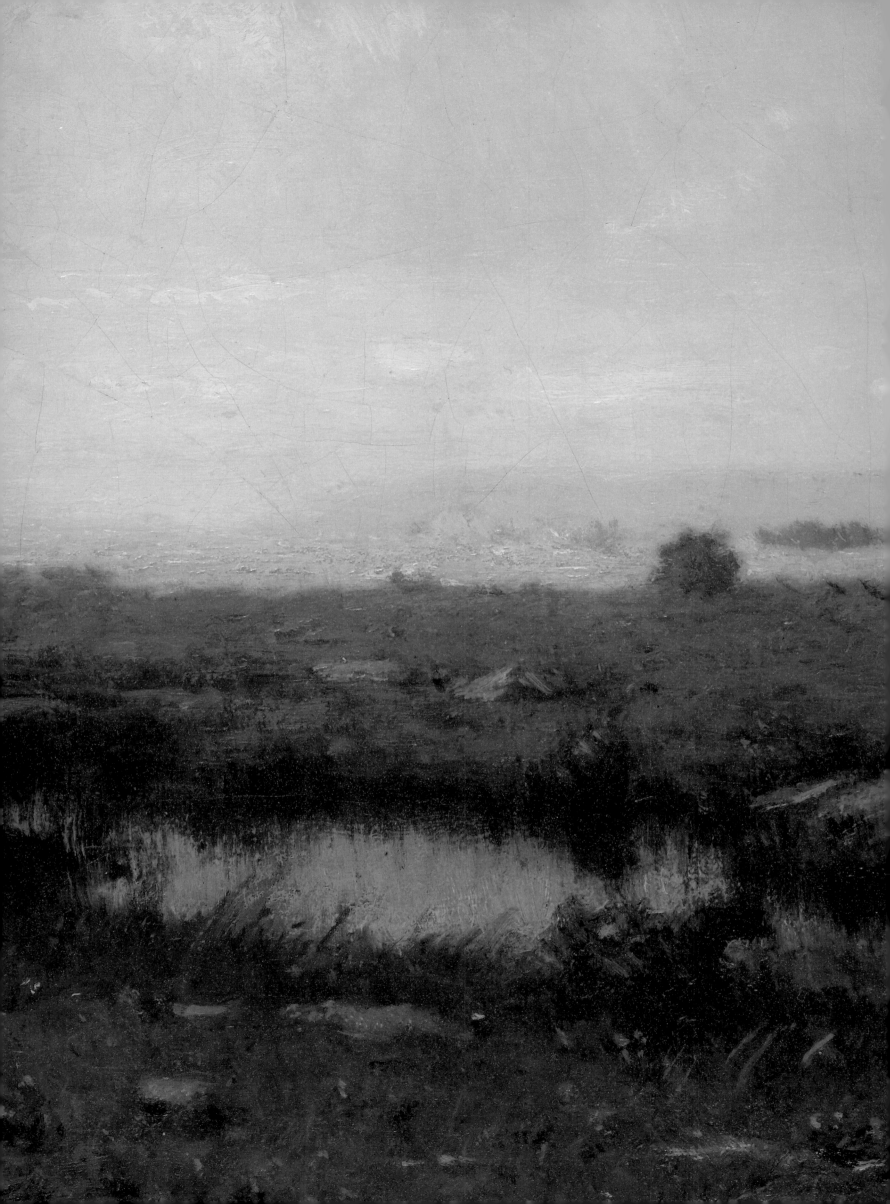

Catalogue

Bruce Crane

(1857, New York City–1937, Bronxville, New York)

DESCRIBED in *Art Amateur* as "among [America's] most popular painters of landscape," Bruce Crane garnered widespread acclaim for his evocative views of peaceful rural locales inspired by scenery he encountered in the northeastern United States.[1] Indeed, his poetic mode of painting inspired one commentator to rank him as the "most idyllic" of native landscapists.[2] Crane exhibited his paintings at key Tonalist venues, such as the Lotos Club and the National Academy of Design, where he won numerous awards and prizes. His work also caught the eye of such prominent businessmen as William T. Evans and George A. Hearn, who admired his ability to translate fugitive outdoor effects into paint.

Crane's introduction to a mode of landscape painting that emphasized mood over topographical description came from Alexander Wyant (Cats. 44–46), with whom he studied during 1877–78. About 1878, preferring the civilized landscape over untamed wilderness, he began making trips to the east end of Long Island, where he painted Barbizon-inspired views of ponds, meadows, and farmyards that brought him his earliest critical and financial success. Crane's move toward an art of subjectivity was reinforced by a trip to France in 1882, when he studied with the French landscape painter Jean-Charles Cazin and fraternized with other Americans working in the artists' colony at Grèz-sur-Loing. Secure in his aesthetic direction, he returned to the United States and painted bucolic landscapes, working primarily in the countrysides of New Jersey, New York, and southern Connecticut. He maintained his studio in Manhattan until 1914, when he settled in Bronxville, New York, and became a noted member of the local art colony there. Crane also held strong ties to the artistic life of Old Lyme, Connecticut—an area he first visited during the early 1900s and that became one of his favorite haunts during the 1920s and 1930s.

Crane's well-known predilection for seasonal themes, as well as the Tonalist partiality for depicting

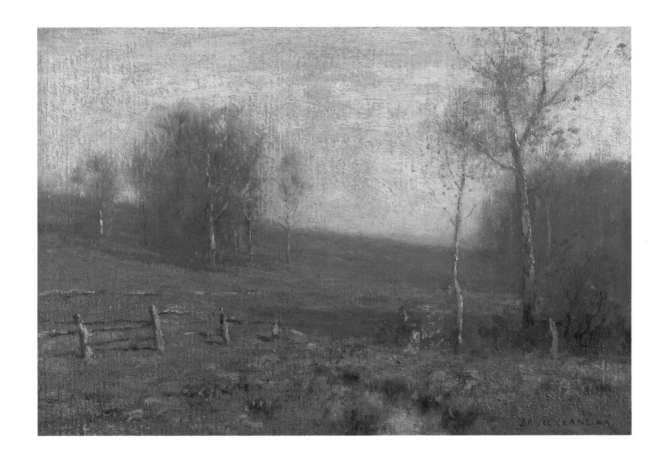

1.
Late Autumn, after 1901
Oil on canvas
14 × 20 inches
Signed lower right:
Bruce Crane NA

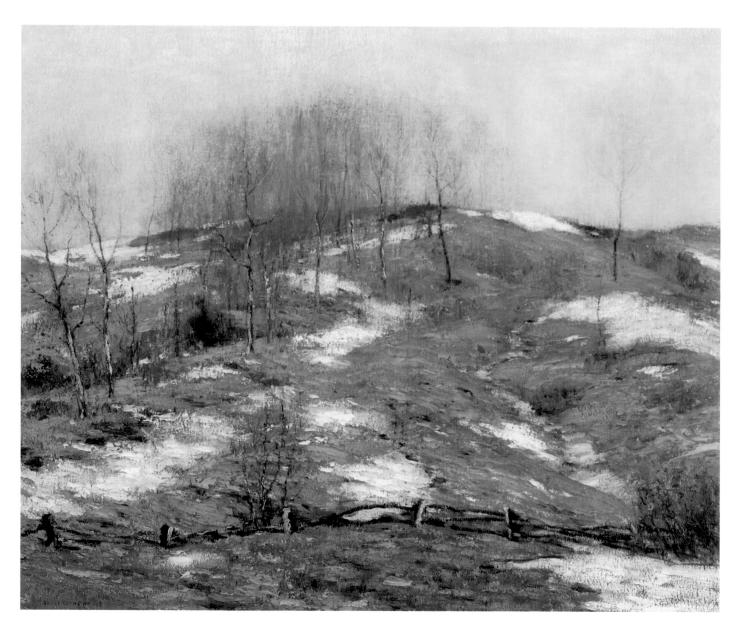

2.
Lingering Winter, 1925
Oil on canvas
30 × 36 inches
Signed lower right:
Bruce Crane NA 1925
Florence Griswold
Museum, Old Lyme,
Connecticut, Gift of
The Hartford Steam
Boiler Inspection and
Insurance Company

the unassuming corners of nature, is evident in works such as *Late Autumn*, a typically broadly rendered canvas that underscores his dictum that "A work of art is not a scientific statement."[3] To be sure, Crane worked in the studio, using sketches and relying on memory and imagination to create his paintings. This lyrical oil demonstrates the most salient hallmarks of Tonalism—a subdued luminosity, a palette composed of a limited number of hues, and a fluent technique that suggests rather than describes.

Like his Tonalist colleagues, among them Birge Harrison (Cats. 12–15) and Leonard Ochtman (Cat. 27), Crane also created winterscapes, especially after 1910. In *Lingering Winter* he adhered to a reductive composition featuring leafless saplings on a rolling hillside covered with patches of snow. His low-keyed palette evokes the emptiness and quietude associated with the final vestiges of winter, while his expressive handling helps capture a

sense of the fleeting moment, as well as the underlying essence of his subject. Certainly, both oils affirm Crane's reputation as a master of the contemplative landscape.

CL

1. "Bruce Crane and His Work," *Art Amateur* 31 (September 1894), p. 70. For a recent account of Crane's career, see Charles Teaze Clark and Mary Muir, *Bruce Crane (1857–1937): American Tonalist*, exh. cat. (Old Lyme, Conn.: Florence Griswold Museum, 1984).
2. "A Painter of Idylls—Bruce Crane," *Brush and Pencil* 11 (October 1902), p. 1.
3. Bruce Crane quoted in Edgar Holger Cahill, "Bruce Crane: Master of Landscape," *Shadowland* 6 (June 1922), p. 70.

Leon Dabo

(1865, France–1960, New York City)

LEON DABO enjoyed a long and prolific career during which time he attracted widespread acclaim for his atmospheric depictions of the Hudson and East rivers of New York shown at daybreak and twilight—the silent, introspective times of day that appealed to the Tonalist sensibility. As observed by the English critic, John Spargo, Dabo's canvases were painted "idealistically, with a poet's vision of subtle and hidden things . . . he loves Nature in all her moods, but he loves best of all her serenity, so . . . his pictures are delicate, ethereal visions of Nature's vast, universal simplicity, beauty and peace."[1] Spargo's comments would certainly apply to *Hudson River*, which, in its restrained chromaticism, minimalist design, pliant brushwork, and subjective vision, stands as a quintessential example of Tonalism. The painting also brings to mind the comments of the poet Edwin Markham, who proclaimed: "The Hudson River of Dabo is not on any atlas; it is not the Hudson of commerce It is the Hudson of romantic lure and vision. It is the Hudson of the faerie lights and sibylline fogs."[2]

The son of Ignace Scott, an artist who specialized in architectural decoration, Dabo grew up in Detroit, Michigan, where his family settled in 1871.[3] After serving an apprenticeship under his father, he set out for New York, where he worked as an architectural designer at the J. & R. Lamb Studios and befriended such prominent artists as the painter and muralist John La Farge. In 1886 he traveled to Paris, attending classes at the Ècole des Arts Décoratifs, the Académie Julian, and the Ècole des Beaux-Arts. His travels also took him to Italy and to London, where he visited the studio of James McNeill Whistler (Cat. 43), whom his father claimed to have known during his early years in Paris. Although Dabo's encounter with the American expatriate painter is undocumented, Whistler's "art-for-art's-sake" philosophy, his fluent technique, his predilection for muted hues, his interest in riverside motifs, and the inclusion of a monogram in his signature had a profound effect on Dabo's art. Dabo later considered himself an expert on Whistler, authenticating the master's work, writing articles on his style, and describing visits to his London atelier.

Returning to New York in 1892, Dabo resumed his career as a successful decorator of civic and religious buildings while painting landscapes in his spare time. He initially worked in a tight, academic manner; however, after assimilating a variety of influences, ranging from Whistler to French Impressionism and Japanese masters such as Hiroshige and Hokusai, he came into his own as an artist, developing a manner of painting in which he emphasized gentle nuances of light and atmosphere, luminous color effects, and an innovative handling of space. A turning point in his career as a fine artist occurred in 1905, when he had an important solo exhibition at the National Arts Club in New York that attracted critical accolades and brought his painting into the public eye. His oils were subsequently acquired by club member William T. Evans, an enthusiastic collector and promoter of Tonalist painting.

In addition to creating the dream-like river scenes for which he is best known, Dabo also painted still lifes of flowers that prompted comparisons with those of Odilon Redon and Henri Fantin-Latour. During the 1920s he frequently lectured at museums and universities, expounding on such topics as art education and the work of specific artists, among them the aforementioned La Farge and Whistler.

CL

1. John Spargo, "Leon Dabo, Poet in Color," *Craftsman* 13 (December 1907), pp. 261–62.

2. Edwin Markham, quoted in Ivan Narodny, *American Artists* (New York: Roerich Museum Press, 1930), p. 30.

3. The fact that Dabo's father assumed a new name—Ignace Scott (or Ignatius Schott)—on immigrating to America, raises suspicions about the reason he brought his family to the New World. For this issue, as well as matters pertaining to Dabo's birthdate—which has been determined to be 1865 rather than 1868, as commonly thought—see Arlene Pancza's excellent essay on the artist in J. Gray Sweeney et al., *Artists of Michigan from the Nineteenth Century*, exh. cat. (Muskegon, Mich.: Muskegon Museum of Art, 1987), pp. 154–59, 199–200.

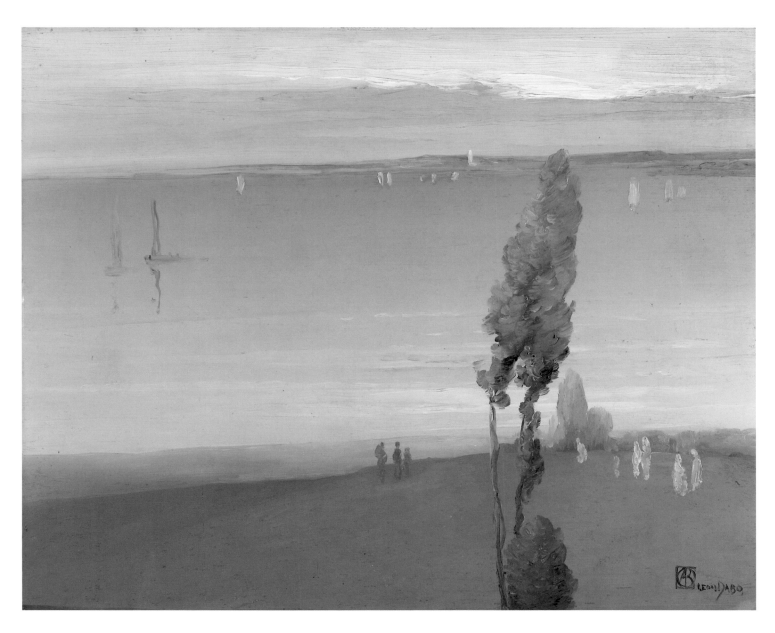

3.
Hudson River, 1918
Oil on canvas
15¼ × 19¼ inches
Signed and monogrammed
lower right: *Leon Dabo*

Charles Harold Davis

(1856, Amesbury, Massachusetts–1933, Nutley, New Jersey)

ONE OF the finest and most successful American landscape painters of his day, Charles Harold Davis employed the technical and thematic strategies of Tonalism during the 1880s and 1890s. His work in this vein is said to have appealed to art aficionados with a penchant for the "serene phases of landscape art"; indeed, in an era of increasing urbanization and industrialization, and unprecedented wealth, Davis found a ready audience for his work, attracting patronage from such prominent collectors as Thomas B. Clarke and George Seney.[1]

Davis was a son of James H. Davis, a school teacher and librarian, and his wife, Elizabeth, a woman of culture and refinement whose friends included the poet John Greenleaf Whittier.[2] As a young man, he mastered the clarinet and became an accomplished draftsman. At the age of fifteen, Davis abandoned his formal schooling to embark on an apprenticeship to a carriage maker, although he continued to paint and draw in his spare time, experimenting with watercolor techniques. Four years later, feeling unfulfilled with his work, he decided to pursue an artistic career, a decision that was prompted by viewing some drawings by French Barbizon painters such as Jean-François Millet—whose work was becoming increasing popular in Boston art circles—at the Boston Athenaeum.

In 1880, after a period of study with Otto Grundman at the School of the Museum of Fine Arts, Boston, Davis went to Paris, refining his skills in depicting the human form at the Académie Julian under the tutelage of Jules-Joseph Lefebvre and Gustave Boulanger. More importantly, he made a trip to the village of Barbizon and was so captivated by the beauty of the surrounding countryside that he decided to abandon his formal studies at Julian's and pursue landscape painting instead.

Davis subsequently settled in the town of Fleury, not far from Barbizon. He remained in France for a decade, painting contemplative, mood-filled sunset and twilight scenes that he exhibited at the Paris Salons, at the national annuals back in America, and at the galleries of Doll and Richards in Boston. As observed by one commentator, his work from this period was "almost pure Barbizon; simple in composition, solidly drawn, somber and severe in tonality, but . . . characterized by nice relation of planes and an aim at expression not bounded by realism"— qualities that were integral to the Tonalist point of view and that are apparent in works such as *Landscape with Fence and Trees*.[3] However, as revealed by *Summer Landscape*, painted during his French period, Davis was beginning to incorporate the pastel hues of Impressionism into his views of rural

4.
Landscape with Fence and Trees, ca. 1878
Oil on board
6½ × 10¼ inches

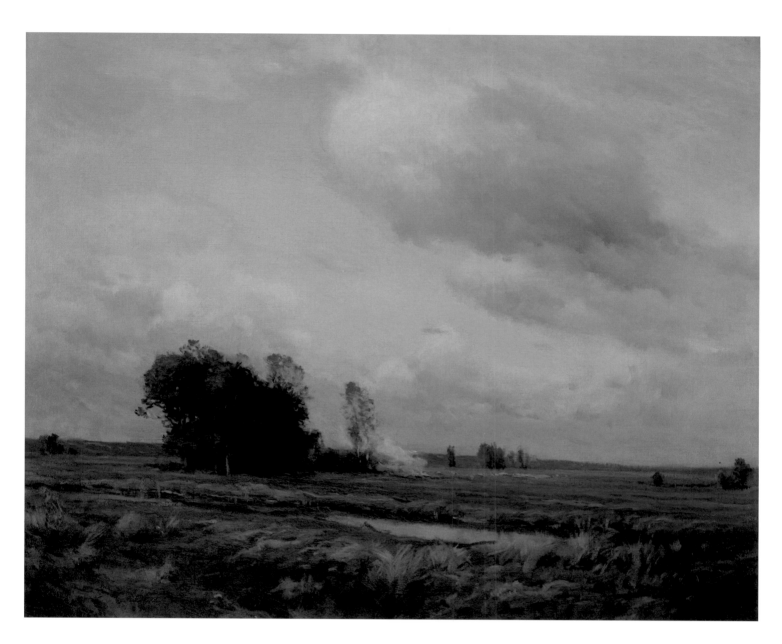

scenery, in addition to exploring the pictorial potential of clouds, which became his signature theme after the turn of the century.

In the fall of 1891, Davis settled in the coastal town of Mystic, Connecticut, drawn to its bucolic countryside, which reminded him of Barbizon. He went on to play a lively role in local art life as the leading member of the town's art colony and founder of the Mystic Art Association. By about 1894, responding to the growing popularity of Impressionism in American art circles, Davis turned to an increasingly brighter chromaticism and a dynamic technique, imbuing his paintings with a greater degree of luminosity and a joyous mood; by 1905, he had abandoned his tonal manner altogether and had become critically linked with the Impressionist movement in the United States. Thereafter, he painted sparkling views of the New England countryside, retaining the love of nature that had characterized his work as a Tonalist.

CL

1. William Howe Downes, "Charles H. Davis's Landscapes," *New England Magazine* 27 (December 1902), p. 429.

2. For Davis, see *Charles H. Davis, N.A., 1856–1933*, exh. cat. (Mystic, Conn.: Mystic Art Association, 1982).

3. Louis Bliss Gillet, "Charles H. Davis," *American Magazine of Art* 27 (March 1934), p. 105.

5.
Summer Landscape, 1886
Oil on canvas
28 × 35 inches
Signed and dated lower left: *C H Davis 1886*
Thomas Colville
Fine Art, LLC

Thomas Wilmer Dewing

(1851, Boston–1938, New York City)

LANDSCAPE was the central thematic occupation of Tonalist painters; however, this was not the case with Thomas Wilmer Dewing, who applied the strategies of Tonalism to depictions of contemporary women shown in moments of idle repose in stark, unadorned interiors or verdant outdoor settings. His contemplative paintings appealed to Gilded Age art aficionados with an eye to delicacy, refinement, and feminine beauty, among them the Detroit industrialist Charles Lang Freer, who admired the Whistlerian qualities of Dewing's work. He was also a favorite of the New York–based patron John Gellatly and his wife, Edith, who owned thirty-one paintings by the artist, among them *Young Girl Seated*.[1]

Dewing began his career in his native Boston, working as a lithographer while attending drawing classes at the School of the Museum of Fine Arts, Boston.[2] In 1876, after a stint as a portraitist in Albany, New York, he went to Paris, honing his expertise as a figure painter at the Académie Julian under the tutelage of Gustave Boulanger and Jules-Joseph Lefebvre. On returning to the United States in the autumn of 1877, he established his studio in Boston and became a teaching assistant at the Museum School. In the autumn of 1880 he moved to New York City, drawn to its lively art community and hoping to broaden the market for his paintings. A few months later he joined the faculty at the Art Students League, where he remained until 1888. In 1881 Dewing married Maria Richards Oakey, a gifted painter of floral subjects. After 1885 the couple would typically spend their summers in Cornish, New Hampshire, where, for many years, they formed an integral part of the local art colony. From 1906 until 1914 Dewing and his wife spent their summers in East Conway, New Hampshire.

During the 1880s, inspired by the British Aesthetic Movement, Dewing specialized in allegorical figure paintings that, in their solid construction and careful draftsmanship, reflected the legacy of his Parisian training. However, by about 1890, looking to the simplified designs of James McNeill Whistler and to the Japanese print tradition as his stylistic antecedents, he took his art in a new direction, focusing on the quiet and very imaginative portrayals of idealized female types for which he is best known (and often placing his oils in frames designed by his friend, the architect Stanford White). As is apparent in *Young Girl Seated*, his models' gazes were always directed away from the viewer, giving them a Vermeer-like sense of psychological detachment that is at once mysterious, enigmatic, and soulful—open to various interpretations depending on the point of view of the observer.[3] Dewing did not confine his intriguing interpretation of womanhood to his easel paintings; an expert draftsman, he also created equally beautiful pastels and silverpoint drawings of elegant, wistful women that contributed to his high ranking in the art world.

Dewing's genteel subject matter and his membership in Ten American Painters, a group of celebrated artists who exhibited together in small, non-juried shows from 1898 until 1919, connects him with the tradition of Impressionism in the United States.[4] However, his love of muted, opalescent colors and softly brushed forms and his preference for a vague, nuanced atmosphere, which dematerialized figures to the point where they acquired an ethereal, otherworldly quality, link him to the pictorial concerns of Tonalism and its emotional and spiritual underpinnings.

Dewing's art, often compared to that of Dwight W. Tryon, was championed by the leading critics of his day, among them Charles de Kay, Charles Caffin, Sadakichi Hartmann, and Royal Cortissoz. During the early years of the twentieth century, as modernism and the gutsy realism of Robert Henri and his cohorts began to gain a foothold on the art scene, Dewing continued to paint reflective images of women, enhancing the suggestive aspect of his figures by conceiving them as thin, elongated forms. Writing for the *New York Sun* in 1911, the critic James Huneker called him "The Bonzi of American art, a Whistler who has refined upon himself . . . he is our last word in subtle tonalities."[5]

CL

1. Gellatly bequeathed his collection of American art to the National Gallery of Art (now the Smithsonian American Art Museum) in 1929.

2. For a comprehensive study of Dewing, see Susan A. Hobbs and Barbara Dayer Gallati, *The Art of Thomas Wilmer Dewing: Beauty Reconfigured*, exh. cat. (New York: Brooklyn Museum, in association with the Smithsonian Institution Press, 1996).

3. For an interpretation of the meaning of Dewing's paintings, see Barbara Dayer Gallati, "Beauty Unmasked: Ironic Meaning in Dewing's Art," in Hobbs and Gallati, *The Art of Thomas Wilmer Dewing: Beauty Reconfigured*,

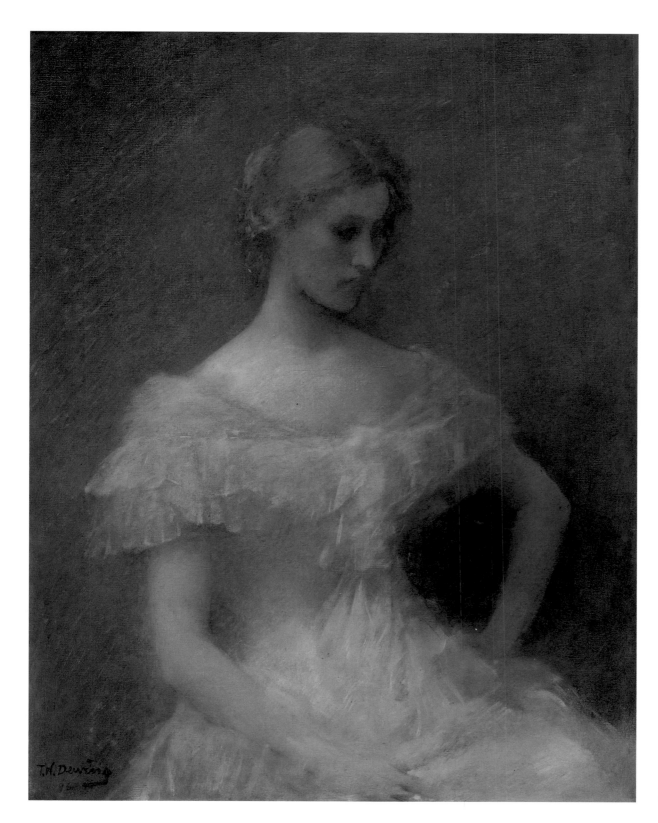

6.
Young Girl Seated, 1896
Oil on canvas
20⅛ × 16⅛ inches
Signed and dated lower
left: *T. W. Dewing / 96*
Smithsonian American Art
Museum, Washington, D.C.,
Gift of John Gellatly

pp. 51–82. For a discussion of *Young Girl Seated* and other
works by Dewing in relation to the mental health of women
during the late nineteenth century, see Zachary Ross, "Rest
for the Weary: American Nervousness and the Aesthetics of
Repose," in Katherine Williams et al., *Women on the Verge:
The Culture of Neurasthenia in Nineteenth-Century America*,
exh. cat. (Stanford, Calif.: Iris & B. Gerald Cantor Center
for Visual Arts, 2004), pp. 21–35.

4. The majority of the group, which included John Henry
Twachtman and J. Alden Weir, were Impressionists. See
William H. Gerdts et al., *Ten American Painters*, exh. cat.
(New York: Spanierman Gallery, 1990).

5. James Huneker, "Ten American Painters," *New York
Sun*, March 22, 1911, p. 6.

Charles Warren Eaton

(1857, Albany, New York–1937, Glen Ridge, New Jersey)

A PERCEPTIVE landscape painter and an important exponent of Tonalism, Charles Warren Eaton loved to depict the peaceful and intimate aspects of his environment. Accordingly, he focused on the ethereal light of dawn and dusk—times of day that stir the soul and inspire contemplation on the part of the viewer. Devoid of reference to man or architecture, Eaton's Tonalist landscapes have an aura of tranquility that appealed to art audiences of his day, among them the writer Thomas Whipple Dunbar, who lauded the artist's ability to convey "A spiritual quality that moves the observer into a similar attitude of mind."[1]

Eaton began sketching and painting during the mid- to late 1870s, while working at a dry-goods store in his hometown of Albany. In 1879 he moved to New York City, where he divided his time between working as a clerk at the H. B. Claflin & Company and taking classes in figure painting at the Art Students League and the National Academy of Design. In 1886 he traveled to Europe, accompanied on his voyage by fellow painters Leonard Ochtman (Cat. 27) and Ben Foster (Cat. 10). While in France, Eaton visited Paris, where he saw examples of French Barbizon painting, and spent time in the countryside, at popular artists' haunts such as Fontainebleau and Grèz-sur-Loing. These experiences influenced his move away from a topographical approach to landscape painting, as did his contact with George Inness (Cats. 19–21), a major exponent of Barbizon painting in the United States, whom Eaton had met at the Art Students League in 1882. In 1888 he settled in Bloomfield, New Jersey, and in the following years he remained in close touch with Inness and his son, the painter George Inness, Jr. Exploring the aesthetic potential of a wide range of media, such as oil, pastel and watercolor, Eaton created suggestive works of art inspired by rural scenery in the northeastern United States, as well as in Holland and Belgium.

Eaton's most thorough forays into Tonalist strategies are apparent in his views of a pine grove silhouetted against sunset skies, which he painted in both rural Connecticut and New Jersey from about 1900 to 1910 (a thematic predilection that earned him the nickname "the Pine Tree Painter"). As demonstrated by works such as *Snowy Landscape at Dusk* and *Moonrise*, he favored simple, well-structured compositions divided into clearly defined areas of landscape and sky, and would typically depict a strip of pines close-up on the picture plane, a method that allowed him to explore the decorative potential of branches, trunks, and foliage. Influenced by the example of contemporary photography, and by his own investigation of that medium, he would abruptly crop the upper portions of the trees, creating an impression that they extend heavenward, beyond their earthly boundaries. Eaton conjoins these methods with fluid brushwork and a balanced palette of dark earth tones and luminous pastel hues and in so doing successfully captures what one critic defined as "that sad, indefinable something that goes with such a scene at such a time, and holds one looking, waiting for the darkness to close in."[2]

During the 1910s Eaton responded to the immense popularity of Impressionism by brightening his palette and turning his attention to sunlit daytime scenes he encountered in the New England countryside, the Pennsylvania woods, and Italy's Lake Como. However, his evocative "tone" paintings remain his finest and best-known contributions to the American landscape tradition, underscoring the fact that his was an art born "of contemplation, of quiet delight in nature in her romantic moods."[3]

CL

1. Thomas Whipple Dunbar, "Charles Warren Eaton—Landscape Painter," *Art World Magazine*, February 10, 1925. For a recent examination of Eaton's life and career, see Charles Teaze Clark, *Charles Warren Eaton (1857–1937): An American Tonalist Rediscovered*, exh. cat. (New York: Spanierman Gallery, 2004).
2. Henry Martin, *News and Currier* (Charleston, N.C.), March 24, 1908.
3. Robert W. Macbeth, *Memorial Exhibition of Paintings by Charles Warren Eaton (1856–1937)*, exh. cat. (Montclair, N.J.: Montclair Art Museum, 1938).

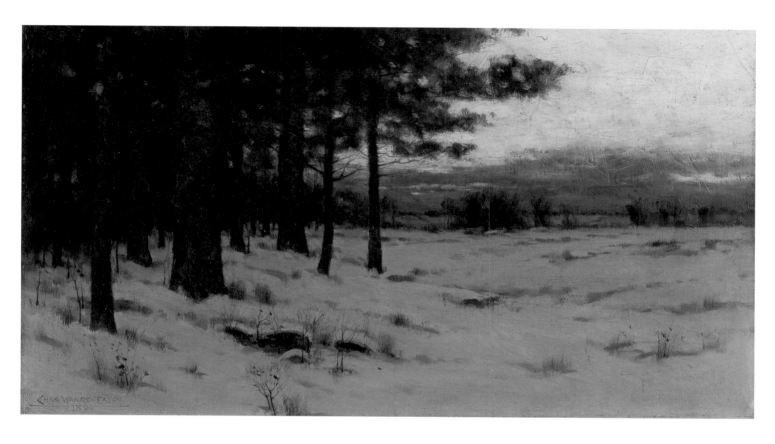

7.
Snowy Landscape at
Dusk, 1890
Oil on canvas
12¼ × 22 inches
Signed and dated
lower left: *Chas Warren*
Eaton / 1890

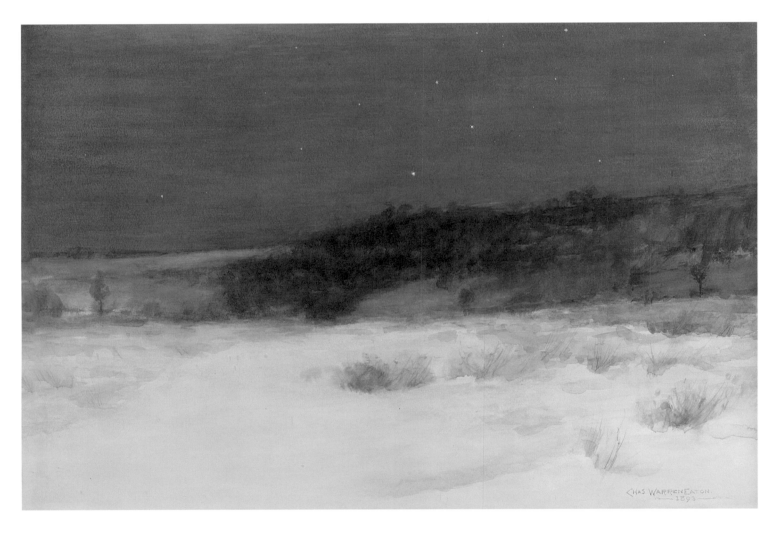

8.
Winter Night, 1893
Watercolor and pastel
on paper
20 × 30 inches
Signed and dated
lower right: *Chas Warren
Eaton / -1893-*

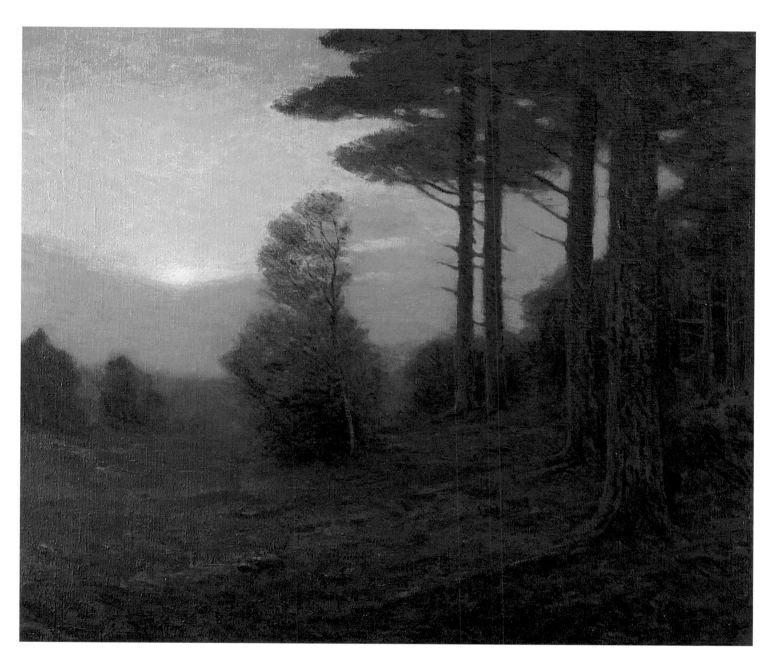

9.
Moonrise, ca. 1900–10
Oil on canvas
30 × 36 inches
Signed lower right:
Chas Warren Eaton

Ben Foster

(1852, North Anson, Maine–1926, New York City)

KNOWN FOR his views of the woods and fields of rural New England, Ben Foster was a successful landscape painter who conjoined the fluid handling of Impressionism with Tonalism's emphasis on poetic effects. His bucolic views of nature attracted patronage from leading collectors of contemporary American art, among them such notables as William T. Evans.[1]

The younger brother of the portrait and landscape painter, Charles Foster (1850–1931), Foster spent his early years in his native Maine. In 1870 he moved to New York City, where he worked in the mercantile business to study art. He took classes at the Art Students League of New York and private with the Paris-trained painter Abbott Handerson Thayer, under whose influence he created floral still lifes in a painterly Realist manner.

In the summer of 1886 Foster went to Paris, accompanied by fellow artists Leonard Ochtman (Cat. 27) and Charles Warren Eaton (Cats. 7–9), with whom he had shared a studio at 9 East 17th Street in New York. While his cohorts went on to London and Holland before returning to New York, Foster remained in the French capital, studying under Aimé Morot, Luc Oliver Merson, and Harry Thompson and exhibiting his work at the Paris Salon. He also made summer excursions to the French countryside, working in the pastoral locales favored by French Barbizon painters such as Charles-François Daubigny and Camille Corot. After returning to America in 1887, he divided his time between his studio in Manhattan and his country house in Cornwall Hollow, Connecticut.

Thereafter, Foster spent the majority of his time painting landscapes, focusing his attention on the intimate corners of his environment—usually tree-lined ponds, fields, and woodlands—that he liked to depict at contemplative times of day, such as dawn or dusk, and during intermediary times of year. The artist—who once said, "I like my pictures better without people"[2]—was especially fond of portraying the "opulent and mellow seasons," which allowed him to bring out the more evocative qualities of his subject.[3] Works such as Forest Edge reveal the hallmarks of his style, identified by one contemporary commentator as a preference for "rich but low-keyed color, and feeling of love for the shadows and the glories of the dying year," and underscores the fact that "so many of . . . [his] most brilliant canvases were in the tawny reds, browns, and grays of autumn with touches of darker evergreen among the swift changing trees."[4] In keeping with Tonalist practice, Foster painted his landscapes in his studio rather than out-of-doors, a process that allowed him to instill his work with a sense of memory and experience.

Foster exhibited his landscapes at the major national annuals, where they won a number of awards and prizes, as well as critical acclaim. When he was not creating art, he wrote critical reviews for the New York Evening Post and was an occasional contributor to the Nation. In fact, Foster's standing in the art world was such that in the wake of his death in 1926, his fellow members at the National Arts Club issued a memorial notice that demonstrated the wide esteem in which he was held, making special mention of his "gentleness, his humour, his wide review of events," and characterizing him as "the ideal type of artist, dignified, courteous, modest, original . . . ardent in seeking deeper meanings, but indifferent to the casual and popular."[5]

CL

1. Evans owned three works by Foster: Amid the Cool and Silence (location unknown), Birch-Clad Hills (Smithsonian American Art Museum, Washington, D.C.), and The Lonely Road (location unknown). See William H. Truettner, "William T. Evans: Collector of American Paintings," American Art Journal 3 (Fall 1971), p. 74.

2. Ben Foster, quoted in the Editor, "A Collection of Ben Foster's Landscapes," Fine Arts Journal 34 (April 1916), p. 176.

3. Ibid., p. 178.

4. Ibid.

5. Minutes of the Meeting of the Board of Governors, February 2, 1926, Records of the National Arts Club, Smithsonian Institution, Washington, D.C.

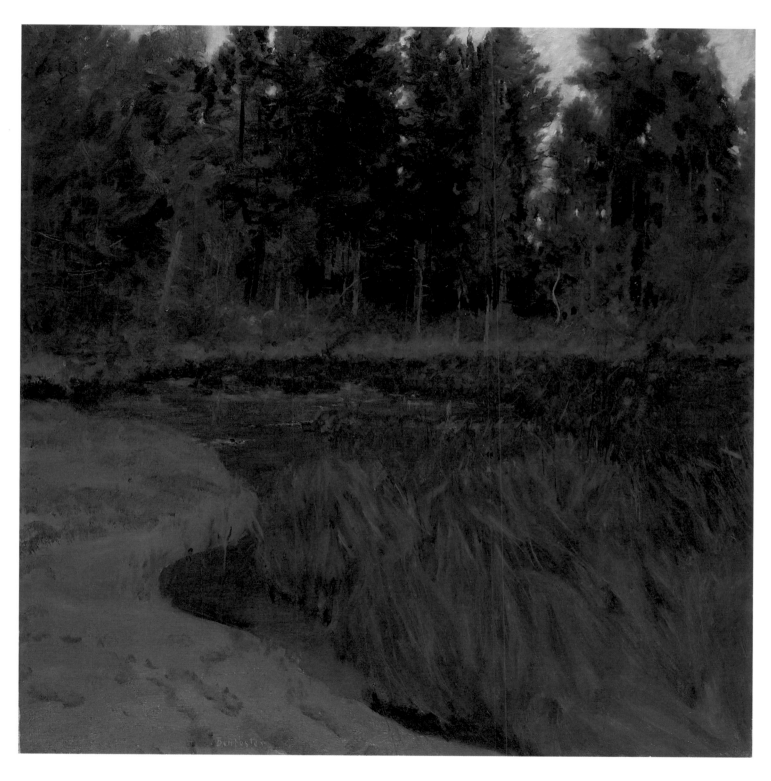

10.
Forest Edge, ca. 1900
Oil on canvas
24 × 24 inches
Signed lower left: *Ben Foster*

George Fuller

(1822, Deerfield, Massachusetts–1884, Brookline, Massachusetts)

A PAINTER of portraits, landscapes, and figure subjects, George Fuller rose to artistic maturity during the 1870s, developing an innovative and highly expressive manner of painting that made him a precursor to Tonalism. The subjective nature of his art, along with his penchant for subdued color schemes and softly defined forms, caught the eye of many critics, among them Mariana G. Van Rensselaer, who deemed his work "pure, lovely . . . [and] original," and likened it to "painted poetry."[1] His admirers also included such esteemed literary figures as William Dean Howells and John Greenleaf Whittier, as well as a generation of younger American artists and critics who lauded his painterly technique, his distaste for the traditional realist approach advocated by the conservative art establishment, and his modern outlook. They included the painter Francis D. Millet, who, after Fuller died, declared

> He had a conspicuous following of the younger men in the profession, . . . The lesson of Fuller's life is just what we need now, . . . We are painting the surfaces of things, . . . Fuller was the forerunner of a new tendency in our art . . . he has turned our attention from bric a brac, from pots and pans, from beggars and rags, and has made us look for the nobler facts in nature.[2]

Fuller had initially planned to become a daguerreotypist; however, by 1841 he was painting portraits in western New York and taking art lessons from the sculptor Henry Kirke Brown in Albany. By the end of 1842 he had settled in Boston, where he studied the work of Washington Allston, America's first Romantic painter, and continued his training at the Boston Art Association. In 1847 he moved to New York and quickly immersed himself in local art life, exhibiting at the National Academy of Design and the American Art-Union. During a trip to Europe in 1860, Fuller studied the paintings of such old masters as Rembrandt, Titian, and Velázquez and familiarized himself with the work of contemporary artists, including J. W. M. Turner and the French Barbizon painters Camille Corot and Jean-François Millet.

Returning to America in 1861, Fuller settled on the family farm in Deerfield, dividing his time between farming and painting. In the following years—taking his cue from the examples of Allston,

the Boston figure and landscape painter William Morris Hunt, and the French Barbizon tradition—he worked in a suggestive style that set him apart from the artistic mainstream and that epitomized the cosmopolitan spirit of the day.

Fuller's manner became hazier and more lyrical during the late 1870s and early 1880s, as revealed in works like *Ideal Head*, in which a lovely woman is shown against the typically mysterious background he favored for such works. To be sure, most of the figure is in shadow, with the exception of the patch of light that gently illuminates portions of the model's neck and hair and lends a note of mystery to the picture. Working with a restrained palette dominated by gold, oranges, and an array of dark earth tones, the artist describes his subject with pliant brushwork, eschewing detail and tight contours in favor of a generalized approach to form—one that makes the model appear as if enveloped in an atmospheric veil. As was characteristic of his approach, Fuller applies his pigment with a loaded brush, building up the surface of the canvas in such a way as to create lush textural effects that contribute to the aura of sensuality that pervades the image. Indeed, in *Ideal Head*, Fuller successfully combines his interest in creating a picture of a beautiful woman with his desire to convey mood through a highly lyrical style. Accordingly, this intimate vignette identifies him as a sensitive and individualistic artist whose "poetry is seductive, not compelling; idyllic, not passionate; marks him as a dreamer, not a seer. But it is true poetry, and proper to himself alone."[3]

CL

1. Mariana G. Van Rensselaer, "George Fuller," *Century Magazine*, n.s., 5 (November 1883–April 1884), pp. 229, 236.
2. F. D. Millet, "An Estimate of Fuller's Genius," in *George Fuller: His Life and Works*, ed. Josiah B. Millet (Boston: Publisher, 1886), p. 62. For a recent account of Fuller, see Sarah Burns, "A Study of the Life and Poetic Vision of George Fuller (1822–1844)," *American Art Journal* 1 (Autumn 1981), pp. 11–37.
3. Van Rensselaer, "George Fuller," p. 236.

11.
Ideal Head, ca. 1880
Oil on panel
11⅛ × 8½ inches
Signed lower left: G. *Fuller*

Birge Harrison

(1854, Philadelphia–1929, Woodstock, New York)

T HE EVOCATION of mood, along with the use of simplified compositions, fluid brushstrokes, and a palette dominated by variations of a single hue, constitute the key pictorial concerns of the artists linked with Tonalism. Accordingly, Birge Harrison can be viewed as the quintessential exponent of that aesthetic. Indeed, hailed by the critic-painter Arthur Hoeber (Cats. 16–17) as "one of the leading landscape men of this country,"[1] Harrison made a name for himself as a painter of lyrical scenes of winter twilight and rainy weather, as well as the evanescent luminosity associated with "moonlight and mist, the moments when things are glimpsed rather than seen."[2]

Harrison had originally intended to become a figure painter, attending classes at the Pennsylvania Academy of the Fine Arts in his native Philadelphia before going to Paris, where he honed his skills under Charles-Émile-Auguste Carolus-Duran and

Alexander Cabanel.[3] Responding to the prevailing interest in pleinairism, he made summer painting trips to the art colonies of Grèz-sur-Loing, near the Fontainebleau Forest, and Pont-Aven and Concarneau, in Brittany, where he painted female peasants in pastoral settings.

Harrison's decision to switch to landscape subjects was possibly inspired by his 1883 trip to London, where he first saw and was deeply impressed by the light-filled, atmospheric canvases of John Constable and John Crome. However, shortly thereafter, poor health forced him to stop painting for several years. During this time he traveled to India, Australia, and the South Seas and wrote illustrated travel articles for leading magazines. Harrison lived in Santa Barbara, California, from about 1890 to 1896, when he returned to the Northeast, settling in Plymouth, Massachusetts. Working with the limited palette and softly diffused

12.
Late Winter Afternoon,
ca. 1903–10
Oil on canvas
22 × 32 inches
Signed lower right:
Birge Harrison

13.
Fifth Avenue at Twilight,
ca. 1905–10
Oil on canvas
30 × 23 inches
Signed lower right:
Birge Harrison
The Detroit Institute
of Arts, City of Detroit
Purchase

brushwork associated with Tonalism, he began painting snowscapes in New England, as well as in Québec City, where he spent six winters. He also explored the artistic possibilities of Manhattan, depicting the city's streets and landmarks at dawn and dusk, as in *Fifth Avenue at Twilight*. In keeping with the Tonalist point of view, Harrison avoided the bright sunlight of midday, believing that "veiled and half-seen things make a stronger appeal to the human imagination."[4] This comment would certainly apply to his portrayals of radiant moonlit skies, among them *Soaring Clouds*, in which fluent brushwork allows forms to merge gently with one another to create what the artist called a "lost-edge" quality.[5]

Later in his career, Harrison was active in New Hope, Pennsylvania, as well as in Charleston, South Carolina, where he continued to explore the evanescent beauty of nocturnal skies in works like *Charleston Harbor*. His affiliation with Woodstock, New York, commenced in 1904, when he began teaching at the Byrdcliffe Arts and Crafts colony.

Two years later, he left that position to become director of the Art Students League's Summer School in Woodstock, retaining that post until 1911. Although Woodstock emerged as a center for modernism after the Armory Show of 1913, Harrison's presence there during the early 1900s helped establish the town as a leading American art colony and a center of Tonalism. While Harrison is primarily linked to that aesthetic, he often experimented with Impressionist strategies and urged his students to do the same. Many young artists, among them John F. Carlson and Zulma Steele, drew inspiration from his techniques and theories, as espoused in classes and in his book, *Landscape Painting* (1909).

CL

1. Arthur Hoeber, "Birge Harrison, N.A., Landscape Painter," *International Studio* 44 (July 1911), p. 111.
2. Birge Harrison, "The 'Mood' in Modern Painting," *Art and Progress* 4 (July 1913), pp. 1015–16.
3. For biographical details about the artist, see Andrea Husby, "Birge Harrison: Artist, Teacher and Critic," Ph.D. diss., City University of New York, 2003.
4. Harrison, "The 'Mood' in Modern Painting," p. 1015.
5. Birge Harrison, *Landscape Painting* (New York: C. Scribner's Sons, 1909), p. 48.

14.
Charleston Harbor,
ca. 1908
Oil on canvas
25 × 30 inches
Signed lower left:
Birge Harrison
Private Collection

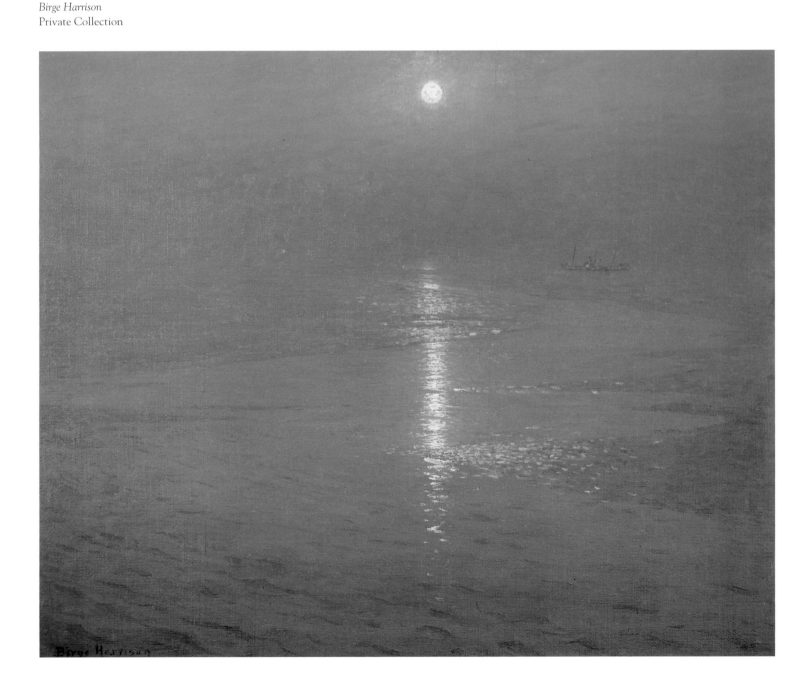

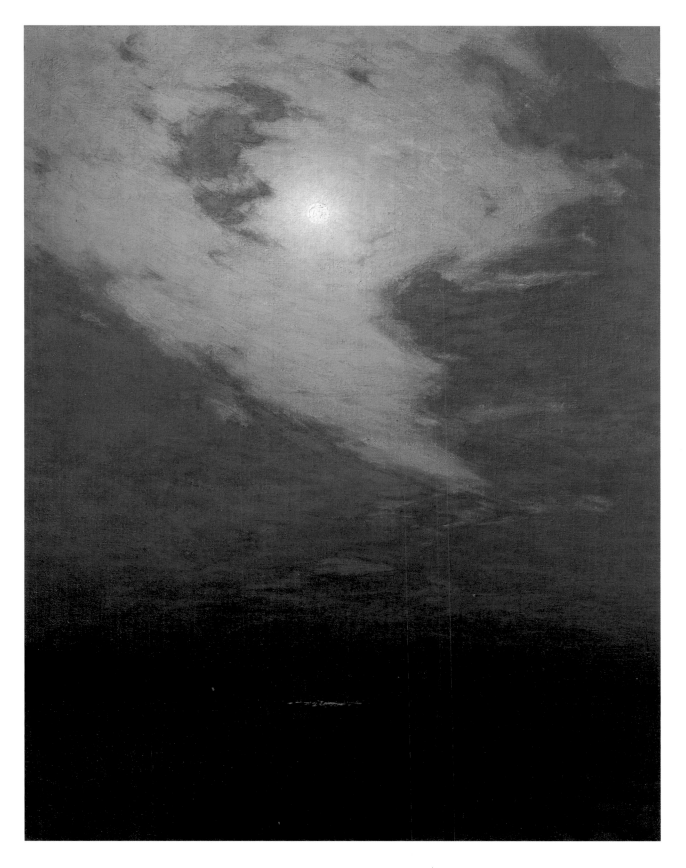

15.
Soaring Clouds,
ca. 1908
Oil on canvas
30 × 23½ inches
Signed lower left:
Birge Harrison
The National Arts Club,
New York, Permanent
Collection

Arthur Hoeber

(1854, New York City–1915, Nutley, New Jersey)[1]

ARTHUR HOEBER investigated figure subjects and genre scenes, but he was best known for his Tonalist landscapes. Focusing on the quiet, unassuming corners of his environment, he created mood-filled portrayals of marshlands and waterways in New Jersey and New England that exemplify his passion for translating the "poetry and charm of nature" into paint.[2]

Hoeber developed an interest in art as a boy, sketching and painting watercolors in his spare time. Later he took evening art classes at the Cooper Union, after which he enrolled at the Art Students League of New York. In 1881 he traveled to England, armed with a letter of introduction from the actor Lew Wallack to his brother-in-law, the painter Sir John Everett Millais. At the latter's suggestion, Hoeber went to Paris, continuing his training under the eminent figure and history painter Jean-Léon Gérôme at the École des Beaux-Arts and studying privately with Gustave Courtois.

During his six years in France, Hoeber spent his summers in Brittany, painting rural landscapes and genre scenes in Concarneau and Pont-Aven and fraternizing with a coterie of American and English artists that included Alexander Harrison, Eugene Vail, Mortimer Mempes, and Stanhope Forbes.

Returning to New York City, Hoeber increasingly painted landscape subjects, initially inspired by the coastal scenery of Cape Cod and Long Island. In 1892 he settled in Nutley, New Jersey, north of Newark, where he painted views of tidal wetlands and emerged as the foremost landscape painter associated with the local art colony there. He later spent many summers in Hyannisport, Massachusetts, where he also painted many important works.

Consistent with the aesthetic tenets of Tonalism, Hoeber's landscapes are characterized by simple compositions—usually low-lying marshes, pastures, or quiet ponds bounded by a broad expanse of

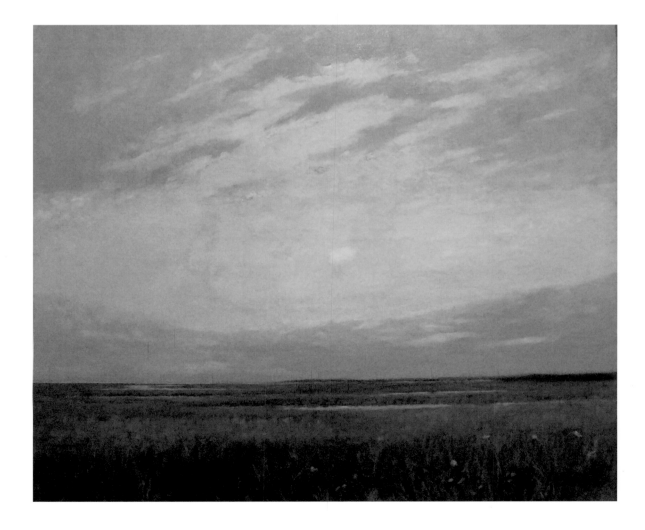

16.
Sunset on Quiet Meadow, Long Island, after 1887
Oil on canvas
25½ × 30¼ inches
Singed lower right:
Arthur Hoeber
Jersey City Museum, New Jersey, Bequest of Dr. Henry Shipman Drayton, 1923

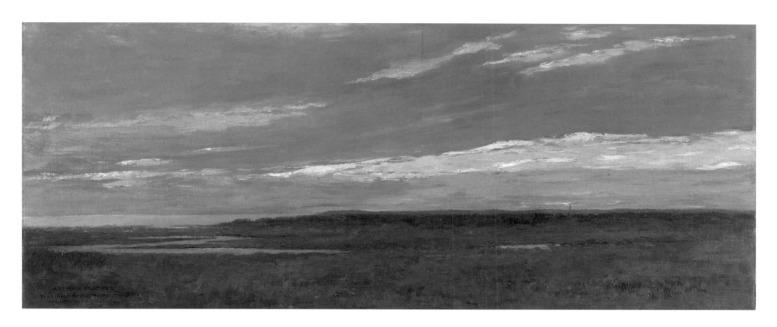

sky—painted with fluid brushwork and identified by titles referring to a season or time of day. Inspired by the example of Impressionism, he employed a rich palette, a strategy that is readily apparent in *The Marshes from Sunset Hill*, with its reductive, near-abstract design and meandering waterway. Hoeber's ability to capture the luminous glow of twilight—demonstrated to perfection in *Sunset on Quiet Meadow, Long Island*—was a key element of his work, prompting the influential critic James Huneker to describe his paintings as "refined, intimate, [and] poetic."[3]

In addition to his activity as a painter, Hoeber was an avid penman, writing articles and reviews for the *New York Times*, *Harper's Weekly*, the *New York Globe*, *Art Interchange*, *International Studio*, and other leading periodicals. In 1896 he contributed an essay on the Barbizon painter Narcisse-Virgile Diaz de la Peña to John Van Dyke's *Modern French Masters*, and in 1912 he published his own book, *The Barbizon Painters: Being the Story of the Men of Thirty*. A traditionalist at heart, Hoeber was an outspoken critic of modernism; he frequently attacked avant-garde painters such as Henri Matisse and Max Weber, claiming that their work was extremist, lacking in grace, elegance, and craftsmanship—qualities that were central to the Tonalist point of view.

CL

1. Some sources indicate his birthplace as Nutley, New Jersey.

2. Arthur Hoeber, "Unrest in Modern Art," *Forum* 41 (June 1909), p. 528.

3. James Huneker, "Around the Galleries," *New York Sun*, April 5, 1907, p. 8.

17.
The Marshes from Sunset Hill, 1901
Oil on canvas
12 × 30 inches
Signed, dated, and inscribed lower left:
Arthur Hoeber / 1901 /
To his friend Perit C. Myers /
with affectionate greetings.

William Morris Hunt

(1824, Brattleboro, Vermont—1879, Appledore, Isles of Shoals, New Hampshire)

WILLIAM MORRIS HUNT played a seminal role in creating the trend, in American painting of the 1860s and 1870s, toward a more suggestive and lyrical approach to depicting nature.[1] Accordingly, he is viewed today as one of the forerunners of Tonalism, a painter who sought to convey the underlying beauty and poetry of his subject by means of an expressive technique that focused on essentials rather than details. A talented artist and influential teacher whose outlook was thoroughly cosmopolitan, he set an important example for a younger generation of progressive-minded painters in Boston who rebelled against the transcriptive realism of the Hudson River School.

Born into an influential New England family, Hunt began studying art as a young man. In 1844 he toured Europe, eventually settling in Rome, where he learned about sculpture under Henry Kirke Brown. A year later he enrolled at the art academy in Düsseldorf but, finding the curriculum unchallenging, he went to Paris to resume his studies in sculpture. However, after seeing Thomas Couture's *The Falconer* on display in an art store, he decided to pursue painting instead, studying under Couture from 1846 to 1852. Hunt was deeply inspired by Couture's technique, which stressed generalized forms and painterly brushwork and emphasized memory rather than factual analysis in the creative process—a clear departure from the classical academicism promoted at the official École des Beaux-Arts.

During this period, Hunt also became friendly with the Barbizon painter Jean-François Millet, working alongside the master during 1852–53 and again in 1855. Inspired by Millet's direct, spontaneous approach to painting, Hunt soon developed an interest in pleinairism and rural subject matter. He also introduced the work of Millet and his counterparts to Boston society and through this means helped create a taste for Barbizon painting in that city.

By the early 1860s Hunt was painting portraits and figural pieces in which he employed a broad handling and dark, tonal palette. In 1866 he went back to Europe, visiting Millet and Camille Corot while in France. Returning to Boston in 1868, he began focusing on small-scale landscape studies executed in oil and charcoal and opened his studio to women. His theories about art, based on the notion that perception was more important than technique, were compiled by one of his students, Helen Knowlton, and published as *W. M. Hunt's Talks on Art* in 1875 and 1883.

In 1872 Hunt lost much of his work, as well as his collection of French paintings, in a fire that destroyed a large part of central Boston. After a brief trip to northeastern Florida, he came back to Boston and devoted himself to landscape themes, applying his dictum—"it is the impression of the thing you want"—to such works as *Pasture by a Pond*, with its soft, atmospheric fluency, evocative light effects, and wistful mood.[2] He continued in this direction until 1878, when he received a commission to paint two murals for the Assembly Chamber of the State Capitol at Albany, which he was compelled to complete in only two months. Unfortunately, his life was cut short the following summer when he drowned while vacationing on the Isle of Shoals in New Hampshire.

CL

1. For Hunt, see Sally Webster, *William Morris Hunt, 1824–1879* (New York: Cambridge University Press, 1991).

2. William Morris Hunt, quoted in Helen M. Knowlton, comp., *W. M. Hunt's Talks on Art: Second Series* (1883, reprint, Boston: Houghton Mifflin, 1911), p. 7.

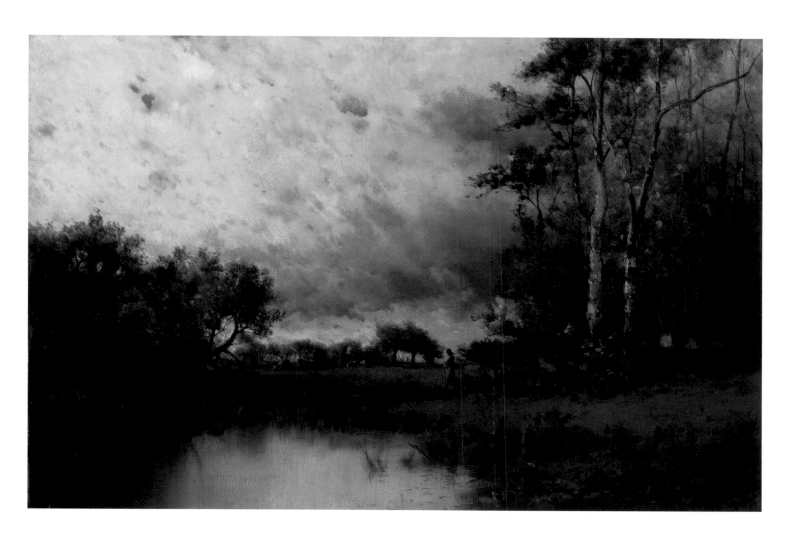

18.
Pasture by a Pond, ca. 1875
Oil on canvas
18¼ × 28¼ inches
Signed lower right with
the artist's monogrammed
initials: *WMH*

George Inness

(1825, Newburgh, New York–1894, Bridge-of-Allan, Scotland)

As others were realists in the fixed states of nature, so Inness was a realist in the moods of nature. The fleeting effects, the passing shadows, the coming storm, the twilight, the setting sun—all were themes for his brush. No phase in nature was too delicate, no phase too fleeting for him to attempt: the early spring, the misty morning, the rainbow, the changing colors of the fall; the greens of summer, the frosty morning were a joy to him, and he reveled in their difficulties. There have been poets, there have been painters, but few painter-poets that achieved his success.

—Frederick Stymetz Lamb, 1917[1]

REGARDED by many as America's foremost landscape painter of the late nineteenth century, George Inness was one of the first artists of his generation to reject the topographical approach of the Hudson River School in favor of a modern, cosmopolitan aesthetic in which painterly brushwork and evocative colors were used to create an art of poetry and feeling in relation to the "civilized" landscape. In so doing, he set the stage for the development of Tonalism, whose exponents carried on his practice of depicting intimate, domesticated settings with a fluid technique and refined color harmonies.

The son of a well-off grocer, Inness's formal training was minimal, consisting of some art lessons with John Jesse Barker, an itinerant painter, and an apprenticeship with Sherman and Smith, an engraving firm in New York City. About 1843 he spent a few weeks studying with the French-born landscapist Régis-François Gignoux in Brooklyn, who introduced him to the work of such seventeenth-century old masters as Claude Lorrain. At this point in his career, Inness's work consisted of elegantly composed views of nature that demonstrate his knowledge of the pictorial conventions of classical landscape painting.

While traveling in Europe during 1853–54, Inness found himself drawn to the work of French Barbizon painters such as Théodore Rousseau, under whose influence he began to take an interest in intimate rural scenes and a looser application of pigment. Aware of the stylistic and thematic shortcomings of the American landscape school, he became more and more preoccupied with depicting the tranquil side of nature, evident in works such as *Peace and Plenty* (1865; Metropolitan Museum of Art, New York).

Despite his progressive vision, Inness achieved little recognition from critics during the 1860s and subsequently left Manhattan, residing in Medfield, Massachusetts (1860–64), and Eagleswood, New Jersey (1864–67), before returning to New York in 1867. He lived in Italy from 1870 to 1874. On coming back to the United States, he lived briefly in Boston and then New York. In 1878—the year the collector Thomas B. Clarke became his dealer—he acquired a home and studio in Montclair, New Jersey.

Inness's oeuvre of the 1870s includes such well-known oils as *The Monk* (1873; Addison Gallery of American Art, Phillips Academy, Andover, Massachusetts), an inventive work in which he explored aspects of two-dimensional design while retaining that interest in mood with which he had come to be identified. Increasingly aware of the power of color, he also created more expressive canvases featuring dramatic twilight scenes and threatening storms. It was during this period that he began to formulate the theoretical guidelines for his art, as espoused in the article "A Painter on Painting," which appeared in *Harper's New Monthly Magazine* in February 1878. Here, Inness expressed, to an anonymous interviewer, what became the most salient idealogy of Tonalism, stating,

The highest art is where has been most perfectly breathed the sentiment of humanity.... Some persons suppose that landscape has no power of communicating human sentiment. But this is a great mistake. The civilized landscape peculiarly can; and therefore I love it more and think it more worthy of reproduction that that which is savage and untamed.[2]

Inness produced his most influential and innovative oils during the last decade of his life, when he had reached the pinnacle of his success. Working exclusively in his studio, he painted suggestive and very tranquil landscapes that were derived from experience and the imagination rather than on firsthand observation of nature. To be sure, Inness had become a follower of the Swedish mystic and theologian Emanuel Swedenborg, whose

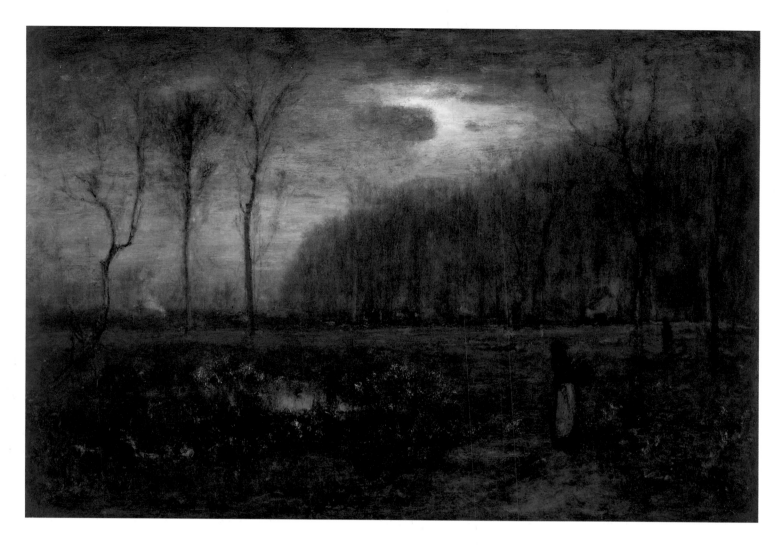

19.
Virginia Sunset, 1889
Oil on canvas
30¼ × 45¼ inches
Signed and dated lower
left: G. *Inness 1889*
Mead Art Museum,
Amherst College, Amherst,
Massachusetts, Gift of
Herbert W. Plimpton,
the Hollis W. Plimpton
(class of 1915) Memorial
Collection

teachings, brought to his attention during the 1860s, emphasized the link between the spiritual world and reality.[3] Seeking to translate Swedenborg's ideas into paint—in other words, to transport the viewer from the physical world into the realm of the divine—he adopted an expressive chromaticism and enveloped his scenes in a vague, hazy atmosphere that obscured forms and created an otherworldly ambience of shifting appearances, an approach that is demonstrated in *Sundown* and *Virginia Sunset*, in which the glowing, crepuscular light of dusk takes on a mysterious and transitory character. Inness's mastery of the metaphysical landscape and his love of portraying what he referred to as the "reality of the unseen"[4] are also apparent in *Summer, Montclair (New Jersey Landscape)*, a lyrical canvas that in its spare design, generalized forms, and lack of specifics borders on the abstract. Such paintings remind us of the words of the critic Charles de Kay, who opined that "In the mind of Inness, religion, landscape, and human nature mingle so thoroughly that there is no separating the several ideas. . . . Let us, then rather say of his religion that he does not express, but hides it, in his art."[5]

About 1890 Inness began to spend his winters in Tarpon Springs, Florida. His sojourns in that verdant locale resulted in approximately twenty-five oils,[6] some of them daytime scenes, others exquisite images of dusk, such as *Moonlight, Tarpon Springs, Florida* (1892; The Phillips Collection, Washington, D.C.), which exude that misty ambiance and feeling of quietism that came to be associated with the "tonal school of America."[7] Inness's work from these years coincided with the newfound popularity of Impressionism in the United States, and on a number of occasions his paintings were described as "impressionistic." However, the artist was never concerned with the scientific aspects of light and air; rather, his preference for simplified, blurry forms, rich hues, and lush atmospheric effects derived from his belief that landscape painting could be used as a vehicle for conveying subjective feeling and the underlying spirit of nature.

In 1894, despite poor health, Inness once again traveled to Europe, making an ambitious tour of galleries and museums in France and Germany before going to the village of Bridge-of-Allan,

20.
Sundown, ca. 1889
Oil on board mounted
on panel
23½ × 18½ inches
Signed lower right:
G. Inness

Scotland, for a much-needed rest. Although his constitution appears to have been restored, he succumbed to a stroke on the day of his arrival. The many tributes that followed in the wake of his death included an homage from Montgomery Schuyler, who declared:

> The fire and vitality, the insatiable curiosity, the willingness to try new experiments, were as strong in him at the end of his life as they were at the beginning, and his latest paintings bore abundant evidence of new attempts to reach and to render the secrets of the aspects of nature.[8]

CL

1. Frederick Stymetz Lamb, "Reminiscences of George Inness," *Art World* 1 (January 1917), p. 250.

2. "A Painter on Painting," *Harper's New Monthly Magazine* 56 (February 1878), p. 461.

3. For this aspect of Inness's art, see Adrienne Baxter Bell, *George Inness and the Visionary Landscape*, exh. cat. (New York: George Braziller, 2003).

4. George Inness, quoted in Nicolai Cikovsky, Jr., *George Inness* (New York: Harry N. Abrams, 1993), p. 112.

5. Charles de Kay, "George Inness," *Century Magazine* 24 (May 1882), p. 63.

6. Henry Adams, "George Inness, 1825–1894," in *Celebrating Florida: Works of Art from the Vickers Collection*, ed. Gary R. Libby, exh. cat. (Daytona Beach, Fla.: Museum of Arts and Sciences, 1996), p. 74.

7. Clara Ruge, "The Tonal School of America," *International Studio* 27 (January 1906), pp. lvii–lxvi.

8. Montgomery Schuyler, "George Inness," *Harper's Weekly* 38 (August 18, 1894), p. 787.

21.
Summer, Montclair (New Jersey Landscape), 1891
Oil on canvas
30¼ × 45 inches
Signed and dated lower right: G. *Inness 1891*
Private Collection

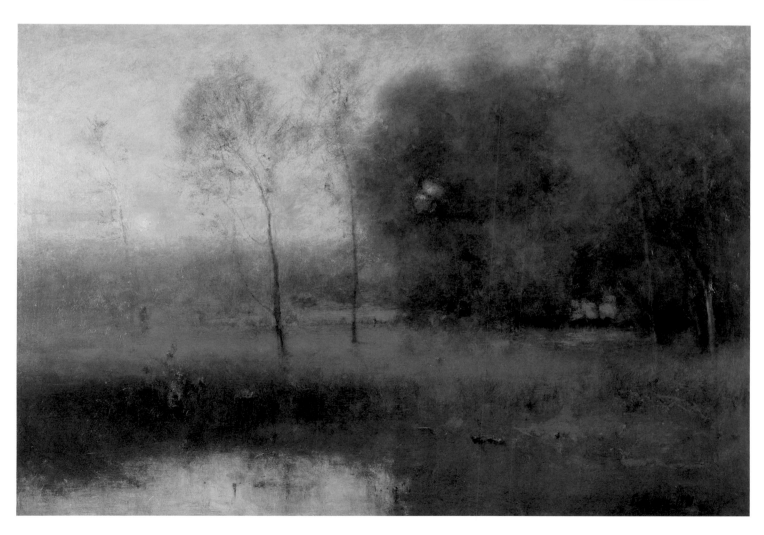

Hermann Dudley Murphy

(1867, Marlboro, Massachusetts–1945, Lexington, Massachusetts)

Dᴜʀɪɴɢ the late nineteenth century, many American painters drew inspiration from the art of James McNeill Whistler (Cat. 43), with its emphasis on simplified, near-abstract designs and a reductive palette composed of soft, harmonious hues.[1] Hermann Dudley Murphy was among his most enthusiastic disciples, applying Whistlerian precepts to the landscapes and coastal scenes he painted in Massachusetts, Maine, upstate New York, and in Europe at the turn of the twentieth century, among them *Nocturne*, which is not just a littoral scene but an exercise in delicacy and refinement.[2] The artist's fluent brushwork, limited color range, and concern for capturing an ephemeral mood links him with the Tonalist movement and reveals the fact, as noted by one critic, that it was Murphy's "strongly marked decorative feeling, and his sensitiveness to poetic effects that gives the charm to his work."[3]

Murphy received his earliest formal training at the School of the Museum of Fine Arts, Boston (1886), where he studied with the painters Otto Grundman and Joseph DeCamp. After working as a mapmaker and illustrator—during which time he made drawings for an article on Whistler appearing in *American Art Illustrated*—he traveled to the French capital in 1891, enrolling in classes under Jean-Paul Laurens and Benjamin Constant at the Académie Julian and enhancing his familiarity with Whistler's work, which was then all the rage in Paris. In 1897 he returned to Boston and painted portrait and figure subjects, as well as evocative landscapes in a Whistlerian vein. In keeping with the tenets of the Aesthetic Movement and the notion of the totality of a work of art, Murphy also created stunning frames that were designed to complement the painting in both size and hue.

In 1903 Murphy built a house and studio called Carrig-Rohane, in Winchester, Massachusetts. He also established a framing business with Charles Prendergast and W. Alfred Thulin, with whom he produced the famous Carrig-Rohane frames that were intended to complement the lyrical tonal paintings being produced by artists in their circle. The shop was so successful that it relocated to Boston in 1905 and eventually became part of Vose Galleries. The hardworking Murphy was also a teacher, serving as a drawing instructor at the Harvard School of Architecture from 1901 until 1937. He taught as well at the Worcester Museum School (1903–1907) and during the summers of 1903, 1904, and 1905 was active at the Byrdcliffe Arts and Crafts colony in Woodstock, New York, where he gave art lessons, painted views of local scenery, and operated a frame-making shop.

In his work of the mid- to late 1910s and 1920s, Murphy adopted a brighter palette and more energetic brushwork in response to several visits to tropical locales like Puerto Rico. He later turned his attention to colorful floral still lifes, executed in an academic Impressionist style that brought him abundant critical acclaim and contributed to his reputation as a leading member of the Boston School.

CL

1. For Murphy, see *Hermann Dudley Murphy (1867–1945): "Realism Married to Idealism Most Exquisitely,"* exh. cat. (New York: Graham Gallery, 1982); and *Hermann Dudley Murphy, 1867–1945: Boston Painter at Home and Abroad,* exh. cat. (New York: Graham Gallery, 1985).
2. The work may have been painted in Venice, which Murphy visited during his student years in Paris.
3. M. F. B., "Mr. Murphy's Paintings," unidentified newspaper clipping, Hermann Dudley Murphy Papers, Archives of American Art, Smithsonian Institution, Washington, D.C., reel 4039, frame 232. I would like to thank Robert G. Bardin for bringing this reference to my attention.

22.
Nocturne, 1895
Oil on canvas
12½ × 20 inches
Signed with the artist's
monogrammed initial
and dated lower left:
M 95 [illeg.]

J. Francis Murphy

(1853, Oswego, New York–1921, New York City)

JOHN FRANCIS MURPHY was born in western New York but in 1868 moved with his family to Chicago, where, as a teenager, he painted theater backdrops. Primarily self-taught, his formal training was negligible, consisting of a few weeks of instruction at the Chicago Academy of Design. About 1870, he was employed as a sign painter. Five years later he moved to New York City, where he initially made his living by working as an illustrator.

Murphy began his career painting in the detailed mode of the Hudson River School. However, during the 1870s, aware that this approach had become passé, he looked to the lyrical rural and woodland scenes of the French Barbizon painters for inspiration, adopting an individual manner of painting that emphasized a gentle luminosity, softly defined shapes, and lush contrasts of light and dark. Murphy was also influenced by the example of his countrymen, George Inness (Cats. 19–21) and Alexander Wyant (Cats. 44–46), who had likewise abandoned mid-

century literalism and wilderness motifs in favor of suggestive views of unpretentious locales at tranquil moments of the day. In fact, Murphy is known to have copied some comments made by Inness to a writer for *Harper's New Monthly Magazine* in 1878 into his notebook,[1] in which he promoted the notion that landscape, especially the "civilized" landscape, could serve as vehicle for communicating the temperament of the artist.[2]

Murphy's shift to pastoral subjects served him well, for by 1880 he was being referred to as "the American Corot."[3] His standing in the art world was further enhanced in 1885, when one of his bucolic landscapes, *Tints of a Vanished Past*, was awarded the Second Hallgarten Prize at the National Academy of Design's annual exhibition, prompting his election as an associate member of the institution that same year.[4]

In 1886, Murphy made a six-month trip to France, where he deepened his familiarity with the work of the French Barbizon artists. During the late 1880s and 1890s his paintings became increasingly

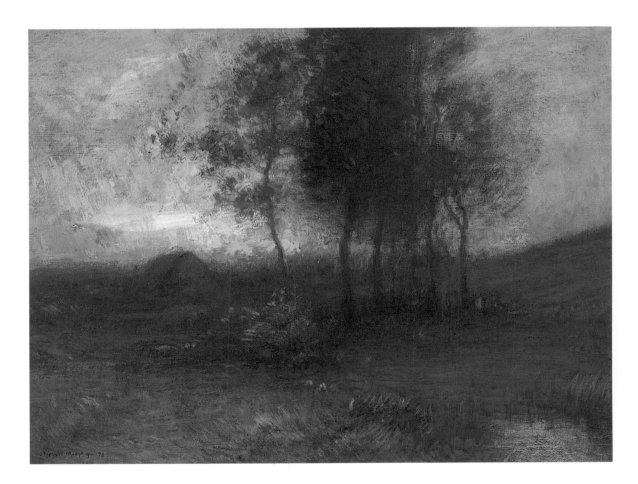

23.
Autumnal Landscape, 1898
Oil on canvas
12 × 16 inches
Signed and dated lower
left: *J. Francis Murphy. '98*

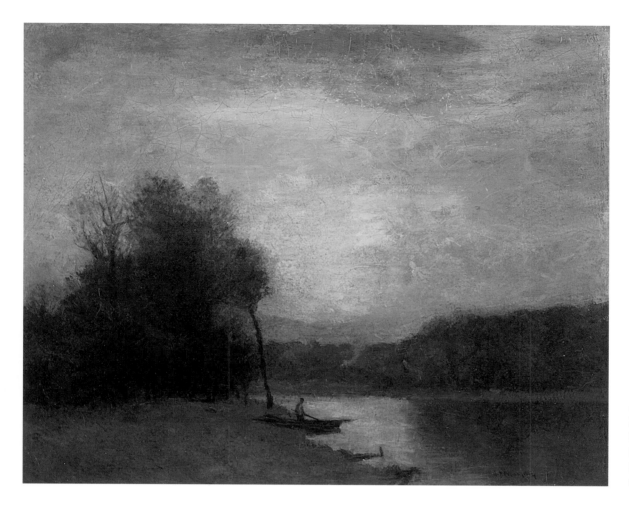

24.
Man in a Boat, 1891
Oil on canvas
8¾ × 11¼ inches
Signed and dated lower
right: *J. F Murphy '91*

intimate as he moved from picturesque rustic
motifs to more spiritual conceptions of nature,
favoring what his first biographer, Eliot Clark,
referred to as "the simple theme of earth and sky, of
air and expanse, the serenity and beauty of nature's
unaffected harmony."[5] Working on small-scale sup-
ports, he painted vignettes of low-lying fields and
placid waterways, often at twilight. Housed in
heavy, Baroque-style frames, these darkly mysteri-
ous cabinet pictures proved tremendously popular
with Gilded Age collectors, who hung them in the
parlors and drawing rooms of their mansions. One
such example, *Man in a Boat*, stands out for its sen-
suous gradations of light and dark and rich surface
effects, as well as for its aura of brooding introspec-
tion—a pictorial statement that is rooted in nature
yet based on feeling and fancy: as Murphy once
told an admirer of one of his oils, it did not record a
specific place but was "a 'composition' only, as are
all my pictures."[6]

After 1887 Murphy and his wife, the painter
Ada Clifford Murphy, would spend eight months of
each year in the town of Arkville, New York, in the
southern Catskills (which also became a retreat for
the aforementioned Wyant), where he made
sketches of nature that he used, back in his studio
at the Chelsea Hotel in New York, to remind him
of the emotions he had experienced at the time. As

noted by Clark, Arkville provided Murphy with a
spiritual refuge, for "he lived largely in this quiet
but responsive world and drew from it much of the
contentedness and serenity that found its ultimate
expression in his pictures."[7] These comments
would surely apply to *Autumnal Landscape*, a classic
example of Tonalist painting in its free brushwork,
vague, indistinct forms, and emphasis on an inter-
mediary season and time of day.

Around the turn of the twentieth century,
Murphy enlarged his format and lightened his
palette in response to Impressionism, while main-
taining the evocative quality and intimist vision
associated with Tonalism. According to one com-
mentator of the day,

> The smoked glasses of the past fell from
> Murphy's eyes. . . . This new Murphy, dating
> from 1900, forsakes a mere prettiness and
> attempts the commendable difficulty of inter-
> esting you in desolation. Gaunt, naked uplands
> are bathed in a luminous bath of golds, grays
> and greens, quivering and vibrating like heat
> waves, snapping and sparkling like frozen jew-
> ellery [sic].[8]

As revealed by *The Willows*, the artist continued to
favor minimalist designs, usually focusing on stark
pasturelands, but he moved away from the heavy

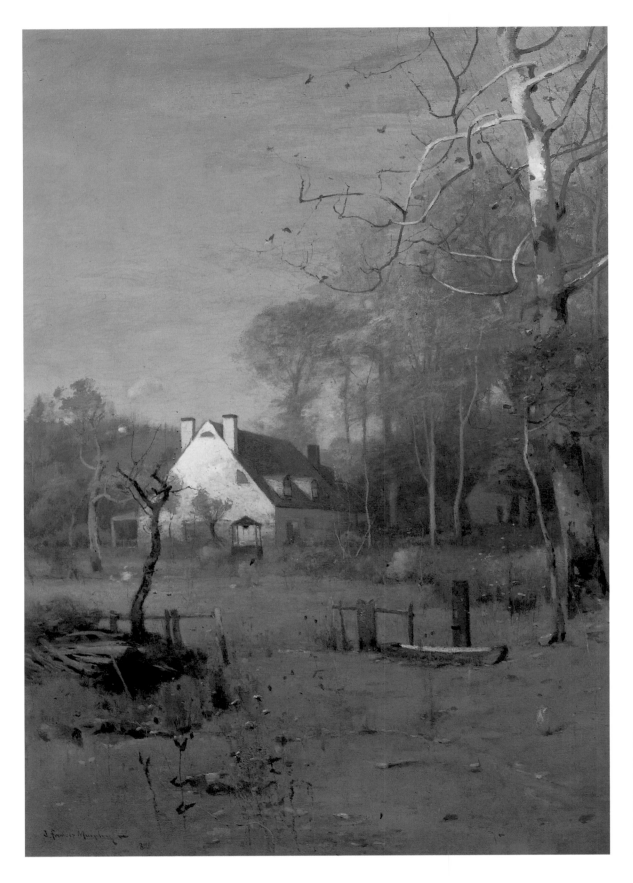

25.
*Tints of a Vanished
Past,* 1884
Oil on canvas
33 × 30 inches
Signed and dated lower
left: *J. Francis Murphy 84*
Cheeckwood Museum of
Art, Nashville, Tennessee

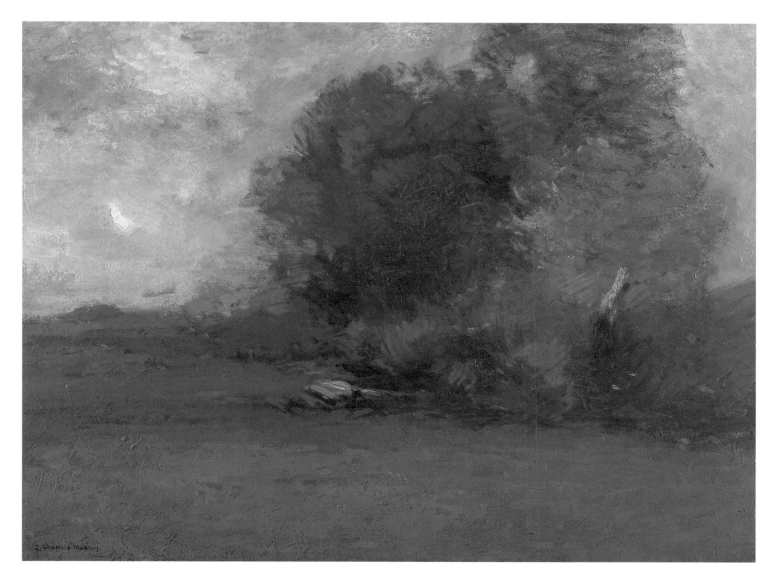

paint handling of the past in favor of a more lively and expressive brushstroke as a means of capturing fleeting effects.

Murphy died in New York City but was buried in his beloved Arkville, the country retreat where he experienced "the peaceful tranquility of nature" that he captured so beautifully in his paintings.[9]

CL

1. See Francis Murphy, *J. Francis Murphy: The Landscape Within, 1853–1921*, exh. cat. (Yonkers, N.Y.: Hudson River Museum, 1982), p. 10.

2. "A Painter on Painting," *Harper's New Monthly Magazine* 56 (February 1878), p. 469

3. Murphy, *J. Francis Murphy: The Landscape Within*, p. 10.

4. Murphy was elected a full academician in 1887.

5. Eliot Clark, *J. Francis Murphy* (New York: Privately printed, 1926), p. 23.

6. J. Francis Murphy, quoted in Murphy, *J. Francis Murphy: The Landscape Within*, p. 10.

7. Clark, *J. Francis Murphy*, p. 17.

8. Charles L. Buchanan, "J. Francis Murphy: A Master of American Landscape," *International Studio* 53 (July 1914), p. viii.

9. Clark, *J. Francis Murphy*, p. 17.

26.
The Willows, ca. 1910
Oil on canvas
19 × 26 inches
Signed lower left:
J. F. Murphy.

Leonard Ochtman

(1854, Zonnemaire, Holland–1934, Cos Cob, Connecticut)

L IKE HIS fellow Tonalist Charles Warren Eaton (Cats. 7–9), Leonard Ochtman grew up in Albany, New York, where his family had settled in 1866. In 1870, after receiving some basic art instruction from his father, Jan, a painter, he began working as a draftsman for a local wood engraver while painting outdoors in his spare time. On trips to New York City he familiarized himself with the latest trends in contemporary landscape painting, going to exhibitions at the National Academy of Design, the Society of American Artists, and in local commercial galleries, where he saw work by a younger generation of American artists whose loose, sketchy styles reflected the impact of their training in the art schools of Munich and Paris.

After attending classes at the Art Students League of New York during the winter of 1879, Ochtman established his studio in Albany. He made his first trip abroad in 1886, spending much of his time in his native Holland, where he studied the atmospheric landscapes of such Hague School painters as Jacob Maris and Anton Mauve. On returning to America, he settled in New York in 1887 and adopted a nonliteral approach to depicting nature, favoring muted colors and a fluid handling of pigment. He began painting in Cos Cob, Connecticut, in 1890, and after his marriage in 1891, he settled there permanently, helping transform that tiny coastal fishing village into a thriving art colony whose members included the American Impressionists John Henry Twachtman (Cats. 38–40) and Childe Hassam.

Ochtman was at the height of his success during the 1890s and early 1900s, when his mellifluous landscapes brought him an abundance of awards and honors at the national annuals, patronage from the likes of George A. Hearn and William T. Evans,[1] and a well-deserved reputation as "the Keats of landscape."[2] He tended to favor fall or winter scenes bathed in the calming light of dawn or dusk, which he painted in the studio. Although his oils were often preceded by informal sketches created in the modest, gently rolling countryside around Greenwich, Ochtman relied primarily on experience and memory in producing his landscapes, stating,

> I . . . paint all my pictures in the studio from memory or notes. They are arranged, composed; they represent no particular place, but give to the best of my ability the character, color, and atmospheric conditions of the country in which I live . . . after all, we want the effect of the day, hour or moment, the mood and not a transcript of the place. . . . It is our object to create a picture of the sentiment, the emotion one feels in observing the scene.[3]

Ochtman once told his daughter that he could paint snowscapes "out of my head in the summer time," which could certainly have been the case with the present example.[4] Notable for its lyrical beauty and high level of craftsmanship, *Winter Landscape* underscores the artist's penchant for simple designs, expressive brushwork, and a decorative handling of tree forms. In keeping with his approach, Ochtman adheres to a restricted palette, although the inclusion of luminous pastel colors in the sky indicates that, like other adherents of Tonalism, he often incorporated the light and coloristic strategies of Impressionism into his work.

CL

1. Evans, for example, owned Ochtman's *Evening on the Mianus* (1893; location unknown) and *Morning Haze* (1909; Smithsonian American Art Museum, Washington, D.C.). See William H. Truettner, "William T. Evans: Collector of American Paintings," *American Art Journal* 3 (Fall 1971), p. 77.

2. Frederick W. Morton, "Leonard Ochtman, Landscape-Painter," *Brush and Pencil* 9 (November 1901), p. 65.

3. Leonard Ochtman, "A Few Suggestions to Beginners in Landscape Painting—Concluded," *Palette and Bench* 1 (August 1909), p. 243.

4. See Susan G. Larkin, *The Ochtmans of Cos Cob*, exh. cat. (Greenwich, Conn.: The Bruce Museum, 1989), p. 24.

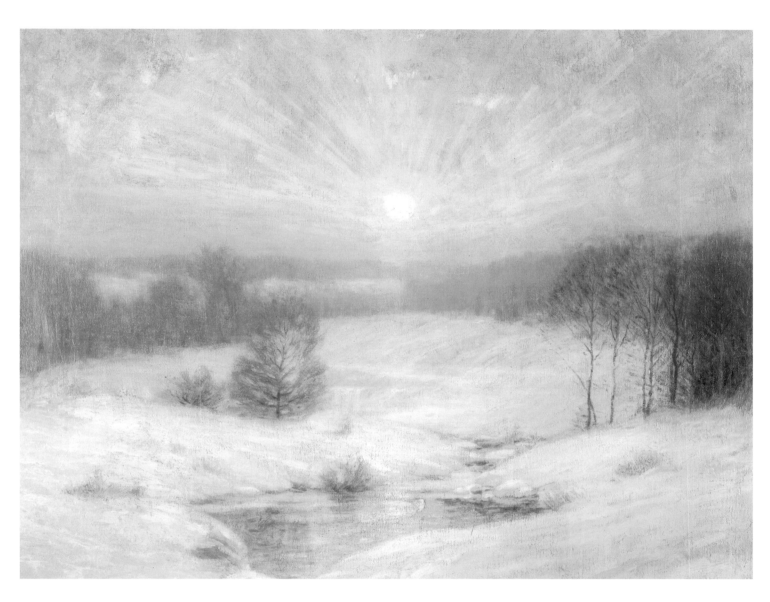

27.
Winter Landscape, 1898
Oil on canvas
30 × 40 inches
Signed and dated lower
left: *Leonard Ochtman 1898*
Private Collection

Charles Rollo Peters

(1862, San Francisco–1928, San Francisco)

THE ART-FOR-ART'S-SAKE theories of James McNeill Whistler inspired a number of American Tonalists, among them Charles Rollo Peters, recognized for his moonlit portrayals of the landscape, coastline, and Spanish-style architecture of northern California, especially the scenery he encountered in and around his home and studio in Monterey.

Born into an affluent pioneer family, Peters received his education at Bates Private School for Boys in San Francisco and at the City College of San Francisco, where his talent for sketching and painting first emerged. After graduating, he attempted to establish a career in the commercial world, but eventually lost interest in this line of work. About 1885 he studied privately with the painter Jules Tavernier and attended classes under the painters Virgil Williams and Christian A. Jorgensen at the California School of Design while spending his free time painting the scenery in San Francisco and the Bay area. In 1886 he went to Paris, enrolling at the Académie Julian and at the prestigious École des Beaux-Arts, where he was taught by the academic painters Jean-Léon Gérôme and Fernand Cormon.

Peters returned to San Francisco in 1890 but a year later made another extended trip to England and France. There he immersed himself in Whistlerian aesthetics and painted his earliest nocturnes—moonlight views of Brittany and Paris. He remained abroad until about 1895, when he settled in Monterey and made night scenes his forte, favoring spare designs and a palette dominated by rich blues. Like other exponents of Tonalism, he painted his canvases indoors; residents of Monterey often encountered him

> wandering about in the semi-darkness . . . taking down notes here and there, studying the different phases of light, and creating a vivid mental picture of the scene he wished to paint. Returning to his studio with every detail of the scene definitely fixed in his mind, he would work at his easel until every contour, each shadow, and the ghostly atmosphere of the night, were faithfully repeated in oil.[1]

On a trip to New York City in 1899, Peters met the influential collector Thomas B. Clarke, who was so impressed with his work that he invited him to exhibit a selection of his recent paintings at the Union League Club. The event was reviewed favorably by the local press, a reviewer for the *Sun* observing: "The artist has studied the atmospheric effect of the night to good purpose, and in the representation of the silvery gray of moonlight he has arrived at singular proficiency."[2] Dubbed "the Poet of the Night," Peters also exhibited his evocative oils in the annuals of the San Francisco Art Association and the Bohemian Club, and along with William Keith, Xavier Martinez, Karl Neuhaus, and Will Sparks, helped establish the Del Monte Art Gallery in Monterey, the first gallery devoted specifically to promoting the work of California-based artists.[3]

Works such as *Sand Dunes, Monterey* reflect Peters at his best, demonstrating his ability to transform an ordinary corner of nature into a magical, dreamlike conception—one that conveys that "strong, silvery shimmer of weird brilliancy of the California moon"[4] and reflects the artist's belief—rooted in the artistic theories of Whistler—that "local color is not deadened by moonlight, but only softened and modified."[5]

CL

1. "Charles Rollo Peters, 1862–1928: Biography and Works," *California Art Research* 10 (1937), p. 81.

2. *New York Sun*, November 27, 1899, quoted in "Charles Rollo Peters, 1862–1928: Biography and Works," p. 71.

3. See Harvey L. Jones, *Twilight and Reverie: California Tonalist Painting, 1890–1930*, exh. cat. (Oakland, Calif.: Oakland Museum, 1995), p. 10.

4. "Charles Rollo Peters," *Collector and Art Critic* 11 (November 1, 1899), p. 21.

5. F. W. Ramsdell, "Charles Rollo Peters," *Brush and Pencil* 4 (July 1899), p. 206.

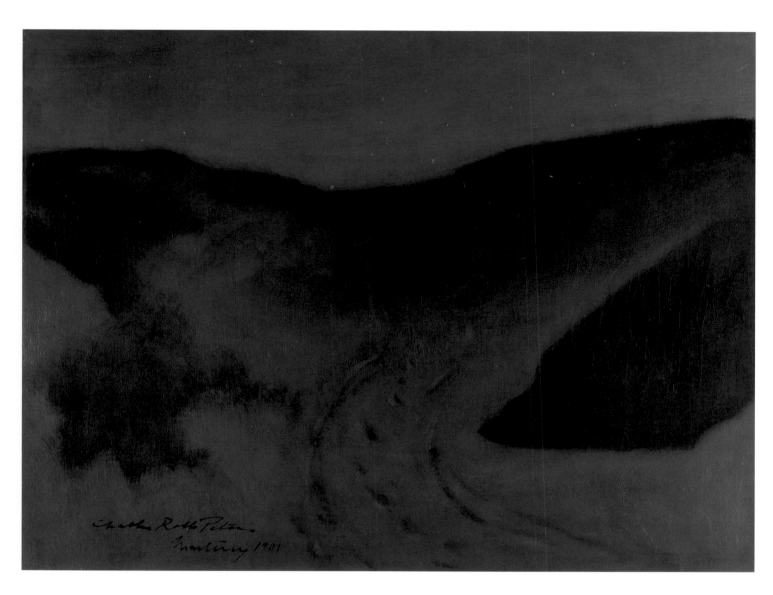

28.
Sand Dunes, Monterey, 1901
Oil on canvas
21 × 29 inches
Signed, dated, and
inscribed lower left: *Charles
Rollo Peters / Monterey 1901*
Private Collection

Henry Prellwitz

(1865, New York City–1940, East Greenwich, Rhode Island)

Henry Prellwitz's oeuvre is split between the allegorical figural works that were the emphasis of his early career, when he was closely associated with Thomas Wilmer Dewing (Cat. 6), and the reductive landscapes he created after the turn of the twentieth century, which reflect a merging of Tonalist and Impressionist influences.[1] His images of both of these subjects reflect his belief that art should not seek to portray an objective truth; instead, it should distill visual experiences to a poetic essence that could speak directly to the emotions.

Prellwitz was one of five sons of Prussian-born parents and grew up in New York City, where his father owned a cigar store. He entered City College of New York at age fourteen, where he studied classical literature and was introduced to art by Leigh Hunt, an instructor of shading and perspective. Three years later he enrolled at the Art Students League, studying under Dewing, George de Forest Brush, and Robert Reid. Of these, Dewing was the most important. Becoming Prellwitz's mentor, Dewing engaged the younger artist as a studio apprentice and invited him to visit Cornish, New Hampshire, where Dewing and his wife, Maria Oakey Dewing, were at the center of a lively artists' colony. From 1887 through 1890 Prellwitz lived abroad, training at the Académie Julian in Paris, spending time in the Anglo-American art colony in Giverny—home to Claude Monet—and visiting Spain with the artists William Howard Hart and Philip Leslie Hale.

In 1894 Prellwitz married the painter Edith Mitchill, whom he had met at the league and whose studio had been opposite his in the Holbein Building in New York. Both equally educated and refined in their interests and tastes, the two would remain mutually supportive of each other's careers for the rest of their lives.

In the summer of 1895 the couple built a small cottage in Cornish, near those of the Dewings and the sculptor Augustus Saint-Gaudens, which became known as Prellwitzes' Shanty. When their "little place" was destroyed by fire in the summer of 1898, it led the painters to "a change of habit," and they rented a summer house in Peconic, on the North Fork of Long Island, which they found quieter than the island's tourist-filled South Fork. They also became enamored of the picturesque farms, mills, country roads, and serene bays and inlets of Long Island Sound. The couple was soon joined in Peconic by many of their artist-friends, including Irving Wiles and Edward August Bell. A year later, they bought a house in Peconic that they eventually converted to a studio. In 1911 they purchased an early-nineteenth-century house, which they had transported to land they purchased on Indian Neck, a promontory jutting into Peconic Bay. Eventually, after adding two studios to the house, the couple became year-round residents of Long Island, but in 1928 they returned to New York City, where they lived in on East Forty-first Street.

Inspired by the quiet beauty of his surroundings, during his Peconic years Prellwitz turned away from the painting of narrative images within the context of his studio and began to render intimate views in which he focused on nuances of light and atmosphere and created succinct, minimalist designs. He often created nocturnal images, such as *Moonlight Ring*, in which he captured the strange phenomenon of a lunar corona emerging against the darkness. Such works reflect a Tonalist perspective, drawing the viewer from the observable world into a realm of pure contemplation.

LNP

1. The primary sources on Henry Prellwitz are Ronald G. Pisano, *Henry and Edith Mitchill Prellwitz and the Peconic Art Colony*, exh. cat. (Stony Brook, N.Y.: The Art Museum, The Museums at Stony Brook, 1995); and Ronald G. Pisano and William H. Gerdts, *Painters of Peconic: Edith Prellwitz (1864–1944) and Henry Prellwitz (1865–1940)*, exh. cat. (New York: Spanierman Gallery, LLC, 2002).

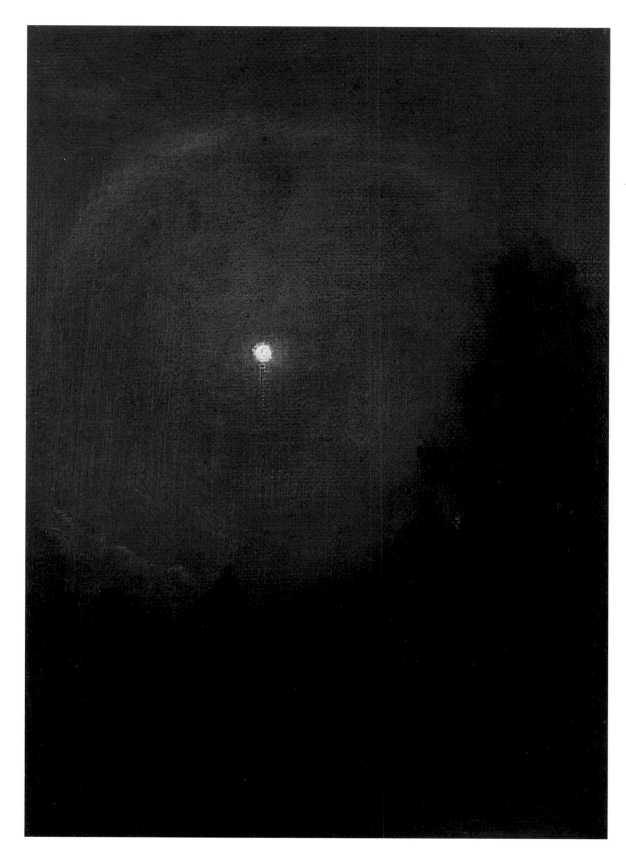

29.
Moonlight Ring,
ca. 1910s–20s
Oil on canvasboard
14 × 11 inches

Henry Ward Ranger

(1858, Geneseo, New York–1916, New York City)

ELITE COLLECTORS such as William T. Evans and George A. Hearn provided encouragement, support, and patronage to a number of distinguished Tonalists, among them Henry Ward Ranger, recognized for his lyrical landscapes and littoral scenes. The two examples in the present exhibition attest to the fact that he was a "forceful and able" painter who "had a strength of composition, a sense of the picturesque, a delicate and glowing scheme of color that were distinctly his own. He loved and painted the New England coast and woodland in Spring, Summer and Autumn."[1]

Ranger spent his formative years in Syracuse, New York, where his father, a commercial photographer, taught photography and drawing at Syracuse University.[2] In 1875, after completing a course of study at the university's College of Fine Arts, he started working in his father's studio, retouching photographs while painting watercolors in his spare time. During these years, Ranger made frequent visits to Manhattan, where he wrote music criticism, saw examples of French Barbizon painting in commercial galleries, and established himself as a watercolorist of considerable ability. His familiarity with contemporary artistic trends was enhanced by trips to Europe;

in Holland, he was deeply inspired by the atmospheric rural views of Hague School artists such as Anton Mauve, Joseph Israels, and the Maris brothers.

After moving to New York City in 1885, Ranger took up easel painting. He initially created somber, broadly brushed landscapes indebted to the example of the Hague School, but eventually turned to a richer chromaticism and a poetic vision that suggest the impact of the later work of George Inness (Cats. 19–21). In 1898 he began working in the countryside and along the coast of Connecticut, which provided him with the type of intimate setting that appealed to the Tonalist sensibility. His first summer in Connecticut was spent in East Lyme, on Long Island Sound, and he found the area so appealing that he came back a year later, although this time he went to nearby Old Lyme, residing at the boardinghouse of Miss Florence Griswold. He returned to Old Lyme in the summer of 1900, accompanied by a group of fellow painters who also favored intimate pastoral settings, and in doing so established the town as an American version of Barbizon.

Ranger worked in the studio, creating expressive canvases based on sketches made in Old Lyme. His subjective approach to depicting nature, as revealed in *Spring Woods*, reminds us that

> The Tonalist catches the laughter of shimmering light, and transmutes it into pictorial joy.... With a simple palette ... he expresses breadth, teasing transparency, mysterious distances, the illusion of luminosity—in a word, the drama of air, light, and colour. Taken all in all, his pictures challenge, please, and convince. As a last refinement, he permeates them with his own individuality, and thus may he be called a creator.[3]

This mode of creative expression would dominate artistic activity in Old Lyme until 1903, when the arrival of the Impressionist Childe Hassam established a new aesthetic direction for the colony. Thereafter, Ranger summered in Noank, a small fishing village at the mouth of the Mystic River, where he painted poetic views of the local harbor and Mason's Island. Ranger also applied Tonalist precepts to European subjects, as well as views of Québec and Manhattan.

Ranger was an integral member of the New York art community at the turn of the twentieth century, affiliated with the National Academy of

30.
Fall Landscape, 1894
Oil on board
12¼ × 16¼ inches
Signed and dated lower
left: *H. W. Ranger 94*

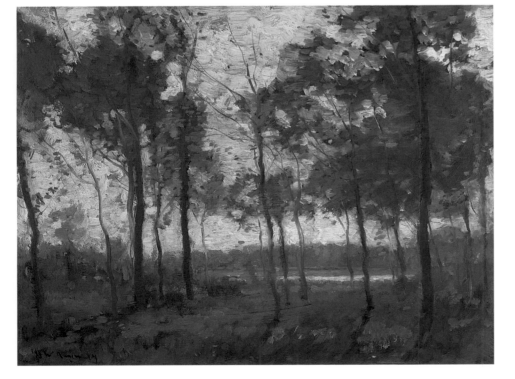

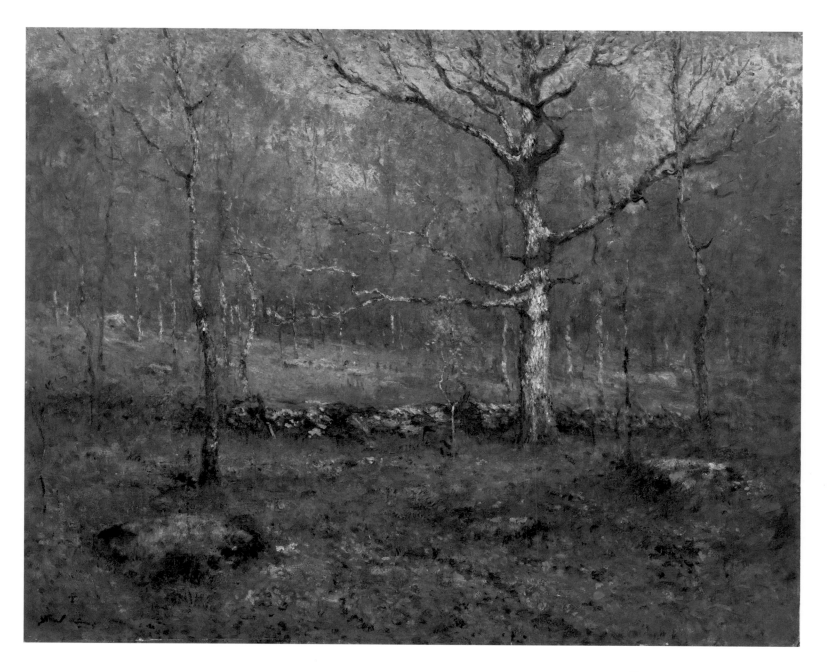

Design and the National Arts Club, among other organizations. At the Lotos Club he helped William T. Evans organize the exhibition *Some Tonal Paintings of the Old Dutch, Old English, Barbizon, Modern Dutch, and American Schools*, held in 1896, which included examples of his own "tone" paintings. An avid penman, he wrote articles on watercolor painting and other topics. The series of interviews he gave to Ralcy Husted Bell, published as *Art-Talks with Ranger* (1914), contains information about his painting methods and his aesthetic outlook.

CL

1. "W. Gedney Bunce and Henry W. Ranger," *Academy Notes* 11 (October 1916), p. 128.

2. For Ranger's life and career, see Jack Becker, Lance Mayer, and Gay Myers, *Henry Ward Ranger and the Humanized Landscape*, exh. cat. (Old Lyme, Conn.: Florence Griswold Museum, 1999); and Estelle Riback, *Henry Ward Ranger: Modulator of Harmonious Color* (Fort Bragg, Calif.: Lost Coast Press, 2000).

3. Ralcy Husted Bell, *Art-Talks with Ranger* (New York: G. P. Putnam's Sons, 1914), 9-10.

31.
Spring Woods, ca. 1900
Oil on canvas
28¼ × 36 inches
Signed lower left:
H W Ranger
The Metropolitan Museum of Art, New York, Gift of George A. Hearn, 1906

Chauncey Foster Ryder

(1868, Danbury, Connecticut–1949, Wilton, New Hampshire)

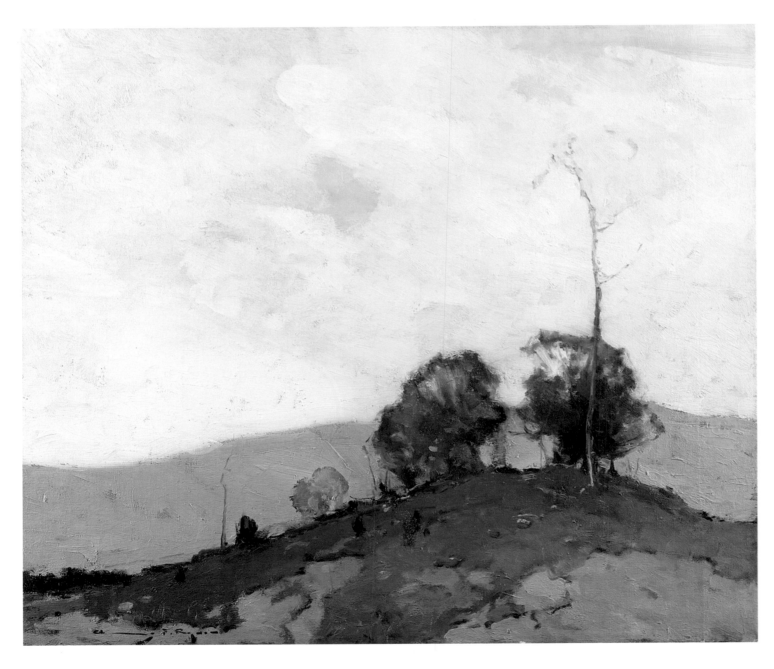

32.
Hilltops, ca. 1910s–20s
Oil on canvas
25 × 30 inches
Signed lower left:
Chauncey F. Ryder

ONE OF THE most successful painters associated with the Macbeth Gallery in New York City during the early years of the twentieth century, Chauncey Ryder created work that struck a responsive chord among art audiences that took great delight in his suggestive landscapes inspired by the scenery of rural New England. An artist whose work straddled the line between Tonalism and Impressionism, it was said that "Noticeable in all his paintings is the simplicity and balance of his composition—a harmony of colors in which there is no disturbing note—a delicate adjustment—of strength and tenderness."[1]

Ryder grew up in New Haven, Connecticut, but while in his twenties he moved to Chicago.[2] During the mid-1890s he worked as an illustrator and attended classes at the school of the Art Institute of Chicago. A few years later he spent two years at Smith's Art Academy, also in Chicago, initially as a student and later as a teacher. In 1901 he traveled to Paris, enrolling in figure classes at the Académie Julian. From 1904 until 1907 Ryder lived in the port town of Étaples, France, where he

associated with a cadre of American-born artists that included Max Bohm and Roy Brown. During this period he painted genre scenes that he exhibited at the Paris Salon. However, his subsequent travels in the French countryside, as well as in Italy and Holland, stimulated an interest in landscape painting, which became his primary thematic interest.

In 1907 Ryder returned to America, settling in New York City. Three years later he joined the stable of artists affiliated with the Macbeth Gallery and purchased a house in Wilton, New Hampshire, where he lived from April to November of each year. Although Ryder made painting trips to other parts of New England and to upstate New York, he spent the majority of his time painting views of the valleys and meadowlands he encountered in the vicinity of Wilton. In works such as *Pasture*, he expertly fuses the muted light, restrained color range, and unpretentious subject matter of Tonalism with the animated handling of Impressionism, creating a work replete with lush atmospheric effects. Ryder's *Hilltops* indicates a similar preoccupation with the pale luminosity and elegiac mood of Tonalism, although in this instance his thickly impastoed brushwork, minimalist design, and radical simplification of form suggest an awareness of the pictorial concerns of modernism.

The artist's long-term association with the Macbeth Gallery—he had one-man shows there in 1910, 1921, 1923, 1927, and 1930 and participated in numerous group exhibitions—attests to his enduring popularity with contemporary collectors who were drawn to paintings that inspired a reflective state of mind and who admired Ryder's ability to achieve "the right proportion between the real and the unreal, between detail and vagueness."[3]

CL

1. Sidney C. Woodward, "Ryder, Chauncey Foster," typescript, [ca. 1922], p. 4, Sidney C. Woodward Papers, Archives of American Art, Smithsonian Institution, Washington, D.C., reel D195, frame 990.

2. For Ryder, see Ronald G. Pisano, "Chauncey Foster Ryder: Peace and Plenty," *Art and Antiques* 1 (September–October 1978), pp. 76–83; and *Chauncey F. Ryder: A Retrospective*, exh. cat. (Loveland, Colo.: Anderson and Anderson Gallery, 1982).

3. Woodward, "Ryder," p. 4.

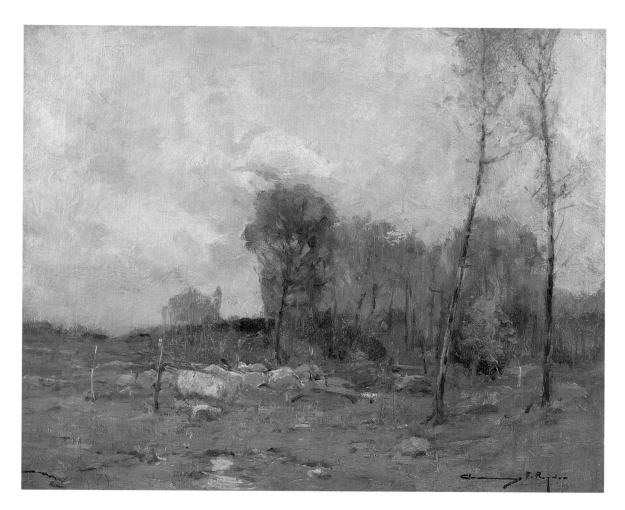

33.
Pasture, ca. 1910s–20s
Oil on canvas
16 × 20 inches
Signed lower right:
Chauncey F. Ryder

Dwight William Tryon

(1849, Hartford, Connecticut–1925, South Dartmouth, Massachusetts)

ACCORDING to the painter–art historian Samuel Isham, Dwight Tryon was the "successor" of George Inness (Cats. 19–21) in that he painted American scenery "with deep, personal feeling and with a *technique* complete, original, and modern."[1] Indeed, Tryon was among the front rank of Tonalists, an artist whose landscapes were rooted in natural fact yet interpreted through an individual temperament—one that brought out the gentle lyricism of his subject. As Isham observed, in a painting by Tryon:

> Rocks, groves, streams, and sky are knit together as firmly and logically as a proposition of Euclid; but on this reality [Tryon] begins to work with mists and shifting lights and feathery spring foliage until it almost disappears under the

shimmering web of poetry that he has wrapped about it, yet underneath still lie the stone walls and the gray ridges of New England rock ready to emerge in all their uncompromising strength the instant that the east wind sweeps up their enveloping veil.[2]

Initially a self-taught artist, Tryon spent his early career painting in the detailed manner of the Hudson River School. After achieving some success in New York and in his native Hartford, he went to Paris in 1876, taking drawing classes with Jacquesson de la Chevreuse, a disciple of Jean-Auguste-Dominique Ingres. Most importantly, he spent a summer in the countryside, studying with the French Barbizon painter Charles-François Daubigny, who approached nature in terms of the

34.
The End of Day,
ca. 1887
Oil on canvas
32 × 48 inches
Signed lower left:
D. W. Tryon

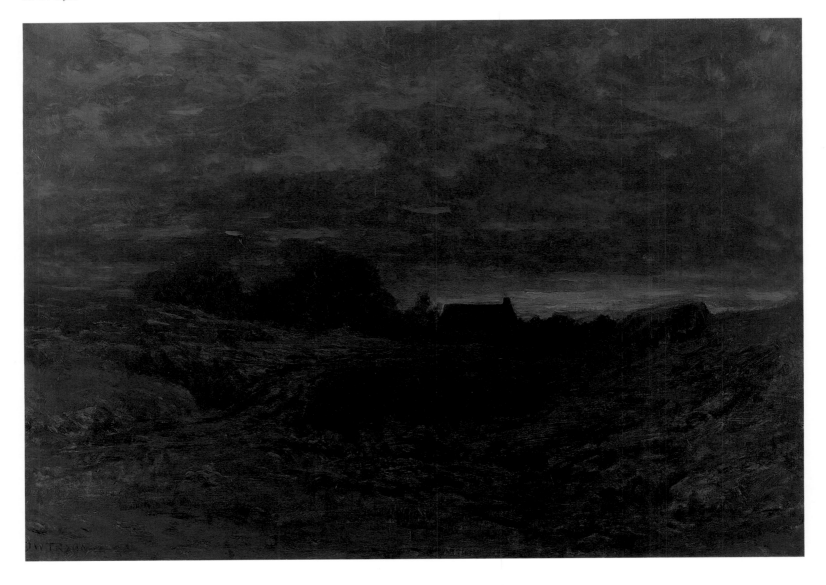

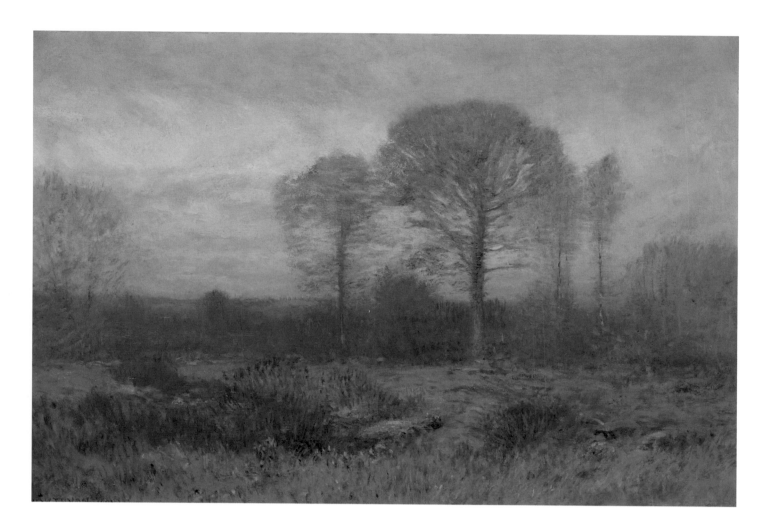

35.
November, 1904–1905
Oil on wood
20 × 30 inches
Signed and dated lower left:
DW. Tryon 1904–5
Smithsonian American Art
Museum, Washington, D.C.,
Gift of William T. Evans

personal and the poetic. He also worked with the landscapists Henri-Joseph Harpignies and J.-B. Antoine Guillemet, who, along with Daubigny, inspired Tryon's concern for depicting unprepossessing pastoral sites and prompted his subsequent move from an art of description to one of suggestion.

Tryon returned to the United States in 1881 and settled in New York City, where he fraternized with other painters who had also looked abroad for aesthetic inspiration. By 1883 he was spending his summers in the picturesque fishing town of South Dartmouth, Massachusetts, where, in 1887, he built a small house called the "Cottage." His work from this period includes a number of twilight and evening scenes such as *The End of Day* and *Newbury Haystacks in Moonlight*, which, in their rural subjects, low-keyed palette, and fluid handling, reflect the impact of Tryon's contact with the Barbizon painters. Described by the collector Duncan Phillips as portrayals of "black nights with troubled skies," these moody oils also underscore his awareness of the Nocturnes of James McNeill Whistler (Cat. 43), an artist he is known to have admired.[3]

By the end of the 1880s Tryon's conception of native scenery became more sensitive and refined when, seeking an idealized conception of landscape, he evolved what became his standard composition: a patch of meadowland, bounded by groupings of tall, graceful trees with wispy foliage in the middle ground, bathed in the soft, ethereal luminosity of early spring or fall. Such is the case with *November*, in which Tryon's subtle palette and nuanced brushwork convey an aura of serenity and contentment that reflects the artist's personal reaction to nature. To be sure, the view was inspired by scenery around Tryon's summer home, but it was painted in his Manhattan studio rather than outdoors, the artist drawing on memory, intuition, and feeling to determine his composition and the overall mood. During this period, Tryon also began to work in pastel, feeling that the medium offered him "new beauties and possibilities" in attaining that fugitive, otherworldly quality that permeates his mature art.[4] He conveys this effect in *Twilight*, an ode to springtime in which he skillfully melds the subdued colors of Tonalism with the pastel hues of Impressionism and, taking advantage of the expressive potential of his medium, interprets the tree forms in a summary manner that gives them that vague, delicate appearance we associate with a Tryon landscape.

From 1886 to 1924 Tryon served as professor of art at Smith College in Northampton, Massachusetts, where he advised on acquisitions for its art collection, touting the work of many of his Tonalist counterparts, such as Inness and Thomas Wilmer

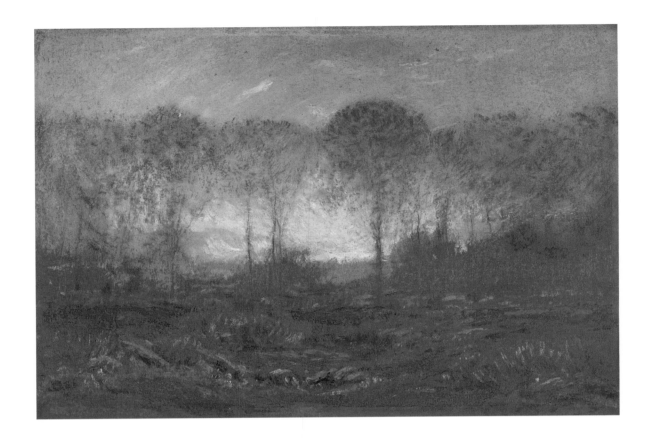

36.
Twilight, 1913
Pastel on board
8 × 12 inches
Signed and dated lower
left: *D. W. Tryon 1913*

Dewing (Cat. 6). Described as an artist who wielded a "magic brush,"[5] Tryon's paintings brought him accolades from critics such as Charles Caffin, his earliest biographer, and an abundance of awards and honors.[6] His extensive patron base included the foremost collectors of Tonalist painting, among them Charles Lang Freer, the affluent industrialist who commissioned a set of decorative murals for his Detroit home and who likened Tryon's subdued color schemes and harmonious designs to those of Whistler.[7] His devotees also included Thomas B. Clarke, the first collector of his generation to eschew work by European artists in favor of contemporary American art, who was the original owner of *The End of Day*.[8] The businessman William T. Evans, who did so much to promote turn-of-the-century painting through his activities at the Lotos Club and the National Arts Club in New York, was the first owner of *November*.[9]

CL

1. Samuel Isham, *The History of American Painting*, new ed., with supplemental chapters by Royal Cortissoz (New York: Macmillan Co., 1943), p. 454.

2. Ibid., p. 457.

3. Duncan Phillips, "Dwight W. Tryon," *American Magazine of Art* 9 (August 1918), p. 392.

4. Dwight William Tryon to Charles Lang Freer, January 24, 1894, quoted in Linda Merrill, *An Ideal Country: Paintings by Dwight William Tryon in the Freer Gallery of Art* (Washington, D.C.: Smithsonian Institution, 1990), p. 120.

5. Sadakichi Hartmann, *A History of American Art*, new ed., rev. (New York: Tudor Publishing Co., 1934), p. 129.

6. See Charles H. Caffin, *The Art of Dwight W. Tryon: An Appreciation* (New York: Forest Press, 1909).

7. See Lee Glazer, "Whistler, America, and the Memorial Exhibition of 1904," in Linda Merrill et al., *After Whistler: The Artist and His Influence on American Painting*, exh. cat. (Atlanta, Ga.: High Museum of Art; New Haven, Conn.: Yale University Press, 2003), p. 87.

8. See H. Barbara Weinberg, "Thomas B. Clarke: Foremost Patron of American Art from 1872 to 1899," *American Art Journal* 8 (May 1976), pp. 52–83.

9. William H. Truettner, "William T. Evans, Collector of American Paintings," *American Art Journal* 3 (Fall 1971), p. 78. See also, Jack Becker, "Studies in American Tonalism," Ph.D. diss., University of Delaware, 2002, and Carol Lowrey, "The National Arts Club: Its Founding, Early History and the Artist Life Membership Program," Ph.D. diss., City University of New York, 2003.

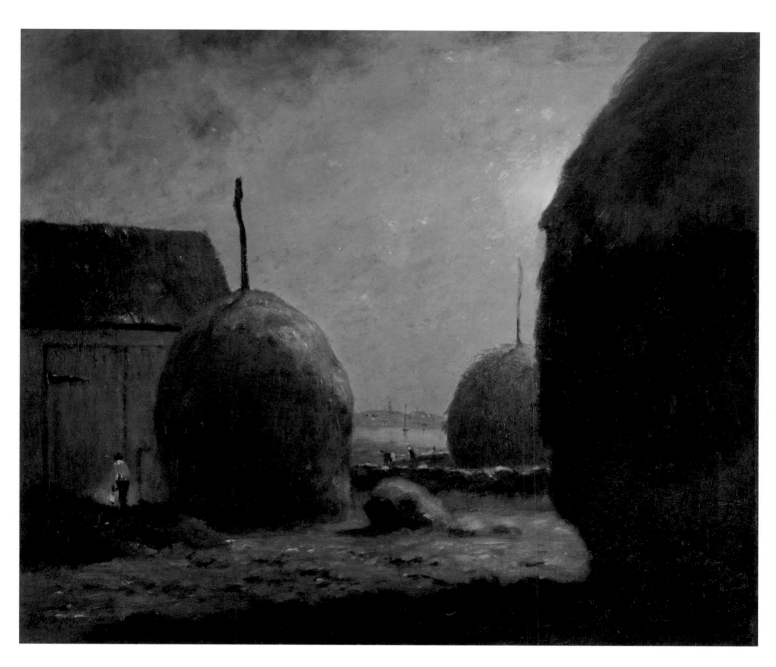

37.
Newbury Haystacks in
Moonlight, ca. 1887
Oil on canvas
25 × 30 inches
Signed lower left:
D. W. Tryon

John Henry Twachtman

(1853, Cincinnati, Ohio–1902, Gloucester, Massachusetts)

BORN IN 1853 in Cincinnati, Ohio, John Twachtman followed a career path that was typical for an American artist of his generation. He focused for about a decade on acquiring foreign training and then returned permanently to America, where he applied the lessons of European art to his familiar surroundings.[1] He studied in his hometown from 1868 through 1875, when he departed for Munich, where he was a pupil for two years at the Royal Academy. He painted in Venice from the spring of 1877 through the following spring and then spent a year in New York City, rendering the harbors of the Hudson River near West Tenth Street. He traveled to Europe in the fall of 1880 (to teach at the school that his friend Frank Duveneck had established in Tuscany), in the spring of 1881 (on his honeymoon, spent primarily in southern Holland), and in the fall of 1883, when he went to Paris to resume his studies, enrolling at the popular Académie Julian.

During the subsequent two summers he painted in Normandy and Holland. Demonstrating the impact of his Parisian lessons in draftsmanship, he simplified his arrangements, abandoning the choppy brushwork and irregular surfaces of his earlier art. He also replaced the dark palette of his Munich style with a range of soft grays and greens, creating images that in their harmonious and reductive schemes suggest his awareness of the art of James McNeill Whistler (Cat. 43). Although some of these works, most notably his *Arques-la-Bataille* (Fig. 35), are akin in their minimalism to Whistler's purely abstract Nocturnes, they reflect the artist's response to his sites. This aspect of his French period works was understood by critics of his time who observed how he had omitted topographic details to capture the feelings his subjects evoked. One wrote in 1886 that in his landscapes, Twachtman had "discriminated delicately," producing pictures that "while lacking the truth of form of

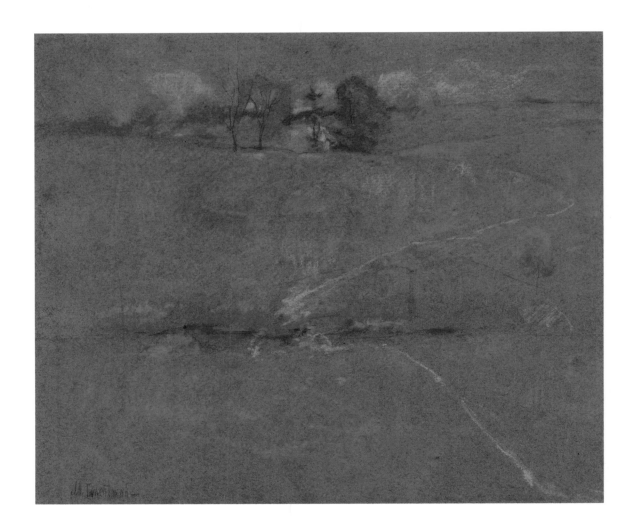

38.
*Path in the Hills,
Branchville, Connecticut,*
ca. 1889–91
Pastel on paper
10 × 12 inches
Signed lower left:
J. H. Twachtman

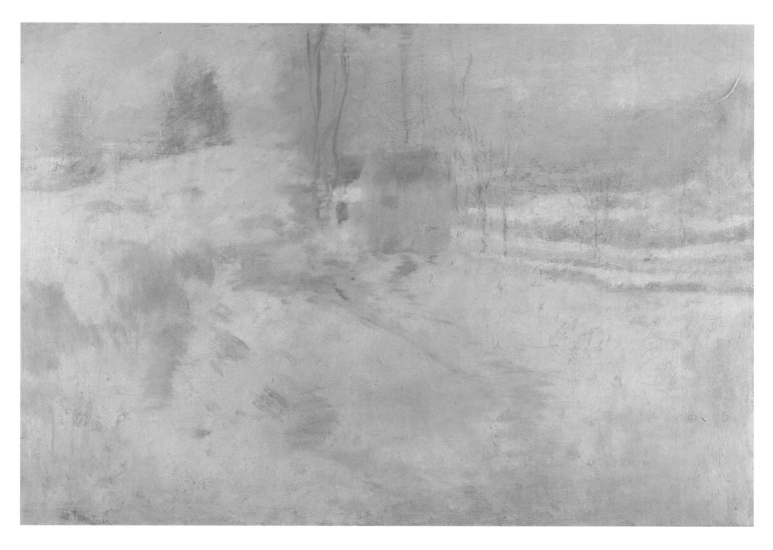

39.
*Barn in Winter, Greenwich,
Connecticut*, ca. 1890s
Oil on canvas
18 × 26 inches
Signed lower left:
J. H. Twachtman

Nature, yet has that which is always sacrificed—
truth of impression."[2]

Twachtman concluded the European phase of
his career at the end of 1885, and after a period
of time when he was in and near Cincinnati, he
moved east in the summer of 1888, renting a house
in Branchville, Connecticut, near that of his friend
J. Alden Weir (Cat. 42). During that summer
and in the years that followed, pastels absorbed a
significant amount of Twachtman's attention. He
had begun to use the medium in the summer of
1885, when he created moonlit scenes of Holland
that paralleled the Tonalist landscapes he was
producing at the time. While spending time in
Branchville, he adopted a new approach. Roaming—
often with Weir—on open, rolling hillsides, he
worked on toned papers with rough finishes, devel-
oping a succinct plein-air method in which even
the slightest shift in the pressure or force of his

touch or the subtlest application of color became
an expressive vehicle, and he integrated the paper's
underlying tone into his images as atmosphere or
to indicate the raw ground rather than using it as
a backdrop.

His approach is readily apparent in *Path in the
Hills, Branchville, Connecticut*, in which he rubbed
the flat side of his green crayon over his oatmeal-
grained paper, suggesting the delicate undergrowth
emergent across a hillside in early spring. Drawing
the forms of trees in an expressive rather than a
descriptive manner, applying lithe touches of blue
and white to portray wispy clouds, and indicating
the sinuous curve of a path following the contours
of the landscape, he suggested the light, buoyant
feeling of the season and his own pleasure in
meandering through the countryside.

By the fall of 1889 Twachtman had begun
teaching at the Art Students League in New York

and had moved to Greenwich, Connnecticut, where he purchased a small farmhouse and land that eventually totaled about seventeen acres. There, his house and property, including a brook that cascaded through his backyard, became his principal subject matter for the rest of his life. During his Greenwich years he incorporated Impressionist techniques into his art, earning a reputation as one of the leading representatives of Impressionism in America.

Exhibiting a vibrant chromatic range and broken brushwork, many of Twachtman's Greenwich works were perceived at the time as exemplifying an extreme form of the French style, and he was often associated by critics with Claude Monet; for example, one noted in 1893 that he pursued "light, color, and air" in a method akin to that of the noted French artist.[3] Yet Twachtman rarely painted sunlit days, gravitating instead to rendering landscape forms blurred by mists and hazy atmospheric conditions or under snow in various conditions of iciness or thaw. In these works, he tended to use a range of closely modulated subdued tonalities, creating images that commentators of his time praised for such qualities as "tender vaporousness," "abstracting the quaint essence of a scene," and for lending "serenity to the soul" by making us "feel even more than we see."[4]

Although Twachtman was never termed a Tonalist, nor was he a member of the Lotos Club, both the stylistic modes he used and the philosophical attitudes that his art expressed connect him with the broad current that is now identified as American Tonalism. *November Haze*, a view across the dry bed of Horseneck Brook to the southeast of his Greenwich home, combines the spontaneity of Impressionism with the poeticism of Tonalism. In the foreground, a knoll directly below us is flush with and cropped by the picture plane and its grassy, rock-speckled turf is seen at such close range that it appears rhythmically broken into pure lines and colored shapes Due to the narrowed vantage point, the middle ground and background appear to merge, forming a hazy zone in which spatial distinctions are lost. The effect of the work is of the experience of the landscape rather than a pictorial representation of it, a depiction that suggests the indeterminacy of vision in the understanding of the mystery of nature.

The feeling is similar in *Barn in Winter, Greenwich, Connecticut*. Only by looking at this snow-covered landscape through a hazy atmosphere for some time do the features of the site gradually materialize. Translucent snow cover and thawed patches of ground reveal the path through the backyard leading to the artist's square, high-roofed barn, the carriage tracks breaking through the snow on Round Hill Road at the right, the delicate lines of bare trees, and winglike shape of the hill to the north of the artist's house, where the silhouettes of evergreens may be discerned. Painting with a thin, broken layer of white impasto over underlayers of pastel tonalities, Twachtman conveyed the variegated nature of the snow cover. Yet the central presence of the barn with its faded edges restricts us from interpreting the scene literally, compelling a decorative reading of it, as the lines and shapes in the landscape seem to radiate from its form, drawing us from the damp chill of the site itself into a feeling of deep quietude.

LNP

1. For sources on Twachtman, see Lisa N. Peters, "'Spiritualized Naturalism': The Tonal-Impressionist Art of J. Alden Weir and John H. Twachtman," in this catalogue, p. 87, footnote 1.
2. "Paintings and Pastels by J. H. Twachtman," *Boston Evening Transcript*, January 23, 1886, p. 6.
3. "Some French and American Pictures," *New York Evening Post*, May 8, 1893, p. 7.
4. "Art Notes," *New York Times*, March 9, 1891, p. 4; "My Notebook," *Art Amateur* 24 (April 1891), p. 116; and "A Criticism," *Studio*, April 25, 1891, p. 203.

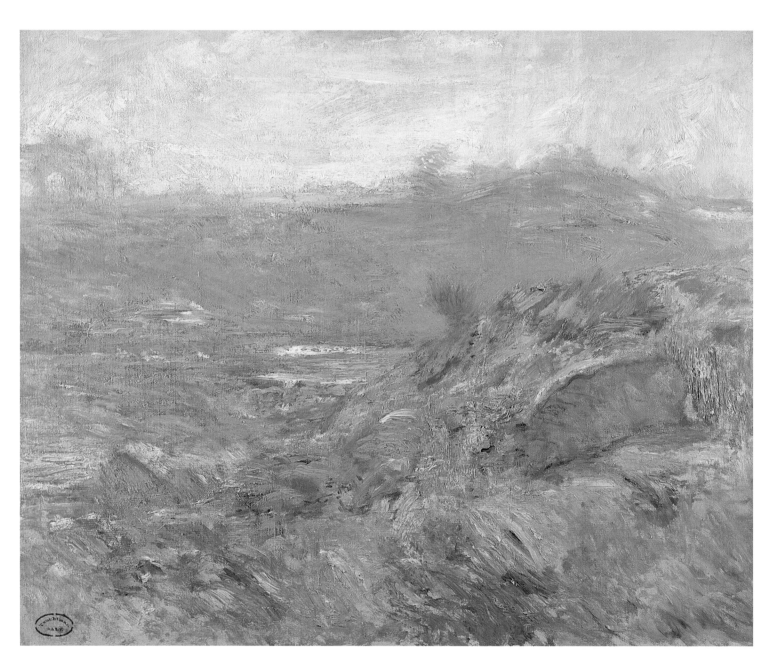

40.
November Haze, ca. 1890s
Oil on canvas
25 × 30 inches
Estate stamp lower left:
Twachtman sale

Manuel Valencia

(1856, Marin County, California–1935, Sacramento, California)

A NUMBER OF California-based artists incorporated Tonalist strategies into their work, among them Manuel Valencia, a painter of landscapes and historical subjects who was associated with the San Francisco art scene in the early twentieth century.[1] Born on the Rancho San Jose into an early California family, he received his formal education at the Santa Clara College for Boys (today the University of Santa Clara).[2] As an artist Valencia was primarily self-taught, although he is known to have received some basic instruction from the painter Jules Tavernier and attended a few classes at the Esquela de Bellas Artes in Mexico City.

Valencia initially was a commercial artist, designing calling cards, working as an illustrator for the *San Francisco Chronicle*, and creating illustrations for the Salvation Army newspaper, *War Cry*. After the great earthquake and fire of 1906 he lived in various locales within commuting distance of San Francisco, where he maintained several studios. He also kept studios in Santa Cruz and in Monterey. There, he explored moonlight effects in mood-filled canvases such as *Monterey Customs House*, which, in its pared-down design and reductive palette, demonstrates an awareness of the Nocturnes of Whistler and of the equally suggestive evening scenes of fellow Californian Charles Rollo Peters (Cat. 28).

After 1912, when he began exhibiting his work in San Francisco, at such galleries as S. & J. Gumps, and in New York City, at the Macbeth Gallery and at fashionable dining spots such as Delmonico's, Valencia's work became popular with collectors like President William McKinley, who purchased one of his views of the Yosemite Valley. Valencia's oeuvre also includes depictions of California missions and desert scenes of Arizona and New Mexico. San Francisco remained his home base until the early 1930s, when he moved permanently to Sacramento. Following his death, family members scattered his ashes on Mount Tamalpais.

CL

1. For Valencia, see *Southern California Artists, 1890–1940*, exh. cat. (Laguna Beach, Calif.: Laguna Beach Museum of Art, 1979), pp. 182–83.

2. Valencia's grandfather went to California with the DeAnza expedition in 1774 and eventually became administrator of the Presidio in San Francisco. Valencia Street in San Francisco bears the family name.

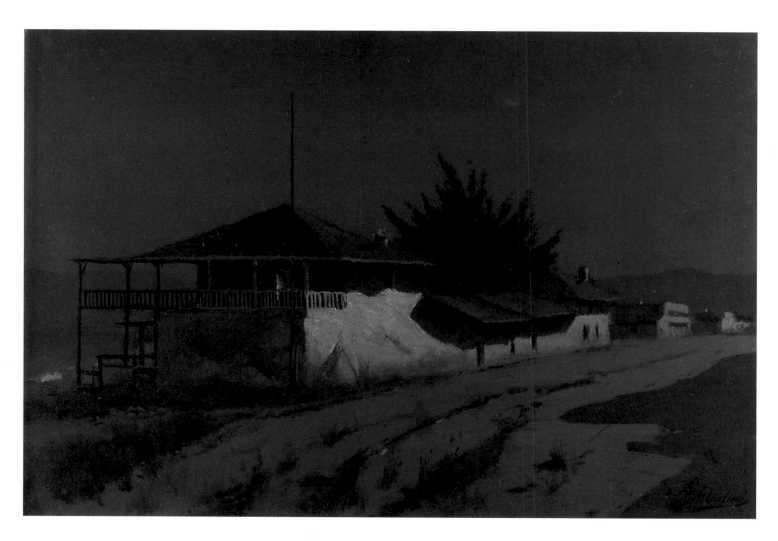

41.
Monterey Customs House,
ca. 1910s
Oil on canvas
20 × 30 inches
Signed lower right:
M *Valencia*

J. Alden Weir

(1852, West Point, New York–1919, New York City)

OVER THE course of a long career, Julian Alden Weir created works reflecting the complicated interchange between academic, French Barbizon, Impressionist, and Tonalist directions in American art at the end of the nineteenth century.[1] His early career was rooted in the artistic traditions of the prebellum years. His father, Robert W. Weir, a teacher of drawing at the United States Military Academy at West Point, New York, painted formal portraits, genre scenes modeled on old master paintings, and landscapes, rendered with the meticulous detail and panoramic perspectives typical of the Hudson River School. As a youth, Weir followed his father's example in portraiture as well as in at least one painting in the Hudson River School idiom.[2] Weir pursued his training, first at the National Academy of Design, beginning in 1869, and then in 1873, he entered the Paris atelier of Jean-Léon Gérôme, a master academician, from whom Weir developed a classical approach to figural rendering and to pictorial structure that would remain a foundation for his art in the decades that followed.

By the mid-1870s Weir had begun to gravitate toward a new stylistic mode, influenced by his exposure to the art of the French Barbizon painters during sojourns in the French countryside and through his involvement in the circle of the French artist Jules Bastien-Lepage, whose images of peasant figures set in landscapes were suffused with naturalistic light. However, Weir was not yet receptive to Impressionism. On seeing the third show of the French Impressionists, in 1877—as perhaps the only American to attend the show—he was shocked at the exhibitors' inattention to drawing and form. In the late 1870s and early 1880s he traveled back and forth between Europe and New York, focusing mostly on figural work.

In 1882 Weir married and exchanged a painting for a piece of property in Branchville, Connecticut, which included 155 acres of land and an old farmhouse. In the years that followed, he shifted his emphasis to landscape painting, as his affection for his rural surroundings increased. Toward the end of the decade, his resistance to Impressionism diminished as the French mode was embraced by many of his peers in the wake of the large exhibition of Impressionist art brought to New York in the spring of 1886 by the Paris art dealer Paul Durand-Ruel. The summer of 1888, when his close friend John Henry Twachtman (Cats. 38–40) stayed near him

in Branchville, seems to have been a turning point for Weir. As the two artists experimented with pastels in the open air and came to understand the aesthetic embodied by this medium, they found that Impressionist methods were precisely suited to their aim of capturing the subtleties that gave the countryside its particular appeal, one that had become increasingly apparent to Weir over the years. As he later explained, "you must make a subject a part of yourself before you can properly express it to others."[3]

Dated 1888, *Farm Scene* epitomizes the important point in Weir's art when he was making the transition to Impressionism and combining all of his aesthetic sources. The hazy, diffused light in the work is reminiscent of the atmospheric approach of Bastien-Lepage, yet the softened edges and blurred forms demonstrate Weir's departure from the clear outlines in Bastien's works as he sought to paint forms as perceived through the filter of light and atmosphere. The overall green tones in the work, while reminiscent of Barbizon art, are imbued with a light translucency, evoking Weir's progression toward Impressionism. The shadowed forms of hedgerows, in the right foreground and the left background, imbue the work with the balance that reflects Weir's strong academic background. At the same time, his fluid treatment of trees and branches is far from the linearity of Gérôme, revealing the spontaneity that he and Twachtman were spurring each other to achieve. Balancing between the freshness of observation and an image in which nature is artistically composed, *Farm Scene* demonstrates the way that Impressionism was often blended by American artists into an older, more poeticized approach to landscape painting that would evolve into a reductive mode called Tonalism in the next decade.

It is possible that Weir included *Farm Scene* in his 1891 exhibition at the Blakeslee Galleries in New York that was viewed by critics of the time as representing his debut as an Impressionist. It included works, currently unidentified, with titles such as *The Hillside*, *Across the Fields*, and *A Misty Day*, which were described as "roughly treated, pale-colored, yet still poetic products of his new brush."[4]

In the years that followed, Weir's reputation was firmly established as an Impressionist, but he continued to create works characterized by gentle tonal harmonies that expressed his affection for

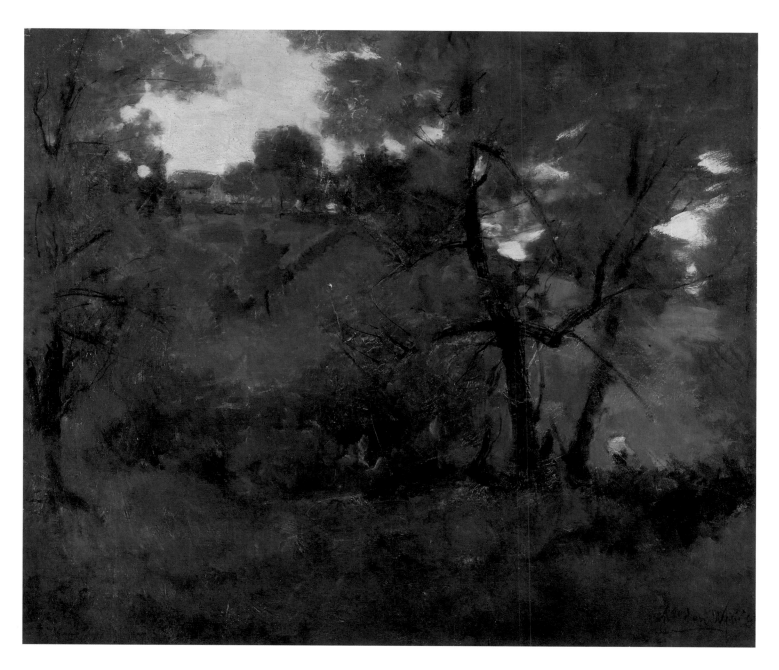

the quiet, unassuming appeal of the Branchville countryside. The critic Royal Cortissoz encapsulated this sensibility in 1922:

> The light of the Impressionists became the light of Weir, silvery and exquisite. Earth and sky took on an investiture of artistic freshness which only he could give them—and moved us with the urgency of poignant truth. When he painted one of those landscapes of his, he gave it the delicate visionary loveliness of a dream, yet he left the picture the unmistakable portrait of a place.[5]

CL

1. For sources on Weir, see Lisa N. Peters, "'Spiritualized Naturalism': The Tonal-Impressionist Art of J. Alden Weir and John H. Twachtman," in this catalogue, p. 87, footnote 1.

2. See Hildegard Cummings, "Home Is the Starting Place," in Cummings, Fusscas, and Larkin, *J. Alden Weir: A Place of His Own*, p. 25, fig. 3 (J. Alden Weir, *View of the Hudson River*, 1870, oil on canvas, 24 × 32½ inches, location unknown).

3. Quoted in J[oseph] Walker McSpadden, *Famous Painters of America* (New York: Dodd, Mead and Co., 1917), pp. 388–89.

4. "Some Questions of Art," *New York Sun*, January 2, 1891, p. 4.

5. Royal Cortissoz, "Weir," in *Julian Alden Weir: An Appreciation of His Life and Works*, ed. J. B. Millet (New York: E. P. Dutton and Company, 1922), p. 64.

42.
Farm Scene, 1888
Oil on canvas
21 × 25 inches
Signed and dated lower right: *J. Alden Weir '88*
Private Collection

James McNeill Whistler

(1834, Lowell, Massachusetts–1903, London)

ALTHOUGH born in the United States, James McNeill Whistler spent his professional life abroad and eventually achieved international acclaim. He wielded an enormous influence on the generation of American artists active around 1900, the period in which Tonalism flourished. If Americans were reluctant to adopt his philosophy of Aestheticism, they were eager to emulate his refined aesthetic style and assimilate his principles of design, notably the narrowing of the palette to a few carefully modulated color tones.

Whistler's artistic education began at the Imperial Academy of Fine Arts in Russia, while his father oversaw construction of the Moscow–St. Petersburg railroad, and continued during an ill-advised stint at West Point. At twenty-one Whistler went to Paris to embark on a career as an artist, but in the end settled in London, where he quickly established an unassailable reputation as an etcher. At the same time, he began to paint in oil, initially taking the Realist approach of his mentor the Frenchman Gustave Courbet but gradually, as he came under the spell of Japanese art, moving in an altogether different direction. Finally, as a proponent of art for art's sake, Whistler sought to divest his works of anecdote, sentiment, and anything else he regarded as incidental to aesthetic experience. To emphasize the purely formal qualities of his art, he frequently used musical titles. His mature style, characterized by reticence and repose, is exemplified in the now-famous portrait of his mother and the series of lyrical paintings he called "Nocturnes." In departing from realistic interpretation and illusionistic effect, Whistler's art often approaches abstraction.

In 1879, after failing to win substantial damages in the libel suit he brought against the critic John Ruskin, Whistler went to Venice and produced an extraordinary number of works on paper, primarily etchings and pastels.[1] He returned to England late in 1880 and continued working on the small scale that had brought him such satisfaction abroad. It was in the first part of that decade that watercolor painting became a serious pursuit. Although in his student days he had made watercolor sketches related to his etchings, Whistler's most accomplished works in the medium before 1880 were studies of blue-and-white Chinese porcelain—necessarily monochrome—illustrating the catalogue of an important private collection.[2] In the 1880s, when Whistler was struggling financially and traveling restlessly in search of new subject matter, watercolor proved to be both portable and inexpensive. The medium also lent itself naturally to rendering the sea and shore, prevalent themes in his work at that time. And as at least one of his patrons pointed out, his pastels were beautiful but fragile, and watercolor was more lasting.[3]

Whistler mastered the technique in no time and produced, in all, some three hundred watercolor paintings.[4] Once he had decided to more fully explore the medium's aesthetic potential, he was compelled to reform his customary painting practice, which involved repeated (and often agonizing) revision and reworking. As a result, his watercolors convey a sense of liberation and release: he himself referred to them as little "games."[5] Yet watercolor painting was also the natural counterpart to Whistler's idiosyncratic use of oil, which he customarily dissolved in lots of medium and used like a wash to produce canvases that appeared more stained than painted. Similarly, in an extraordinary series of watercolor Nocturnes made in Amsterdam in 1883 and 1884, Whistler applied liquid paint to dampened paper, saturating the scenes in atmosphere.[6]

Roughly contemporary with the Amsterdam Nocturnes, *Seascape* represents an especially appealing phase of Whistler's work in watercolor. Here, at the seaside, the artist exults in the translucent tones of a summer's day. Calm, azure waters occupy three-quarters of the composition, and a pair of sailboats, already at some distance from the harbor on the right, hover on the horizon just off-center, as if heading out to sea. Only a subtle lightening of touch and palette distinguishes the ocean from the sky, mottled with billowing clouds. The picture's perspective implies the artist's presence on a boat or raft floating on quiet waters far from the shore, but anchored to the spot by the butterfly emblem (his signature) in the lower left. Read in three dimensions, this little painting might suggest the vastness of the sea. Yet it can as easily be regarded as a two-dimensional pattern of blurring forms and luminous color, a "delicate monotony of hues and soft accentuations," as the critic Charles Caffin described Whistler's tonal compositions—or, to borrow the artist's own terminology, a harmony in blue and white.[7]

The locale of this particular *Seascape* is not known: it could be Essex or Guernsey, Dieppe or Dordrecht, St. Ives or Honfleur.[8] In any event,

Whistler maintained that he painted not portraits of places but personal impressions of a scene. If watercolor allowed him to escape the confines and anxieties of the studio and to work, like his contemporaries the French Impressionists, *en plein air*, Whistler remained true to the tenets of Aestheticism, so that even these casual transcriptions conform to his principles of design. Unlike the works of the American Tonalists, Whistler's portrayals of nature carry no intimations of a deeper meaning: his art resides on the surface of things. In its reticence and refinement, the image of Whistler's peaceful *Seascape* settles in the mind as softly as a memory.

LM

1. Whistler did produce at least one watercolor in Venice, *Venice Harbor*, now in the collection of the Freer Gallery of Art, Washington, D.C. David Curry has suggested that Whistler deliberately avoided using watercolor in Venice since it was regarded as "Turner's medium" and he had no wish to invite comparison with Ruskin's favored artist. David Park Curry, *James McNeill Whistler at the Freer Gallery of Art* (Washington, D.C.: Freer Gallery of Art, in association with W. W. Norton & Company, 1984), p. 176, pl. 91.

2. *A Catalogue of Blue and White Porcelain Forming the Collection of Sir Henry Thompson*, illustrated by the Autotype process from drawings by James Whistler, Esq., and Sir Henry Thompson (London: Ellis and White, 1878).

3. Writing to Whistler at St. Ives, Cornwall (January 5, 1884), William C. Alexander expressed the hope that his work was "taking the form of watercolour not that I don't like your pastels above all, but I always regret its being so easily destroyed." Library of Congress, Manuscript Division, Pennell-Whistler Collection 1/2/1, in *The Correspondence of James McNeill Whistler, 1855–1903*, ed. Margaret F. MacDonald, Patricia de Montfort, and Nigel Thorp (on-line edition, Centre for Whistler Studies, University of Glasgow, 2003), http://www.whistler.arts.gla.ac.uk/correspondence (hereafter LC/GUW).

4. Margaret F. MacDonald, *James McNeill Whistler: Drawings, Pastels, and Watercolours: A Catalogue Raisonné* (New Haven: Yale University Press, 1995). This number does not include *Seascape*, a newly discovered work; it will appear in a forthcoming addendum to the catalogue raisonné.

5. Whistler to Helen Euphrosyne Whistler (his sister-in-law), [January 1884?], and to Charles William Deschamps (an art dealer), [January 8, 1884], from St. Ives, 3/26/1 and 1/23/5, LC/GUW.

6. See MacDonald, *Whistler*, cat. nos. 877 (probably painted in December 1882) and 943–46 (1883/84).

7. Charles H. Caffin, *American Masters of Painting* (New York: Doubleday, Page & Co., 1902), p. 46. Whistler watercolors entitled *Blue and White—Dutch* and *Blue and Silver—The Sunny Sea* (locations unknown) were shown in Whistler's solo exhibition "*Notes*"—"*Harmonies*"—"*Nocturnes*" at Messrs. Dowdeswells', London, in May 1884 (see Macdonald, *Whistler*, cat. nos. 941–42).

8. In style and subject matter, *Seascape* appears most closely related to the group of watercolors painted in 1883 or 1884 at Southend-on-Sea on the Essex coast: see MacDonald, *Whistler*, cat. nos. 887–92.

43.
Seascape, ca. 1883–84
Watercolor on paper
10 × 6⅞ inches
Signed lower left with the
artist's butterfly insignia
Private Collection

Alexander H. Wyant

(1836, Evans Creek, Ohio–1892, New York City)

ONE OF the most celebrated American landscapists of the late nineteenth century, Alexander H. Wyant began his career working in the realistic manner advocated by proponents of the Hudson River School and by their counterparts in Düsseldorf, Germany, painting crisply detailed panoramas of wilderness scenery. However, his attitudes about landscape painting began to change after he met George Inness (Cats. 19–21) in New York City in 1859 and, most importantly, after seeing the atmospheric canvases of J. M. W. Turner and John Constable during a trip to London in 1865. Inspired by their example, and by that of the increasingly popular French Barbizon painters, Wyant sought to align himself with more progressive artistic tendencies that emphasized feeling and ambience over fact. He evolved a lyrical aesthetic characterized by broad brushwork and a low-keyed palette that he applied to intimate views of quiet pastoral locales enveloped in the muted light of dawn or dusk. His fluent technique became even more pronounced after 1874, when, as a result of a debilitating stroke he suffered on an excursion to the Southwest, he lost the use of his right arm and had to learn to paint with his left hand instead. Wyant spent his early years in Cincinnati, where he received support and encouragement from the collector Nicholas Longworth. In 1863 he settled in New York City, spending his summers in Keene Valley, in the Adirondack Mountains. In 1889 he moved to the village of Arkville, in the Catskill Mountains of New York, a locale that was also home to the Tonalist painter J. Francis Murphy (Cats. 23–26).

Wyant's shift in style enhanced his reputation in American art circles, bringing him patronage from a host of esteemed collectors such as George A. Hearn and William T. Evans. Members of the art press were equally receptive, identifying him as one of the first painters to reject the old-fashioned transcriptive method of the Hudson River School in favor of a more subjective manner in which gentle nuances of light, generalized forms, and a restrained palette were employed as a means of conveying transient moods, apparent in works such as *In the Berkshires*. Accordingly, Wyant is viewed today as an early exponent of Tonalism, a source of inspiration for landscapists like Bruce Crane (Cats. 1–2), among others.

Wyant's numerous admirers included the critic Charles Caffin, who described his paintings as being "pregnant with suggestion," representing a "search for the spiritual, poetic side of nature through an expressive simplification of composition and tone."[1] His comments bring to mind canvases such as *Marsh Landscape*, in which the artist focuses on an ordinary patch of countryside and adheres to a reductive, almost abstract design. Actually, the sky dominates the composition in almost all of Wyant's mature paintings, its delicate gradations and sense of spaciousness heightened by the presence of the terra firma below. This particular example appears to be among a group of oils painted during the mid-1880s in which Wyant depicted flat, marshy pasturelands bathed in a muted luminosity emanating from cloud-filled skies.[2] Forms are purposefully blurry and indistinct, the artist eschewing topographic exactitude to create a lush, palpable atmosphere and to convey the underlying essence of nature—effects that are enhanced by his typically low-keyed palette of neutral grays and earth tones. The painting brings to mind the words of Rilla Evelyn Jackman, who, in assessing Wyant's contribution to American art, declared: "[His work] reveals beauties in nature not seen before, his pictures give pleasure and will always be counted as good."[3]

CL

1. Charles Caffin, *American Masters of Painting* (New York: Doubleday, Page and Co., 1902), pp. 12–13.
2. See Robert Olpin, "Alexander Helwig Wyant (1836–1892), American Landscape Painter: An Investigation of His Life and Fame and a Critical Analysis of His Work with a Catalogue Raisonne of Wyant Paintings," Ph.D. diss., Boston University, 1971, p. 194.
3. Rilla Evelyn Jackman, "Alexander H. Wyant," in *American Arts* (Chicago: Rand McNally and Company, 1928), p. 75.

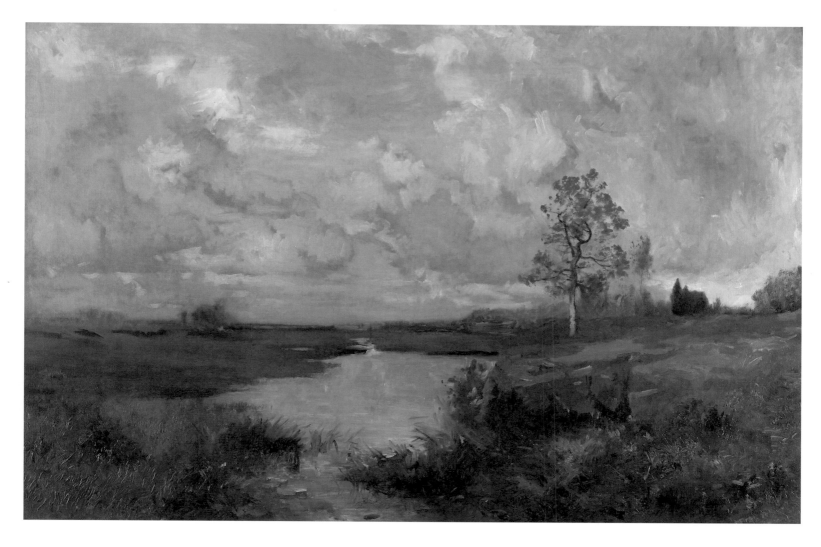

44.
Marsh Landscape,
ca. 1885
Oil on canvas
35¾ × 55½ inches
Signed lower right:
A. H. Wyant

45.
Stormy Twilight, Autumn,
The White Cottage,
Coytesville, New Jersey,
ca. 1880s
Oil on board
10½ × 8¾ inches
Signed lower left:
A. H. Wyant

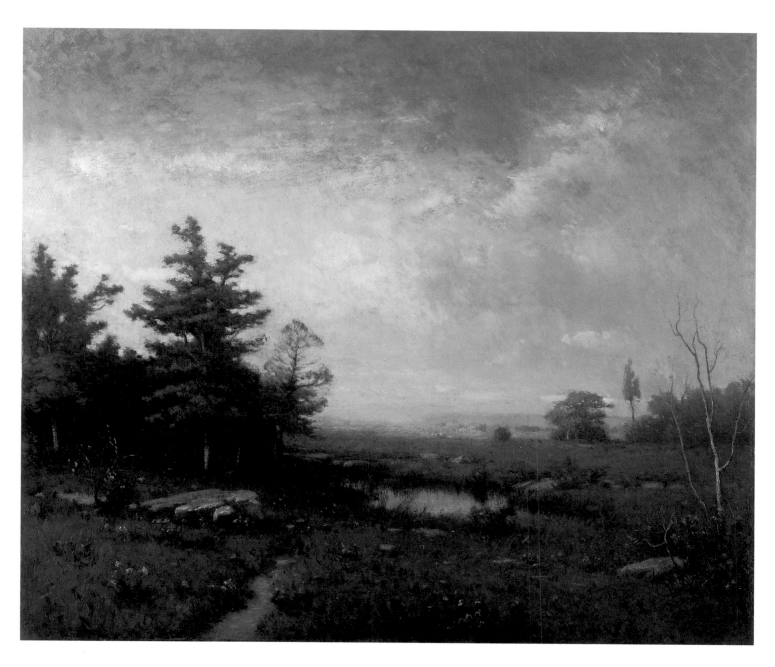

46.
In the Berkshires, ca. 1885
Oil on canvas
20 × 24 inches
Signed lower right:
A. H. Wyant

Appendix

Index of Participants at the Society of Landscape Painters
and Key Lotos Club Exhibitions

THE FOLLOWING provides a listing of artists who exhibited at the Society of Landscape Painters (abbreviated as SLP; see essay by William H. Gerdts, pp. 38–50) and those who participated in selected exhibitions at the Lotos Club, New York (abbreviated as LC; see essay by Jack Becker, pp. 29–37), from 1896 through 1914, the years in which the club was most fully involved in the promotion of Tonalist art. These same abbreviations (SLP and LC) signal membership of individual artists in these organizations. The Lotos Club shows noted below are the key exhibitions in which paintings in a Tonalist vein were prominently represented. They include the exhibitions in which art belonging to the collectors who, as members of the club, had significant holdings of paintings that can be deemed Tonalist: William T. Evans, John Harsen Rhoades, Alexander C. Humphreys, Samuel T. Shaw, and Louis Ettlinger (see biographies at the end of the index).

Shows featuring exclusively or mostly European art as well as those of figural works, which tended to include painting by artists working in a traditional, academic mode, have been omitted, as have single-artist exhibitions and those after the turn of the century that featured Impressionist art, specifically the exhibition of December 1910, entitled *Exhibition of Paintings by French and American Luminists*, in which paintings by French and American Impressionist artists were juxtaposed. The titles of the works exhibited have been omitted, owing to lack of space in this catalogue.

The material for this index was provided courtesy of Jack Becker and William H. Gerdts, and we are grateful for their generosity in making it available.

LNP

Exhibition Citations and Abbreviations

LC, *American Landscape Painters*, 3/96
Exhibition of the Work of American Landscape Painters, Arranged by Mr. William T. Evans, Lotos Club, New York, March 28, 1896, and following days.

LC, *American Landscape Painters*, 12/96
Exhibition of the Work of American Landscape Painters Arranged Mr. William T. Evans, Lotos Club, New York, December 26, 1896, and following days.

LC, *Tonal Painting*, 3/97
Exhibition of Tonal Painting: Ancient and Modern, Lotos Club, New York, March 27, 1897, and following days.

LC, *Paintings by Artist Members*, 3/98
Exhibition of Paintings by Artist Members of the Lotos Club, Lotos Club, New York, March 26, 1898, and following days.

LC, *Paintings by Artist Members*, 2/99
Exhibition of Paintings by the Artist Members of the Lotos Club, Lotos Club, New York, opened February 5, 1899.

SLP, New York, 3/99
First Annual Exhibition of the Society of Landscape Painters at the American Art Galleries, Madison Square South, March 24–April 5, 1899.

LC, *Landscapes and Marines*, 3/99
Exhibition of American Landscapes and Marines, Lotos Club, New York, March 25, 1899, and following days.

SLP, Chicago, 4/99
Catalogue of an Exhibition of the Society of Landscape Painters, The Art Institute of Chicago, April 15–May 14, 1899.

SLP, New York, 5/00
Second Annual Exhibition of the Society of Landscape Painters at the American Art Galleries, Madison Square South, May 2–26, 1900.

LC, *Paintings by Artist Members*, 2/01
Paintings by Artist Members of the Club, Lotos Club, New York, February 23–26, 1901.

LC, *Paintings from Hearn Collection*, 3/01
Exhibition of American Paintings from the Collection of George Hearn, Lotos Club, New York, March 1901.

SLP, New York, 4/01
Third Annual Exhibition of the Society of Landscape Painters, Clausen Galleries, New York, April 1901.

LC, *Paintings from the Pan-American*, 12/01
Exhibition of Paintings Selected from the Pan-American Exposition, Lotos Club, New York, December 28, 1901, and following days.

SLP, New York, 4/02
Society of Landscape Painters, Fourth Annual Exhibition, M. Knoedler and Company, New York, April 1–15, 1902.

LC, *Paintings from Rhoades Collection*, 1/03
Exhibition of American Paintings from the Collection of John Harsen Rhoades, Esq., Lotos Club, New York, January 31, 1903, and following days.

LC, *Paintings by Artist Members*, 2/03
Exhibition of Paintings by Artist Members of the Lotos Club,
Lotos Club, New York, February 28, 1903, and following days.

LC, *Paintings from Humphreys Collection*, 3/03
Exhibition of American Paintings from the Collection of
Mr. Alexander C. Humphreys, Lotos Club, New York,
March 28, 1903, and following days.

SLP, New York, 4/03
Society of Landscape Painters, Fifth Annual Exhibition,
M. Knoedler and Company, New York, April 15–29, 1903.

LC, *Paintings from Shaw Collection*, 4/04
Exhibition of American Paintings from the Collection of
Samuel T. Shaw, Esq., Lotos Club, New York, April 2, 1904,
and following days.

LC, *Paintings by Artist Members*, 3/05
Exhibition of Paintings by the Artist Members of the Lotos Club,
Lotos Club, New York, March 4, 1905, and following days.

LC, *Paintings from Rhoades Collection*, 12/05
Exhibition of American Paintings from the Collection of
John Harsen Rhoades, Esq., Lotos Club, New York,
December 23, 1905, and following days.

LC, *Paintings from Ettlinger Collection*, 1/06
Exhibition of American Paintings from the Louis Ettlinger, Esq.,
Lotos Club, New York, January 27, 1906, and following days.

LC, *Paintings by Artist Members*, 2/06
Exhibition of Paintings by Artist Members of the Lotos Club,
Lotos Club, New York, February 24, 1906, and following days.

LC, *Paintings from Evans Collection*, 3/06
Exhibition of American Paintings from the Collection of
William T. Evans, Esq., Lotos Club, New York,
March 31, 1906, and following days.

LC, *Paintings from Humphreys Collection*, 3/07
Exhibition of American Paintings from the Collection of
Dr. Alexander C. Humphreys, Lotos Club, New York,
March 30, 1907, and following days.

LC, *Paintings from Evans Collection*, 12/12
Exhibition of Paintings from the Collection of Mr. William T.
Evans, Lotos Club, New York, December 7, 1912, and
following days.

LC, *Paintings from Humphreys Collection*, 10/13
Exhibition of Paintings from the Collection of Dr. Alex. C.
Humphreys, Lotos Club, New York, October–November 1913.

LC, *Paintings from Rhoades Collection*, 1/14
Exhibition of American Paintings from the Collection Formed by
the Late John Harsen Rhoades, Esq., Lotos Club, New York,
January 31, 1914, and following days.

Artist List

JOHN WHITE ALEXANDER (1856–1915)
LC, *Paintings from the Pan-American*, 12/01

HUGO BALLIN (1879–1956)
LC, *Paintings from Evans Collection*, 12/12

GEORGE R. BARSE, JR. (1861–1938)
LC, *Paintings from Shaw Collection*, 4/04
LC, *Paintings from Ettlinger Collection*, 1/06

GIFFORD BEAL (1879–1956)
LC, *Paintings by Artist Members*, 3/05

REYNOLDS BEAL (1867–1951) (LC)
LC, *Paintings by Artist Members*, 2/01
LC, *Paintings by Artist Members*, 2/03
LC, *Paintings by Artist Members*, 3/05
LC, *Paintings by Artist Members*, 2/06
LC, *Paintings from Humphreys Collection*, 3/07

J. CARROLL BECKWITH (1852–1917) (LC)
LC, *Paintings by Artist Members*, 3/05

FRANK W. BENSON (1862–1951)
LC, *Paintings from Shaw Collection*, 4/04

FRANK ALFRED BICKNELL (1866–1943) (LC)
LC, *Paintings by Artist Members*, 2/99
LC, *Paintings by Artist Members*, 3/05
LC, *Paintings by Artist Members*, 2/06

WILLIAM VERPLANCK BIRNEY (1858–1909) (LC)
LC, *Paintings by Artist Members*, 2/03
LC, *Paintings by Artist Members*, 3/05
LC, *Paintings by Artist Members*, 2/06

RALPH ALBERT BLAKELOCK (1847–1919)
LC, *American Landscape Painters*, 3/96
LC, *American Landscape Painters*, 12/96
LC, *Landscapes and Marines*, 3/99
LC, *Paintings from Hearn Collection*, 3/01
LC, *Paintings from the Pan-American*, 12/01
LC, *Paintings from Rhoades Collection*, 1/03
LC, *Paintings from Humphreys Collection*, 3/03
LC, *Paintings from Rhoades Collection*, 12/05
LC, *Paintings from Ettlinger Collection*, 1/06
LC, *Paintings from Evans Collection*, 3/06
LC, *Paintings from Humphreys Collection*, 3/07
LC, *Paintings from Evans Collection*, 12/12
LC, *Paintings from Humphreys Collection*, 10/13
LC, *Paintings from Rhoades Collection*, 1/14

MYER (MILES) EVERGOOD BLASHKI (1871–1939) (LC)
LC, *Paintings by Artist Members*, 2/03
LC, *Paintings by Artist Members*, 3/05
LC, *Paintings by Artist Members*, 2/06

ROBERT FREDERICK BLUM (1857–1903)
LC, *Paintings from Rhoades Collection*, 1/03

GEORGE HENRY BOGERT (1864–1944) (LC, SLP)
LC, *American Landscape Painters*, 3/96
LC, *American Landscape Painters*, 12/96
LC, *Tonal Painting*, 3/97
LC, *Paintings by Artist Members*, 2/99

LC, *Landscapes and Marines*, 3/99
SLP, New York, 3/99
SLP, Chicago, 4/99
SLP, New York, 5/00
LC, *Paintings by Artist Members*, 2/01
LC, *Paintings from Hearn Collection*, 3/01
SLP, New York, 4/01
LC, *Paintings from the Pan-American*, 12/01
SLP, New York, 4/02
LC, *Paintings by Artist Members*, 2/03
SLP, New York, 4/03
LC, *Paintings from Rhoades Collection*, 12/05
LC, *Paintings from Ettlinger Collection*, 1/06
LC, *Paintings from Evans Collection*, 3/06

GEORGE DE FOREST BRUSH (1855–1941)
LC, *Paintings from Humphreys Collection*, 3/07
LC, *Paintings from Evans Collection*, 12/12
LC, *Paintings from Humphreys Collection*, 10/13

WILLIAM GEDNEY BUNCE (1840–1916)
LC, *Landscapes and Marines*, 3/99
LC, *Paintings from Rhoades Collection*, 1/03
LC, *Paintings from Rhoades Collection*, 12/05
LC, *Paintings from Evans Collection*, 3/06
LC, *Paintings from Humphreys Collection*, 3/07
LC, *Paintings from Evans Collection*, 12/12
LC, *Paintings from Humphreys Collection*, 10/13
LC, *Paintings from Rhoades Collection*, 1/14

CARLETON THEODORE CHAPMAN (1860–1925) (LC)
LC, *Paintings by Artist Members*, 2/03
LC, *Paintings by Artist Members*, 3/05
LC, *Paintings by Artist Members*, 2/06

WILLIAM MERRITT CHASE (1849–1916)
LC, *Paintings from Rhoades Collection*, 1/03
LC, *Paintings from Shaw Collection*, 4/04
LC, *Paintings from Ettlinger Collection*, 1/06
LC, *Paintings from Rhoades Collection*, 1/14

FREDERICK STUART CHURCH (1842–1924) (LC)
LC, *Paintings by Artist Members*, 2/01
LC, *Paintings by Artist Members*, 2/03
LC, *Paintings from Humphreys Collection*, 3/03
LC, *Paintings from Shaw Collection*, 4/04
LC, *Paintings from Ettlinger Collection*, 1/06
LC, *Paintings by Artist Members*, 2/06
LC, *Paintings from Evans Collection*, 3/06
LC, *Paintings from Evans Collection*, 12/12
LC, *Paintings from Humphreys Collection*, 10/13

WALTER CLARK (1848–1917) (SLP)
LC, *American Landscape Painters* 3/96
SLP, New York, 3/99
SLP, Chicago, 4/99
SLP, New York, 5/00
SLP, New York, 4/01
SLP, New York, 4/02
SLP, New York, 4/03

WILLIAM ANDERSON COFFIN (1855–1925) (SLP)
SLP, New York, 3/99
SLP, Chicago, 4/99
SLP, New York, 5/00
SLP, New York, 4/01
SLP, New York, 4/02
SLP, New York, 4/03

LEWIS COHEN (1857–1915) (LC)
LC, *Paintings by Artist Members*, 2/06

SAMUEL COLMAN (1832–1920) (LC)
LC, *Paintings from Rhoades Collection*, 1/03
LC, *Paintings from Rhoades Collection*, 12/05
LC, *Paintings from Rhoades Collection*, 1/14

COLIN CAMPBELL COOPER (1856–1937) (LC)
LC, *Paintings by Artist Members*, 2/06

E. IRVING COUSE (1866–1936) (LC)
LC, *Paintings by Artist Members*, 2/01
LC, *Paintings by Artist Members*, 2/03
LC, *Paintings by Artist Members*, 3/05

BRUCE CRANE (1857–1937) (LC, SLP)
SLP, New York, 3/99
SLP, Chicago, 4/99
LC, *American Landscape Painters*, 3/96
SLP, New York, 5/00
LC, *Paintings by Artist Members*, 2/01
SLP, New York, 4/02
LC, *Paintings by Artist Members*, 2/03
LC, *Paintings from Humphreys Collection*, 3/03
SLP, New York, 4/03
LC, *Paintings from Shaw Collection*, 4/04

CHARLES COURTNEY CURRAN (1861–1942) (LC)
LC, *Paintings by Artist Members*, 2/01
LC, *Paintings by Artist Members*, 2/03
LC, *Paintings from Shaw Collection*, 4/04
LC, *Paintings by Artist Members*, 3/05
LC, *Paintings by Artist Members*, 2/06
LC, *Paintings from Evans Collection*, 3/06

J. FRANK CURRIER (1843–1909)
LC, *Paintings from Rhoades Collection*, 1/03
LC, *Paintings from Rhoades Collection*, 12/05
LC, *Paintings from Rhoades Collection*, 1/14

ELLIOTT DAINGERFIELD (1859–1932) (LC)
LC, *Paintings by Artist Members*, 2/03
LC, *Paintings by Artist Members*, 3/05
LC, *Paintings by Artist Members*, 2/06
LC, *Paintings from Humphreys Collection*, 3/07
LC, *Paintings from Humphreys Collection*, 10/13

ARTHUR B. DAVIES (1862–1928)
LC, *Tonal Painting*, 3/97
LC, *Paintings from the Pan-American*, 12/01
LC, *Paintings from Rhoades Collection*, 1/03
LC, *Paintings from Humphreys Collection*, 3/03
LC, *Paintings from Rhoades Collection*, 12/05
LC, *Paintings from Humphreys Collection*, 3/07
LC, *Paintings from Humphreys Collection*, 10/13
LC, *Paintings from Rhoades Collection*, 1/14

CHARLES HAROLD DAVIS (1856–1933) (LC, SLP)
SLP, New York, 3/99
SLP, Chicago, 4/99
SLP, New York, 5/00
SLP, New York, 4/01
SLP, New York, 4/02
LC, *Paintings by Artist Members*, 2/03
LC, *Paintings from Humphreys Collection*, 3/03
LC, *Paintings by Artist Members*, 3/05
LC, *Paintings from Rhoades Collection*, 12/05

LC, *Paintings by Artist Members*, 2/06
LC, *Paintings from Evans Collection*, 3/06
LC, *Paintings from Humphreys Collection*, 3/07
LC, *Paintings from Humphreys Collection*, 10/13
LC, *Paintings from Rhoades Collection*, 1/14

ARTHUR DAWSON (1857–1922) (LC)
LC, *Paintings by Artist Members*, 2/01
LC, *Paintings by Artist Members*, 2/03
LC, *Paintings by Artist Members*, 3/05
LC, *Paintings by Artist Members*, 2/06

HENRY GOLDEN DEARTH (1864–1918)
LC, *Paintings from Rhoades Collection*, 12/05
LC, *Paintings from Humphreys Collection*, 3/07
LC, *Paintings from Humphreys Collection*, 10/13
LC, *Paintings from Rhoades Collection*, 1/14

MAURITZ FREDERIK DE HAAS (1832–1895)
LC, *Paintings from Ettlinger Collection*, 1/06

FRANKLIN B. DE HAVEN (1856–1934)
LC, *Paintings from Shaw Collection*, 4/04

HERBERT DENMAN (1855–1903)
LC, *Paintings from Shaw Collection*, 4/04

LOUIS PAUL DESSAR (1867–1952) (LC)
LC, *Paintings by Artist Members*, 2/99
LC, *Landscapes and Marines*, 3/99
LC, *Paintings by Artist Members*, 2/01
LC, *Paintings from Hearn Collection*, 3/01
LC, *Paintings from the Pan-American*, 12/01
LC, *Paintings from Rhoades Collection*, 1/03
LC, *Paintings by Artist Members*, 2/03
LC, *Paintings from Humphreys Collection*, 3/03
LC, *Paintings from Shaw Collection*, 4/04
LC, *Paintings by Artist Members*, 3/05
LC, *Paintings from Rhoades Collection*, 12/05
LC, *Paintings from Ettlinger Collection*, 1/06
LC, *Paintings by Artist Members*, 2/06
LC, *Paintings from Evans Collection*, 3/06
LC, *Paintings from Humphreys Collection*, 3/07
LC, *Paintings from Evans Collection*, 12/12
LC, *Paintings from Humphreys Collection*, 10/13
LC, *Paintings from Rhoades Collection*, 1/14

CHARLES MELVILLE DEWEY (1849–1937) (LC)
LC, *American Landscape Painters*, 3/96
LC, *American Landscape Painters*, 12/96
LC, *Landscapes and Marines*, 3/99
LC, *Paintings by Artist Members*, 2/01
LC, *Paintings from the Pan-American*, 12/01
LC, *Paintings from Rhoades Collection*, 1/03
LC, *Paintings by Artist Members*, 3/05
LC, *Paintings from Rhoades Collection*, 12/05
LC, *Paintings by Artist Members*, 2/06
LC, *Paintings from Evans Collection*, 3/06
LC, *Paintings from Evans Collection*, 12/12
LC, *Paintings from Rhoades Collection*, 1/14

THOMAS WILMER DEWING (1851–1938)
LC, *Paintings from the Pan-American*, 12/01
LC, *Paintings from Evans Collection*, 3/06

JOHN HENRY DOLPH (1835–1903) (LC)
LC, *Paintings by Artist Members*, 2/99
LC, *Paintings by Artist Members*, 2/01
LC, *Paintings by Artist Members*, 2/03

PAUL DOUGHERTY (1877–1947) (LC)
LC, *Paintings by Artist Members*, 3/05
LC, *Paintings from Rhoades Collection*, 12/05
LC, *Paintings by Artist Members*, 2/06
LC, *Paintings from Humphreys Collection*, 3/07
LC, *Paintings from Humphreys Collection*, 10/13
LC, *Paintings from Rhoades Collection*, 1/14

THOMAS EAKINS (1844–1916)
LC, *Paintings from Humphreys Collection*, 3/07
LC, *Paintings from Humphreys Collection*, 10/13

CHARLES HARRY EATON (1850–1901) (LC)
LC, *Paintings by Artist Members*, 2/01

CHARLES WARREN EATON (1857–1937) (LC)
LC, *American Landscape Painters*, 3/96
LC, *Paintings from the Pan-American*, 12/01
LC, *Paintings by Artist Members*, 2/03
LC, *Paintings by Artist Members*, 3/05
LC, *Paintings by Artist Members*, 2/06

WYATT EATON (1849–1896)
LC, *Paintings from Evans Collection*, 3/06

DE WITT CLINTON FALLS (1864–1937) (LC)
LC, *Paintings by Artist Members*, 2/01

BENJAMIN RUTHERFORD FITZ (1855–1891)
LC, *Paintings from Evans Collection*, 3/06
LC, *Paintings from Evans Collection*, 12/12

JAMES MONTGOMERY FLAGG (1877–1960) (LC)
LC, *Paintings by Artist Members*, 2/06

BEN FOSTER (1852–1926) (LC)
LC, *Paintings by Artist Members*, 2/01
LC, *Paintings from the Pan-American*, 12/01
LC, *Paintings from Rhoades Collection*, 1/03
LC, *Paintings by Artist Members*, 2/03
LC, *Paintings by Artist Members*, 3/05
LC, *Paintings from Rhoades Collection*, 12/05
LC, *Paintings from Ettlinger Collection*, 1/06
LC, *Paintings by Artist Members*, 2/06
LC, *Paintings from Humphreys Collection*, 3/07

FRANK FOWLER (1852–1910) (LC)
LC, *Paintings by Artist Members*, 3/05
LC, *Paintings by Artist Members*, 2/06

AUGUST FRANZEN (1863–1938) (LC)
LC, *Paintings by Artist Members*, 2/03
LC, *Paintings by Artist Members*, 3/05
LC, *Paintings by Artist Members*, 2/06

JOHN HEMMING FRY (1860–1946) (LC)
LC, *Paintings by Artist Members*, 3/05
LC, *Paintings by Artist Members*, 2/06

GEORGE FULLER (1822–1884)
LC, *Paintings from Rhoades Collection*, 12/05
LC, *Paintings from Evans Collection*, 3/06
LC, *Paintings from Humphreys Collection*, 3/07
LC, *Paintings from Humphreys Collection*, 10/13
LC, *Paintings from Rhoades Collection*, 1/14

HENRY FULLER (1867–1934)
LC, *Paintings from Evans Collection*, 3/06

GILBERT GAUL (1855–1919)
LC, *Paintings from Ettlinger Collection*, 1/06

EDWARD GAY (1837–1928) (LC)
LC, *Paintings from Shaw Collection*, 4/04
LC, *Paintings by Artist Members*, 3/05
LC, *Paintings by Artist Members*, 2/06

R. SWAIN GIFFORD (1840–1905) (SLP)
SLP, New York, 3/99
SLP, Chicago, 4/99
SLP, New York, 5/00
SLP, New York, 4/01
LC, *Paintings from the Pan-American*, 12/01
SLP, New York, 4/02
SLP, New York, 4/03
LC, *Paintings from Evans Collection*, 3/06
LC, *Paintings from Humphreys Collection*, 3/07
LC, *Paintings from Evans Collection*, 12/12

FRANK RUSSELL GREEN (1856–1940) (LC)
LC, *Paintings by Artist Members*, 3/05
LC, *Paintings by Artist Members*, 2/06

ALBERT L. GROLL (185–1940) (LC)
LC, *Paintings by Artist Members*, 2/06

EDGAR SCUDDER HAMILTON (1869–1903)
LC, *Paintings from Rhoades Collection*, 12/05

CHILDE HASSAM (1859–1935) (LC)
LC, *Paintings by Artist Members*, 2/01
LC, *Paintings by Artist Members*, 2/03
LC, *Paintings by Artist Members*, 3/05
LC, *Paintings from Ettlinger Collection*, 1/06
LC, *Paintings by Artist Members*, 2/06
LC, *Paintings from Evans Collection*, 3/06
LC, *Paintings from Humphreys Collection*, 3/07
LC, *Paintings from Humphreys Collection*, 10/13

CHARLES W. HAWTHORNE (1872–1930)
LC, *Paintings from Shaw Collection*, 4/04
LC, *Paintings from Humphreys Collection*, 10/13

HOWARD LOGAN HILDEBRANDT (1872–1958) (LC)
LC, *Paintings by Artist Members*, 2/06

ARTHUR HOEBER (1854–1915) (LC)
LC, *American Landscape Painters*, 3/96
LC, *Paintings by Artist Members*, 3/98
LC, *Paintings by Artist Members*, 2/01
LC, *Paintings by Artist Members*, 2/06
LC, *Paintings from Humphreys Collection*, 3/07
LC, *Paintings from Humphreys Collection*, 10/13

WINSLOW HOMER (1836–1910)
LC, *Landscapes and Marines*, 3/99
LC, *Paintings from Rhoades Collection*, 1/03
LC, *Paintings from Rhoades Collection*, 12/05
LC, *Paintings from Evans Collection*, 3/06
LC, *Paintings from Humphreys Collection*, 3/07
LC, *Paintings from Evans Collection*, 12/12
LC, *Paintings from Humphreys Collection*, 10/13
LC, *Paintings from Rhoades Collection*, 1/14

WILLIAM HENRY HOWE (1846–1929) (LC)
LC, *Paintings by Artist Members*, 2/01
LC, *Paintings from the Pan-American*, 12/01
LC, *Paintings by Artist Members*, 2/03

LC, *Paintings by Artist Members*, 3/05
LC, *Paintings by Artist Members*, 2/06
LC, *Paintings from Humphreys Collection*, 10/13

WILLIAM MORRIS HUNT (1824–1879)
LC, *Paintings from Evans Collection*, 3/06
LC, *Paintings from Humphreys Collection*, 3/07
LC, *Paintings from Humphreys Collection*, 10/13

HENRY IHLEFELD (1859–1932) (LC)
LC, *Paintings by Artist Members*, 2/01

GEORGE INNESS (1825–1894)
LC, *American Landscape Painters*, 3/96
LC, *American Landscape Painters*, 12/96
LC, *Tonal Painting*, 3/97
LC, *Landscapes and Marines*, 3/99
LC, *Paintings from the Pan-American*, 12/01
LC, *Paintings from Hearn Collection*, 3/01
LC, *Paintings from Rhoades Collection*, 1/03
LC, *Paintings from Rhoades Collection*, 12/05
LC, *Paintings from Ettlinger Collection*, 1/06
LC, *Paintings from Evans Collection*, 3/06
LC, *Paintings from Humphreys Collection*, 3/07
LC, *Paintings from Evans Collection*, 12/12
LC, *Paintings from Humphreys Collection*, 10/13
LC, *Paintings from Rhoades Collection*, 1/14

GEORGE INNESS, JR. (1853–1926) (LC, SLP)
LC, *Paintings by Artist Members*, 2/01
SLP, New York, 4/01
SLP, New York, 4/02
SLP, New York, 4/03
LC, *Paintings from Evans Collection*, 3/06

JOSEPH JEFFERSON
 (possibly Joseph Jefferson, IV [1829–1905]) (LC)
LC, *Paintings by Artist Members*, 3/98
LC, *Paintings by Artist Members*, 2/01

EASTMAN JOHNSON (1824–1906) (LC)
LC, *Paintings by Artist Members*, 3/98
LC, *Paintings by Artist Members*, 2/01

HUGH BOLTON JONES (1848–1927)
LC, *Paintings from Shaw Collection*, 4/04
LC, *Paintings from Ettlinger Collection*, 1/06

ALPHONSE JONGERS (1872–1945) (LC)
LC, *Paintings by Artist Members*, 2/01
LC, *Paintings by Artist Members*, 2/03
LC, *Paintings by Artist Members*, 2/06
LC, *Paintings from Rhoades Collection*, 1/14

ISAAC A. JOSEPHI (1860–1954) (LC)
LC, *Paintings by Artist Members*, 2/01
LC, *Paintings by Artist Members*, 2/03
LC, *Paintings by Artist Members*, 3/05
LC, *Paintings by Artist Members*, 2/06

WILLIAM SERGEANT KENDALL (1869–1938)
LC, *Paintings from Shaw Collection*, 4/04

FREDERICK WILLIAM KOST (1861–1923) (LC, SLP)
LC, *Landscapes and Marines*, 3/99
SLP, New York, 3/99
SLP, Chicago, 4/99
SLP, New York, 5/00
LC, *Paintings by Artist Members*, 2/01

SLP, New York, 4/01
SLP, New York, 4/02
LC, *Paintings by Artist Members*, 2/03
SLP, New York, 4/03
LC, *Paintings from Ettlinger Collection*, 1/06
LC, *Paintings from Humphreys Collection*, 3/07

JOHN LA FARGE (1835–1910) (LC)
LC, *Paintings by Artist Members*, 2/99
LC, *Paintings by Artist Members*, 2/01
LC, *Paintings from the Pan-American*, 12/01
LC, *Paintings from Rhoades Collection*, 12/05
LC, *Paintings from Evans Collection*, 3/06
LC, *Paintings from Humphreys Collection*, 3/07
LC, *Paintings from Evans Collection*, 12/12
LC, *Paintings from Humphreys Collection*, 10/13

WILLIAM LANGSON LATHROP (1859–1938)
LC, *American Landscape Painters*, 3/96
LC, *Paintings from Rhoades Collection*, 1/03
LC, *Paintings from Rhoades Collection*, 12/05
LC, *Paintings from Rhoades Collection*, 1/14

SIDNEY M. LAURENCE (1865–1940)
LC, *Paintings from Shaw Collection*, 4/04

HENRY CHARLES LEE (1864–1930) (LC)
LC, *Paintings by Artist Members*, 2/01
LC, *Paintings by Artist Members*, 2/03

HOMER C. LEE (1855–1923) (LC)
LC, *Paintings by Artist Members*, 3/98
LC, *Paintings by Artist Members*, 2/99
LC, *Paintings by Artist Members*, 2/01
LC, *Paintings by Artist Members*, 2/03
LC, *Paintings by Artist Members*, 3/05

LOUIS LOEB (1866–1909) (LC)
LC, *Paintings by Artist Members*, 3/05
LC, *Paintings by Artist Members*, 2/06
LC, *Paintings from Humphreys Collection*, 3/07
LC, *Paintings from Evans Collection*, 12/12
LC, *Paintings from Humphreys Collection*, 10/13

WILL HICKOK LOW (1853–1932) (LC)
LC, *Paintings by Artist Members*, 3/05
LC, *Paintings from Evans Collection*, 3/06

ARTHUR P. LUCAS (LC)
LC, *Paintings by Artist Members*, 3/05
LC, *Paintings from Ettlinger Collection*, 1/06

FERNAND HARVEY LUNGREN (1857–1932)
LC, *Paintings from Humphreys Collection*, 3/07

HOMER DODGE MARTIN (1836–1897)
LC, *American Landscape Painters*, 3/96
LC, *Tonal Painting*, 3/97
LC, *Landscapes and Marines*, 3/99
LC, *Paintings from Hearn Collection*, 3/01
LC, *Paintings from Rhoades Collection*, 1/03
LC, *Paintings from Rhoades Collection*, 12/05
LC, *Paintings from Ettlinger Collection*, 1/06
LC, *Paintings from Evans Collection*, 3/06
LC, *Paintings from Humphreys Collection*, 3/07
LC, *Paintings from Evans Collection*, 12/12
LC, *Paintings from Humphreys Collection*, 10/13
LC, *Paintings from Rhoades Collection*, 1/14

GEORGE WILLOUGHBY MAYNARD (1843–1923)
LC, *Paintings from Shaw Collection*, 4/04
LC, *Paintings from Ettlinger Collection*, 1/06

GEORGE HERBERT McCORD (1848–1909) (LC)
LC, *Paintings by Artist Members*, 2/99
LC, *Paintings by Artist Members*, 2/01
LC, *Paintings from Shaw Collection*, 4/04
LC, *Paintings by Artist Members*, 3/05
LC, *Paintings by Artist Members*, 2/06

CHARLES MORGAN McILHENNEY (1858–1904)
LC, *Paintings from Shaw Collection*, 4/04

WILLARD LEROY METCALF (1858–1925)
LC, *Paintings from Shaw Collection*, 4/04

STANLEY GRANT MIDDLETON (1852–1942) (LC)
LC, *Paintings by Artist Members*, 2/99
LC, *Paintings by Artist Members*, 2/01
LC, *Paintings by Artist Members*, 2/06

CHARLES H. MILLER (1842–1922) (LC)
LC, *American Landscape Painters*, 3/96
LC, *Paintings by Artist Members*, 3/98
LC, *Paintings by Artist Members*, 2/99
LC, *Paintings by Artist Members*, 2/01
LC, *Paintings by Artist Members*, 3/05
LC, *Paintings by Artist Members*, 2/06

ROBERT CRANNELL MINOR, SR. (1839–1904) (LC, SLP)
LC, *American Landscape Painters*, 3/96
LC, *American Landscape Painters*, 12/96
LC, *Tonal Painting*, 3/97
LC, *Paintings by Artist Members*, 3/98
LC, *Paintings by Artist Members*, 2/99
SLP, New York, 3/99
LC, *Landscapes and Marines*, 3/99
SLP, Chicago, 4/99
SLP, New York, 5/00
LC, *Paintings by Artist Members*, 2/01
SLP, New York, 4/01
LC, *Paintings from the Pan-American*, 12/01
SLP, New York, 4/02
LC, *Paintings by Artist Members*, 2/03
LC, *Paintings from Rhoades Collection*, 12/05
LC, *Paintings from Ettlinger Collection*, 1/06
LC, *Paintings from Evans Collection*, 3/06
LC, *Paintings from Humphreys Collection*, 3/07
LC, *Paintings from Humphreys Collection*, 10/13
LC, *Paintings from Rhoades Collection*, 1/14

EDWARD MORAN (1829–1901) (LC)
LC, *Paintings by Artist Members*, 2/99

THOMAS MORAN (1837–1926) (LC)
LC, *Paintings by Artist Members*, 3/98
LC, *Paintings by Artist Members*, 2/99

HENRY MOSLER (1841–1920)
LC, *Paintings from Ettlinger Collection*, 1/06

ADOLFO FELICE MULLER-URY (1868–1947) (LC)
LC, *Paintings by Artist Members*, 2/03
LC, *Paintings by Artist Members*, 3/05

J. FRANCIS MURPHY (1853–1921) (LC, SLP)
LC, *American Landscape Painters*, 3/96
LC, *Landscapes and Marines*, 3/99
SLP, New York, 3/99
SLP, Chicago, 4/99
LC, *American Landscape Painters*, 12/96
SLP, New York, 5/00
LC, *Paintings by Artist Members*, 2/01
LC, *Paintings from Hearn Collection*, 3/01
LC, *Paintings from the Pan-American*, 12/01
LC, *Paintings from Rhoades Collection*, 1/03
LC, *Paintings by Artist Members*, 2/03
LC, *Paintings from Shaw Collection*, 4/04
LC, *Paintings from Rhoades Collection*, 12/05
LC, *Paintings from Ettlinger Collection*, 1/06
LC, *Paintings from Evans Collection*, 3/06
LC, *Paintings from Humphreys Collection*, 3/07
LC, *Paintings from Evans Collection*, 12/12
LC, *Paintings from Humphreys Collection*, 10/13
LC, *Paintings from Rhoades Collection*, 1/14

CHARLES FREDERICK NAEGELE (1857–1944) (LC)
LC, *Paintings by Artist Members*, 2/03

LEONARD OCHTMAN (1854–1934) (LC, SLP)
LC, *Paintings by Artist Members*, 2/99
SLP, New York, 3/99
SLP, Chicago, 4/99
SLP, New York, 5/00
LC, *Paintings by Artist Members*, 2/01
LC, *Paintings from Hearn Collection*, 3/01
SLP, New York, 4/02
LC, *Paintings by Artist Members*, 2/03
SLP, New York, 4/03
LC, *Paintings from Shaw Collection*, 4/04
LC, *Paintings by Artist Members*, 3/05
LC, *Paintings from Ettlinger Collection*, 1/06
LC, *Paintings by Artist Members*, 2/06

WALTER LAUNT PALMER (1854–1932) (SLP)
SLP, New York, 3/99
SLP, Chicago, 4/99
SLP, New York, 5/00

STEPHEN PARRISH (1846–1938)
LC, *Paintings from Humphreys Collection*, 3/07

DEWITT PARSHALL (1864–1936) (LC)
LC, *Paintings by Artist Members*, 3/05
LC, *Paintings by Artist Members*, 2/06

ARTHUR PARTON (1842–1914)
LC, *American Landscape Painters*, 3/96

ERNEST PARTON (1845–1933)
LC, *American Landscape Painters*, 3/96

RICHARD PAULI (1855–1892)
LC, *Paintings from the Pan-American*, 12/01
LC, *Paintings from Ettlinger Collection*, 1/06

FLORIAN PEIXOTTO (b. 1871) (LC)
LC, *Paintings by Artist Members*, 3/98

CHARLES ROLLO PETERS (1862–1928) (LC)
LC, *Paintings by Artist Members*, 2/01

WILLIAM L. PICKNELL (1853–1897)
LC, *Paintings from Rhoades Collection*, 1/03

BERTUS PIETERSZ (1869–1938)
LC, *Paintings from Humphreys Collection*, 3/07

HENRY RANKIN POORE (1859–1940) (LC)
LC, *Paintings by Artist Members*, 2/03
LC, *Paintings by Artist Members*, 3/05
LC, *Paintings by Artist Members*, 2/06

EDWARD H. POTTHAST (1857–1927) (LC)
LC, *Paintings by Artist Members*, 2/01
LC, *Paintings by Artist Members*, 2/03
LC, *Paintings by Artist Members*, 3/05
LC, *Paintings by Artist Members*, 2/06
LC, *Paintings from Humphreys Collection*, 3/07

CHARLES EDWARD PROCTOR (1866–1950) (LC)
LC, *Paintings by Artist Members*, 2/01

HENRY WARD RANGER (1858–1916) (LC)
LC, *American Landscape Painters*, 3/96
LC, *American Landscape Painters*, 12/96
LC, *Tonal Painting*, 3/97
LC, *Paintings by Artist Members*, 2/99
LC, *Landscapes and Marines*, 3/99
LC, *Paintings from the Pan-American*, 12/01
LC, *Paintings from Rhoades Collection*, 1/03
LC, *Paintings by Artist Members*, 2/03
LC, *Paintings from Rhoades Collection*, 12/05
LC, *Paintings from Ettlinger Collection*, 1/06
LC, *Paintings by Artist Members*, 2/06
LC, *Paintings from Evans Collection*, 3/06
LC, *Paintings from Humphreys Collection*, 3/07
LC, *Paintings from Evans Collection*, 12/12
LC, *Paintings from Humphreys Collection*, 10/13
LC, *Paintings from Rhoades Collection*, 1/14

FRANK KNOX MORTON REHN (1848–1914) (LC)
LC, *Paintings by Artist Members*, 2/01
LC, *Paintings by Artist Members*, 2/03
LC, *Paintings by Artist Members*, 3/05
LC, *Paintings by Artist Members*, 2/06

JULIAN RIX (1850–1903) (LC)
LC, *Tonal Painting*, 3/97
LC, *Paintings by Artist Members*, 2/99
LC, *Landscapes and Marines*, 3/99
LC, *Paintings by Artist Members*, 2/01
LC, *Paintings from Humphreys Collection*, 3/07
LC, *Paintings from Humphreys Collection*, 10/13

THEODORE ROBINSON (1852–1896)
LC, *Paintings from Shaw Collection*, 4/04
LC, *Paintings from Humphreys Collection*, 3/07
LC, *Paintings from Evans Collection*, 12/12
LC, *Paintings from Humphreys Collection*, 10/13

WILLIAM S. ROBINSON (1861–1945) (LC)
LC, *Paintings by Artist Members*, 2/01
LC, *Paintings by Artist Members*, 2/03
LC, *Paintings by Artist Members*, 3/05
LC, *Paintings by Artist Members*, 2/06

ALBERT PINKHAM RYDER (1847–1917)
LC, *Tonal Painting*, 3/97
LC, *Landscapes and Marines*, 3/99
LC, *Paintings from Rhoades Collection*, 12/05
LC, *Paintings from Humphreys Collection*, 3/07
LC, *Paintings from Evans Collection*, 12/12
LC, *Paintings from Humphreys Collection*, 10/13
LC, *Paintings from Rhoades Collection*, 1/14

WILLIAM SARTAIN (1843–1924)
LC, *Paintings from the Pan-American*, 12/01
LC, *Paintings from Rhoades Collection*, 12/05
LC, *Paintings from Humphreys Collection*, 3/07
LC, *Paintings from Evans Collection*, 12/12
LC, *Paintings from Humphreys Collection*, 10/13
LC, *Paintings from Rhoades Collection*, 1/14

JOHN GORDON SAXTON (1857–1951) (LC)
LC, *Paintings from the Pan-American*, 12/01
LC, *Paintings by Artist Members*, 2/03
LC, *Paintings by Artist Members*, 3/05
LC, *Paintings by Artist Members*, 2/06
LC, *Paintings from Humphreys Collection*, 3/07

B. SCHERIRO-KRAMER (LC)
LC, *Paintings by Artist Members*, 3/98
LC, *Paintings by Artist Members*, 2/01

ROBERT VAN VORST SEWELL (1860–1924)
LC, *Paintings from Shaw Collection*, 4/04

WALTER SHIRLAW (1838–1909)
LC, *Paintings from the Pan-American*, 12/01
LC, *Paintings from Ettlinger Collection*, 1/06
LC, *Paintings from Evans Collection*, 12/12

ROSWELL MORSE SHURTLEFF (1838–1915) (LC)
LC, *Paintings by Artist Members*, 2/03
LC, *Paintings by Artist Members*, 3/05

GEORGE H. SMILLIE (1840–1921) (LC)
LC, *Paintings by Artist Members*, 2/01
LC, *Paintings by Artist Members*, 2/03
LC, *Paintings by Artist Members*, 2/06

FRANK HILL SMITH (1841–1904) (LC)
LC, *Paintings by Artist Members*, 2/99
LC, *Paintings by Artist Members*, 2/01

HENRY BAYLEY SNELL (1858–1943) (LC)
LC, *Paintings by Artist Members*, 3/05
LC, *Paintings from Humphreys Collection*, 3/07
LC, *Paintings from Humphreys Collection*, 10/13

GEORGE HENRY STORY (1835–1923) (LC)
LC, *Paintings by Artist Members*, 2/99
LC, *Paintings by Artist Members*, 2/01

ARTHUR FITZWILLIAM TAIT (1819–1905) (LC)
LC, *Paintings by Artist Members*, 2/99

ALLEN BUTLER TALCOTT (1867–1908) (LC)
LC, *Paintings by Artist Members*, 2/03
LC, *Paintings by Artist Members*, 3/05
LC, *Paintings by Artist Members*, 2/06

ABBOTT HANDERSON THAYER (1849–1921)
LC, *Paintings from the Pan-American*, 12/01
LC, *Paintings from Rhoades Collection*, 1/14

DWIGHT W. TRYON (1849–1925)
LC, *American Landscape Painters*, 12/96
LC, *Tonal Painting*, 3/97
LC, *Landscapes and Marines*, 3/99
LC, *Paintings from Hearn Collection*, 3/01
LC, *Paintings from Rhoades Collection*, 1/03
LC, *Paintings from Rhoades Collection*, 12/05

LC, *Paintings from Humphreys Collection*, 3/07
LC, *Paintings from Evans Collection*, 12/12
LC, *Paintings from Humphreys Collection*, 10/13
LC, *Paintings from Rhoades Collection*, 1/14

JULES TURCAS (1854–1917) (LC)
LC, *Paintings by Artist Members*, 2/03
LC, *Paintings by Artist Members*, 3/05
LC, *Paintings by Artist Members*, 2/06

JOHN HENRY TWACHTMAN (1853–1902)
LC, *Paintings from Hearn Collection*, 3/01
LC, *Paintings from Rhoades Collection*, 1/03
LC, *Paintings from Rhoades Collection*, 12/05
LC, *Paintings from Ettlinger Collection*, 1/06
LC, *Paintings from Humphreys Collection*, 3/07
LC, *Paintings from Evans Collection*, 12/12
LC, *Paintings from Humphreys Collection*, 10/13
LC, *Paintings from Rhoades Collection*, 1/14

BAYARD HENRY TYLER (1855–1931) (LC)
LC, *Paintings by Artist Members*, 2/03
LC, *Paintings by Artist Members*, 3/05

CHARLES FREDERIC ULRICH (1858–1908)
LC, *Paintings from Rhoades Collection*, 12/05

R. WARD VAN BOSKERCK (1855–1932) (LC)
LC, *Paintings by Artist Members*, 3/05
LC, *Paintings by Artist Members*, 2/06

ALEXANDER THEOBOLD VAN LAER (1857–1920) (LC)
LC, *Paintings by Artist Members*, 2/01
LC, *Paintings by Artist Members*, 2/03
LC, *Paintings by Artist Members*, 3/05
LC, *Paintings by Artist Members*, 2/06

DOUGLAS VOLK (1856–1935)
LC, *Paintings from Shaw Collection*, 4/04

ROBERT W. VONNOH (1858–1891) (LC)
LC, *Paintings by Artist Members*, 3/05

HARRY MILLS WALCOTT (1870–1944)
LC, *Paintings from Shaw Collection*, 4/04

HENRY OLIVER WALKER (1843–1929)
LC, *Paintings from the Pan-American*, 12/01
LC, *Paintings from Shaw Collection*, 4/04
LC, *Paintings from Rhoades Collection*, 12/05

HORATIO O. WALKER (1858–1938)
LC, *Paintings from the Pan-American*, 12/01
LC, *Paintings from Rhoades Collection*, 1/03
LC, *Paintings from Humphreys Collection*, 3/07
LC, *Paintings from Humphreys Collection*, 10/13
LC, *Paintings from Rhoades Collection*, 1/14

HARRY WILLSON WATROUS (1857–1950) (LC)
LC, *Paintings by Artist Members*, 3/05

FREDERICK J. WAUGH (1861–1940)
LC, *Paintings from Evans Collection*, 12/12

J. ALDEN WEIR (1852–1919) (LC)
LC, *Landscapes and Marines*, 3/99
LC, *Paintings from the Pan-American*, 12/01
LC, *Paintings by Artist Members*, 2/06
LC, *Paintings from Evans Collection*, 12/12

MAX WEYL (1837–1914)
LC, *Paintings from Ettlinger Collection*, 1/06

WORTHINGTON WHITTREDGE (1820–1910) (LC)
LC, *Paintings by Artist Members*, 2/99
LC, *Paintings from the Pan-American*, 12/01
LC, *Paintings by Artist Members*, 2/03

CARLETON WIGGINS (1848–1932) (LC, SLP)
LC, *American Landscape Painters*, 3/96
LC, *Paintings by Artist Members*, 2/99
SLP, New York, 3/99
SLP, Chicago, 4/99
SLP, New York, 5/00
SLP, New York, 4/01
SLP, New York, 4/02
LC, *Paintings by Artist Members*, 2/03
SLP, New York, 4/03
LC, *Paintings by Artist Members*, 2/06
LC, *Paintings from Humphreys Collection*, 10/13

IRVING R. WILES (1861–1948) (LC)
LC, *Paintings by Artist Members*, 3/98
LC, *Paintings by Artist Members*, 2/99
LC, *Paintings from Shaw Collection*, 4/04

FREDERICK J. WILEY (LC)
LC, *American Landscape Painters*, 3/96
LC, *Paintings by Artist Members*, 2/01

FREDERICK BALLARD WILLIAMS (1871–1956) (LC)
LC, *Paintings from Rhoades Collection*, 1/03
LC, *Paintings by Artist Members*, 2/03
LC, *Paintings by Artist Members*, 3/05
LC, *Paintings from Rhoades Collection*, 12/05
LC, *Paintings by Artist Members*, 2/06
LC, *Paintings from Humphreys Collection*, 3/07
LC, *Paintings from Evans Collection*, 12/12
LC, *Paintings from Humphreys Collection*, 10/13
LC, *Paintings from Rhoades Collection*, 1/14

ALEXANDER H. WYANT (1836–1892)
LC, *American Landscape Painters*, 3/96
LC, *American Landscape Painters*, 12/96
LC, *Tonal Painting*, 3/97
LC, *Landscapes and Marines*, 3/99
LC, *Paintings from Hearn Collection*, 3/01
LC, *Paintings from the Pan-American*, 12/01
LC, *Paintings from Rhoades Collection*, 1/03
LC, *Paintings from Humphreys Collection*, 3/03
LC, *Paintings from Rhoades Collection*, 12/05
LC, *Paintings from Ettlinger Collection*, 1/06
LC, *Paintings from Evans Collection*, 3/06
LC, *Paintings from Humphreys Collection*, 3/07
LC, *Paintings from Evans Collection*, 12/12
LC, *Paintings from Humphreys Collection*, 10/13
LC, *Paintings from Rhoades Collection*, 1/14

Collector Biographies

LOUIS ETTLINGER (1846–1927) was a prominent figure in the field of lithographic printing and an avid horticulturist. He was born in Germany and immigrated to the United States in 1866, settling in New York. There he established the lithographic firm of Schumacher and Ettlinger, which became the American Lithographic Company in 1892. Ettlinger later was director of the Crowell Publishing Company, which produced *Collier's Weekly*, *Woman's Home Companion*, *American Magazine*, *Farm and Fireside*, and *The Mentor*. He was also chairman of the board of the Persian Rug Manufactory. After purchasing Boscobel, the Henry Ward Beecher estate in Peekskill, New York, Ettlinger continued the preacher's work of transplanting and cultivating trees from foreign countries. Elliott Daingerfield was among the pallbearers at his funeral in 1927.

WILLIAM T. EVANS (1843–1918) earned his fortune in the drygoods business.[1] He was born in Cloghjordan, County Tipperary, Ireland, and was brought to the United States by his parents when he was an infant. After attending the College of the City of New York, Evans worked in an architect's office for a year before becoming employed by the counting house of E. S. Jaffrey and Company. He then joined two senior clerks from the firm in the wholesale dry goods business of Mills and Gibb. He rose from bookkeeper, to secretary in 1899, and to president in 1904. As his wealth increased, Evans acquired art, real estate, and built several homes, including a brownstone mansion on West 76th Street in Manhattan, that had a painting gallery on its main floor. In 1900 he purchased Wentworth Manor in Montclair, New Jersey, from George Inness, Jr., to which he added a gallery. In 1890 Evans sold the European art in his collection and began exclusively to purchase works by American artists, becoming the nation's leading collector of contemporary American art. Evans held a sale of many of his holdings in 1900, but continued to purchase additional works in the years that followed. From 1907 until 1915, he donated paintings from his collection in a series of installments, distributing them to a number of art museums most notably the Smithsonian (now Smithsonian American Art Museum) and the Corcoran, both in Washington, D.C., and the Montclair Art Museum, New Jersey. In 1913 he was forced to sell his collection to cover funds he had removed over the years from Mills and Gibb. For the same reason, he sold Wentworth Manor in 1915. Lawsuits brought against artists and dealers who had received payments from Mills and Gibb were eventually dropped, but Evans was not able to resume his activities as a collector. Evans was a noted figure in the Lotos, National Arts, and Salmagundi Clubs. For sixteen years, from 1894 to 1910, he was chairman of the art committee at the Lotos Club, working to organize exhibitions at the club in close association with Henry Ward Ranger, who served as the club's secretary.

GEORGE ARNOLD HEARN (1835–1913) inherited one of America's most successful dry-goods firms.[2] In 1860, after working for the dry goods firm of Rogers, Catlin, Leavitt and Company, he joined his father's business, which changed its name at the time from Arnold, Hearn and Company to James A. Hearn and Son. The establishment moved in 1879 from 425 Broadway near Canal Street in New York City to a grander building on West Fourteenth Street, between Fifth and Sixth Avenues. It remained in business, vying with Macy's, until 1955. George Hearn gradually gathered a large, eclectic collection, including English and European paintings, Chinese porcelains, gold watches, jade, bronzes, English miniatures, and carved ivories. He added American art to his collection, beginning in the mid-1890s, after befriending several artists and attending annuals at the National Academy of Design. In 1903 Hearn became a trustee of the Metropolitan Museum of Art, an appointment preceded by a number of years in which he had made select gifts to the museum. In recognition of his generosity, he was given the honorary title of museum benefactor in 1905. Although Hearn donated European works to the museum, his efforts were concentrated mostly on building the museum's collection of works by living American artists, some of which he donated and some of which were purchased for the museum from the endowment he provided in the form of the Hearn Fund. When his son died suddenly, Hearn provided the museum in 1911 with a separate endowment fund in his son's memory. Hearn belonged to the New York Chamber of Commerce, the New York Genealogical and Biographical Society, the Seamen's Christian Association, and the Lotos Club, on which he held a position on the art council and often lent works from his collection after becoming a member in 1894. Hearn served on the council of the University of the City of New York and was a patron of the American Museum of Natural History and of the Brooklyn Institute of Arts and Sciences (now the Brooklyn Museum of Art).

ALEXANDER CROMBIE HUMPHREYS (1851–1927) was an engineer and a leader in the oil and gas industry of his time. He was born in Edinburgh, Scotland, and grew up in Boston, where he immigrated with his parents when he was eight. After working in the insurance industry in Boston and New York, he became superintendent of the Bayonne and Greenville Gas Light Company, a job that led to his interest in obtaining technical training. To this end, he attained an engineering degree from the Stevens Institute of Technology, Hoboken, New Jersey, in 1881. He then became the chief engineer for the Pintsch Lighting Company, for which he built oil-gas plants. He continued in this role for the United Gas Improvement Company of Philadelphia, while also conducting experiments and reorganizing the company's administrative infrastructure. In 1892 he formed the firm of Humphreys and Glasgow, headquartered first in London and then in New York, which designed and constructed the first water-gas plant. Humphreys went on to establish similar plants in many nations. In 1902 he gave up his businesses to become president of the Stevens Institute.

JOHN HARSEN RHOADES (1838–1906) was a banker, who led many financial institutions in New York City at the end of the nineteenth century. A descendant of an early Dutch colonist in America, Rhoades was born in New York City and began his career in the drygoods business in 1855. In 1866 he became junior partner in the drygoods firm of Leonard, Schofield and Company, which one year later became Leonard and Rhoades, and then Leonard, Rhoades and Grosvenor. When he was twenty-four, he became a trustee of the Greenwich [Connecticut] Savings Bank. Retiring from the mercantile industry in 1877, when he was thirty-nine, Rhodes became president of the bank's board. Later he held governing roles for the New York Eye and Ear Infirmary, Woman's Hospital, and Roosevelt Hospital. He was also served as director of Bank of America, Greenwich Bank, Candelaria Mining Company, Madison Safe Deposit Company, Lincoln Trust Company, United Shoe Machinery, and the United States and Washington Trust Companies. He held memberships in many New York clubs, including the Century, Lawyers, Lotos, Metropolitan, and Union League. He also belonged to the American Geographical Society, the Municipal Art Society, the New York Chamber of Commerce, and the St. Nicholas Society. Henry Ward Ranger served as a pallbearer at Rhoades's funeral in 1906.

SAMUEL T. SHAW (1861–1945) inherited a real estate empire from his father, James E. Shaw. In 1874 he became the proprietor of New York City's Grand Union Hotel, located across from Grand Central Terminal, where he displayed his extensive collection of American paintings. Shaw was closely associated with the Salmagundi Club, the Society of American Artists, and the National Academy of Design, and offered a number of yearly prizes for the best paintings on view in the annuals of these organizations.

LNP

1. For information on Evans, see William Truettner, "William T. Evans, Collector of American Paintings," *American Art Journal* 3 (Fall 1971), pp. 50–79 and Jack Becker, "A Taste for Landscape: Studies in American Tonalism," Ph.D. diss., University of Delaware, 2002, chapter 2: "William T. Evans, Collector of American Art," pp. 1–56.

2. For information on Hearn, see Carrie Rebora Barratt, "George A. Hearn: 'Good American Pictures Can Hold Their Own,'—Metropolitan Museum of Art Benefactor," *Magazine Antiques* 157 (January 2000), pp. 218–23; Doreen Bolger, "William Macbeth and George Hearn: Collecting American Art, 1903–1910," *Archives of American Art Journal* 15 (1975), pp. 9–15; "In Memoriam: George Arnold Hearn, A Trustee of The Metropolitan Museum of Art 1903–1913," *Metropolitan Museum of Art Bulletin* 9 (January 1914), p. 2; and "Mr. George A. Hearn's Gift to the Museum, and to the Cause of American Art," *Metropolitan Museum of Art Bulletin* 1 (February 1906), pp. 33–37

Selected Bibliography

Ranger, Henry Ward. "Artist Life by the North Sea." *Century Magazine* 45 (March 1893), pp. 753–59.

———. "Mr. H. W. Ranger on Sketching in Holland." *Art Amateur* 28 (April 1993), p. 132.

———. "Sketching Grounds in Holland and Normandy." *Art Amateur* 31 (June 1894), p. 5.

———. "A Basis for Criticism on Painting." *Collector* 6 (November 15, 1894), pp. 24–26.

Crane, Bruce. "Objective and Subjective Painting." *Art Amateur* 36 (July 1897), p. 9.

"What Is Tone?" *Art Amateur* 32 (March 1898), pp. 117–18.

Hunt, Leigh. "Art in America." *Art Collector* 9 (November 1, 1898), pp. 5–6.

———. "Tonality." *Art Collector* 9 (December 1, 1898), pp. 36–37.

"Tonality." *Art Collector* 9 (January 1, 1899), pp. 74–75.

"A Reply to 'The Critic' on 'Tonality.'" *Art Collector* 9 (January 15, 1899), pp. 85–86.

"A Further Word on 'Tonality.'" *Art Collector* 9 (February 1, 1899), pp. 100–101.

Hunt, Leigh. "The Landscape Painters." *Art Collector* 9 (April 1, 1899), p. 165.

Mechlin, Leila. "Contemporary American Landscape Painting." *International Studio* 39 (November 1902), pp. 3–14.

Sturgis, Russell. "The Recent Comparative Exhibition of Native and Foreign Art." *Scribner's Magazine* 37 (February 1905), pp. 253–56.

Ruge, Clara. "The Tonal School of America." *International Studio* 27 (January 1906), pp. 57–66.

Slocum, Grace L. "An American Barbizon: Old Lyme and Its Artist Colony." *New England Magazine* 34 (July 1906), pp. 563–71.

Harrison, Birge. *Landscape Painting*. New York: Charles Scribner's Sons, 1909, 1910.

———. "The Future of American Art." *North American Review* 109 (January 1909), pp. 26–34.

———. "The True Impressionism in Art." *Scribner's Magazine* 46 (October 1909), pp. 491–95.

———. "The 'Mood' in Modern Painting." *Art and Progress* 4 (July 1913), pp. 1015–20.

———. "The Appeal of the Winter Landscape." *Fine Arts Journal* 30 (May 1914), pp. 191–96.

Bell, Ralcy Husted. *Art-Talks with Ranger*. New York and London: G.P. Putnam's Sons, 1914.

Harrison, Birge. "The New Art in America." *Scribner's Magazine* 57 (March 1915), pp. 391–94.

Hoeber, Arthur. *The Barbizon Painters, Being the Story of the Men of Thirty*. New York: Frederick A. Stokes, 1915.

Daingerfield, Elliott. "Color and Form: Their Relationship." *Art World* 3 (December 1917), pp. 179–80.

Siegfried, Joan C. *Some Quietest Painters: A Trend Toward Minimalism in Late Nineteenth-Century American Painting*. Exh. cat. Saratoga Springs, N.Y.: Hathorn Gallery, Skidmore College, 1970.

Bermingham, Peter. "Barbizon Art in America: A Study of the Role of the Barbizon School in the Development of American Painting." Ph.D. diss., University of Michigan, 1972.

Corn, Wanda M. *The Color of Mood: American Tonalism 1880–1910*. Exh. cat. San Francisco: M. H. De Young Memorial Museum and the California Palace of the Legion of Honor, 1972.

Bermingham, Peter. *American Art in the Barbizon Mood*. Exh. cat. Washington, D.C.: Smithsonian Institution, 1975.

Muir, Mary Margaret Morgan. "Tonal Painting, Tonalism, and Tonal Impressionism." M.A. thesis, University of Utah, 1978.

Andersen, Jeffrey W. *Old Lyme: The American Barbizon*. Exh. cat. Old Lyme, Conn.: Florence Griswold Museum, 1982.

Gerdts, William H. et al. *Tonalism: An American Experience*. Exh. cat. New York: Grand Central Art Galleries, 1982.

Jones, Harvey L. *Twilight and Reveries: California Tonalist Painting, 1890–1935*. Exh. cat. Oakland, Calif.: Oakland Museum, 1995.

Grinnell, Nancy Whipple. *The Light Beyond: Paintings and Prints from the Permanent Collection Depicting Dawn, Twilight, and Moonlight*. Exh. cat. Duxbury, Mass.: Art Complex Museum, 1996.

Becker, Jack. *Encouraging American Art: The Lotos Club, 1870–1920*. New York: Lotos Club, 1997.

Avery, Kevin J. and Diane P. Fischer. *American Tonalism: Selections from the Metropolitan Museum of Art and the Montclair Art Museum*. Exh. cat. Montclair, N.J.: Montclair Art Museum, 1999.

Becker, Jack. "A Taste for Landscape: Studies in American Tonalism." Ph.D. diss., University of Delaware, 2002.

Opposite:
Leon Dabo
Hudson River
(detail of Cat. 3)

Contributors

JACK BECKER, president/CEO Cheekwood Botanical Garden and Museum of Art in Nashville, Tennessee and formerly curator, Florence Griswold Museum, Old Lyme, Connecticut; he is the author of "The American Artist in New England," in *Envisioning New England: Treasures from Community Art Museums* (2004, University Press of New England); *The California Impressionists at Laguna*, (2000, Florence Griswold Museum); *Henry Ward Ranger and the Humanized Landscape*, (1999, Florence Griswold Museum); *American Garden Literature in the Dumbarton Oaks Collection (1785–1900)*, (with Joachim Wolschke-Bulmahn, 1998, Dumbarton Oaks Research Library and Collection); and *Encouraging American Art: The Lotos Club, 1870–1920*, (1997, The Lotos Club).

NICOLAI CIKOVSKY, JR., retired senior curator, American and British painting, National Gallery of Art, Washington, D.C., and formerly chairman, art departments, Pomona College and the University of New Mexico; among his many publications are *Winslow Homer* (1993, Harry N. Abrams); *George Inness* (1992, Harry N. Abrams); *Raphaelle Peale Still Lifes* (1992, Harry N. Abrams); *Winslow Homer Watercolors* (1991, Hugh Lauter Levin); exhibition catalogues, including *Winslow Homer* (with Franklin Kelly, 1995, National Gallery of Art); *William Merritt Chase: Summers at Shinnecock, 1891–1902* (with D. Scott Atkinson, 1988, National Gallery of Art); *George Inness* (with Michael Quick, 1985, Los Angeles County Museum of Art); and *Sanford Robinson Gifford, 1823–1880* (1970, University of Texas, Austin); and contributions to exhibition catalogues, including *James McNeill Whistler* (1994, Tate Gallery); *William M. Harnett* (1993, Metropolitan Museum of Art); and *John Singer Sargent's El Jaleo* (1992, National Gallery of Art).

ELLEN PAUL DENKER, museum consultant, writer, and independent scholar specializing in American ceramic history; her publications include *From Tabletop to TV Tray: China and Glass in America, 1880–1980* (2000, Harry N. Abrams), *Miller's 20th-Century Ceramics* (1999, Millers/ Mitchell Beazley), *Treasures of State: Fine and Decorative Arts in the U.S. Department of State* (1991, Harry N. Abrams), *Lenox China: Celebrating a Century of Quality, 1889–1989* (1989, New Jersey State Museum), among many others. She recently received the Robert C. Smith Award from the Decorative Arts Society for the most distinguished article on the decorative arts published in 2002.

DIANE P. FISCHER, independent scholar and consultant, formerly associate curator at the Montclair Art Museum; she has taught at Montclair State University, Seton Hall University, and Pratt Institute; her publications include *Paris 1900: The 'American School' at the Universal Exposition* (editor and primary author, 1999, Montclair Art Museum and Rutgers University Press; French edition, 2001, Paris Musées); *Primal Visions: Albert Bierstadt 'Discovers' America* (2001, Montclair Art Museum); *American Tonalism: Selections from the Metropolitan Museum of Art and the Montclair Art Museum* (with Kevin J. Avery, 1999, Montclair Art Museum); and *The Montclair Art Colony: Past and Present* (with Gail Stavitsky, 1997, Montclair Art Museum).

WILLIAM H. GERDTS, professor emeritus of art history, Graduate School of the City University of New York; his writings encompass numerous articles and books, including *The Not-So-Still Life: A Century of California Painting and Sculpture* (with Susan Landauer and Patricia Trenton, 2005); *The Golden Age of American Impressionism* (with Carol Lowrey, 2003, Watson-Guptill); *Joseph Raphael (1869–1950): An Artistic Journey* (2003, Spanierman Gallery); *California Impressionism* (with Will South, 1998, Abbeville); *Impressionist New York* (1994, Abbeville); *William Glackens* (with Jorge H. Santis, 1996, Abbeville); *Monet's Giverny: An Impressionist Colony* (1993, Abbeville); *Art Across America* (1990, Abbeville); *American Impressionism* (1984, Abbeville); *Painters of the Humble Truth: Masterpieces of American Still-Life, 1801–1939* (1981, Philbrook Art Center); *Grand Illusions: History Painting in America* (with Mark Thistlewaite, 1988, Amon-Carter Museum); and *Down Garden Paths: The Floral Environment in American Art* (1983, Farleigh Dickinson University).

CAROL LOWREY, research associate, Spanierman Gallery and curator of the permanent collection, National Arts Club in New York. A specialist in American and Canadian art of the late nineteenth and early twentieth centuries, she is the author of numerous articles, essays, and exhibition catalogues, including *The Golden Age of American Impressionism* (with William H. Gerdts, 2003, Watson-Guptill), *Richard Hayley Lever* (2003, Spanierman Gallery), *Canadian Impressionism* (1995, Americas Society), and *A Noble Tradition: American Paintings from the National Arts Club* (1995, Florence Griswold Museum).

LINDA MERRILL, independent scholar and formerly curator of American art, Freer Gallery, Washington, D.C., and the High Museum, Atlanta; author of *The Peacock Room: A Cultural Biography* (1998, Yale University Press); *Freer: A Legacy of Art* (with Thomas Lawton, 1993, Harry N. Abrams); *A Pot of Paint: Aesthetics on Trial in Whistler v. Ruskin* (1992, Smithsonian Institution); and *An Ideal Country: Paintings by Dwight William Tryon in the Freer Gallery of Art* (1990, University Press of New England); and editor of *After Whistler: The Artist and His Influence on American Painting* (2003, High Museum) and *With Kindest Regards: The Correspondence of Charles Lang Freer and James McNeill Whistler* (1995, Smithsonian Books).

LISA N. PETERS, director of research and publications and co-author, John H. Twachtman Catalogue Raisonné, Spanierman Gallery, LLC; among her publications are an article for *American Art Journal* (2000) on the American artists' colony in Polling, Bavaria, 1872–81; *John Henry Twachtman: An American Impressionist* (1999, High Museum); *Visions of Home: American Impressionist Images of Suburban Leisure and Country Comfort* (1997, Dickinson College); *A Personal Gathering: Paintings and Sculpture from the Collection of William I. Koch* (1996, Wichita Art Museum); and an essay in *John Twachtman: Connecticut Landscapes* (1989, National Gallery of Art).

RALPH SESSIONS, director of drawings, Spanierman Gallery, and formerly chief curator, American Folk Art Museum, director, Abigail Adams Smith Museum in New York City, and director, Historical Society of Rockland County, New York; among his publications are *The Shipcarvers' Art: Figureheads and Cigar Store Figures in Nineteenth-Century America* (2005, Princeton University Press); the sculpture catalogue for Stacey C. Hollander, et al., *American Radiance: The Ralph Esmerian Gift to the American Folk Art Museum* (2001, Harry N. Abrams); and the catalogue for Tom Geismar and Harvey Kahn, *Spiritually Moving: A Collection of American Folk Sculpture* (1998, Harry N. Abrams).

Index to Reproductions

Photography Credits